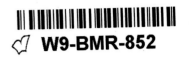
HOWARD PYLE

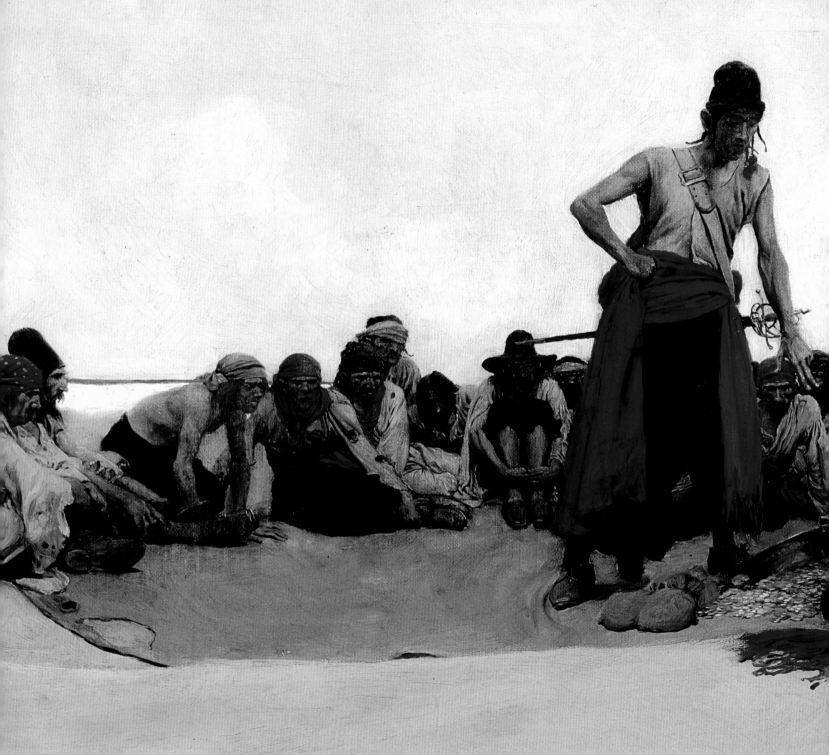

Delaware Art Museum · Wilmington Distributed by the University of Pennsylvania Press, Philadelphia

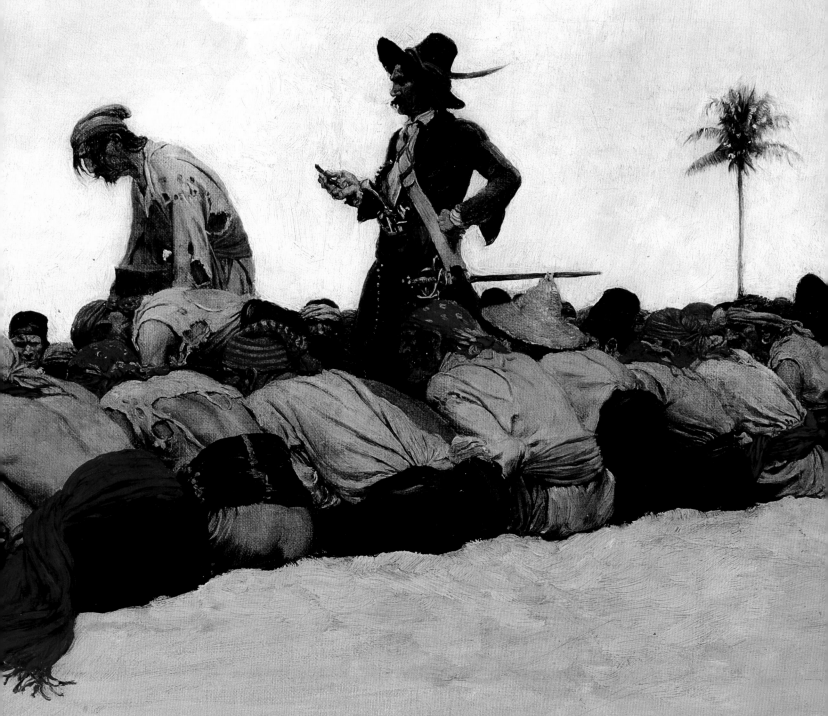

HOWARD PYLE

AMERICAN MASTER REDISCOVERED

Edited by Heather Campbell Coyle

Published in conjunction with the exhibition
Howard Pyle: American Master Rediscovered
Delaware Art Museum
November 12, 2011–March 4, 2012

Norman Rockwell Museum
Stockbridge, Massachusetts
June 9–October 28, 2012

Lenders to the exhibition:
Brandywine River Museum, Chadds Ford
Brooklyn Museum, New York
The Kelly Collection of American Illustration
Philadelphia Museum of Art
The Walters Art Museum, Baltimore
Yale University Art Gallery, New Haven

This exhibition is made possible by:
DuPont, supporting exhibitions and programs related to the Delaware Art Museum's Centennial Celebration

Foundation Sponsor: Henry Luce Foundation
Wyeth Foundation for American Art
Starrett Foundation
Howard Pyle Brokaw
Roberts and Allison Brokaw

Additional support in Delaware is provided by Delaware Division of the Arts, a state agency dedicated to nurturing and supporting the arts in Delaware, in partnership with the National Endowment for the Arts.

Library of Congress
Cataloging-in-Publication Data

Pyle, Howard, 1853–1911.
 Howard Pyle : American master rediscovered /edited by Heather Campbell Coyle.
 p. cm.
 Published in conjunction with an exhibition held at the Delaware Art Museum, Wilmington, Del., Nov. 12, 2011–Mar. 4, 2012 and at the Norman Rockwell Museum, Stockbridge, Mass., June 9–Oct. 28, 2012.
 Includes bibliographical references and index.
 ISBN 978-0-9771644-3-1
 1. Pyle, Howard, 1853–1911—Exhibitions. I. Coyle, Heather Campbell. II. Delaware Art Museum. III. Norman Rockwell Museum at Stockbridge. IV. Title. V. Title: American master rediscovered.
N6537.P94A4 2011
741.6092—dc23 2011030413

Published by Delaware Art Museum. Distributed by University of Pennsylvania Press.

Edited by Laura L. Morris
with Carolyn Vaughan
Photography of most works at Delaware Art Museum and Brandywine River Museum by Rick Echelmeyer
Designed by Jeff Wincapaw
Proofread by Carrie Wicks
Typesetting and layout by Tina Henderson
Color separations by iocolor, Seattle
Produced by Marquand Books, Inc., Seattle
 www.marquand.com

Printed and bound in China by C&C Color Printing Co., Ltd.

Front cover: Howard Pyle, *We Started to Run Back to the Raft for Our Lives* (detail of fig. 25)

Back cover: Unknown photographer. Pyle painting *The Coming of the English* (mural for William J. Brennan Hudson County Courthouse, Jersey City, New Jersey), 1907 (detail). Photograph, 5½ × 3⅜ inches. Frank E. Schoonover Papers, Helen Farr Sloan Library and Archives, Delaware Art Museum

Title page: Howard Pyle, *So the Treasure Was Divided* (detail of fig. 59)

Dedication page: Howard Pyle, *Marooned* (detail of fig. 27)

Table of Contents: Howard Pyle, *The Sailor is Saved* (detail of fig. 1)

p. 10: Howard Pyle, *Old Jacob Van Kleek Had Never Favored Our Hero's Suit*, 1908 (detail of fig. 12)

p. 30: Howard Pyle, *Extorting Tribute from the Citizens* (detail of fig. 24)

p. 46: Howard Pyle, *How Arthur Drew Forth ye Sword* (detail of fig. 40)

p. 58: Howard Pyle, *The Buccaneer Was a Picturesque Fellow* (detail of fig. 55)

p. 72: Howard Pyle, *The Attack upon the Chew House*, 1898 (detail of fig. 69)

p. 88: Howard Pyle, *Peractum Est!* (detail of fig. 80)

p. 106: Howard Pyle, *He Was Standing at an Open Window* (detail of fig. 88)

p. 122: Howard Pyle, *His Army Broke Up and Followed Him, Weeping and Sobbing* (detail of fig. 92)

p. 132: Howard Pyle, *The Duel between John Blumer and Cazaio* (detail of fig. 94)

p. 138: N.C. Wyeth, *In the Crystal Depths* (detail of fig. 106)

p. 156: Norman Rockwell, *Family Tree* (detail of fig. 111)

p. 166: Howard Pyle, *Captain Keitt* (detail of fig. 116)

p. 182: Unknown photographer. Students at Chadds Ford, 1899 (detail). Photograph, 5¾ × 9½ inches. Howard Pyle Manuscript Collection, Helen Farr Sloan Library and Archives, Delaware Art Museum

Dedicated to the memory of Andrew Wyeth (1917–2009)

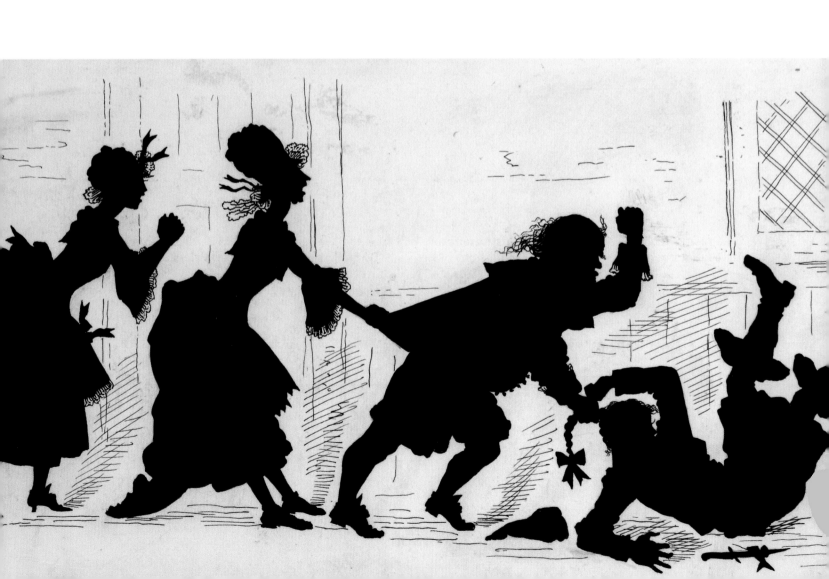

CONTENTS

FOREWORD

Soon after Howard Pyle's death in Florence, Italy, on November 9, 1911, a group of his friends and patrons planned a memorial exhibition of his work. Announcing the exhibition on March 1, 1912, the *Evening Journal* of Wilmington, Delaware, effused: "Mr. Pyle was a master, and to Wilmington he is as illustrious as are the old masters that attract thousands of tourists to Italian towns every year. Not in a thousand years is Delaware likely to produce another such genius."

The exhibition, held in a rented ballroom of the DuPont Building in downtown Wilmington on March 13 and 14, 1912, drew more than ten thousand visitors over the course of those two days. Open from 2:00 to 10:00 P.M. so that working people could attend, the exhibition elicited so much enthusiasm and spontaneous fund-raising that many of Pyle's best paintings were purchased from his widow shortly after it closed. This purchase formed the core of what came to be known as the Wilmington Society of the Fine Arts, which incorporated as an entity in November 1912. The Society's mission mirrored Pyle's passion for education in its stated purpose: "To promote the knowledge and enjoyment of and cultivation of the Fine arts in the State of Delaware by the establishment of schools and other methods of instruction; by books and other publications; by the establishment of a gallery or galleries of paintings and sculpture; and by such other methods as in the judgment of its members may further the promotion of the cultivation of the Fine Arts."

After occupying various temporary locations and undergoing several name changes, the Wilmington Society of the Fine Arts became the Delaware Art Museum in 1970. Although the Museum now houses a diverse collection of American and British art, the Pyle collection is and has always been at the core of the institution. But while Pyle continues to be revered locally and still inspires illustrators and filmmakers, his work nevertheless has been ignored by traditional art history. On the eve of the Delaware Art Museum's centennial anniversary, it therefore seemed both appropriate and necessary to reexamine Pyle's contribution to the history of art.

I am embarrassed to admit that when I first became executive director of the Delaware Art Museum, I had not heard of Pyle: never in my nine years of undergraduate and graduate art history studies had I ever encountered his name. Given his complete absence from my training, my first reaction upon seeing his work was one of surprise. I was taken aback by the quality of his painterly skills. How interesting that someone whose work was made expressly to be reproduced—with often disappointing results as printed in mass-market publications—would take the time to make such beautiful, well-crafted paintings!

Naturally, I soon realized that I was not the only one to admire Pyle's ability as a painter. One of the most welcome interruptions I occasionally experienced during the workday was a call from the front desk informing me that "Mr. Wyeth was in the building." I would drop everything for the opportunity to say a quick hello. I learned that Andrew Wyeth had made a lifelong habit of spending time in our Pyle galleries, where he would look at only one or two paintings for a prolonged period each visit. Having studied art with his father, N. C. Wyeth, a Pyle student, Andrew considered Pyle's paintings to be his true teachers. It was not hard to see what Andrew Wyeth found in Pyle's works: a subtle and sophisticated use of color, a stunning use of light, and innovative compositional devices. We hope this exhibition will help twenty-first-century visitors discover these qualities anew.

An ambitious exhibition and publication require a monumental team effort, and all of our staff members have, in one way or another, contributed to the project. I especially want to thank Margaretta S. Frederick, who led the exhibition planning team, as well as Mary F. Holahan and Heather Campbell Coyle.

I am thankful to DuPont for supporting exhibitions and programs related to the Museum's Centennial Celebration. I also must extend my gratitude to our other generous benefactors: Henry Luce Foundation, Wyeth Foundation for American Art, Starrett Foundation, Howard Pyle Brokaw, and Roberts and Allison Brokaw.

In conclusion, I would like to dedicate this book to Andrew Wyeth, whose unwavering passion for Howard Pyle's art helped to inspire us all.

Danielle Rice
Executive Director
Delaware Art Museum

ACKNOWLEDGMENTS

Howard Pyle: American Master Rediscovered has engaged the entire staff of the Delaware Art Museum, as well as many outside the institution—more than can be adequately cited here. However, several people have gone above and beyond in their contributions to the project. Rachael DiEleuterio, Helen Farr Sloan Librarian at the Museum, was essential in her tireless pursuit of archival materials and sources. Registrars Jennifer Holl and Erin Robin coordinated conservation, loans, and reproduction requests and worked with photographer Rick Echelmeyer to secure stellar images for this publication. Hannah Freece assembled the chronology and helped fact-check the book. Laura L. Morris and Carolyn Vaughan copyedited this book with broad vision and attention to detail, and Jeff Wincapaw of Marquand Books enhanced the visual appeal of Pyle's art with his striking design. We would also like to thank Adrian Lucia, Sara Billups, Rebecca Schomer, and Brynn Warriner at Marquand Books, and Eric Halpern at the University of Pennsylvania Press.

From its inception this project drew on Pyle aficionados and family members. To Ian Schoenherr and Paul Preston Davis, we extend our deepest gratitude and warmest thanks for their shared expertise and enthusiasm, despite the countless questions posed by curators and catalogue essayists. Descendants Howard Pyle Brokaw and Howard Pyle also provided valuable information and support.

This project benefited from the input of many scholars, especially the authors, who brought fresh perspectives to the study of Pyle and his career. Early conversations with Eric J. Segal, David M. Lubin, and Neil Harris helped us expand the scholarly possibilities of this undertaking. Jill and Robert May generously shared drafts of their biography of Pyle. Anne Samuel clarified Pyle's role as a mural painter. Wendy Cooper helped identify the furnishings in photographs of Pyle's studio. In addition, Kevin Ferrara, Robert Horvath, Steven Kloepfer, Dennis Nolan, and Gail Stanislow provided assistance to our authors.

We have enjoyed the participation of our colleagues at the Norman Rockwell Museum, Stockbridge, especially Joyce K. Schiller and Stephanie Haboush Plunkett, who prepared essays for this volume. We have also benefited from our collaboration with Virginia O'Hara and James Duff of the Brandywine River Museum, Chadds Ford, as well as with Richard Kelly, Elizabeth Alberding, and Joyce Hill Stoner, who share our dedication to the art of Pyle and his students.

The following individuals and their host institutions assisted with loans and image requests: Anne Coco, Margaret Herrick Library, Beverly Hills; Bethany Engel, Brandywine River Museum; Kathy Foster, Philadelphia Museum of Art; Meredith Lippman, William Brennan Courthouse, Jersey City; Susan Newton, Winterthur Museum, Garden and Library, Delaware; John Rockwell, Norman Rockwell Family Agency; Karen Sherry, Brooklyn Museum, New York; and Henry Sweets, Mark Twain Boyhood Home and Museum, Hannibal, Missouri.

Finally, we recognize the generous funders who made all these efforts and their presentation to the public possible. The extraordinary support of the Henry Luce Foundation has been vital to this exhibition and publication. Early endorsement of the project from the Wyeth Foundation for American Art was crucial in getting this venture off the ground and in conserving works for display and travel. The benevolence of Howard Pyle Brokaw—collector and scholar of his grandfather's work—is also deeply appreciated.

Heather Campbell Coyle
Curator of American Art
Delaware Art Museum

Margaretta S. Frederick
Chief Curator and Curator of the Samuel and
Mary R. Bancroft Memorial Collection
Delaware Art Museum

Heather Campbell Coyle

INTRODUCTION: PERSPECTIVES ON PYLE

In 1891 Howard Pyle wrote to the author Edmund Stedman, describing his own life as "hermit-like" and "very secluded."[1] This seems an overstatement. Judging from Pyle's copious correspondence, he was very much in contact with friends and associates and, through his astounding output of illustrations that year, was also connected more loosely to much of the nation. Yet Pyle stayed primarily in Wilmington, Delaware, as he would for most of his life, shipping his sought-after pictures to publishers in New York. Born in Wilmington in 1853 into an old Quaker family, Pyle had roots in the area that ran deep. While in personality he was a homebody, Pyle's imagination ranged over distant times and places, transporting him and thousands of American readers to ancient Rome, Arthurian England, colonial Massachusetts, and Porto Bello in the Golden Age of Piracy.

One hundred years after his death, Pyle's reputation remains strongest in the Delaware Valley, where more than a thousand of his pictures are in the collections of the Delaware Art Museum in Wilmington and the Brandywine River Museum in Chadds Ford, Pennsylvania. Although important works by Pyle are scattered around the nation, in both public institutions and private collections, and several of his murals remain in situ, Howard Pyle is not a household name—unlike Norman Rockwell, who admired him greatly. Famous among practicing illustrators, as well as collectors, scholars, and enthusiasts of American illustration, Pyle is absent from surveys of American art.

During his lifetime Pyle was an influential teacher and a well-known illustrator whose name sold books and magazines. In almost any given month between 1877 and 1911, hundreds of thousands of Americans saw his published pictures, making Pyle a major contributor to the nation's visual culture. Several of the essays in this book seek to reinsert Pyle into the conversation about turn-of-the-century art and culture—analyzing his pictures, examining his influences, and exploring the context of his images and writing—that is, to treat him like a significant American artist. This volume of essays does not particularly dwell on Pyle's biography, which has been recently treated by Robert May and Jill May.[2] It concentrates on neither the tradition of American illustration nor the publication and advertising industries that provided the focus for Michele H. Bogart's excellent studies.[3] Instead this book aims to provide a variety of recent perspectives

on Pyle, situating his images, writing, and instruction within the story of American art.

This introduction provides a brief outline of Pyle's career, presented through close readings of a selection of his lesser-known works. In the book's first essay the author and illustrator James Gurney explores Pyle's picture-making strategies, analyzing the visual operations of specific works and pairing his observations with Pyle's instructions to his students. The next three essays examine three of Pyle's main areas of interest: the Lupacks discuss Pyle's version of the Arthurian legends; Anne M. Loechle explores the cultural context of his pirate tales; and I analyze his images of American history. Then Margaretta S. Frederick, Mary F. Holahan, and Eric J. Segal place Pyle's work in broad cultural contexts, examining the influence exerted on Pyle by, respectively, the transatlantic print trade, the Swedenborgian religion, and the rhetoric of masculinity. Essays by Joyce K. Schiller and Virginia O'Hara explore Pyle's work as a teacher, and, rounding out the catalogue, Stephanie Haboush Plunkett and David M. Lubin consider his legacy in popular illustration and film.

Readers should note that images in this book have been taken from original paintings and drawings whenever possible; these are denoted in the captions as illustrations *for* specific works. Images taken directly from published books or magazines are designated as illustrations *from* these sources. Most dates assigned to Pyle's illustrations, in the text and in the captions, denote when the illustrations were first published.

PYLE'S BACKGROUND AND EARLY YEARS

Pyle proudly traced his heritage back to English settlers who received a land grant from William Penn, and the Pyle family did not stray far. His father was a leather dealer in Wilmington. A lackluster student, Pyle found himself interested in art.

Around 1869 his parents agreed to fund his training, sending him to study with a private instructor in Philadelphia. Had it been a few years earlier or later, he probably would have enrolled in the city's Pennsylvania Academy of the Fine Arts, but the Academy was closing for renovations and would not reopen in permanent quarters until

1876. (Pyle would explore the Academy's offerings briefly in 1870 and 1871.[4]) Like many art teachers in the United States, Pyle's instructor, the Dutch painter Francis Van der Wielen, was academically trained, having studied at the Royal Academy of Fine Arts in Antwerp. His European background and education provided him the pedigree to find work as an art teacher in Philadelphia, despite the fact that his deteriorating eyesight made it impossible for him to produce ambitious paintings. In the third quarter of the nineteenth century, American art schools remained ill equipped compared to their European counterparts, and, like Pyle, many art students chose to study privately with painters trained in Europe. The most ambitious aspiring artists hoped to travel abroad to complete their education.

NEW YORK, 1876–79

Only in his youth and at the end of his life would Pyle venture long from his home. After his training in Philadelphia, Pyle spent a few years working in the family business and began to submit writings and illustrations to publishers. Meeting with some success, in 1876 he moved to New York to launch a career in the nation's center of publishing and art. Pyle quickly became acquainted with important figures in both arenas. Roswell Smith, the business manager of the publishing house Charles Scribner's Sons, befriended him. Richard Watson Gilder, an editor at *Scribner's Monthly*, recommended that Pyle attend the Art Students League in New York to improve his figure drawing. The League had been formed the previous year by ambitious young artists, including Gilder's wife, Helena DeKay Gilder, who were influenced by European methods and styles. Frustrated with the conservatism of the National Academy of Design, also in the city, the group founded the new school on a cooperative basis to better represent what they believed would be its students' interests. In particular, the League accommodated life study (that is, working from nude models), the centerpiece of French academic training and the area in which Pyle needed improvement.

The circle around the League encompassed up-and-coming artists and illustrators, including many recently

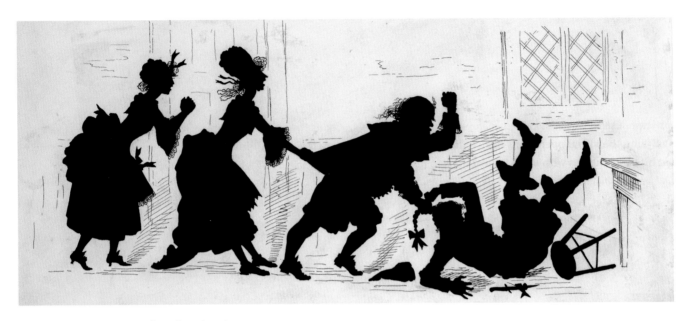

Figure 1. Howard Pyle (1853–1911). *The Sailor Is Saved.* For R. C. V. Meyers, "Papa Hoorn's Tulip." *Scribner's Monthly*, January 1877. Ink on illustration board, 5⅛ × 10⅜ inches. Delaware Art Museum, Gift of Willard S. Morse, 1923

returned from study in Europe, as well as the Gilders and Helena's brother Charles DeKay, art critic for the *New York Times*. The New York art world was still fairly small in the 1870s. Through the League and his publishing contacts, Pyle befriended some of the leaders of the younger generation of American painters, including Edwin Austin Abbey, William Merritt Chase, Walter Shirlaw, and Julian Alden Weir. Pyle remained in New York for less than three years, studying at the League, socializing with internationally trained artists, and getting to know many of the most influential illustrators and editors in the United States.

With Richard Watson Gilder on staff, *Scribner's* regularly published engravings of paintings by his sophisticated friends, as well as significant articles about art in the United States and Europe.[5] Progressive New York–based artists, including Frederick Dielman, Wyatt Eaton, and Shirlaw, pro-

duced images for the magazine, which also showcased the work of leading illustrators like Charles S. Reinhart. Beginning to receive regular commissions from *Scribner's* and the rival *Harper's Monthly*, where Abbey was a featured illustrator, Pyle was in excellent company. Among his first assignments for *Scribner's*, Pyle's illustrations for the story "Papa Hoorn's Tulip" (1877, fig. 1) provide a good sense of his early approach and are a harbinger of his mature practices and interests. For this project Pyle adopted an elegant silhouette technique: solely through outline did he communicate the actions, emotions, and personalities of his characters. With delicate line drawing, he indicated diamond-paned windows and wainscoting to signal a Dutch seventeenth-century interior. The illustrations display Pyle's interest in historical detail and the strongly decorative sensibility that would characterize his children's books, from *Yankee Doodle:*

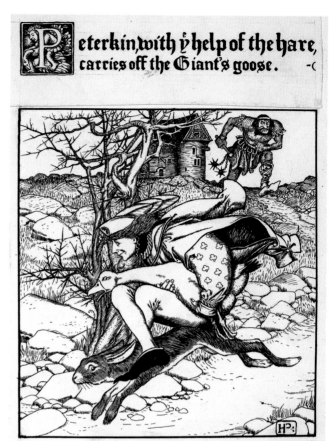

Figure 2. Howard Pyle (1853–1911). *Peterkin Makes Off with the Giant's Goose.* For Howard Pyle, "Peterkin and the Little Gray Hare." *Harper's Young People,* March 23, 1886. Published subsequently in *The Wonder Clock, or Four and Twenty Marvellous Tales, Being One for Each Hour of the Day.* New York: Harper and Brothers, 1887. Ink on bristol board, 9⅜ × 6¾ inches. Delaware Art Museum, Museum Purchase, 1919

An Old Friend in a New Dress (1881, see fig. 74) to his Arthurian volumes (1903–10, fig. 13).

Unusual in Pyle's oeuvre, the silhouette style appears to have reflected then current fashion rather than the illustrator's personal vision. Pyle was likely inspired by the publication in spring 1876 of a series of silhouette drawings by Livingston Hopkins in *St. Nicholas,* another Scribner's periodical.[6] Of Hopkins's drawings, the *New York Times* observed: "Nothing better than some of these has appeared even in St. Nicholas."[7] In the illustrations for "Papa Hoorn's Tulip," the exaggerated gestures and physiognomies, as well as the backgrounds rendered through line drawing, resemble Hopkins's examples. New to the field and eager to please, Pyle adopted an appropriate model for his assignment: the clean lines and flat shapes of his drawings accommodated both the tastes and technologies of the publishing industry of 1877, and he would reprise the same manner for two assignments that appeared the following year.[8]

Early in his career Pyle experimented with different styles, trying to discern what his publishers wanted. In New York in the late 1870s Pyle spent time meeting with editors, art editors, and professional engravers to figure out how to best adjust his style for magazine reproduction. Throughout his career Pyle's letters reveal regular negotiations with authors and editors, and, as essays in this book confirm, he would continue to adapt his work to meet the changing technological and aesthetic challenges of illustration.

THE 1880s: BEAUTIFUL BOOKS FOR AMERICA'S YOUTH

In 1879 Pyle returned to Wilmington as a successful illustrator. During his time in New York he had formed strong contacts with publishers and art editors, and his work was in demand. He could thus work from afar on commissions. Saving money by living with his family and saving time by leaving the social whirl of an artist's life in New York, Pyle settled in to work on ambitious book projects. He began planning his own books almost immediately after his return to Wilmington. His first independent publications, an edition of Alfred, Lord Tennyson's *The Lady of Shalott* (see figs. 37 and 38) and *Yankee Doodle,* appeared in 1881 under the imprint of Dodd, Mead and Company. In published form these early attempts at color illustration feature garish hues. *The Lady of Shalott* was skewered by a reviewer in the *New York Times* for its poor color quality, and Pyle's illustrations for *Yankee Doodle* appear in bright, primary colors in comparison to the delicate watercolors on which they are based.[9] Color-printing technology was far from perfect, and Pyle would struggle with its limitations throughout his career.

Although his first experiments with color printing did not satisfy the illustrator or his critics, Pyle's black-and-white books for children and youth were unqualified successes. Artistically and financially, the books he both wrote and illustrated—*Pepper and Salt, or Seasoning for Young Folk*

(1885); *The Wonder Clock, or Four and Twenty Marvellous Tales, Being One for Each Hour of the Day* (1887); *Otto of the Silver Hand* (1888); and *The Merry Adventures of Robin Hood of Great Renown, in Nottinghamshire* (1883)—supported Pyle and his own growing family in the 1880s. Pyle had married Anne Poole in 1881, and their first child was born the next year. Within the decade two additional children would be born, and in the 1890s the Pyles had four more.

Delightful books for young children like Pyle's own, *Pepper and Salt* and *The Wonder Clock* combine gentle humor, imaginative composition, and delicate line drawings. Although he maintained some of the exaggerated physiques and expressions, as well as the decorative sensibility and fine delineation of his early work, in illustrations such as *Peterkin Makes Off with the Giant's Goose* (1886, fig. 2), Pyle moved well past the derivative style of his "Papa Hoorn's Tulip" images. *Pepper and Salt* and *The Wonder Clock* brought together illustrated tales and verses originally published in *Harper's Young People* in a manner typical of the late nineteenth century, when magazines like *Harper's Monthly* and *Scribner's* existed in part to launch serialized versions of books forthcoming from their publishing houses.

In his illustrations for *Otto of the Silver Hand*, set in medieval Germany, Pyle adopted a woodcut style influenced by German Renaissance artist Albrecht Dürer. Similar in graphic appeal to *The Wonder Clock*, the images have a more static character, appropriate to their setting in and around a monastery. In *Poor Brother John Came Forward and Took the Boy's Hand* (1888, fig. 3), among others, the figures are often depicted either frontally or in precise profile and are arranged parallel to the picture plane, creating a stable and decorative composition.

In these books from the 1880s Pyle produced classic examples of children's illustration. His pictures tell a story convincingly, while demonstrating a strong sense of pattern and an obvious pleasure in drawing. Solidifying his appeal to the youth audience, in 1887 Pyle began to write and illustrate tales of pirate adventures, a subject that would engage him through the rest of his career. As Loechle and Lubin discuss, Pyle would render buccaneers and marauders with motion

and drama, and, eventually, with bright, saturated color, creating an enduring vision of pirate life. Throughout the 1880s Pyle refined his ability to set the proper tone—in his images and text—for his subject and audience. By the close of the decade Pyle had established himself as a leading author and artist of books for American youth, with fine editions released each fall to capture the holiday gift market.

Figure 3. Howard Pyle (1853–1911). *Poor Brother John Came Forward and Took the Boy's Hand.* For Howard Pyle, *Otto of the Silver Hand.* New York: Charles Scribner's Sons, 1888. Ink on bristol board, 7⅜ × 5¾ inches. Delaware Art Museum, Museum Purchase, 1915

Figure 4. Howard Pyle (1853–1911). *They Scrambled Up the Parapet and Went Surging Over the Crest, Pell Mell, upon the British.* For Paul Leicester Ford, *Janice Meredith.* New York: Dodd, Mead and Company, 1899. Oil on canvas, 23¼ × 15½ inches. Delaware Art Museum, Museum Purchase, 1912

THE 1890s: ILLUSTRATING AMERICAN HISTORY

Despite his enormous professional success, the 1890s opened on a tragic note for Pyle, for his son Sellers had died in 1889, while Pyle and his wife were in Jamaica investigating a locale for his pirate stories. Left in the care of his grandmother in Delaware, Sellers became ill and rapidly declined. He was dead before his parents could be contacted.[10] In her essay in this volume Holahan explains how his child's death intensified Pyle's involvement with his Swedenborgian faith and inspired literary efforts for adults and youth, including the beautifully illustrated *The Garden behind the Moon: A Real Story of the Moon-Angel* (1895, see figs. 88–91).

Alongside his spiritual stories, in the middle of the 1890s Pyle produced important illustrations of American historical events. For books by Woodrow Wilson and Henry Cabot Lodge, he created powerful evocations of the nation's founding fathers and significant military engagements. Similarly, for Paul Leicester Ford's historical novel *Janice Meredith*, Pyle pictured a key moment of the Battle of Yorktown (1899, fig. 4), when colonial troops spilled over a hill to descend upon the British. Though the redcoats dominate the composition, the injured figure in the foreground indicates the turning tide: the Battle of Yorktown would be the last major fight of the Revolutionary War, and the British went on to surrender. In illustrating *Janice Meredith*, Pyle was assisted by students from Drexel Institute of Art, Science, and Industry, where he had begun his career as an instructor in 1894. As Schiller and O'Hara discuss, Pyle was a popular and inspiring teacher, and part of his appeal was his ability to connect his students with publishers. For several summers between 1898 and 1903, Pyle invited his best students to stay in Chadds Ford and continue their studies. His own engagement with colonial subjects colored the experience of his summer school students, who were housed in buildings that had once hosted Generals George Washington and Marquis de Lafayette. Trips were taken to the Brandywine Battlefield, and models were posed in colonial attire. In 1904 Pyle told his students:

> Colonial life appeals so strongly to me that to come across things that have been handed down from that

time fills me with a feeling akin to homesickness—so that merely to pick up a fragment of that period is all that is necessary to bring before me that quaint life—and my friends tell me that my pictures look as tho' I had lived in that time.[11]

Pyle did not always represent battles or famous men in his historical paintings, preferring at times to depict the "quaint life" of the past. In 1895 he composed "By Land and Sea," a set of charming vignettes about a young woman choosing a suitor in the federal period. The tale seems to be set in Pyle's hometown of Wilmington, for the city's late seventeenth-century Old Swedes Church can be found among the settings depicted. The first illustration, *In the Wood-Carver's Shop* (1895, see fig. 5), is a scene of a young woman modeling for a ship's figurehead. Together the full-page illustrations present a convincing blend of history and genre painting by showing everyday life—rather than momentous occasions—in an earlier era. During the second half of the nineteenth century, this modest type of history painting became popular in England, France, and the United States, and it had echoes in American painting and illustration well into the twentieth century.[12]

One famous American example is Thomas Eakins's most important historical subject, *William Rush Carving His Allegorical Figure of the Schuylkill River* (1876–77, see fig. 6), a work that resonates with and illuminates Pyle's painting. Also setting his picture in the federal period, Eakins depicted Philadelphia sculptor William Rush carving a sculpture for Fairmount Park. To prepare, Eakins had researched Rush as well as his sculpture, studio, and sitter, an approach that demonstrates the influence of Eakins's teacher Jean-Léon Gérôme, a renowned French master of historical genre scenes studded with archaeological details. But one aspect of Eakins's picture was far from accurate. As Elizabeth Johns has stated: "It was not in the least likely that Rush modeled any of his figures from the nude: the practice had not yet been established in the city."[13] Instead, she argues, Eakins featured the nude model to present Rush as an ancestor to his own controversial practice. While teaching at the

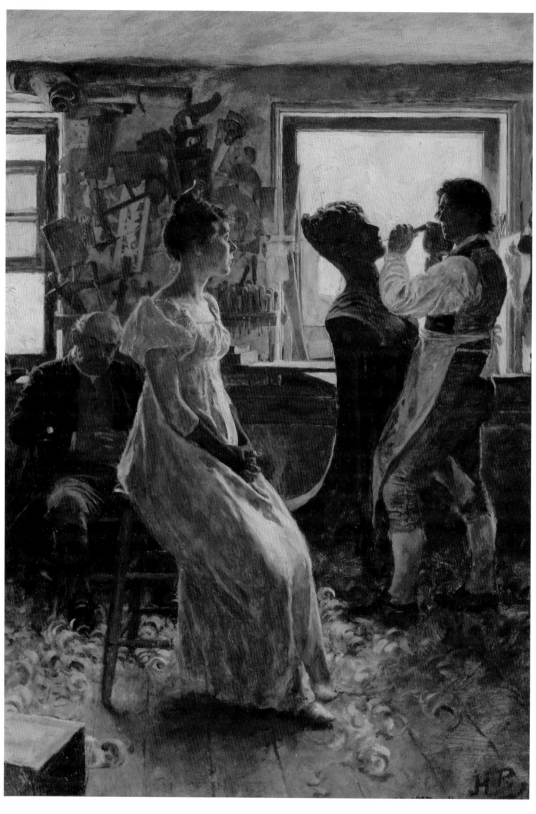

Figure 5. Howard Pyle (1853–1911). *In the Wood-Carver's Shop.*
For Howard Pyle, "By Land and Sea." *Harper's New Monthly Magazine,*
December 1895. Oil on board, 14¾ × 10 inches. Delaware Art Museum,
Museum Purchase, 1912

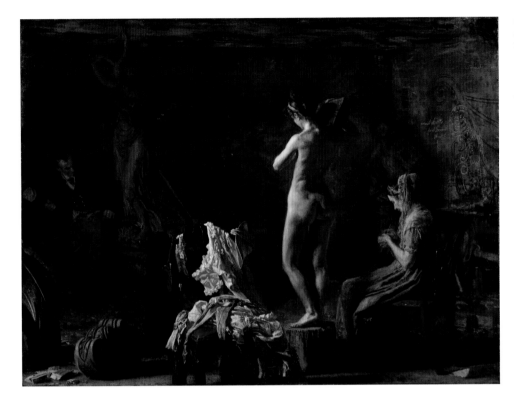

Figure 6. Thomas Eakins (1844–1916). *William Rush Carving His Allegorical Figure of the Schuylkill River*, 1876–77. Oil on canvas (mounted on Masonite), 20⅛ × 26⅛ inches. Philadelphia Museum of Art, Gift of Mrs. Thomas Eakins and Miss Mary Adeline Williams, 1929

Pennsylvania Academy of the Fine Arts, Eakins advocated intensive study of anatomy and the nude figure; his painting of Rush working from an undraped model provided a dignified antecedent.[14] In the years following the creation of this painting, Eakins's practices would come under fire, eventually leading to his resignation as director of the schools at the Academy in 1886. As an accomplished artist with expertise in both painting and sculpting the figure, Eakins would be hired to lecture on anatomy at American art schools, including Drexel, where Pyle began teaching a class in illustration in 1894. *William Rush Carving His Allegorical Figure of the Schuylkill River* has been read as a statement of Eakins's working and teaching methods, and the same can be said of Pyle's *In the Wood-Carver's Shop*, which encapsulates Pyle's more decorous approach toward illustration and instruction.

With its curls of wood shavings, wall full of tools, and seated chaperone, Pyle's painting recalls Eakins's canvas: even the twist of Pyle's model's hair and her white dress—discarded in the foreground of the painting of Rush—echo Eakins's scene.[15] (Of course, there are significant differences: Pyle's model is clothed, and his carver is at work not on an allegorical statue but on a ship's figurehead—a sculptural adornment more akin to an illustration than a studio painting.) The similarity of the two paintings may have resulted from more than a shared interest in using a depiction of a federal-era sculptor to embody their principles. Pyle could have seen Eakins's painting at the annual exhibition of the Society of American Artists in New York in 1878 or at the *Special Exhibition of Paintings by American Artists at Home and in Europe* held at the Pennsylvania Academy of the Fine Arts in 1881.[16]

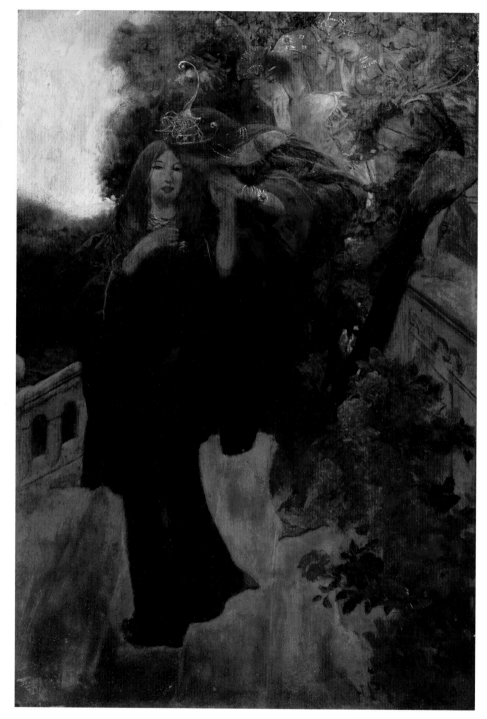

Figure 7. Howard Pyle (1853–1911). *Truth Leaves Her Heavenly Home,* 1900. Oil on panel, 12 × 8 inches. Delaware Art Museum, Museum Purchase, 1912

Harper's Monthly published *In the Wood-Carver's Shop* in December 1895, just nine months after Eakins was dismissed from Drexel for including a nude male model in an anatomy lecture for an audience of men and women. At that time Pyle was the rising star at the school, the instructor of a popular class in illustration. The illustration program designed by Pyle did not include classes with nude models, and he frequently reiterated the importance of study from costumed models.[17] Pyle's tentative attitude toward the nude was reflected in other comments as well: he once compared

the nude figure to a plucked chicken, and he lamented "the dreadful naked nymphs that hang so unblushingly upon the walls in the exhibitions of academic art."[18]

Whether or not *In the Wood-Carver's Shop* was produced as a riposte to Eakins's work, Pyle's painting not only presented a more plausible image of a federal-era sculptor at work on a practical project but also suggested a more palatable vision of artistic training in late nineteenth-century Philadelphia. Replacing the nude model with a clothed one and the sculpture with a figurehead, Pyle made a case for art that was proper and practical.

In the second half of the 1890s Pyle was at the top of his game, deeply engaged in historical illustration and working as a successful instructor. So popular were his classes at Drexel that the school founded an illustration department under him, giving him the opportunity to design a course of training specific to his field. In 1897 Pyle began to publish essays on the state of American art and illustration, promoting his approach to art education. In 1900 Pyle decided to resign. He opened the Howard Pyle School of Art in Wilmington, which allowed him to teach on his own terms to a carefully selected group of talented young artists who planned to become professional illustrators.

THE FINAL DECADE

The new century found Pyle experimenting with color again. An accomplished illustrator with a commitment to understanding and adapting to new commercial-printing technologies, Pyle was given the opportunity to test out emerging processes for reproducing pictures in full color. For their holiday issue of 1900, the editors at *Harper's Monthly* wanted to feature color illustrations and invited Pyle to produce a series of full-color paintings to illustrate the Danish writer Erik Bøgh's "The Pilgrimage of Truth." Pyle painted several jewel-toned panels (1900, fig. 7), which were photographed through a series of colored filters. The resulting photographs

Figure 8. Howard Pyle (1853–1911). *Truth Leaves the Fairies' Wonderland.* For Erik Bøgh, "The Pilgrimage of Truth." *Harper's New Monthly Magazine,* December 1900. Ink on paper, 7⁹⁄₁₆ × 5¹⁄₁₆ inches. Delaware Art Museum, Bequest of Gertrude Brincklé, 1973

Figure 9. Howard Pyle (1853–1911). *Truth Leaves the Fairies' Wonderland.* From Erik Bøgh, "The Pilgrimage of Truth." *Harper's New Monthly Magazine,* December 1900. Printed matter. Helen Farr Sloan Library and Archives, Delaware Art Museum

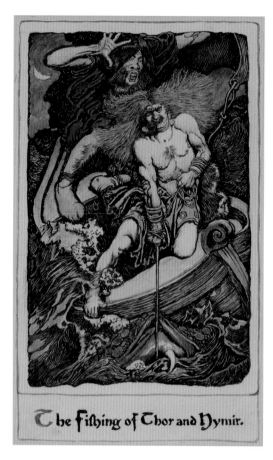

Figure 10. Howard Pyle (1853–1911). *The Fishing of Thor and Hymir.* For Howard Pyle, "North-Folk Legends of the Sea." *Harper's Monthly Magazine,* January 1902. Watercolor on illustration board, 7¹³⁄₁₆ × 4½ inches. Delaware Art Museum, Museum Purchase, 1912

color, transferred to the paper from separate plates (1900, see fig. 9).

Despite this disappointment, Pyle continued to paint in color, biding his time while methods of reproduction were rapidly refined. A little more than a year later the situation had improved, and Pyle saw better results when his illustrations for "North-Folk Legends of the Sea" (1902, fig. 10) were printed in *Harper's Monthly*. Though far from perfect, the printed color resembled his watercolors more closely than had earlier efforts.

Known for his dedication to accuracy and skill with composition, Pyle continued to excel as an illustrator of scenes set in the past, working with leading authors in some cases and writing his own texts in others. Pyle moved seamlessly between dramatic battle scenes and light romances, peppering both with correct details of costume and setting (figs. 11 and 12).

Pyle continued to receive invitations to give lectures and write essays on his views of American art. He gave an address at the Boston Society of Arts and Crafts, which was published in the organization's magazine in 1902. The following year he spoke at the graduation ceremony for the School of Fine Arts of Yale University in New Haven, and in 1904–05 he gave a series of lectures at the Art Students League in New York. In fall 1905 he toured the Midwest, speaking at the Art Institute of Chicago, Milwaukee-Downer College, and the Elks Club in Green Bay.

A recurring theme in Pyle's essays and talks on art was the dependence of American artists on European styles and training. He complained that American exhibitions were filled with pictures that "might as well have been painted in the studios of Paris, as in those of Boston or New York." Such paintings, he continued, "do not tell anything of the Americanism of the men who wrought them; they lack 'subject,' and I do not wonder that Americans do not seem to care to buy them. American Artists appear to be so overawed by the influence of their European masters that they are afraid to paint like Americans."[20]

Pyle felt the cure for this was to be found in American illustration, where he and others were attempting to forge a

were used to produce a set of four plates—one each for red, yellow, blue, and black—for each canvas. In theory, with each plate properly inked, the images could be layered so that the color spectrum would reemerge in the printing process. However, this experimental technology failed, and the editors asked Pyle to draw the pictures to accommodate more traditional methods of color printing.[19] Pyle complied and drew the illustrations in pen and ink (1900, see fig. 8): during printing, the white areas were filled in with flat washes of

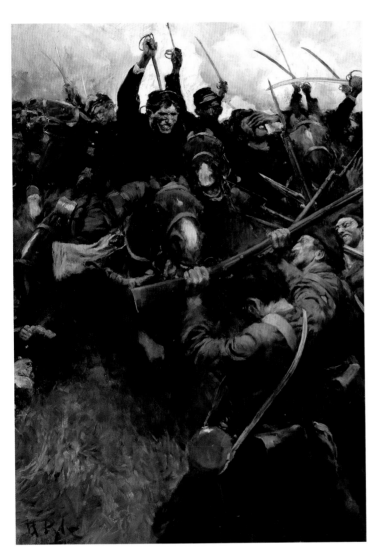

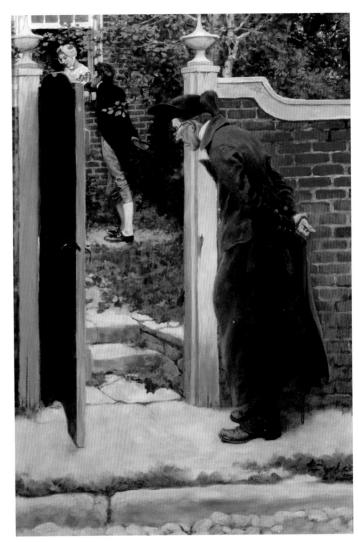

Figure 11. Howard Pyle (1853–1911). *The Charge.* For Robert W. Chambers, "Non-Combatants." *Harper's Monthly Magazine,* November 1904. Oil on canvas, 24⅛ × 16⅛ inches. Brokaw Family Collection, Brandywine River Museum

Figure 12. Howard Pyle (1853–1911). *Old Jacob Van Kleek Had Never Favored Our Hero's Suit.* For Howard Pyle, "The Mysterious Chest." *Harper's Monthly Magazine,* December 1908. Oil on canvas, 29¼ × 19½ inches. Delaware Art Museum, Museum Purchase, 1912

"distinctly American Art."[21] Yet for all his nationalism, as the essays in this volume attest, Pyle himself adapted compositions and stylistic elements from French and English artists and illustrators. Perhaps some of these borrowings were unconscious—European art permeated American visual culture—or perhaps, in an age when copying was the basis of artistic training, Pyle saw no conflict in his use of European sources to create "distinctly American Art."

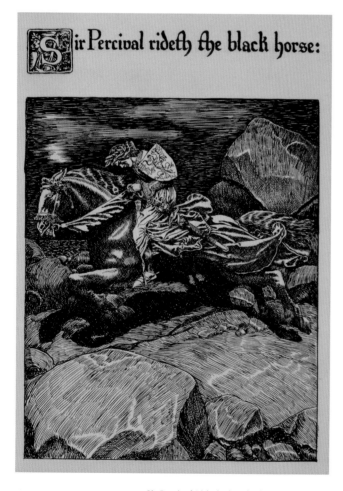

Figure 13. Howard Pyle (1853–1911). *Sir Percival Rideth the Black Horse.* For Howard Pyle, *The Story of the Grail and the Passing of Arthur.* New York: Charles Scribner's Sons, 1910. Ink on paper, 11⅝ × 8¾ inches. Delaware Art Museum, Museum Purchase, 1912

In the early twentieth century Pyle returned to producing his own books, releasing the four books of Arthurian stories discussed by the Lupacks in their essay. As did *The Merry Adventures of Robin Hood of Great Renown, in Nottinghamshire* and *Otto of the Silver Hand*, Pyle's Arthurian tales became classics of youth literature. These illustrations, rendered in a flat pen-and-ink style, rank among his most compelling works (figs. 13 and 39–46). Pyle's student N. C. Wyeth considered his teacher's Arthurian pictures to be "Pyle's most important contribution to the world of art."[22]

Not all of Pyle's medieval subjects were produced for his Arthuriad. He also illustrated medieval tales for popular magazines. For a time between 1903 and 1909 he received regular assignments from *Harper's Monthly* to paint full-color pictures for James Branch Cabell's humorous historical fiction, much of it set in the age of chivalry. In the middle of his own Arthurian masterpiece, Pyle bristled at illustrating such frivolous literature, complaining that he was "manufacturing drawings for magazine stories which I cannot regard as having any really solid or permanent literary value."[23] Of Cabell's stories specifically, he commented: "They are neither exactly true to history nor exactly fanciful, and, whilst I have made the very best illustrations for them which I am capable of making, I feel that they are not true to medieval life, and that they lack a really permanent value such as I should now endeavor to present to the world."[24]

Rich in color and costume, Pyle's romantic images, such as *So for a Heart-Beat She Saw Him* (1905, fig. 14), were popular with Cabell and the editors at *Harper's Monthly*. Despite Pyle's reservations about Cabell's stories, Pyle's vibrant paintings of medieval times must have served as inspirations for his students, including Frank Schoonover and Wyeth, who would produce their own full-color illustrations for later volumes of Arthurian tales.

Finding himself frustrated by some of his commissions, Pyle seemed ready for new projects in 1905. In seeking an art editor for a new magazine that was in the planning stage, the publisher S. S. McClure made what appeared to be a logical decision in hiring Pyle, a sought-after illustrator with ties to many younger talents. He agreed to devote about half his

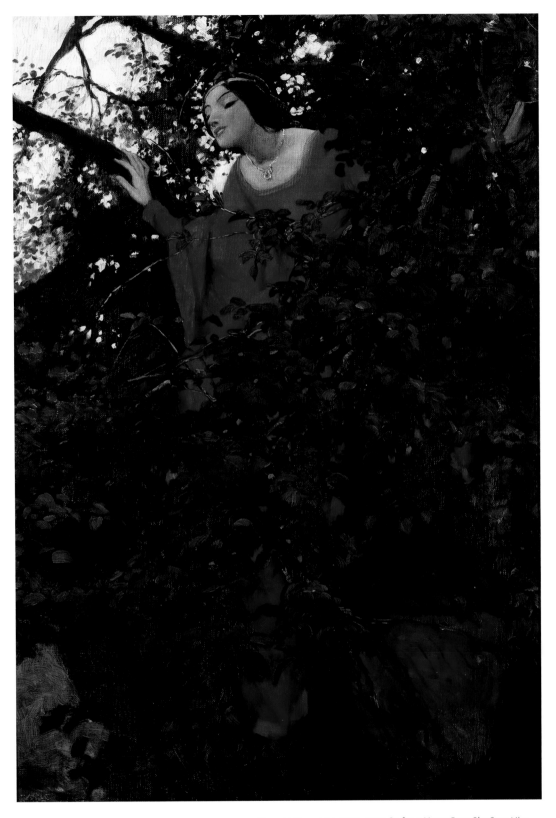

Figure 14. Howard Pyle (1853–1911). *So for a Heart-Beat She Saw Him.*
For James Branch Cabell, "The Fox Brush: Retold from the French of Nicholas de
Caen." *Harper's Monthly Magazine*, August 1905. Oil on canvas, 24⅛ × 16 inches.
Delaware Art Museum, Gayle and Aline Hoskins Endowment Fund, 1983

time to McClure, reserving the rest for other projects. However, the magazine did not take shape as planned. The editors cancelled the proposed publication and installed Pyle as art editor at the extant *McClure's Magazine*. As editor he attempted to lure his colleagues and former students to the publication, while endeavoring to improve the magazine's design, but it was an uphill battle. His friends and protégés

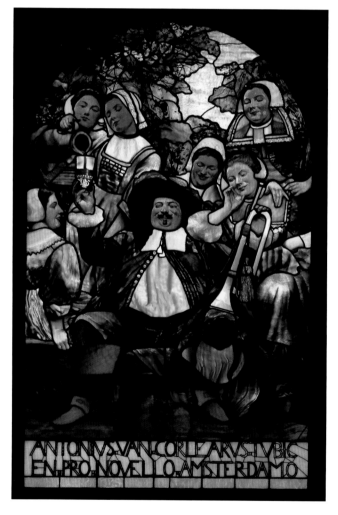

Figure 15. Howard Pyle (1853–1911) and Tiffany Glass Company. *Anthony Van Corlear, the Trumpeter of New Amsterdam*, c. 1896. Leaded glass, mounted in wood light box, 64½ × 39½ inches. Delaware Art Museum, F. V. du Pont Acquisition Fund, 1984

had other commitments, and the company was in flux. Pyle lasted only six months in the position.

More successful was Pyle's next venture: attempting to translate his ability as a historical illustrator into mural painting. By 1900 the nation was in the midst of the American Renaissance, and architects were designing Beaux-Arts edifices that required mural decoration. Moreover, artists and critics were advocating for the inclusion of both allegorical and historical paintings inside public buildings to uplift, educate, and incite patriotism in a wide range of visitors.[25] Mural painting occupied many of the leading academically trained artists of Pyle's generation, including Edwin Howland Blashfield and Kenyon Cox, as well as illustrators like Abbey and Pyle's student Violet Oakley. Pyle hoped to produce a mural of a historical subject, and his friends lobbied for him to receive a public commission.

One difficulty of mural painting, especially in the case of historical subjects, is the balancing of narrative and decorative elements, and Pyle felt he was up to the challenge given his strengths and past achievements. His strong decorative sensibility had been apparent since he had created his early children's books in the 1880s. In the mid-1890s he designed a leaded-glass window with a historical subject to be produced by Tiffany and Company for the stairway of the Colonial Club in New York (c. 1896, fig. 15). Hoping to hone his skills in composing for a large scale, Pyle executed murals for his own home, one of which was displayed at the *Twentieth Annual Exhibition* of the Architectural League of New York in 1905.

Later that year Pyle received his first mural commission —from Cass Gilbert, the architect for the Minnesota State Capitol—to paint *The Battle of Nashville* (1905–06). For this assignment Pyle traveled to Saint Paul to do research and interviewed former governor Lucius F. Hubbard, who had commanded the Minnesota regiment in that Civil War battle.[26] Like many American artists, Pyle painted his murals in oil on canvas, producing them in his studio in Wilmington. He described *The Battle of Nashville* as being "not so much a decoration as it is a wall painting," and it was displayed as such: encased in a large frame and installed on the

Figure 16. Howard Pyle (1853–1911). *The Landing of Carteret* (study for mural in Essex County Courthouse, Newark, New Jersey), 1907. Oil on canvas, 19 × 53 inches. Delaware Art Museum, Gift of Mrs. R. R. M. Carpenter, 1957

wall.[27] Since he enjoyed the project, he actively sought similar commissions.

Gilbert invited Pyle to make another mural in March 1906, which led to Pyle's creation of *The Landing of Carteret* (1907), for the Essex County Courthouse in Newark, New Jersey. Granted land by the Duke of York, Philip Carteret was appointed the first governor of New Jersey. Carteret arrived in 1665 with a constitution and would set up a liberal government with a governor, council, and representatives chosen by each town. Information about his arrival was thin, leaving Pyle to imagine the event.

A study for the mural (1907, fig. 16) demonstrates Pyle's vision of how the episode might have unfolded. Carteret stands before colonists and Native Americans, while his secretary announces his credentials, officially installing him as governor. On the dock behind him are colonists disembarking from the ship anchored in the background. Dressed in red, the new governor is the focus of the composition. In the final version the figures are grouped more tightly, eliminating the empty space at the center of the study. Although Pyle

had little to go on, he was able to create a convincing scene with period details and an attractive, clear composition.

In 1910 with the assistance of Schoonover and Stanley M. Arthurs, Pyle completed his third mural commission, a series of decorations for the Hudson County Courthouse in Jersey City. While competent in execution and attractive in color, the murals do not demonstrate his usual strength of composition and storytelling, and they are marred by the placement of vents on the wall. Pyle sensed their weakness, admitting that they were not quite as decorative as he had hoped. It was Pyle's desire to improve his mural painting that convinced him to finally visit Europe.[28] In November, several weeks after completing the Hudson County commission, Pyle and his family boarded a steamer for Italy. Pyle had avoided European study and published vehemently in opposition to foreign influences in American art; however, if he were going to continue as a muralist, he believed he should see the Italian masters.

After stopping in Rome at the end of 1910, Pyle stayed in and around Florence for the next ten months. He marveled at

the paintings he saw and wrote glowing letters to his former students Arthurs, Ethel Pennewill Brown, and Schoonover, encouraging them to come to Italy. His correspondence from summer 1911 indicates that he was frequently ill, and on November 9 Pyle died of Bright's disease, a chronic kidney ailment, at the age of fifty-eight.

Pyle's death shocked his friends and colleagues in the United States. He was memorialized in the magazines in which his work had appeared.[29] His students were interviewed for newspaper articles.[30] In Delaware the community united to assemble a memorial exhibition of Pyle's art, which opened in the ballroom of the DuPont Building in Wilmington on March 13, 1912. After that showing several of the exhibition's organizers decided to purchase a large number of the paintings and drawings that remained in Pyle's studio. These works would form the basis of the Delaware Art Museum's collection.

Through his teaching and his widely circulated illustrations, Pyle's legacy has endured. One hundred years after his death Pyle's major books for young people remain in print, and his tales of King Arthur and Robin Hood can now be obtained for e-readers. His historical images continue to enliven textbooks and book covers, and his pirates live on in films. In Wilmington and Chadds Ford, where his original work can be seen, Pyle's influence has been particularly strong. It is with great pride that the Delaware Art Museum celebrates its centennial with an exhibition and publication that shed new light on his work.

NOTES

1 Howard Pyle to Edmund Stedman, Jan. 25, 1891, Edmund Clarence Stedman Papers, 1840–1960, Columbia University Libraries, New York.

2 Robert May and Jill May, *Howard Pyle: Imagining an American School of Art* (Champaign: University of Illinois Press, forthcoming).

3 Several publications from the 1970s provided important background information for this essay, including: Delaware Art Museum, *The Golden Age of American Illustration, 1880–1914* (Wilmington: Delaware Art Museum, 1972); Stephanie E. Meyer, *America's Great Illustrators* (New York: Harry N. Abrams, 1978); Henry C. Pitz, *200 Years of American Illustration* (New York: Random House, 1977); and Dorey Schmidt, ed., *The American Magazine, 1890–1940* (Wilmington: Delaware Art Museum, 1979). More recently Michele H. Bogart has examined Pyle and other American illustrators through the framework of their industry: Bogart, "Artistic Ideals and Commercial Practices: The Problem of Status for American Illustrators," in *Prospects* (New York: B. Franklin, 1990) 15: 225–81; and Bogart, *Artists, Advertising, and the Borders of Art* (Chicago: University of Chicago Press, 1995).

4 Pyle was admitted into the antique class of the Pennsylvania Academy of the Fine Arts in 1870, although his name never appears in the attendance records for that year. However, he signed in for several sessions of a life class at the Academy in March 1871. Pennsylvania Academy of the Fine Arts Records, Archives of American Art, Smithsonian Institution, Washington, D.C.

5 William Merritt Chase's *Ready for the Ride, 1795*, a significant canvas at the first annual exhibition of the Society of American Artists, was reproduced in *Scribner's Monthly* 16, no. 5 (Sept. 1878): 609. Among the important articles on American art published in *Scribner's* were William C. Brownell's "The Art Schools of New York," *Scribner's Monthly* 16, no. 6 (Oct. 1878): 761–81; and "The Art Schools of Philadelphia," *Scribner's Monthly* 18, no. 5 (Sept. 1879): 737–51. In addition, Brownell wrote a three-part series, "The Younger Painters of America," which appeared in *Scribner's Monthly* 20, no. 1 (May 1880): 1–16; *Scribner's Monthly* 20, no. 3 (July 1880): 321–36; and *Scribner's Monthly* 22, no. 3 (July 1881): 321–34.

6 The images by Livingston Hopkins appeared in three consecutive issues: T. B. Aldrich, "The Cat and the Countess," *St. Nicholas* 3, nos. 7–9 (May–July 1876): 411–20, 476–85, 542–51.

7 "New Publications: The May Magazines," *New York Times*, April 22, 1876.

8 Pyle reprised the silhouette style for a story and a poem: Anne Eichberg, "The Story of Lesken," *Scribner's Monthly* 16, no. 2 (June 1878): 192–206; and S. C. Stone, "How Willy-Wolly Went A-Fishing," *St. Nicholas* 5, no. 8 (June 1878): 562–64.

9 "New Books," *New York Times*, Dec. 24, 1881.

10 Henry C. Pitz, *Howard Pyle: Writer, Illustrator, Founder of the Brandywine School* (New York: Clarkson N. Potter, 1975), 69.

11 Ethel Pennewill Brown and Olive Rush, "Notes from Howard Pyle's Monday Night Lectures, 1904–1906," June 27, 1904, 6, Howard Pyle Manuscript Collection, box 3, folder 2, Helen Farr Sloan Library and Archives, Delaware Art Museum.

12 On the taste for paintings that fuse genre and history, see Barbara J. Mitnick, "Paintings for the People: American Popular History Painting, 1875–1930," in

William S. Ayres, ed., *Picturing History: American Painting, 1770–1930* (New York: Rizzoli in association with Fraunces Tavern Museum, 1993), 157–66.

13 Elizabeth Johns, *Thomas Eakins: The Heroism of Modern Life* (Princeton, N.J.: Princeton University Press, 1983), 102. For a discussion of the Eakins painting, see ibid., 82–114; Kathleen Foster, *Thomas Eakins Rediscovered: Charles Bregler's Thomas Eakins Collection at the Pennsylvania Academy of the Fine Arts* (New Haven: Yale University Press, 1997), 144–50; and Lloyd Goodrich, *Thomas Eakins* (New Haven: Yale University Press, 1982), 145–57. All these books are also excellent resources on Eakins's life and career.

14 On Eakins's program at the Academy, see William Brownell, "The Art Schools of Philadelphia," *Scribner's Monthly* 18, no. 5 (Sept. 1879): 737–51.

15 In composition Pyle's illustration more closely resembles Jean-Léon Gérôme's painting *The Artist's Model* (c. 1890–93), which was in the collection of Charles T. Yerkes of Chicago by 1893.

16 In 1878, when Eakins showed *William Rush Carving His Allegorical Figure of the Schuylkill River* at the Society of American Artists' exhibition, Pyle was living in New York and friendly with such participants in the exhibition as Chase and Walter Shirlaw. When *William Rush* was exhibited at the Pennsylvania Academy of the Fine Arts in 1881, it was reproduced in the catalogue with an artist's statement about the subject of the painting. In 1893 an illustrated article on Rush was published in a popular magazine, which could have provided a more immediate inspiration for Pyle's image of a woodcarver in his studio: E. Leslie Gilliams, "A Philadelphia Sculptor," *Lippincott's Monthly Magazine* (Aug. 1893): 249–53.

17 Pyle wrote multiple times on the importance of the study of the costumed model. See, for example, Howard Pyle, "A Small School of Art," *Harper's Weekly* 41, no. 2,117 (July 17, 1897): 711.

18 Cornelia Greenough to Richard Wayne Lykes, Feb. 19, 1947, quoted in Lykes, "Howard Pyle, Teacher of Illustration," *The Pennsylvania Magazine of History and Biography* 80, no. 3 (July 1956): 341, n. 6; Pyle, "Small School of Art," 711. The Howard Pyle Manuscript Collection, boxes 18 and 19, in the Helen Farr Sloan Library and Archives at the Delaware Art Museum contains copies of Lykes's correspondence with various Pyle students, including the letter from Greenough.

19 The story behind these two sets of illustrations is related in Pitz, *Howard Pyle: Writer, Illustrator*, 169.

20 Howard Pyle, "The Present Aspect of American Art from the Point of View of an Illustrator," *Handicraft* 1, no. 6 (Sept. 1902): 128–29.

21 Howard Pyle, "Concerning the Art of Illustration," in *First Year Book* (Boston: Bibliophile Society, 1902), 21.

22 N. C. Wyeth, "Introduction," in Charles D. Abbott, *Howard Pyle: A Chronicle* (New York: Harper and Brothers, 1925), xiv.

23 Pyle to Thomas B. Wells (editor of *Harper's Monthly Magazine*), Apr. 23, 1907, quoted in Abbott, *Howard Pyle: A Chronicle*, 125–26. James Branch Cabell is best known for his escapist fiction. He had little interest in historical accuracy, and his stories often had satirical undertones.

24 Ibid.

25 A good general resource on the American Renaissance is the exhibition catalogue of Brooklyn Museum, *The American Renaissance, 1876–1917* (New York: Brooklyn Museum, 1979).

26 Delaware Art Museum, *Howard Pyle: The Artist, The Legacy* (Wilmington: Delaware Art Museum, 1987), 15–16. Ian Schoenherr assisted the author in sorting out the chronology of Pyle's career as a muralist and many other details for this introduction.

27 Pyle to W. Walton, July 28, 1906, quoted in Abbott, *Howard Pyle: A Chronicle*, 233.

28 Pyle to Edwin Howland Blashfield, Oct. 13, 1910, Edwin Howland Blashfield Papers, 1870–1956, New-York Historical Society, New York.

29 Henry M. Alden, "Howard Pyle: An Appreciation," *Harper's Weekly* 55, no. 2,865 (Nov. 18, 1911): 8. Harper and Brothers also included "Howard Pyle, Illustrator, 1853–1911: Some Notable Examples of His Work from *Harper's Magazine*," in *Harper's Monthly Magazine* 124, no. 740 (Jan. 1912): 255–63.

30 In 1912 the *Christian Science Monitor* published recollections of Pyle by two of his students: Sydney M. Chase, "How Artist Talked in the Composition Class Is Related," and N. C. Wyeth, "Association of the Students with Their Master Described," *Christian Science Monitor*, Nov. 13, 1912, 11.

James Gurney

1. | PYLE AS A PICTURE MAKER

One frosty autumn day Howard Pyle brought his illustration students outdoors to find some wild hickory nuts. After they had gathered up the fallen harvest from alongside the banks of a millstream, they noticed many more nuts resting on the stream bottom. "Well boys, there is only one way to get them," one of his students, Frank Schoonover, recalled him saying.[1] Pyle removed his shoes and stockings and rolled up the sleeves of his sweater. He waded into the icy water, plunging his arms down to the streambed to gather the remainder. Pyle did not allow the moment to pass without a lesson. "The poor soldiers at Valley Forge felt the cold, just as we feel the cold now," he said. "The ragged lot that marched against the Hessians at Trenton felt the icy water and the numbing cold and I don't believe it's possible to paint a picture of that sort within the four walls of your studio unless you feel the cold even as they did."[2]

In Pyle's illustration *Washington and Steuben at Valley Forge* (1896, see fig. 17), the two leaders trudge through the snowy camp, as the soldiers give a desultory salute. The composition alternates dense clusters of figures with stark, empty expanses of snow and sky. The cold wind flutters a flag and tugs at the hem of Washington's cloak.

One of Pyle's chief attributes as an artist was this quality of "mental projection," the ability to envision unseen worlds through the lens of direct experience.[3] In Pyle's way of seeing, every object stands as a token for something unseen. A seashell, for example, derives its beauty not only from its iridescence and its curving form but also because it stirs the imagination to contemplate distant, palm-fringed shores. "It is not the mere outward part—the part the eye sees—that holds the interest," Pyle remarked, "but what the soul feels."[4] This principle was woven through every aspect of his picture-making process: the preliminary sketch, the compositional design, the dramatic staging, and the use of models.

Although Pyle did not leave behind a systematic theory or method in his own writings, many of his students kept copious notes of his spoken words. Thornton Oakley recalled: "During three years with him he did not mention a word about materials, methods, mediums or techniques."[5] Too much emphasis on technique, Pyle warned, would result in a kind of mannered overindulgence, where the means become more important than the message.

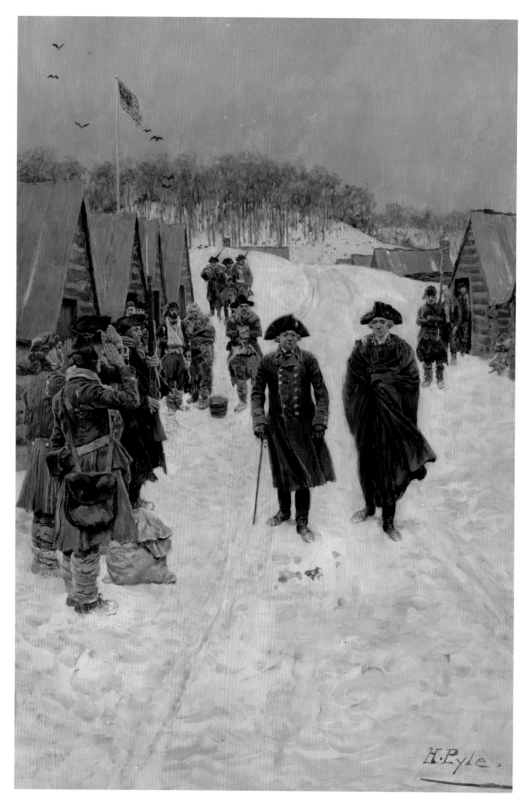

Figure 17. Howard Pyle (1853–1911). *Washington and Steuben at Valley Forge.* For Woodrow Wilson, "General Washington." *Harper's New Monthly Magazine,* July 1896. Oil on canvas. Boston Public Library, Image courtesy of the Trustees of the Boston Public Library/Print Department

PRELIMINARY SKETCHES

Nevertheless, Pyle's picture-making process can be documented both from his teaching and from his surviving preliminary works. When an idea for a picture began to germinate in his imagination, he made many thumbnail sketches in pen or pencil before he settled on the final design.

The sketches for *The Coming of Lancaster* (1908, figs. 18–21) show several tentative explorations of the subject in pencil. In each of the sketches the horse and rider emerge from what appears to be an almost random doodle, with loose lines moving in and out of the form. The positions of the heads are established as knotlike circles drawn more darkly, as if Pyle recognized that they would attract the most attention. Student Charles DeFeo recalled seeing a desk drawer filled with thousands of such sketches, as many as fifty for a single picture. "If the first sketch looks like the one I want to do," said Pyle, "to make sure—I always make the other forty-nine anyway."[6]

Sometimes the process of generating thumbnail sketches acquired an almost mystical intensity. Pyle once described the feeling of an unseen hand guiding his own.[7] His sketches give the impression of a fleeting vision snatched from the ether, a snapshot from the swirling creative vortex, or a half-remembered dream. Another student, Harvey Dunn, who himself later became an influential teacher, characterized this stage as the formation of the "pictorial concept," with the emphasis on defining the emotional or spiritual force behind the image and expressing it very simply, often devoid of detail.[8]

Pyle liked to think of picture ideas in elemental terms. When critiquing a railroad subject by one of his students, he advised imagining the train's engine as a monster, "a thing formed of the metals of the earth—moved by fire and water."[9] It was vital that the picture express a single idea. A second idea, he told his students, weakens the picture by half, and a third by a compound ratio.[10]

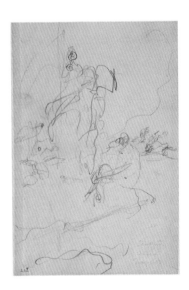 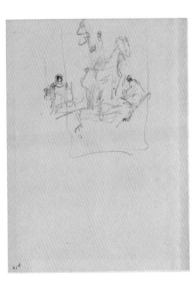 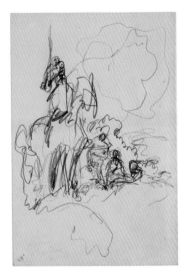 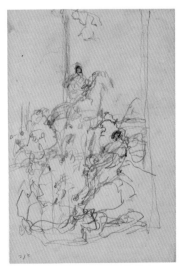

Figure 18. Howard Pyle (1853–1911). Sketch for *The Coming of Lancaster*, 1908. Pencil on paper, 8½ × 5½ inches. Delaware Art Museum, Gift of Willard S. Morse, 1925

Figure 19. Howard Pyle (1853–1911). Sketch for *The Coming of Lancaster*, 1908. Pencil on paper, 7³⁄₁₆ × 5⁹⁄₁₆ inches. Delaware Art Museum, Gift of Willard S. Morse, 1925

Figure 20. Howard Pyle (1853–1911). Sketch for *The Coming of Lancaster*, 1908. Pencil on paper, 8⅜ × 5⅜ inches. Delaware Art Museum, Gift of Willard S. Morse, 1925

Figure 21. Howard Pyle (1853–1911). Sketch for *The Coming of Lancaster*, 1908. Pencil on paper, 8⅜ × 5⅜ inches. Delaware Art Museum, Gift of Willard S. Morse, 1925

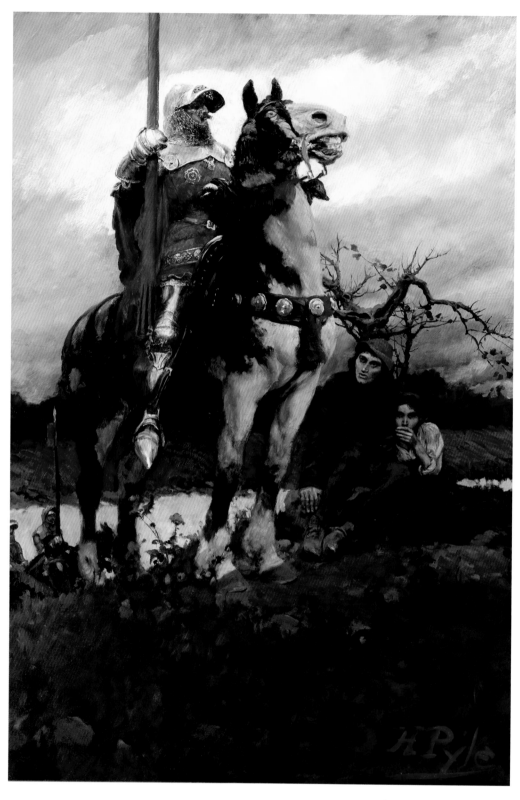

Figure 22. Howard Pyle (1853–1911). *The Coming of Lancaster*.
For James Branch Cabell, "The Scabbard." *Harper's Monthly Magazine*,
May 1908. Oil on canvas, 35½ × 23¼ inches. Delaware Art Museum,
Museum Purchase, 1912

PRINCIPLES OF COMPOSITION

Pyle's compositions are so arresting and original that it is tempting to analyze his images purely in abstract terms: contour, shape, thrust, asymmetry, and so on. Although his paintings are notable for their aesthetic appeal, they were not conceived with design alone in mind. To Pyle, art did not exist for its own sake but rather for the sake of the story. The expression of an emotion or an idea was paramount. Pyle's student Jessie Willcox Smith recalled how one's awareness of the story influenced the choices in composition:

> At the [Pennsylvania] Academy [of the Fine Arts] we had to think about compositions as an abstract thing, whether we needed a spot here or a break over there to balance, and there was nothing to get hold of. With Mr. Pyle it was absolutely changed. There was your story, and you knew your characters, and you imagined what they were doing, and in consequence you were bound to get the right composition because you lived these things. . . . It was simply that he was always mentally projected into his subject.[11]

On a regular basis, usually once or twice a week, each of his students submitted a large outline drawing in charcoal. It was supposed to be made without models on a theme that each person came up with independently. Pyle reviewed the submissions and chose the ones he wanted to talk about.[12] It is from his students' notes on these critique sessions that we can best understand Pyle's thinking about composition.

It was essential to keep the picture simple in tone. "The fewer tones the simpler and better your pictures," Pyle said.[13] Sometimes he unified shapes by connecting them with an enveloping shadow; sometimes the light areas spilled over into one another. Pyle recommended lightening the light areas and darkening the dark areas, so that the lights and darks were distinct and merged to make larger tonal shapes.[14] By deliberately placing two shapes of similar value adjacent to each other, the shapes formed a larger unit. "Put your white against white, middle tones (groups) against grays, black against black, then black and white where you

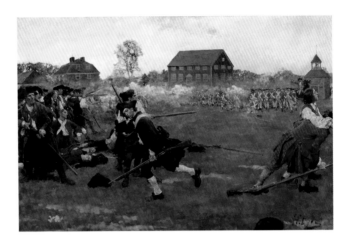

Figure 23. Howard Pyle (1853–1911). *The Fight on Lexington Common, April 19, 1775.* For Henry Cabot Lodge, "The Story of the Revolution." *Scribner's Magazine*, January 1898. Oil on canvas, 23¼ × 35¼ inches. Delaware Art Museum, Museum Purchase, 1912

want your center of interest," Pyle advised. "This sounds simple, but is difficult to do."[15]

In the case of *The Fight on Lexington Common, April 19, 1775* (1898, fig. 23), for example, the white crossbelt over the shoulder of the running minuteman blends into the white sleeve of the figure behind him, while his brown breeches and coat form a larger unit with the legs of the figures behind. To concentrate attention on the face of the running figure, Pyle sharply contrasted the black tricorn hat atop the figure's head with the white shirt behind it. The head becomes even more of a focal point because of the way the lines of two musket barrels radiate from that point of the picture.

This careful arrangement benefits the storytelling in two ways. First, it directs the viewer's attention to the narrative focus of the picture without the distraction of trivial details. And, second, it allows the picture to be read from quite a distance, even if reproduced at a small size. Pyle recommended establishing the tonal structure of the picture immediately in the painting process: "After the first half-hour of work," he said, "your lay-in should kill at a hundred yards."[16]

The Lexington illustration demonstrates another design strategy. Pyle arranged the group of soldiers on the left into a dense cluster, with detail layered upon detail, while leaving large areas of the ground and the sky open. This clustering principle, which Pyle called "the elaboration of groups," can also be seen in *Extorting Tribute from the Citizens* (1905, fig. 24).[17] In front of the arch, a crowd of faces contrasts with the blank walls nearby. In *We Started to Run Back to the Raft for Our Lives* (1902, fig. 25), Pyle could have spaced his figures out evenly, with each silhouette separate from the others. Because he clustered them together, however, the eye sees them as one shape first and then sorts them out.

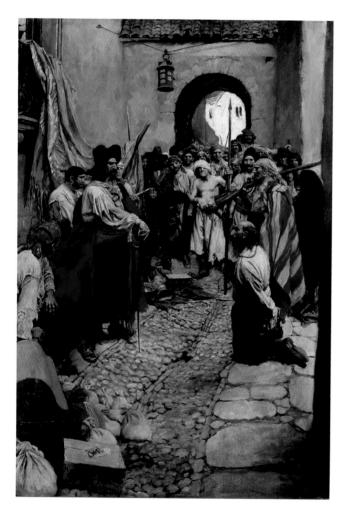

Figure 24. Howard Pyle (1853–1911). *Extorting Tribute from the Citizens*. For Howard Pyle, "The Fate of a Treasure Town." *Harper's Monthly Magazine*, December 1905. Oil on canvas, 29½ × 19½ inches. Delaware Art Museum, Museum Purchase, 1912

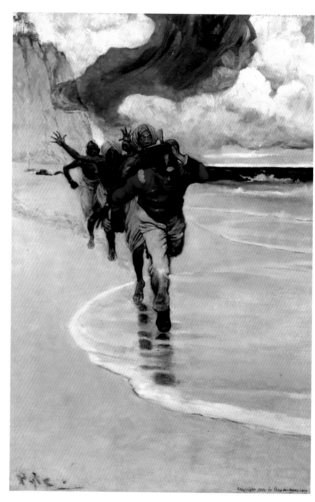

Figure 25. Howard Pyle (1853–1911). *We Started to Run Back to the Raft for Our Lives*. For Arthur T. Quiller-Couch, "Sinbad on Burrator." *Scribner's Magazine*, August 1902. Oil on canvas, 24¼ × 16¼ inches. Delaware Art Museum, Museum Purchase, 1912

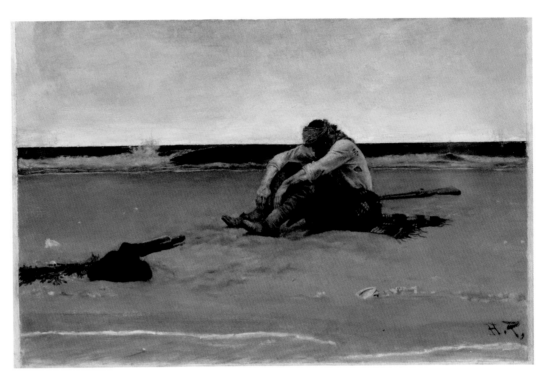

Figure 26. Howard Pyle (1853–1911). *Marooned*. For Howard Pyle, "Buccaneers and Marooners of the Spanish Main." *Harper's New Monthly Magazine*, September 1887. Oil on canvas, 18 × 25¾ inches. Private collection

Pyle ruthlessly removed any element in a picture that was not essential to conveying the story. "They will never shoot you for what you leave out of a picture," he once said.[18] His reductive instinct sometimes gnawed for years on a picture until it stripped the idea to the bone. The full-color oil painting *Marooned* (1909, see fig. 27), for example, was preceded by a black-and-white composition in oil (1887, fig. 26), which Pyle had created to illustrate his own pirate story. As the visual idea matured in his mind, he took away the gun, made both the near waves and the far sea smaller, and reduced the size of the hat, the sash, and, most importantly, the figure itself. "He teaches the necessity of elimination,"

said a student. "That is, after a composition is once created the eliminations are more important than the additions."[19] The power of subtraction echoed through Pyle's student N. C. Wyeth to Wyeth's son Andrew, who expressed the belief that an element removed from a picture still remains as a phantom presence.[20]

By grouping, clustering, and eliminating elements, Pyle pushed every picture toward extremes. "If you're painting a sky full of birds, or a garden of flowers, or any objects—show one or a thousand," he urged his students. "If an object in the foreground of your picture looks too big, make it bigger. If it looks too small, make it smaller."[21]

Figure 27. Howard Pyle (1853–1911). *Marooned*, 1909. Oil on canvas, 40 × 60 inches. Delaware Art Museum, Museum Purchase, 1912

DRAMATIC STAGING

Pyle regarded the picture as a stage, and figures as actors in a drama. He believed that the faces of the principle actors should be turned toward the audience, as in theater, because "dramatic Art is nearest akin to our art."[22] In his pictures Pyle often kept the foreground relatively empty to focus attention on the central subject.

In every story he looked for what he called the "supreme moment," the phase of action that conveys the most suspense, often a fateful encounter or a moment of decision.[23] In the composition *Walking the Plank* (1887, see fig. 51), the hapless prisoner faces his doom, while his captors watch mercilessly. When scenes of extreme action were called for, Pyle often chose to portray a moment just before or just after

the peak of the action, believing that putting figures amid violent action is less dramatic.[24] Similarly, in *The Shell* (1908, fig. 28), illustrating a Civil War story, we hold our breath with dread anticipation of the impending explosion. The figures are arranged in a trapezoidal shape. Their reactions form

Figure 28. Howard Pyle (1853–1911). *The Shell.* For William W. Lord, Jr., "A Child at the Siege of Vicksburg." *Harper's Monthly Magazine*, December 1908. Oil on canvas, 30¼ × 20 inches. Collection of the Brandywine River Museum, Gift of Mr. and Mrs. Howard P. Brokaw

a visual crescendo: the man has dropped to his hands and knees, and the African American woman leans to the side in an attempt to protect the cowering white woman, who has dropped her parasol. They are all frozen in horror at what is about to happen.

Every moment depicted in an illustration by Pyle is plucked from a broader timeline of dramatic events. Pyle was always conscious of what came before and what came after the moment he portrayed. He left a series of clues in *Dead Men Tell No Tales* (1899, see fig. 60), which suggests the previous incidents leading to the dramatic cliff-hanger depicted. As David M. Lubin explores in this catalogue, Pyle's dramatic sensibilities influenced not only the field of illustration but also the emerging motion-picture industry, as film directors translated stories of pirates, Robin Hood, and American history to the art of the cinema in the twentieth century.

USE OF MODELS

Pyle painted some of his illustrations completely from his imagination and others with the benefit of posed models. A pencil study of a draped figure (1902, see fig. 29), a preparatory sketch for a later painting, is an example of a study drawn from a model. The folds of the gown show careful observation, though the reference is used somewhat summarily in the final painting, *In the Meadows of Youth* (1902, see fig. 30), as if Pyle were concerned that too much attention to the folds and wrinkles of fabric would take away from the larger poetic statement.[25] Painting directly from posed models was a central part of his teaching. He wanted his students to study costumed models, since so few of the subjects they would interpret as illustrators would call for nudes. Pyle once compared painting a nude model to painting a plucked bird.[26] His substantial collection of vintage and reproduction costumes aided him in his quest for historical accuracy (1903, see fig. 31)—and they also came into service occasionally for lighthearted, mock theatrical performances.

He sometimes had his students painting directly from a model posed outdoors. The students were not expected to copy exactly what they saw in such exercises. Instead

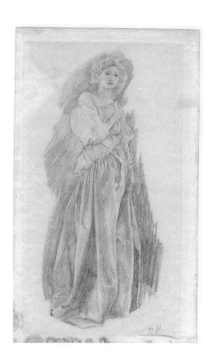

Figure 29. Howard Pyle (1853–1911).
Study of Costumed Model, 1902.
Pencil on paper, 12 × 6½ inches.
Collection of Ian Schoenherr

Figure 30. Howard Pyle (1853–1911). *In the Meadows of Youth.* For Howard Pyle, "The Travels of the Soul." *The Century Magazine,* December 1902. Oil on canvas, 31½ × 17½ inches. The Neville Public Museum of Brown County and the Green Bay and De Pere Antiquarian Society

Pyle wanted them to interpret what they saw in terms of an assigned theme. Once, for example, Pyle suggested "home from the war." He enlisted a young man to pose as a drummer boy in front of an old mill. The boy wore short red breeches and a homemade white shirt and had an authentic Revolutionary War drum over his shoulder, while a girl posed beside the door holding a pitcher and a sandwich.[27]

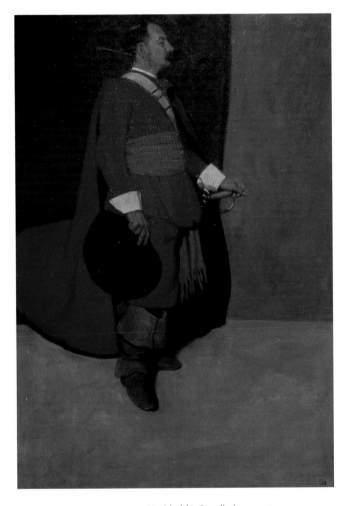

Figure 31. N. C. Wyeth (1882–1945). *Untitled (A Cavalier)*, 1903. Oil on canvas, 30 × 20 inches. Private collection

According to his daughter Eleanor, Pyle frequently took his own photographs, both for his own amusement and for reference.[28] Most of the reference photos relate to locations, such as a canal scene whose elements Pyle recomposed to simplify the trees and the distant farm buildings for his illustration (see figs. 32 and 33). Pyle never condemned the artistic use of photographs: he encouraged N. C. Wyeth to bring a camera along to document his trip to the West in 1904.

During Pyle's years of maximum productivity in the late 1880s, when he painted over two hundred illustrations per year, he understandably could not find the time to use models or costumes for every figure, so he relied instead on his imagination. Sometimes the lack of models is evident in poses or faces that are less than fully convincing. But being able to trust one's imagination and to work without references were skills important to him:

> You should not need models. You know how a face looks—how an eye is placed and the form of it and you should be able to draw it from your knowledge. That is the very difficulty with students from other schools . . . People say "That is a good draughtsman." Yet ask him to draw without the model and he is utterly helpless. He has learned nothing of real value, for you cannot draw until you can be independent of the model. And so I would advise you to draw your figures and carry them as far as you can without the model then get the model to correct by.[29]

PYLE AND THE ACADEMIC TRADITION

Pyle received his early artistic education not at the Pennsylvania Academy but at a private art school run by Antwerp-trained Francis Van der Wielen, who taught him rigorous drawing, in the academic tradition, from plaster casts and from models in long poses. The students Pyle later taught at the Drexel Institute of Art, Science, and Industry in Philadelphia and at his own school in Wilmington arrived with a similar grounding.[30] Although he required that his incoming students possess a mastery of accurate observational drawing skills, he maintained that they had to unlearn some of

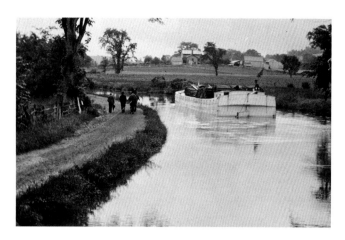

Figure 32. Howard Pyle (1853–1911). *Champlain Canal*, c. 1895. Photograph. Private collection

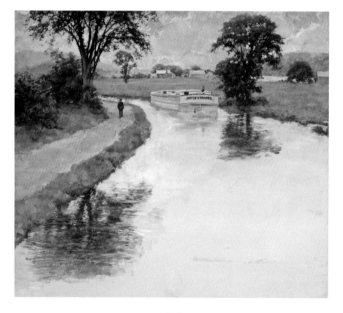

Figure 33. Howard Pyle (1853–1911). *Untitled*. For Howard Pyle, "Through Inland Waters, Part II." *Harper's New Monthly Magazine*, June 1896. Oil on board, 12¼ × 11 inches. Collection of Ian Schoenherr

that training to be successful. He drew a distinction between imitative and creative art, and he believed that concentrating solely on copying stifled the imagination.[31] He chided one student who had been drawing a cast of a Donatello sculpture for regarding his subject as a piece of plaster. Pyle urged him to envision the Italian noblewoman who must have posed for Donatello surrounded in her medieval palace by silks, damasks, and courtiers.[32]

Yet Pyle must have been aware that the grand European tradition of art education developed not merely to perfect copying skills but to equip painters to visualize stories from the Bible, from classical myths, and from Greek and Roman history—subjects similar to those in his own illustrations. Though he did not travel to Europe until his last years, he would have been familiar with the academic painters associated with the French Salon and the British Royal Academy. As Margaretta S. Frederick discusses in detail in this catalogue, Pyle knew their work by means of prints and illustrations in magazines: notable canvases from the Salon were frequently reproduced side by side with pictures by American illustrators in *Harper's Monthly* and the *Century Magazine*. Likewise, private and public American collections burgeoned with European academic paintings. During the fertile period of the American Renaissance, Pyle was a member of many artistic social circles, where the means and methods of the foreign academies were discussed at length.[33]

Many of Pyle's compositions show strong parallels to the conceptions of earlier French painters, especially the military and history specialists Édouard Détaille, Jean-Léon Gérôme, and Ernest Meissonier. For example, Pyle evidently saw reproductions, if not the original, of Gérôme's famous painting *Pollice Verso* (1872, fig. 34), which shows Roman gladiators locked in a battle to the death.[34] Pyle's own painting of gladiatorial combat, *Peractum Est!* (1897, fig. 35), bears a striking resemblance to the Gérôme canvas in its staging of foreground drama. In both paintings thin bars of sunlight slash across the sandy ground, with the distant crowd bathed in shadow or light.

Throughout the late nineteenth and early twentieth centuries, advances in printing technology, literacy, and mail

Figure 34. Jean-Léon Gérôme (1824–1904). *Pollice Verso*, 1872. Oil on canvas, 15½ × 23 inches. Phoenix Art Museum, Museum Purchase

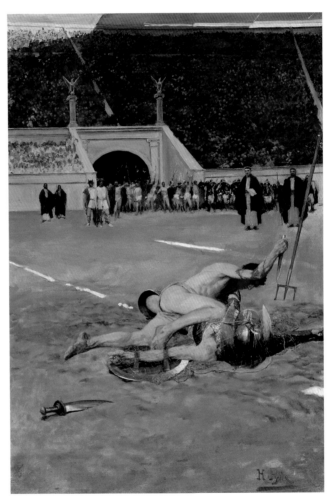

Figure 35. Howard Pyle (1853–1911). *Peractum Est!*, 1897. For Henryk Sienkiewicz, *Quo Vadis*. Boston: Little Brown and Company, 1897. Oil on canvas, 26 × 16¾ inches. Delaware Art Museum, Gift of Mrs. Richard C. du Pont, 1965

delivery transformed the way images were presented, creating new opportunities for artists, and altering the system of patronage and distribution. The popular demand for realistic narrative images continued unabated, remaining fixed in the public's center of vision, despite the emergence of Impressionism and modernism. Just as a great deal of music moved from the performance stage to the phonograph recording, the forum for storytelling pictures steadily shifted from original art in public exhibitions—such as the Salon in Paris or the 1893 World's Columbian Exposition in Chicago—to reproductions on the printed page. Pyle recognized that the mainstream of art was flowing into a new channel. As he put it, "The great art of the world is constructed upon a line almost identical with that of book and magazine illustration."[35]

At times late in his career Pyle questioned the lasting value of book and magazine illustration. Some of his final pictures, such as *The Mermaid* (1910, see fig. 36) and *Marooned*, were conceived as easel paintings. His voyage to Europe in the last year of his life was largely driven by a desire to develop his mural painting skills. N. C. Wyeth suffered similar bouts of ambivalence about illustration in his later years. In the end the enduring artistic legacy of both Pyle and Wyeth is rooted in their work for the printed page. "A wider impression can be made upon the world of American Art through book illustration," Pyle said, "than through any other medium."[36]

He fondly recalled his first encounters with the art of books: "We—my mother and I—liked the pictures in books

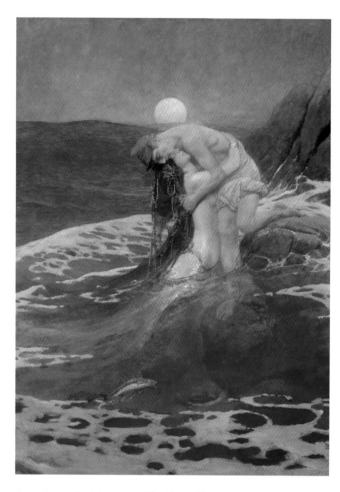

Figure 36. Howard Pyle (1853–1911). *The Mermaid*, 1910. Oil on canvas, 57⅞ × 40⅛ inches. Delaware Art Museum, Gift of the children of Howard Pyle in memory of their mother, Anne Poole Pyle, 1940

the best of all. I may say to you in confidence that even to this very day I still like the pictures you find in books better than wall pictures."[37] Pyle surely would have been pleased to know that one hundred years after his death, his artwork continues to be appreciated not just by scholars but also by artists, writers, parents, and children, and that his images reach a modern audience whether they are illustrations on the pages of books or "wall pictures" hanging in museums.

NOTES

The author gratefully acknowledges the assistance of the following people in the preparation of this essay: Heather Campbell Coyle, Kevin Ferrara, Robert Horvath, Steven Kloepfer, Dennis Nolan, Joyce K. Schiller, Ian Schoenherr, and Gail Stanislow.

1 Howard Pyle quoted in Frank Schoonover, "Howard Pyle," in Howard Pyle, *The Story of the Champions of the Round Table, The Howard Pyle Brandywine Edition, 1853–1933* (New York: Charles Scribner's Sons, 1933), unpaginated.

2 Ibid.

3 Schoonover described "mental projection" as Pyle's "great theory," and stated that Pyle based all his criticism on it. In Richard K. Doud, Oral History Interview with Frank Schoonover, Apr. 6, 1966, Archives of American Art, Smithsonian Institution, Washington, D.C. Transcript, p. 6, in Howard Pyle Manuscript Collection, box 4, folder 12, Helen Farr Sloan Library and Archives, Delaware Art Museum.

4 Pyle quoted in Ethel Pennewill Brown and Olive Rush, "Notes from Howard Pyle's Monday Night Lectures, 1904–1906," Aug. 15, 1904, 32, Howard Pyle Manuscript Collection, box 3, folder 2, Helen Farr Sloan Library and Archives, Delaware Art Museum. After the lectures the two Pyle students wrote down what they recalled and later combined their efforts in what they called their "little red books." Ibid., 1. Some of these notes are published in Delaware Art Museum, *Howard Pyle: Diversity in Depth* (Wilmington, Del.: Wilmington Society of the Fine Arts, 1973).

5 Thornton Oakley quoted in Richard Wayne Lykes, "Howard Pyle, Teacher of Illustration," *The Pennsylvania Magazine of History and Biography* 80, no. 3 (July 1956): 357, n. 59.

6 Charles DeFeo, "Personal Reminiscences of Howard Pyle," in Delaware Art Museum, *Howard Pyle: Diversity in Depth* (Wilmington, Del.: Wilmington Society of the Fine Arts, 1973), 17.

7 Pyle is quoted as having said: "In doing a composition we often make sketch after sketch without getting what we want when suddenly an unseen force seems to guide the hand and we exclaim, 'Why, *that* is what I wanted!'" In Brown and Rush, "Notes from Howard Pyle's Monday Night Lectures," Aug. 15, 1904, 37. This mystical orientation is consistent with Pyle's interest in Swedenborgianism. (For more on that subject, see the essay by Mary F. Holahan in this catalogue.)

8 Charles J. Andres, "Harvey Dunn Class Notes." http://www.e-pix.com/ArtMuseum/Dunnclassno.html.

9 Pyle quoted in Brown and Rush, "Notes from Howard Pyle's Monday Night Lectures," Sept. 5, 1904, 54.

10 On the importance of a single idea, see ibid., June 20, 1904, 2, and July 25, 1904, 18.

11 Jessie Willcox Smith quoted in Edward D. Nudelman, *Jessie Willcox Smith: American Illustrator* (Gretna, La.: Pelican Publishing Company, 1990), 23.

12 Doud, Oral History Interview. Transcript, 10.

13 Pyle quoted in W. H. D. Koerner, Notes Taken in Pyle's Class, Howard Pyle Manuscript Collection, box 3, folder 6, Helen Farr Sloan Library and Archives, Delaware Art Museum.

14 Ibid.

15 DeFeo, "Personal Reminiscences," 17.

16 Ibid.

17 Drexel Institute of Art, Science, and Industry, *Catalogue of the Department of Fine and Applied Arts, 1894–95* (Philadelphia: Drexel Institute of Art, Science, and Industry, 1894), 7–8.

18 DeFeo, "Personal Reminiscences," 17.

19 "In the Art Schools," *American Art News* 3, no. 72 (Mar. 25, 1905): 2. About the final *Marooned* painting, Gertrude Brinklé wrote: "This was painted on very hot days, and Mr. John Weller said he had very nearly gotten a sunstroke when he was posing for it. After the painting was finished, Mr. Pyle asked Mr. Schoonover and Mr. Clifford Ashley if the sky looked perhaps a little lonely. Mr. Ashley suggested putting in those birds. Mr. Pyle put them in, painted them out, and then finally put them in again. This marooned is the third painting of this subject—with slight differences." Notes on Howard Pyle Collection from a conversation between Gertrude Brinklé and Frank Schoonover, Feb. 1949, Howard Pyle Manuscript Collection, box 5, folder 4, Helen Farr Sloan Library and Archives, Delaware Art Museum.

20 Andrew Wyeth spoke multiple times about the importance of simplification and elimination in his work. See, for example, "Andy's World," *Time* 82, no. 26 (Dec. 27, 1963): 51. For an in-depth discussion of his practice, see Kathleen A. Foster, "Meaning and Medium in Wyeth's Art: Revisiting Groundhog Day," in Anne Classen Knutsen, ed., *Andrew Wyeth: Memory and Magic* (Atlanta: High Museum of Art; Philadelphia: Philadelphia Museum of Art in association with Rizzoli, New York, 2005), esp. 102.

21 DeFeo, "Personal Reminiscences," 17.

22 Several times Pyle criticized figures looking away from the viewer. He said: "It is an axiom in Dramatic Art that the face should always be turned towards the audience and Dramatic Art is nearest akin to our art—As soon as the face is turned away the interest begins to flag. You should see the face with its varied expressions." Quoted in Brown and Rush, "Notes from Howard Pyle's Monday Night Lectures," Aug. 29, 1904, 48.

23 Brown and Rush, "Notes from Howard Pyle's Monday Night Lectures," June 27, 1904, 9.

24 Pyle instructed his students to do the same. See Brown and Rush, "Notes from Howard Pyle's Monday Night Lectures," Aug. 15, 1904, 38.

25 Lykes states: "He was always fearful that the artist would lose his sense of proportion in a maze of trifles." In Lykes, "Howard Pyle, Teacher of Illustration," 357.

26 "The human family having worn cloths [*sic*] for generations, their cloths were a part of them, it was like taking the feathers off a bird before you draw or paint it." Cornelia Greenough to Richard Wayne Lykes, Feb. 19, 1947, quoted in Lykes, "Howard Pyle, Teacher of Illustration," 341 n. 6.

27 Doud, Oral History Interview. Transcript, 10.

28 Rowland Elzea, A. Haslam, Elizabeth Hawkes, J. McDowell, and Eleanor Pyle Crichton, Tape-Recorded Interview with Pyle Crichton, Nov. 4, 1982, Howard Pyle Manuscript Collection, box 4, folder 8, Helen Farr Sloan Library and Archives, Delaware Art Museum.

29 Brown and Rush, "Notes from Howard Pyle's Monday Night Lectures," Aug. 22, 1904, 45.

30 "I would not belittle the necessity of accurate technical training. I insist upon that in my own school even more strenuously," wrote Pyle to W. M. R. French, Apr. 13, 1905. Quoted in Charles D. Abbott, *Howard Pyle: A Chronicle* (New York: Harper and Brothers, 1925), 222.

31 Pyle revealed his thinking about art training in a series of letters to French, who was director of the Art Institute of Chicago, in spring and summer 1905. They are quoted at length in ibid., 220–27.

32 Sidney M. Chase, "How Artist Talked in the Composition Class Is Related," *Christian Science Monitor*, Nov. 13, 1912, 11.

33 In his Monday night lectures on composition, Pyle encouraged his students to study the work of, among others, Antoine-Louis Barye, John Everett Millais, and Vasily Vereshchagin. Pyle's social circle in New York included members of the Society of Illustrators, the Tile Club, and many other arts organizations. See Brandywine River Museum, "Howard Pyle and the American Renaissance," in Traditional Fine Arts Organization, Resource Library, 2007, "page 1": http://www.tfaoi.com/aa/7aa/7aa719.htm; "case labels": http://www.tfaoi.com/aa/7aa/7aa719a.htm; and "label copy": http://www.tfaoi.com/aa/7aa/7aa719b.htm.

34 *Pollice Verso* was purchased by department-store magnate Alexander T. Stewart and exhibited publicly in New York. It was in Stewart's collection in New York by January 1875. Gerald M. Ackerman, "Thomas Eakins and His Parisian Masters Gérôme and Bonnat," *Gazette des Beaux-Arts*, series 6, 73 (Apr. 1969): 241–42.

35 Pyle to French, Apr. 20, 1905. Quoted in Abbott, *Howard Pyle: A Chronicle*, 224.

36 Ibid.

37 Howard Pyle, "When I Was a Little Boy: An Autobiographical Sketch," *Woman's Home Companion* 39, no. 4 (Apr. 1912): 5, 103.

Alan Lupack and Barbara Tepa Lupack

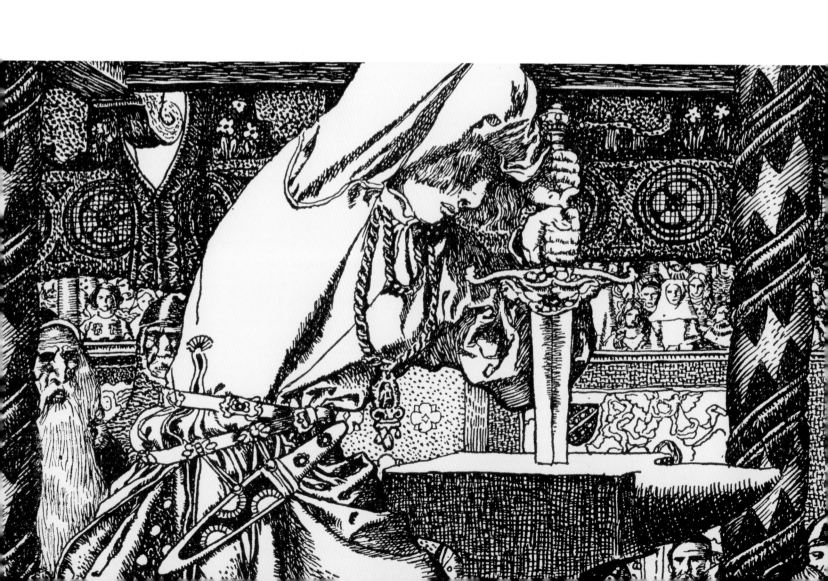

HOWARD PYLE AND THE ARTHURIAN LEGENDS

2.

In his much-beloved Arthurian tetralogy—*The Story of King Arthur and His Knights* (1903), *The Story of the Champions of the Round Table* (1905), *The Story of Sir Launcelot and His Companions* (1907), and *The Story of the Grail and the Passing of Arthur* (1910)—Howard Pyle retold and illustrated the legendary tales of Arthur from his birth to his death. The books not only became a staple of juvenile literature; they also helped to shape the American Arthurian tradition for years to come.

Yet Pyle's first Arthurian work was not his popular tetralogy but an early and admirable experiment in color illustration that is now largely forgotten: an edition of Alfred, Lord Tennyson's poem "The Lady of Shalott." Designed to resemble an illuminated medieval manuscript, Pyle's version, published in 1881 by Dodd, Mead and Company, is composed of ornately decorated pages that feature elaborate initial capital letters as well as images of characters from the poem, interesting backgrounds, and a variety of scenes from nature as described in Tennyson's lines. The text, hand-lettered over the images in a kind of black Gothic script, is repeated in regular type on the opposing page. Complementing the pseudo-manuscript pages and evoking the poem's central tension of art versus life are discrete, large, color drawings of the Lady of Shalott. When Sir Lancelot rides past her tower window on his wild-eyed steed and the lady abandons her web and her loom to glimpse the great knight firsthand (1881, see figs. 37 and 38), the mirror through which she views the world cracks—a metaphor for the shattering of her circumscribed life.[1] Eventually, she finds among the reeds a boat that will carry her "down ye stream toward Camelot," where Lancelot beholds her corpse and even Arthur mourns her passing—all events that Pyle depicted in full-page illustrations.[2]

Complementing the floral imagery in the larger illustrations are small roundel portraits, which Pyle used symbolically and paired iconographically with flowers.[3] Framing the portrait of the Lady of Shalott, for example, is a single stem of orange lilies; Lancelot is pictured in profile with a rose, representing the lady's passion for him, as well as a sword, representing his chivalric obligation. Recurring throughout the volume are images of peasant couples and lovers, whose happiness offers a contrast to the lady's eventual tragedy.

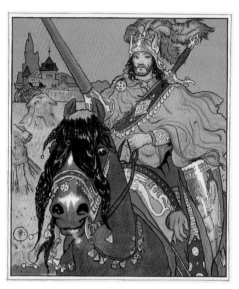

Figure 37. Howard Pyle (1853–1911). *Untitled.* From Alfred, Lord Tennyson, *The Lady of Shalott.* New York: Dodd, Mead and Company, 1881. Printed matter. Helen Farr Sloan Library and Archives, Delaware Art Museum

Figure 38. Howard Pyle (1853–1911). *Untitled.* From Alfred, Lord Tennyson, *The Lady of Shalott.* New York: Dodd, Mead and Company, 1881. Printed matter. Helen Farr Sloan Library and Archives, Delaware Art Museum

Similarly, the shepherd boy, the milkmaid, the gleaners, and even the birds and other animals—all part of Tennyson's natural world—are portrayed in sharp opposition to the artifice and isolation of the lady's world of mirrors.

As in his later Arthurian pen-and-ink drawings, Pyle attempted to create mood and tone by his use of light and dark: the lady's insular world is full of shadows and tapestried walls, on which life is still and unchanging, while the real world beyond her tower is bustling and bright. But, as Muriel Whitaker observes, since print technology at that time was "incapable of producing anything but flat primary colours and insipid green," there is no real "medieval brilliance" to the book. Despite Pyle's conscious imitation of the illuminator's style in details such as the lettering, "zoomorphic interlace [,] . . . and a profusion of acanthus leaves," Whitaker concludes that *The Lady of Shalott* was not an aesthetic triumph.[4] Although it was a significant early example of color illustration, Pyle himself was disappointed in the book, which was never reprinted and is generally unknown today.

That is clearly not the case with Pyle's Arthuriad, which remains almost as popular as it was a century ago. According to his fellow Brandywine artist N. C. Wyeth, Pyle's pen drawings for the tetralogy are not only his most important contribution to the Arthurian canon; they are also "Pyle's most important contribution to the world of art."[5]

Serialized in the acclaimed young people's magazine *St. Nicholas* and first published in book form in 1903, *The Story of King Arthur and His Knights* consists of "The Book of King Arthur" and "The Book of Three Worthies," which tell the stories of Merlin, Sir Pellias, and Sir Gawaine and afford "a perfect example of courage and humility" of "these excellent men."[6] Pyle's numerous line drawings and black-and-white portraits not only enhance the narrative but also comment on it by contrasting the elegant yet artificial world of the court with the natural world of woods and waters. Pyle also employed familiar recurring motifs such as birds, roses, and other symbols of fecundity, and balanced images of authority—crowns, thrones, orbs, scepters, weapons—with more humble and democratic motifs, like the simple cap and garb worn by Arthur when disguised as the gardener lad.[7]

Published two years later, *The Story of the Champions of the Round Table*—which contains "The Story of Launcelot," "The Book of Sir Tristram," and "The Book of Sir Percival"—chronicles the adventures of "certain other worthies," most notably Sir Launcelot of the Lake, whose virtues and shortcomings were representative of "those of us who are his brethren."[8] Launcelot is also the focus of the third volume, *The Story of Sir Launcelot and His Companions*, published in 1907; told in seven parts, that "further history" effectively blends realism with romance.[9]

The final volume is, Pyle alleged, the saddest of his four Arthurian books.[10] Divided into three parts, *The Story of the Grail and the Passing of Arthur* brings Arthur's story to its inevitable conclusion. But the book was also the culmination of Pyle's own artistic quest. It proved to be his last major project: he died in 1911, only a year after its publication.

Pyle's Arthuriad is based primarily on Sir Thomas Malory's *Morte d'Arthur* (1469–70), which he had first read in his youth. Notably, though, Pyle made no attempt to derive every word of his text or the subject of every illustration from the *Morte* or from his other sources, which included the *Mabinogion*, some French versions of the legends, and ballad material such as Thomas Percy's *Reliques of Ancient English Poetry* (1765).[11] In fact, his approach to the legends may be best understood by means of an analogy to his philosophy of teaching art. As his fellow illustrator Henry C. Pitz recounts, Pyle would introduce his students to the posing model by telling them to examine the figure carefully. Then he advised the students "to make a picture—a picture more than a copy!"[12] That is precisely what Pyle did in his Arthuriad: by adding imagination to the technical skill of the imitator, he reinterpreted his sources and created "pictures," both visual and verbal, that were more than just "copies." In this way Pyle created an entirely new version of the legends, a version clearly intended for young readers but one that never patronized them.

Perhaps the most obvious yet most skillful way that Pyle went beyond his model was by the subtle interplay of text and illustrations.[13] In many instances the visual and the literary are complementary, as in the treatment of the characters, whom he rarely describes at length. Of King Arthur's traitorous bastard son Mordred, for example, Pyle writes that "he hath ever had a dark and gloomy spirit," but offers no extended description of his appearance. There is, however, a visual depiction of Mordred, looking contemptuous and ill at ease, that perfectly captures his evil nature.[14]

Similarly, as Lucien L. Agosta notes, the illustration of Queen Guinevere is a richly suggestive icon (1903, fig. 39). Her portrait, which distills the various roles she plays in Arthurian history, "is studded with emblems suggesting both the harmony she brings to the realm with her dowry of the Round Table and the strife she precipitates at the narrative's conclusion." The two knights battling against each other in the distance at her left, moreover, allude to "both the youthful Arthur's early duel in the winning of his queen and those final fatal clashes over her which end Arthur's reign." The image thus provides "a telescopic insight" into the events that Guinevere causes.[15]

Throughout his tetralogy, Pyle uses such portraits—thirty-one of them in all (ten in the first book, nine in the second, eight in the third, and four in the fourth)—as a means of describing both major and minor characters. In each portrait, as Patricia Dooley observes, Pyle eliminates or reduces most of the background imagery and allows the "sitter [to

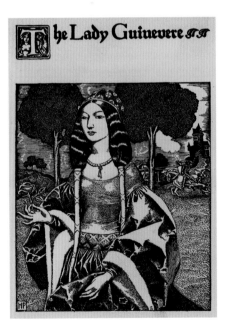

Figure 39. Howard Pyle (1853–1911). *The Lady Guinevere*. From Howard Pyle, *The Story of King Arthur and His Knights*. New York: Charles Scribner's Sons, 1903. Printed matter. Helen Farr Sloan Library and Archives, Delaware Art Museum

bear a freight of decorative and symbolic designs on armor, clothing, or jewelry." By removing the subjects from their natural settings—the women from the castle, scene of their loves and tragedies; the men from the field of battle or quest—Pyle invites his reader to discover "an individuality and depth of character not usually found in Romances," and he achieves a "synthesis of distance and immediacy" that alters the focus from setting to the characters and their actions.[16]

Another way in which Pyle uses text and illustrations to complement each other is in the presentation of natural description. In the illustration *Sir Mellegrans Interrupts the Sport of the Queen* (1907), for instance, Guinevere and her attendants are merrymaking on a grassy plain.[17] Although a few flowers are visible, the image conveys little sense of the spring season that leads to the Maying party. Such description is reserved for the text, which details the "hedges," "clouds," "fields," "meadow-lands," "birds," and "dew."[18] This emphasis on the natural world, indicative of Pyle's basically romantic approach to the Arthurian legends, is an essential element in the picture-beyond-the-model that he adopts. After another lengthy description of nature in *The Story of Sir Launcelot and His Companions*, Pyle comments on his own inclination to dwell on such scenes: "Wherefore I pray you to forgive me if I have recounted more of those things than need be, who am writing a history of chivalry and of knightly daring."[19] But, of course, Pyle is doing more than writing a history of chivalry. He is providing a model for behavior and in the process Americanizing, or at least democratizing, the medieval legends. The apology for extended natural description is a familiar literary device, as insincere as Chaucer's apology for the vulgarity of his pilgrims. Yet it is also Pyle's way of linking himself to the knights and presumably to his audience, who cannot help being drawn into the story by those stirring passages.

Furthermore, Pyle suggests that by conducting themselves properly, his readers can achieve the moral equivalent of knighthood or kingship. Such moralizing harks back to James Russell Lowell's influential nineteenth-century poem *The Vision of Sir Launfal* (1848), in which Launfal learns that the Grail is not some precious object to be found by search-

ing distant places but rather exists in his own castle—indeed, in his own heart, especially when he shares lovingly with those in need.[20]

In his version of the legends though, Pyle democratizes not only the Grail but also the concept of nobility itself. Early in *The Story of King Arthur and His Knights*, after Arthur draws the sword from the anvil (1903, fig. 40), Pyle writes: "Wherefore when your time of assay cometh, I do hope it may be with you as it was with Arthur that day, and that ye too may achieve success with entire satisfaction unto yourself and to your great glory and perfect happiness."[21] The conclusion to the final adventure in *The Story of King Arthur and His Knights*, a retelling of the tale of the handsome and valiant Gawaine, who agrees to marry a loathly lady in order to save Arthur's life, provides a similar link between the audience and the citizens of Camelot. Pyle advises his readers that although one's duty may at times appear "ugly and exceedingly ill-favored unto his desires," as the loathly lady initially does to Gawaine, "when he shall have wedded himself unto that duty so that he hath made it one with him as a bridegroom maketh himself one with his bride, then doth that duty become of a sudden very beautiful unto him and unto others," as Gawaine's bride becomes.[22] Thus, by being "wedded" to duty, Pyle's young readers can be "equally worthy with that good knight and gentleman Sir Gawaine."[23] The moral is underscored by an illustration of Gawaine seeing his gorgeous new wife, formerly the loathly lady, for the first time (1903, fig. 41).[24]

Pyle's treatment of Arthur and Gawaine is clearly consistent with what the *New York Times* called his "intense Americanism."[25] This democratization, the notion that it is not the armor that makes the knight but rather his virtuous and dutiful action, is supported in numerous ways throughout the tetralogy. For example, after a haggard old woman asks Sir Pellias to take her across a river on his horse, the maiden Parcenet scolds the hag. But then Pellias scolds Parcenet, reminding her that—like "the perfect looking-glass of knighthood," King Arthur—a true knight must give aid to anyone who needs it.[26] By contrast, the code formulated by Malory's Arthur does not go nearly so far. It advises knights to

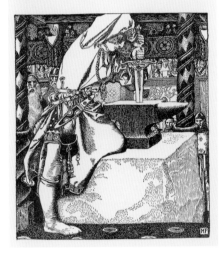

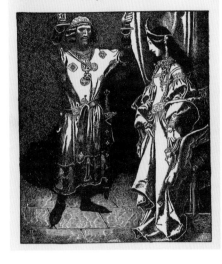

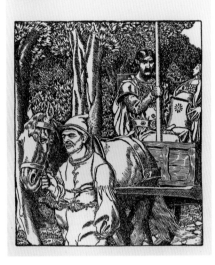

Figure 40. Howard Pyle (1853–1911). *How Arthur Drew Forth ye Sword*. From Howard Pyle, *The Story of King Arthur and His Knights*. New York: Charles Scribner's Sons, 1903. Printed matter. Helen Farr Sloan Library and Archives, Delaware Art Museum

Figure 41. Howard Pyle (1853–1911). *Sir Gawaine Finds the Beautiful Lady*. From Howard Pyle, *The Story of King Arthur and His Knights*. New York: Charles Scribner's Sons, 1903. Printed matter. Helen Farr Sloan Library and Archives, Delaware Art Museum

Figure 42. Howard Pyle (1853–1911). *How Sir Launcelot Rode Errant in a Cart*. From Howard Pyle, *The Story of Sir Launcelot and His Companions*. New York: Charles Scribner's Sons, 1907. Printed matter. Helen Farr Sloan Library and Archives, Delaware Art Museum

avoid murder and treason and to succor ladies and damsels.[27] But Malory says nothing—as Pyle so vividly does—of withered hags with eyes red with "rheum" and chin covered with "bristles." The fact that the hag turns out to be the Lady of the Lake in disguise and that she rewards and later assists Pellias does not diminish the force of the principle that he espouses.

Pyle's democratization of the legends takes other forms as well. He tells a number of tales in which knights assume the duties or the appearance of commoners or interact with them, and he introduces characters from the lower classes into both text and illustrations. Launcelot, in *How Sir Launcelot Rode Errant in a Cart* (1907, fig. 42), responds to the jeers of those who consider his mode of transport unseemly by saying that his adventure itself is "so worthy that it will make worthy any man who may undertake it, no matter how he may ride to that adventure."[28] Launcelot's response, like

Pyle's illustration, echoes the notion that the chivalrous act itself defines nobility, not the trappings of chivalry usually associated with the wealthy upper class.

Pyle adds to the model that such traditional stories provide by recounting a tale in *The Story of King Arthur and His Knights* about how Arthur won Guinevere as his queen.[29] In Pyle's version of the wooing, Arthur dresses himself as a gardener's boy, so he can be close to Guinevere. Aware of the ruse, Guinevere makes Gawaine, Ewaine, Geraint, and Pellias serve a meal to the disguised king, a scene that Pyle emphasizes by his illustration *Four Knights Serve the Gardener Lad* (1907). Although the astonished knights comply, they attend "the poor peasant fellow" with "very ill grace."[30] Naturally, after Arthur reveals his true identity, his royalty saves him from retribution; but the lesson that Pyle offers once again seems to be that a person's worth cannot be judged by what

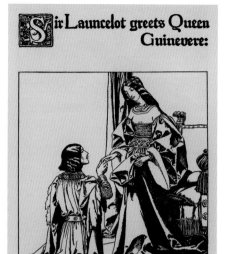

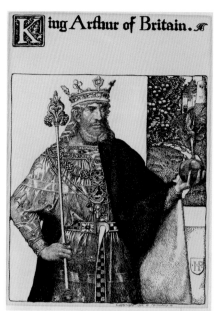

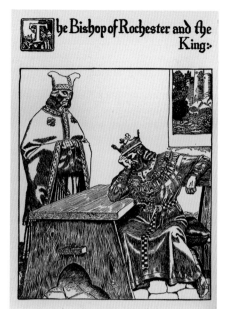

Figure 43. Howard Pyle (1853–1911). *Sir Launcelot Greets Queen Guinevere.* From Howard Pyle, *The Champions of the Round Table.* New York: Charles Scribner's Sons, 1905. Printed matter. Helen Farr Sloan Library and Archives, Delaware Art Museum

Figure 44. Howard Pyle (1853–1911). *King Arthur of Britain.* For Howard Pyle, *The Story of King Arthur and His Knights.* New York: Charles Scribner's Sons, 1903. Ink on illustration board, 11¾ × 9¼ inches. Delaware Art Museum, Gift of Anne Poole Pyle, 1920

Figure 45. Howard Pyle (1853–1911). *The Bishop of Rochester and the King.* From Howard Pyle, *The Story of the Grail and the Passing of Arthur.* New York: Charles Scribner's Sons, 1910. Printed matter. Helen Farr Sloan Library and Archives, Delaware Art Museum

he wears. Such passages and illustrations dramatically reinforce Pyle's conviction that nobility does not reside in the external knightly trappings.

Another of Pyle's innovations is his treatment of the relationship between Launcelot and Guinevere. While redactors like his contemporary Sidney Lanier gloss over the affair in order to make their tales suitable for children, Pyle does not avoid the issue. Instead he casts it in the best possible light by suggesting that Launcelot's "friendship" with the queen is inherent in his role as her champion.[31]

But as his treatment of Launcelot and Guinevere develops, Pyle is forced to create a relationship, though not a sexual one, between the two. Although Launcelot marries Elaine (a combination of the two Elaines from Malory), he is still drawn to Guinevere—an affection that is evident in illustrations as early as *Sir Launcelot Greets Queen Guinevere* (1905, fig. 43).[32] Even after Elaine dies and Mordred and Agravaine trick Launcelot into visiting Guinevere's chamber, an event depicted in the illustration *Sir Launcelot Defends the Door* (1910), Pyle insists that the Queen was ever "honorable"

and "pure."[33] Torn between his duty and his love (though Pyle does not call it that) for Guinevere, Launcelot cannot tell "whether he did altogether ill or somewhat well in remaining at the King's court as he did."[34] Yet perhaps even this flaw in Launcelot is meant to be part of the pattern of democratization of knighthood. It is the human failing that helps readers identify with Launcelot and allows them to hope to imitate his virtues in their own lives.[35]

The notion of flawed perfection, moreover, underlies Pyle's entire vision of the Arthurian world. Like other American writers such as Mark Twain and Edwin Arlington Robinson, Pyle employs the Arthurian legends as a vehicle for the Edenic theme that is so pervasive in American literature. One critic observed: "Pyle repeatedly demonstrates, especially in his treatment of Launcelot, the dangers of attempting to remain in the youthful Arcadian realm of freedom from adult responsibilities."[36] But it is not quite as simple as that: Launcelot, after all, wants to make the world better, a desire that implies the world is imperfect. And yet the hope for perfection is enhanced by the beauties of the natural

world that provide intimations of Eden. In one of the many passages commenting on the glories of nature, Pyle notes that in the autumn, "All the earth appears to be illuminated with a wonderful splendor of golden light" that recalls "the glory of Paradise."[37]

Pyle employs the paradisal garden imagery again, in two particularly fine illustrations that serve to summarize Arthur's history and function as bookends for the tetralogy. *King Arthur of Britain* (1903, fig. 44), the frontispiece illustration in *The Story of King Arthur and His Knights*, Agosta suggests, alludes to Arthur's noble character and promise. Standing against a blank white wall, Arthur holds in his hand an orb; his arm, extended, points to a path that leads through the garden to the castle. The implication is "that Arthur will, at least for a time, transform the rude realm entrusted to his governing hand into a civil and fruitful place."[38] *The Bishop of Rochester and the King* (1910, fig. 45), the second full-page illustration toward the end of *The Story of the Grail and the Passing of Arthur*, however, shows the King negotiating for an end to his sad war with Launcelot. Agosta aptly describes the interaction: "Pointedly echoing the initial volume's frontispiece depicting a youthful Arthur directing the orb into the paradisal garden, this illustration depicts a tired King now with his back to that garden, his left hand devoid of the orb, his left arm bent away from the casement and no longer guiding us through it, his head wearily resting on his right hand now empty of his scepter."[39] The Wheel of Fortune has clearly turned, and the sunlight that Arthur beheld so gloriously shining when he was at the top of the wheel has "left the King."[40]

Yet Pyle's optimistic and romantic view of the Arthurian world—and the modern world that it stands for—does not allow him to leave his characters in darkness. Launcelot and some of his followers become hermits and dwell, Pyle says, "in great peace and concord."[41] Though Guinevere does not share this idyllic existence with him, she too leads a holy life. The final vision of her—in *The Passing of Guinevere* (1910, fig. 46), in which a ray of sun shines through the window of the dark chamber and casts a warm glow on the Queen's smiling corpse—places her in a heavenly light, which is the culmina-

tion of the verbal and visual images of light throughout the tetralogy.[42] And, perhaps most significantly, Pyle suggests that Arthur will return, but only when men learn to live in peace.[43]

Pyle's influence on Arthurian illustration was so strong that it extended well beyond his own books.[44] The most natural successor to Pyle proved to be N. C. Wyeth. Among the most memorable of Wyeth's numerous illustrations are his color images for the reissue of Sidney Lanier's *The Boy's King Arthur: Sir Thomas Malory's History of King Arthur and His Knights of the Round Table* (1917), which form an integral part of the book.[45] With their romantic vision of noble knights and comely ladies and their realistic details of the terrain (based on the sweeping landscapes of the Brandywine Valley), the illustrations stress the chivalric ideals of bravery,

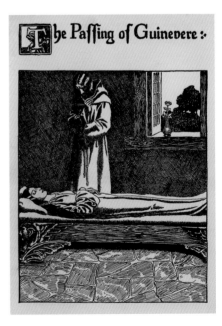

Figure 46. Howard Pyle (1853–1911). *The Passing of Guinevere*. From Howard Pyle, *The Story of the Grail and the Passing of Arthur*. New York: Charles Scribner's Sons, 1910. Printed matter. Helen Farr Sloan Library and Archives, Delaware Art Museum

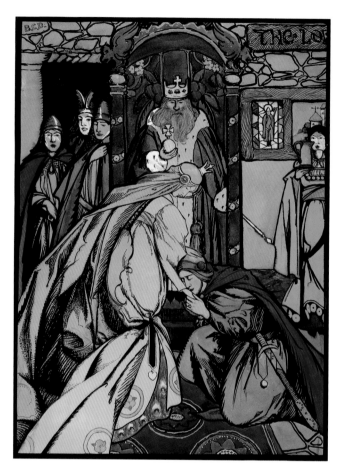

Figure 47. Bertha Corson Day (1875–1968). *Wondering and Awe-struck Sir Gawain Sank before the Lady on One Knee.* For Katharine Pyle, *Where the Wind Blows.* New York: R. H. Russell, 1902. Ink and watercolor on paper, 23⅛ × 17⅜ inches. Delaware Art Museum, Gift of Mrs. J. Marshall Cole, 1988

loyalty, devotion, and friendship that Pyle advocated as appropriate values for younger readers to adopt.[46]

Although Wyeth was the best known, he was not the only pupil of Pyle's to take up Arthurian themes. Frank Schoonover contributed a color frontispiece of the young Arthur pulling the sword from the stone to an edition of Sir James Thomas Knowles's *King Arthur and His Knights* (1923), published by Harper and Brothers and illustrated by Louis Rhead.[47] Schoonover also provided all the illustrations for

a later edition of Henry Frith's *King Arthur and His Knights* (1932), published by Garden City Publishing Company.[48] Using a simple, unadorned style, Schoonover created jousting knights, galloping horses, devoted lovers, and brightly colored pavilions—all vibrant action images to which his readers could relate.

Both Schoonover and N. C. Wyeth also contributed original artwork to *The Howard Pyle Brandywine Edition [1853–1933]*, a special set of five volumes published in 1933 by Charles Scribner's Sons to commemorate the eightieth anniversary of Pyle's birth. The volumes—facsimile reprints of the first editions with new color frontispiece illustrations (repeated as large roundels on the red covers) and brief personal reminiscences by five of Pyle's most distinguished former students—include *Robin Hood*, for which N. C. Wyeth drew the new illustration, and the four books of Pyle's Arthuriad. For *The Story of King Arthur and His Knights*, W. J. Aylward provided a striking image of Morgan le Fay's enchanted barge. For *The Story of the Champions of the Round Table*, Schoonover illustrated Guinevere and Launcelot approaching his castle Joyous Gard in the hope of respite from the turmoil of the intrigues of court. For *The Story of Sir Launcelot and His Companions*, Harvey Dunn created a charming, almost impressionistic image of Elaine riding through the woods. Finally, Stanley M. Arthurs pictured the noble Launcelot, unhorsed and disarmed, with a view of Camelot looming in the distance in *The Story of the Grail and the Passing of Arthur*.[49]

Notably, Andrew Wyeth, the son of N. C. Wyeth, carried on the family's tradition of Arthurian illustration. His four full-page line drawings for John W. Donaldson's *Arthur Pendragon of Britain: A Romantic Narrative by Sir Thomas Malory as Edited from Le Morte Darthur* (1943) published by G. P. Putnam's Sons, however, are radically different from his father's vivid, action-oriented, color images for *The Boy's King Arthur*. Black-and-white character portraits with virtually no castles, horses, or other traditional details in the background to offer definition or create context, Andrew Wyeth's stark drawings bring a distinctly fresh and modern sensibility to the legendary tales.

Another of Pyle's students, Bertha Corson Day (later Bertha Corson Day Bates), also deserves mention. Day, who studied under Pyle first at Drexel Institute and later at Pyle's summer program in Chadds Ford in 1899, enjoyed a promising but brief career as a book and magazine illustrator, which began in the late 1890s and ended soon after her marriage in 1902. Her most important and ambitious work was a series of twenty-two designs for *Where the Wind Blows* (1902), a collection of fairy tales from various countries by Pyle's sister Katharine, published by R. H. Russell.[50] For "The Marriage of Sir Gawain," the only Arthurian story in the volume, Day provided a headpiece and a full-page ink and watercolor illustration that portrayed the joyous transformation of Gawain's new bride from an ugly hag to a gorgeous damsel (1902, fig. 47). After outlining the drawing in black ink, Day filled it in with vivid colors to create an effect much like that of stained glass and dark tracery, a technique similar to one that Howard Pyle had used in his illustrations for Erik Bøgh's "The Pilgrimage of Truth" (1900, fig. 9) in *Harper's New Monthly Magazine*.[51] Pyle's influence was also apparent in her illustration's medieval style and details.[52]

Although other excellent illustrators who were contemporaries of the Brandywine artists completed some interesting Arthurian work,[53] without question it was Pyle—the only author-illustrator whose Arthuriad rivaled Malory's in length and scope—and his students who helped to define the American Arthurian tradition. Pyle's concern with moral and democratic values, his delight in the exercise of the pictorial imagination, his ability to connect with his young audience—all are evident in his Arthurian book illustrations, which remain among the best known and most accessible of twentieth-century Arthurian images and which have inspired generations of readers.

NOTES

1 The spelling of names of Arthurian characters varies from work to work. We have used the spelling as it appears in the work under discussion. Thus, for example, the name of Arthur's greatest knight will sometimes appear as "Launcelot" (the spelling used by Howard Pyle) and sometimes as "Lancelot" (the spelling used by a number of other authors).

2 Alfred, Lord Tennyson, *The Lady of Shalott*, decorated by Howard Pyle (New York: Dodd, Mead and Company, 1881), unpaginated. Though not a part of the poem, the phrase "The dead lady floateth down ye stream toward Camelot" appears, surrounding an image of the lady afloat, toward the end of Pyle's book.

3 Patricia Dooley comments on the iconographic relation of flowers, particularly floral motifs on borders, to the central illustrations in Pyle's *Robin Hood* and other works in Dooley, "Romance and Realism: Pyle's Book Illustrations for Children," *Children's Literature Association Quarterly* 8, no. 2 (1983): 17.

4 Muriel Whitaker, *The Legends of King Arthur in Art* (Cambridge, England: D. S. Brewer, 1990), 305. Whitaker adds, "The desire to recreate the social scene produces a preponderance of images inconsistent with the aristocratic milieu—a woman with a tambourine, a monk with his breviary, a haymaker, a shepherd, a girl with a stool and milkpail."

5 N. C. Wyeth, "Introduction," in Charles D. Abbott, *Howard Pyle: A Chronicle* (New York: Harper and Brothers, 1925), xiv.

6 *The Story of King Arthur and His Knights* "had been a success when serialized in the pages of *St. Nicholas*, and it was both an immediate and lasting success as a book. Today it occupies a permanent place on the shelf of children's classics," writes Henry C. Pitz in *The Brandywine Tradition* (Boston: Houghton Mifflin, 1968), 149. The quotes are from Howard Pyle, *The Story of King Arthur and His Knights* (New York: Charles Scribner's Sons, 1903), v. Hereafter referred to as *King Arthur*.

7 The illustration *Four Knights Serve the Gardener Lad* appears in *King Arthur*, 112. Other images, like the open books that both Merlin (in *The Enchanter Merlin*, in *King Arthur*, 154) and Morgana (in *Queen Morgana le Fay*, in *King Arthur*, 180) read and that suggest their desire for dangerous or arcane knowledge, owe a debt to Aubrey Beardsley and other earlier illustrators of the Arthurian legends.

8 Howard Pyle, *The Story of the Champions of the Round Table* (New York: Charles Scribner's Sons, 1905), v–vi. Hereafter referred to as *Champions*.

9 That history recounted "the notable adventures that he [Launcelot] performed at this time of his life." Howard Pyle, *The Story of Sir Launcelot and His Companions* (New York: Charles Scribner's Sons, 1907), v–vi. Hereafter referred to as *Launcelot*.

10 Pyle did note, however, that "the adventures and the achievements of such a man [as King Arthur] are not sad." Howard Pyle, *The Story of the Grail and the Passing of Arthur* (New York: Charles Scribner's Sons, 1910), vii. Hereafter referred to as *Grail*.

11 Henry C. Pitz, "Howard Pyle: Father of American Illustration," *American Artist* 10, no. 150 (Dec. 1951): 81. Pitz notes that Pyle's readings also included John Bunyan, Dickens, Thackeray, and German fairy tales.

12 Quoted in Henry C. Pitz, *Howard Pyle: Writer, Illustrator, Founder of the Brandywine School* (New York: Clarkson N. Potter, 1975), 134.

13 In the preface to his book, Lucien L. Agosta mentions the "interdependence of text and illustration" in Pyle's Arthurian books without exploring the nature of that interdependence. See Agosta, *Howard Pyle* (Boston: Twayne Publishers, 1987), unnumbered page.

14 *Grail*, 218; illustration, 222.

15 Lucien L. Agosta, "Howard Pyle's Illustrations as Shorthand Icons," in Susan R. Gannon and Ruth Anne Thomson, eds., *Proceedings of the Thirteenth Annual Children's Literature Association* (West Lafayette: Education Dept., Purdue University, 1988), 90.

16 Dooley, "Romance and Realism," 18–19.

17 The illustration appears in Pyle, *Launcelot*, 2.

18 Later in the same book, as Percival and Ector search for Launcelot, they approach the island where he is residing. While the illustration *Sir Percival and Sir Ector Look upon the Isle of Joy* (*Launcelot*, 278) shows little of the beauty of the scene, the written description adds color and a degree of specificity to the black and white of the drawing.

19 *Launcelot*, 265.

20 James Russell Lowell, *The Vision of Sir Launfal* (Cambridge: George Nichols, 1848).

21 Pyle, *King Arthur*, 35.

22 Ibid., 311–12.

23 Ibid.

24 Pyle had retold the story of the loathly lady earlier, in *The Merry Adventures of Robin Hood of Great Renown, in Nottingham* (New York: Charles Scribner's and Sons, 1883). But the hero in that retelling was Sir Keith, another one of Arthur's brave knights, not Sir Gawaine. A ballad sung by Arthur the Tanner describes how "suddenly a silence came / About the Table Round" when a gruesome dame with hooked nose, bleared eyes, and lank white locks enters the hall (*Robin Hood*, 101). After Lancelot, Tristram, and other knights find excuses to avoid her sole request, Keith displays his knighthood by performing his duty: he kisses the hag—an act that releases her from her spell and wins for him an appropriate reward (a beautiful bride and a handsome dowry of land). Pyle had expressed similar sentiments about nobility and democracy in other Arthurian ballads that he included in *Robin Hood*. For instance, after Will Scarlet recounts a tale about King Arthur, Robin tells his merry band (just as Pyle tells his readers): 'It doth make a man better . . . to hear of those noble men that lived so long ago. When one doth list to such tales, his soul does say, 'Put by thy poor little likings and seek to do likewise.' Truly, one may not do as nobly one's self, but in the striving one is better" (*Robin Hood*, 116).

25 "Howard Pyle Dies in Italy," *New York Times*, Nov. 10, 1911, 11.

26 Pyle notes that King Arthur "hath taught his knights to give succor unto all who ask succor of them, without regarding their condition." *King Arthur*, 210.

27 The oath in Malory's text includes the provision "Alway to doe ladies, damosels, and gentlewomen succour upon paine of death." Thomas Malory, *La Morte d'Arthur: The History of King Arthur and of the Knights of the Round Table*, ed. Thomas Wright (London: J. R. Smith, 1865), 1: 115–16.

28 *Launcelot*, 21.

29 Pyle, in fact, says specifically that the addition is his own. *King Arthur*, 77.

30 Ibid., 120–21.

31 Pyle writes: "For Sir Launcelot always avouched with his knightly word, unto the last day of his life, that the Lady Guinevere was noble and worthy in all ways, wherefore I choose to believe his knightly word and to hold that what he said was true" (*Champions*, 23). Pyle also uses the beauties of nature as an excuse for Launcelot's lack of desire to serve any other woman. He explains that when Launcelot emerged from the realm of the Lady of the Lake, who raised him, into the real world, it seemed so wonderful that he had room in his heart "only for the love of knight-errantry" (*Champions*, 59). By contrast, see Sidney Lanier, ed., *The Boy's King Arthur: Sir Thomas Malory's History of King Arthur and His Knights of the Round Table* (New York: Charles Scribner's Sons, 1917).

32 *Champions*, 12.

33 *Grail*; illustration, 172. Pyle describes the Queen as being "as honorable and as pure as she had been when first she came to King Arthur," 185.

34 *Launcelot*, 308.

35 This seems to be the point Pyle is making when he writes that Launcelot was "like other men, both in his virtues and his shortcomings; only that he was more strong and more brave and more untiring than those of us who are his brethren, both in our endeavors and in our failures" (*Champions*, vi)—qualities that Pyle demonstrates in illustrations such as *Sir Launcelot Slayeth the Worm of Corbin* (in *Launcelot*, 116) and *Sir Launcelot Takes the Armor of Sir Kay* (in *Champions*, 86).

36 Agosta, *Howard Pyle*, 24.

37 Pyle, *Launcelot*, 312. Although the illuminated earth recalls Paradise, the garden of this world contains a serpent, which is presented literally as well as symbolically. In the illustration *The Enchantress Vivien* (in *King Arthur*, 162), for example, the viperous Vivien wears in her hair a decoration that entwines to form a snake on her forehead. The paradisal light is also reflected in the radiant light of the Grail, described in the text and depicted in such images as *The Grail Is Manifested, and Sir Launcelot Sleepeth* (in *Grail*, 100), in which both cup and spear suddenly appear in a ball of light. That light, however, is counterbalanced by the darkness of Mordred's soul and the tragic death of Arthur. Pyle also represents that darkness visually, in the illustrations of *Sir Mordred the Traitor* and *The Passing of Arthur* (in *Grail*, 222, 236), in which the King departs the dark world of sorrow and pain for the joy and healing of Avalon.

38 Agosta, *Howard Pyle*, 51.

39 Agosta, "Howard Pyle's Illustrations as Shorthand Icons," 90.

40 *Grail*, 228.

41 Ibid., 253.

42 Ibid., 248. When Guinevere dies, Launcelot dreams that he sees her standing before him and looking radiant, "as though a bright light shone through her face from behind" (*Grail*, 253). In this instance, as in the earlier instance of Launcelot, Pyle adds to Malory's account, in which Launcelot becomes a hermit (but without mention of the Edenic detail of the tame beasts) and Guinevere's death contains no images of light.

43 According to Pyle, everyone can play a part in King Arthur's return by living "at peace with other men" and wishing them well and treating them well (*Grail*, 246).

44 That influence, as Richard Marschall notes, extended even to popular twentieth-century comic strips. "The work of illustrator Howard Pyle," he

writes, "was [Hal] Foster's inspiration as he created *Prince Valiant*, and as a matter of fact many panels [in *Prince Valiant*] are visual references to illustrations of the King Arthur and Robin Hood stories by Pyle." See Marschall, *America's Great Comic-Strip Artists* (New York: Abbeville Press, 1989), 189.

45 *The Boy's King Arthur* was first published in 1880 with black-and-white drawings by Alfred Kappes.

46 Whitaker, *Legends of King Arthur*, 307, 309.

47 The first edition of Knowles's book, published in 1862, was the first modern adaptation of Malory's tales.

48 Henry C. Pitz, another artist with a Brandywine connection—he was a student of Thornton Oakley, who was Pyle's student at both the Drexel Institute of Art, Science, and Industry and Chadds Ford—illustrated a later version of Henry Frith's *King Arthur and His Knights*, published in 1955 as part of Doubleday's Junior Deluxe Editions. Pitz had earlier illustrated the 1949 Lippincott Classics edition of *The Book of King Arthur and His Noble Knights: Stories from Sir Thomas Malory's Morte d'Arthur*, with a text adapted by Mary Macleod, and a gift edition of Mark Twain's *A Connecticut Yankee in King Arthur's Court*, published by Harper and Brothers in 1917. According to Barry Gaines, Pitz's "open line drawings" in the Frith edition "dispense with extraneous backgrounds and are much more effective than was his crowded color frontispiece." See Gaines, *Sir Thomas Malory: An Anecdotal Bibliography of Editions, 1485–1985* (New York: AMS Press, 1990), 53.

49 The Arthurian illustrations are titled as follows: *These Damsels Came Forward unto Where the Knights Stood* (Aylward); *Come with Me unto My Castle of Joyous Gard* (Schoonover); *Elaine the Fair Goes Forth in Search of Sir Launcelot* (Dunn); and *Sir Launcelot Is Overthrown* (Arthurs).

50 The designs include eleven full-page illustrations, ten headpieces, and a title page. In the volume the stories are told by "the Wind" to his grandmother. According to Elizabeth H. Hawkes, Bertha Corson Day and Katharine Pyle "had collaborated earlier on an illustrated poem for *Harper's*. They were friends and often visited together." From Hawkes, *Bertha Corson Day Bates: Illustrator in the Howard Pyle Tradition* (Wilmington: Delaware Art Museum, 1978), 14. Day began the illustrations for *Where the Wind Blows* in November 1900 and completed them in April 1902.

51 Hawkes, *Bertha Corson Day Bates*, 15.

52 Hawkes writes that Day tried "to design the illustrations for each story in a style evocative of the tale's national origin. For example, a classical style was used to illustrate the Greek story 'Perseus' and an ornate Persian style for 'The Fisherman and the Genii.' . . . 'The Marriage of Sir Gawain' illustration recalls Howard Pyle's King Arthur designs." Ibid., 15–16.

53 Frank Godwin, for example, illustrated Elizabeth Lodor Merchant's compilation of tales of *King Arthur and His Knights* (Philadelphia: John C. Winston, 1927) for John C. Winston's series of classic adventures for younger readers. Godwin had already illustrated several volumes for Winston, including *Tales from Shakespeare* and *Treasure Island* in 1924 and *Kidnapped* and *Robinson Crusoe* in 1925. He would go on to illustrate other volumes for Winston; to draw the popular *Connie* comic strip, which ran from 1927 to 1944; and to apply his talents to book and periodical illustration, as well as to advertising and comic books.

Anne M. Loechle

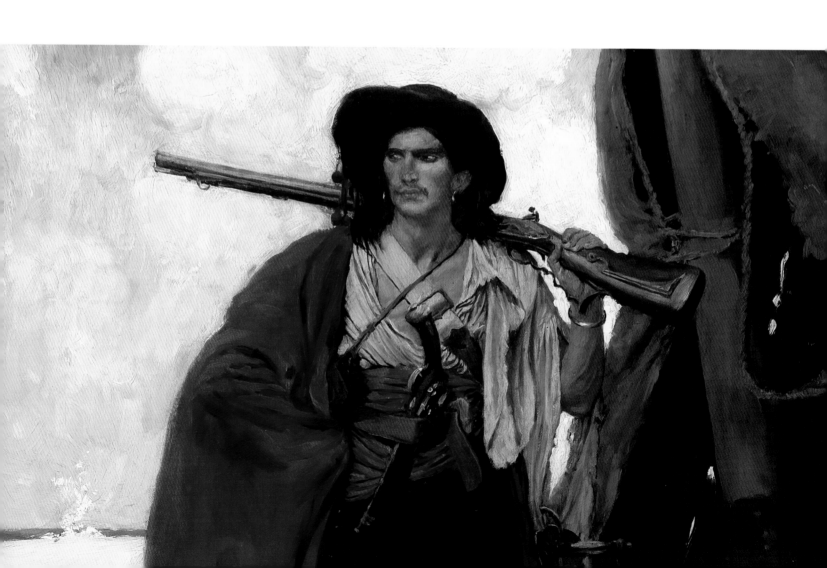

GUNPOWDER SMOKE AND BURIED DUBLOONS: ADVENTURE AND LAWLESSNESS IN HOWARD PYLE'S PIRATICAL WORLD

3.

On the crowded deck of the pirate ship *Adventure*, Blackbeard fights for his life in Howard Pyle's illustration *Blackbeard's Last Fight* (1895, see fig. 48), created for *The Story of Jack Ballister's Fortunes*. He wields a pistol in his muscular hand and holds a sword firmly between his lips. Although Blackbeard is somewhat hidden amid the chaos of fallen, falling, and dueling men, the viewer can tell that his gaze is fixed upon his nemesis, the Royal Navy's Lieutenant Robert Maynard. Two pirate cohorts behind Blackbeard stare out at the viewer: the large, uncertain eyes betray fear in the first, while the other takes his aim, pointing his pistol straight out of the picture. The viewer, it seems, must cower behind the pirate in the right foreground to avoid imminent death. Widely known for depicting such valiant figures as a revolutionary soldier fighting off the British and a medieval knight slaying a dragon, Howard Pyle created more ambiguous heroes as well. In this image, for instance, he imagined the unkempt, half-naked Blackbeard and a crew who attack, among other victims, the viewer him- or herself.

In this manner, Pyle—and later his students Frank Schoonover and N. C. Wyeth—brought to life a paradoxical hero-villain in the figure of the unsavory pirate between 1880 and the 1920s, a period that is sometimes considered to be illustration's golden age. From the first pirate story he wrote, "Rose of Paradise" (1887), to his last, "The Ruby of Kishmoor" (1907), Pyle created illustrated adventures, immersing his heroes—and turn-of-the-century readers—in violent fantasy. These wicked buccaneers are easily identified, being remarkably consistent in appearance: lively and unkempt, they wear headscarves and sashes over tattered clothing. Their captains sport tricornered hats and long coats, though the rebellious Blackbeard does not follow this pattern. Pyle, tacitly acknowledging the anomaly of pirates in his pantheon of heroic types, wrote that they "are hardly of the pacific nature one would expect of a boy with two hundred years of pure Quaker blood in his veins, but I have always had a strong liking for pirates and for highwaymen, for gunpowder smoke and for good hard blows."[1] Fin-de-siècle viewers surely shared his enthusiasms, for the pirate was a popular icon specifically because of his unusual combination of vigor and villainy.

Pyle's construction of the pirate, a character to be envied and feared, was derived from the protagonists of an earlier golden age, one that is sometimes called the Golden Age of

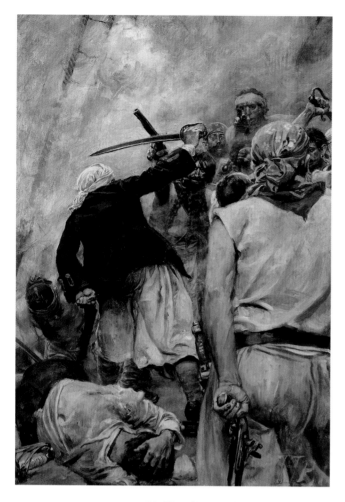

Figure 48. Howard Pyle (1853–1911). *Blackbeard's Last Fight.* For Howard Pyle, *The Story of Jack Ballister's Fortunes.* New York: Century Co., 1895. Oil on canvas, 15⅛ × 10 inches. Delaware Art Museum, Gift of Willard S. Morse, 1923

Piracy. This time period, stretching from the mid-seventeenth to the early eighteenth century, witnessed rampant piracy, which is documented in Alexandre O. Exquemelin's *Buccaneers of America* (first published in English in 1684) and Captain Charles Johnson's *A General History of the Robberies and Murders of the Most Notorious Pyrates* (1724). Each was reissued in several editions after their original publication and throughout the nineteenth century.[2]

Edward Teach, alias Blackbeard, a marauder of the eastern coast of North America during the Golden Age of Piracy, is a particularly salient example of where history and fiction intertwine. An enviable figure and despicable wretch, Blackbeard was a figure easy to romanticize and to vilify. Johnson almost rapturously describes his persona:

This beard was black, which he suffered to grow of an extravagant length; as to breadth, it came up to his eyes. He was accustomed to twist it with ribbons, in small tails, after the manner of our ramilies wigs, and turn them about his ears. In time of action, he wore a sling over his shoulders, with three braces of pistols, hanging in holsters like bandaliers; and stuck lighted matches under his hat, which, appearing on each side of his face, his eyes naturally looking fierce and wild, made him altogether such a figure, that imagination cannot form an idea of a fury, from hell, to look more frightful.[3]

The portrait of Blackbeard (c. 1724, fig. 49) in Johnson's tome does not convey this drama. Blackbeard looks quite respectable, and maybe even a little insipid, in comparison to Johnson's sensational description of him. Though certainly more alluring in writing, Blackbeard remains a one-dimensional scoundrel. Pyle, taking an imaginative leap from Johnson's words and the accompanying illustration, filled out the pirate's character. His Blackbeard is, literally, armed to the teeth, looking positively frightful with his long black beard; but, with a look of determination, he defends himself against an equally vicious, not to mention faceless, pursuer. Here then Pyle painted a captivating portrait of a man who was paradoxically both sympathetic and detestable.

Genuine pirates, like the historical Teach, had all but disappeared by about 1900, especially after legalized piracy was banned internationally in 1856. The waning of real-life accounts allowed pirates to proliferate as entertainment in literary and theatrical works such as Gilbert and Sullivan's opera *The Pirates of Penzance* (1879), Robert Louis Stevenson's novel *Treasure Island* (1883), and James M. Barrie's play *Peter Pan* (1904). The popularity of these British works in the United States inspired American authors, among them Mary Johnston, who wrote *To Have and to Hold* (1900), and Ralph D. Paine, who penned *Blackbeard, Buccaneer* (1922). Public interest also helped generate countless serialized stories, including several by Pyle himself. From 1887 to 1909 Pyle cre-

ated almost sixty pirate illustrations for his own stories, as well as those of fellow adventure writers.

Schoonover, one of Pyle's most prolific protégés, took to heart his teacher's notion of the hero-villain when he illustrated his own version of Blackbeard's fanciful world (1922, fig. 50) for Paine's *Blackbeard, Buccaneer.* Schoonover placed the pirate captain in the center of the composition, in close proximity to the viewer, and made him comparatively tall

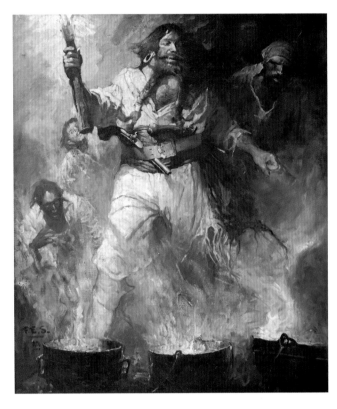

Figure 50. Frank E. Schoonover (1877–1972). *Blackbeard in Smoke and Flame,* 1922. For Ralph D. Paine, *Blackbeard Buccaneer.* New York: Harper and Brothers, 1922. Oil on canvas, 36 × 30 inches. Private collection. Photograph courtesy Schoonover Fund

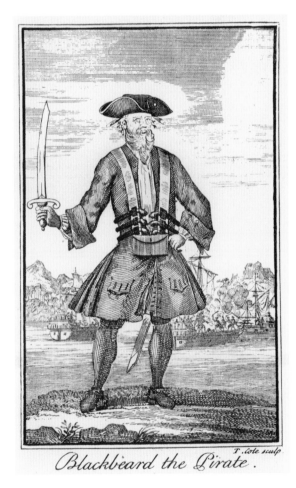

Figure 49. T. Cole (dates unknown). *Blackbeard the Pirate,* c. 1724. From Alexandre O. Exquemelin, *The Buccaneers and Marooners of America: Being an Account of the Famous Adventures and Daring Deeds of Certain Notorious Freebooters of the Spanish Main,* ed. Howard Pyle. New York: Macmillan and Co., 1891. Originally published in Charles Johnson, *A General History of the Robberies and Murders of the Most Notorious Pyrates,* 1724. Printed matter. Helen Farr Sloan Library and Archives, Delaware Art Museum

and bulky among his cowering crew. Lunging toward the viewer, enveloped in smoke and dramatically lit, Blackbeard's body is particularly imposing. "He Loomed Like the Belial Whom He Was So Fond of Claiming as His Mentor," reads the illustration's accompanying caption.[4] Latching onto this comparison to the demon Belial, Schoonover stresses his pirate's underworldliness, as Blackbeard's unusually large frame seems to rise out of the fiery cauldrons at his feet. Schoonover's dangerous character was developed from Pyle's Blackbeard, and this is most evident in Blackbeard's trademark, his braided beard. His physical stature is more pronounced in Schoonover's imagining; however, in both conceptions Blackbeard is strong and spirited but also sinister.

Physical strength, a trait that can be found in Pyle's many pirate creations, links this icon to other turn-of-the-century characters such as the revolutionary soldier and the medieval knight. In one of his earliest pirate images, *Walking the Plank* (1887, fig. 51), Pyle exaggerated the pirates' physicality. The large, clenched fists of the victim, along with his broad shoulders and square jaw, suggest a sturdy body matched only by that of his adversary, the ship's captain. This insistence on corporeality is repeated in other violent images like *He Lay Silent and Still, with His Face Half Buried in the Sand* (1890) and in the quiet image *Marooned* (1887, see fig. 26), in which a man with large hands, forearms, and shoulders must hold his own amid imposing surroundings. Furthermore, the physical presence of Pyle's Blackbeard is undeniable, even if he is hidden behind several combatants. To be sure, Pyle's pirates do not always exhibit such brute strength. *Why Don't You End It?* (1900, fig. 52), an illustration for Johnston's *To Have and to Hold*, for instance, exchanges fitness for finesse, while *Henry Morgan Recruiting for the Attack* (1887) and *Morgan at Porto Bello* (1888), both for *Harper's Monthly*, display the captain acting outright languidly.[5]

Strong bodies, however, proliferated in Pyle's illustrations and persisted in those of his students—N. C. Wyeth's Long John Silver in particular comes to mind (see the figure at right in fig. 53)—because they represented a fantasy of health and well-being for the middle-class audience to which they were meant to appeal. In the years leading up to 1900 physical culture became associated less with respectable work and more with recreation, a result of the changing face of labor. In particular, the population of salaried office workers living in cities grew exponentially. These individuals had more leisure time than their rural counterparts, who were busily tending to their farms.[6] Gone for many was the physical labor previously associated with work, replaced now by work of the mind, such as reading, sending correspondence, and doing clerical work.

Especially for those middle-class brainworkers, the athletic body—a sign of leisure, not a product of manual labor—became both a mark of prestige and an ideal. The boxing ring, for instance, was an appropriate venue for dishing out

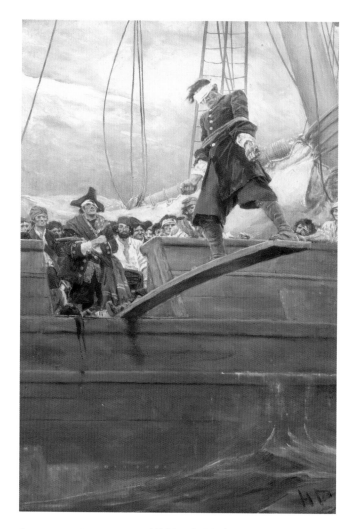

Figure 51. Howard Pyle (1853–1911). *Walking the Plank*, 1887. For Howard Pyle, "Buccaneers and Marooners of the Spanish Main." *Harper's New Monthly Magazine*, September 1887. Oil on board, 19½ × 13 inches. The Kelly Collection of American Illustration

the "good hard blows" Pyle professed to enjoy, as the *masculine primitive* developed idol status. A term later coined by the social historian E. Anthony Rotundo, the *masculine primitive* was a new standard of manhood at the turn of the century, and it embraced the Darwinian metaphors of "man as master animal" and "the world as harsh wilderness."[7] Physical strength, in particular, became an important attribute to this new, ideal type that "stressed the belief that all males—civilised or not—shared in the same primordial instincts for survival" as well as a "special respect—and concern—for a man's physical strength and energy."[8] Popular culture took hold of this savage ideal, as evidenced by the celebrity status

of the heavyweight boxing champion John L. Sullivan and the strongman Eugen Sandow in the 1880s and 1890s. Writer Edgar Rice Burroughs's Tarzan also found fame due to his primal strength and energy.[9]

Burroughs, whose publishing career began a few decades after Pyle's, represents the ultimate urban professional in need of revitalization in the wilderness. Burroughs wrote "Tarzan of the Apes" when he was a thirty-six-year-old

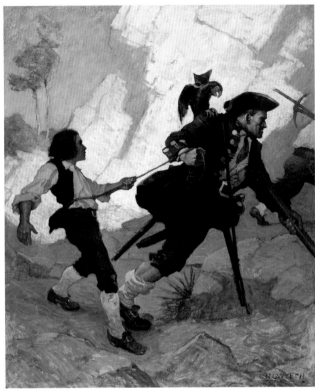

Figure 53. N. C. Wyeth (1882–1945). *For All the World, I Was Led Like a Dancing Bear,* 1911. For Robert Louis Stevenson, *Treasure Island.* New York: Charles Scribner's Sons, 1911. Oil on canvas, 47¼ × 38¼ inches. Collection of Brandywine River Museum, Bequest of Gertrude Haskell Britton, 1992

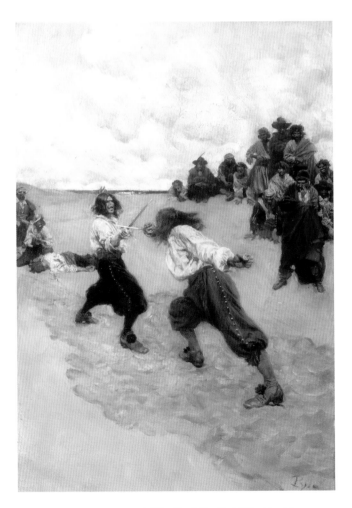

Figure 52. Howard Pyle (1853–1911). *Why Don't You End It?* For Mary Johnston, *To Have and to Hold.* Boston: Houghton Mifflin and Company, 1900. Oil on canvas, 17½ × 12½ inches. The Kelly Collection of American Illustration

urbanite, husband, and father of two stuck in a white-collar job that he detested.[10] The author himself admitted that his Tarzan represented an escape from the city, from his job, and from civilization for himself and his readers:

> We wish to escape not alone the narrow confines of city streets for the freedom of the wilderness, but the restrictions of man made laws, and the inhibitions that society has placed upon us. We like to picture ourselves as roaming free, the lords of ourselves and of our world; in other words, we would each like to be Tarzan. At least I would; I admit it.[11]

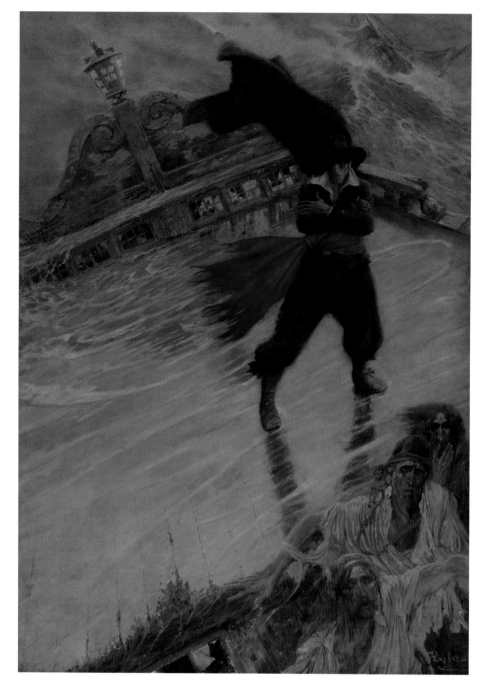

Figure 54. Howard Pyle (1853–1911). *The Flying Dutchman.* For *Collier's Weekly*, December 8, 1900. Oil on canvas, 71⅜ × 47½ inches. Delaware Art Museum, Museum Purchase, 1912

Burroughs's description here informs his art and gives insight into the desires of his audience as well.

Pyle's visual and written depictions of pirates connect him to Burroughs and other "civilized" turn-of-the-century men who sought a return to physicality and freedom. Pyle thought back to childhood when he asked: "To make my meaning more clear, would not every boy, for instance—that is every boy of any account—rather be a pirate captain than a Member of Parliament?"[12] His distinction between pirates and government officials pinpoints the divide between adventurers and contemporary office workers. Pyle made it a point to answer his own question: "It is to be apprehended that to the *unregenerate* nature of most of us, there can be but one answer to such a query."[13] Pirate stories and illustrations, according to Pyle, provided much-needed adventure to adult and young male readers

Physical prowess alone did not make the pirate captain a hero. Rather a fundamental ingredient to his appeal lay with something antiheroic in him: his lawlessness. A smattering of images by Pyle include gold jewelry—for example, *The Buccaneer Was a Picturesque Fellow* (1905, fig. 55), which illustrates his story "The Fate of a Treasure Town." The loops in the picturesque fellow's ears not only attest to the beauty of his body but suggest successful thievery. By the beginning of the twentieth century, gold jewelry had become a standard feature of the pirate type. These ornaments, along with activities such as digging for buried treasure—as in *Kidd at Gardiner's Island* (1894, fig. 56)—and capturing prisoners, act as easy referents to thievery, the behavior for which pirates

Figure 55. Howard Pyle (1853–1911). *The Buccaneer Was a Picturesque Fellow.* For Howard Pyle, "The Fate of a Treasure Town." *Harper's Monthly Magazine*, December 1905. Oil on canvas, 30½ × 19½ inches. Delaware Art Museum, Museum Purchase, 1912

Figure 56. Howard Pyle (1853–1911). *Kidd at Gardiner's Island.* From Thomas A. Janvier, "The Sea Robbers of New York." *Harper's New Monthly Magazine*, November 1894. Printed matter. Helen Farr Sloan Library and Archives, Delaware Art Museum

and specifically to those who idolized the idealized savage type described by Rotundo. Pyle's image *The Flying Dutchman* (1900, fig. 54), atypical in that the pirates in it are practically skeletal rather than robust, emphasizes the dangers of life on the open seas. Facing starvation and the natural elements, pirates survived travails and experiences certainly more exciting than office workers' humdrum daily labor.

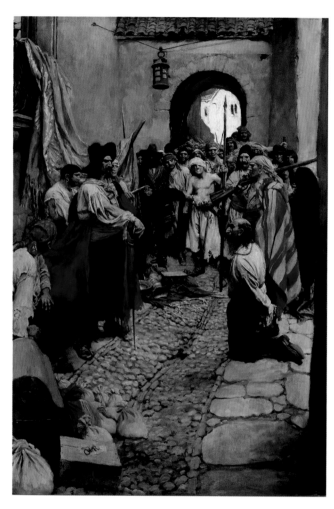

Figure 57. Howard Pyle (1853–1911). *Extorting Tribute from the Citizens.* For Howard Pyle, "The Fate of a Treasure Town." *Harper's Monthly Magazine,* December 1905. Oil on canvas, 29½ × 19½ inches. Delaware Art Museum, Museum Purchase, 1912

As is still touted today, the United States prides itself on the fluidity of its class system, which allows for the so-called self-made man to increase his wealth as well as improve his social status. Yet this system can be a double-edged sword. That selfsame self-made man can find himself falling downward into poverty and social ruin. Both the positives and the negatives of a relatively loose class system were in full swing during the economically unstable fin-de-siècle era, which saw the growth of big business and the subsequent need for salaried office workers. Economic changes created new, yet also risky, opportunities for social advancement. With the growing divide between the wealthy and the destitute, the majority of Americans, who fit within neither category, strove for acceptance into the ranks of the rich and feared joining the poor.

The pirate, as Pyle created him, represented a success story. One could say that the pirate had the enviable task of finding an adequate number of places to bury his copious treasure. And even if, or perhaps because, he received it unfairly, there is no doubt that many viewers coveted his wealth. Pyle made it pointedly clear that he and his readers were attracted first and foremost to the pirate's booty:

> But it is not altogether courage and daring that
> endears him to our hearts. There is another and
> perhaps a greater kinship in that lust for wealth that
> makes one's fancy revel more pleasantly in the story
> of the division of treasure in the pirate's island retreat,
> the hiding of his godless gains somewhere in the sandy
> stretch of tropic beach, there to remain hidden until
> the time should come to rake the dubloons up again
> and to spend them like a lord in polite society, than in
> the most thrilling tales of his wonderful escapes from
> commissioned cruisers through tortuous channels
> between the coral-reefs.[14]

In an era of extreme wealth and poverty with a slippery slope between the two, the greedy pirate provided a fantasy of abundance.

are best known. Looting and robbing are characteristics that separate the pirate from more conventional heroes. Robin Hood, another outlaw character that Pyle painstakingly recreated, stole from the rich, but he used his plunder to help the poor, not to buy gold baubles. However, the fantasy of the pirate's selfish behavior made him appealing to members of a middle class who were struggling to gain and preserve their status within the uncertainties of a changing socioeconomic system.

If Pyle's pirate were merely greedy, however, he could not have claimed hero status. Instead, with his physicality and propensity for thievery, he maintained his popularity precisely because of his lawlessness. First, his body resembled not that of a fat-cat businessman but of an athlete, an important distinction in a society that promoted team sports as an antidote to "some of the most dangerous tendencies in modern life which tends [*sic*] to produce neurotic and luxury-

loving individuals."[15] Furthermore, piracy could turn a class system upside down. For instance, in Pyle's images *Morgan at Porto Bello* and *Extorting Tribute from the Citizens* (1905, fig. 57), the rich—perhaps stand-ins for the bosses of contemporary office workers—must kneel before pirates, who are now in command.

The independent thinking of the pirate captivated Pyle, who asserted that he "was a man who knew his own mind and what he wanted."[16] Pyle was not far off in his assessment. According to the maritime historian Marcus Rediker, historical pirates, such as Blackbeard and Morgan, enjoyed choice and rebellion: "It was a way of life voluntarily chosen, for the most part, by large numbers of men who directly challenged the ways of society from which they excepted themselves."[17] Because a pirate could chase and capture what he wanted, that is, money and power, his was certainly a lifestyle of some appeal to struggling brainworkers.

While it might have been difficult to render the pirate's unorthodox social system in illustrations, Pyle did follow his written praise of the pirate's self-determination with visual examples. For instance, Pyle created *Which Shall Be Captain?* (1911, fig. 58), depicting one way of choosing a leader: whoever shows more physical strength is the victor. Furthermore, in *So the Treasure Was Divided* (1905, see fig. 59), Pyle brought to vivid life the pirate's excessive wealth and the manner in which it was harmoniously divided among the crew. Finally, in his pictures cruelty sometimes takes center stage, as with *Dead Men Tell No Tales* (1899, see fig. 60), in which a pirate captain stands apart from two crewmen he has unceremoniously shot and a third who, judging by the look on the captain's face, will soon meet a similar fate. Such behavior, however, was not always without consequences, as indicated by the lifeless body sprawled in the sand in Pyle's *Pirates Used to Do That to Their Captains Now and Then* (1894, see fig. 61). *That* in the title translates to "kill and leave the deceitful captain unburied."

Pyle usually chose to imagine pirates from a specific time period, that is, the Golden Age of Piracy, when pirates seemed to be particularly rebellious figures. Indeed, he and his students rarely painted pirates from other times in

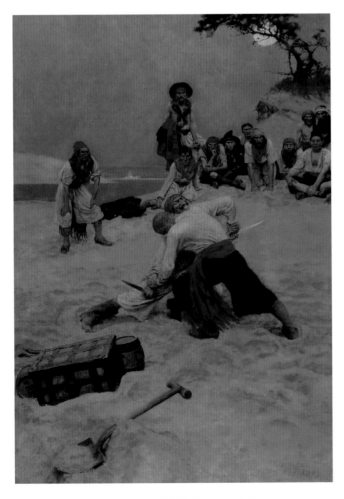

Figure 58. Howard Pyle (1853–1911). *Which Shall Be Captain?* For Don C. Seitz, "The Buccaneers." *Harper's Monthly Magazine*, January 1911. Oil on canvas, 48 × 31¾ inches. Delaware Art Museum, Gift of Dr. James Stillman, 1994

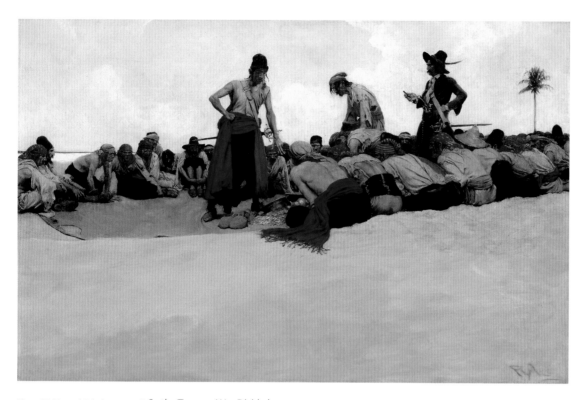

Figure 59. Howard Pyle (1853–1911). *So the Treasure Was Divided*. For Howard Pyle, "The Fate of a Treasure Town." *Harper's Monthly Magazine*, December 1905. Oil on canvas, 19½ × 29½ inches. Delaware Art Museum, Museum Purchase, 1912

history, when they apparently demonstrated stronger social and moral ties. Subsequent to the Golden Age, privateer ships patrolled North America's eastern shores during the American Revolution and prevented the replenishment of supplies to English soldiers fighting American militias. During the War of 1812 Jean Lafitte, a famous corsair of French origin, helped the floundering United States Navy fight those English troops attempting to take control of the Mississippi River Delta and became a war hero. Most pirates in fin-de-siècle stories and images, however, are neither privateers working for government nor American war heroes. They are instead the most piratical pirates: robbers, greedy men, and independents working solely for themselves.[18]

There is also a distinction between Pyle's pirate illustrations and the stories written by him and his contemporaries: his imagery emphasizes glamour and violence, while the corresponding prose usually asserts a moralizing message. It is a rare example when Pyle displays a pirate's ruin in pictorial form, appearing perhaps only once in *Colonel Rhett and Pirate Stede Bonnet* (1901).[19] In this instance, Pyle recreated

a vignette described in Woodrow Wilson's article "Colonies and Nation" in which the humiliated Bonnet stands before his captor. The image accompanies a historical account by an esteemed author rather than one of Pyle's own fictional tales, and this fact likely explains Pyle's restrained choice. More frequently, his illustrations, such as *Blackbeard's Last Fight*, show battles that potentially lead to the pirates' ruin; however, the violent action—not its consequences—is the focus. Blackbeard is indeed captured and killed by British authorities, but this outcome is revealed only in the prose. In this manner Pyle draws his viewers into pirate adventure with his glamorous images, allowing the text to reveal the sober truth that pirates are effectively not the sympathetic heroes but the antagonists.

The pirate tale as moral lesson predated Pyle's illustrated examples. In fact, many of the coming-of-age stories that Pyle wrote and illustrated derive from the plot of *Treasure Island*, in which a young male protagonist is initially mesmerized by the pirate life, but ultimately returns to proper society. In Stevenson's *Treasure Island*, while the protago-

nist Jim Hawkins—and most likely the reader—is fooled into believing Long John Silver is a romantic salt generously helping Jim in his pursuit of pirates' treasure, Jim ultimately discovers Silver's greedy, and in the end cowardly, inclinations. Jim had to learn the hard way: he had been captured by Silver's mutinous crew and, as N. C. Wyeth's image highlights, was humiliated and "led like a dancing bear," as its caption indicates. (Jim is the character at left in fig. 53.) Discovering the pirates' buried treasure is Jim's reward. Silver, on the other hand, is discovered for a pirate, kidnapper, and mutineer. Spineless and penniless, he runs away from the English justice system, an episode in the novel that notably is unillustrated. At the end of the tale, Jim returns to the world of law and order, reuniting with his caretakers, Squire Trelawney and Dr. Livesey.

In Pyle's "The Ghost of Captain Brand" (1896), the sixteen-year-old Barnaby True travels a similar voyage of self-discovery as Hawkins did in *Treasure Island*. Jonathan Rugg, another young Pyle protagonist, does the same in "The Ruby of Kishmoor." Pyle seems to have saved his originality for his illustrations. Even when printed in black and white, these images create a colorful world; by comparison, the accompanying stories, which restore law and order, are unoriginal, even at times tedious, though these qualities did not hurt their popularity.[20]

In his writing Pyle went so far as to make his moral lesson explicit. In 1891 Pyle edited a new version of Exquemelin's *Buccaneers of America*, retitling it *The Buccaneers and Marooners of America* and adding four pirate stories by Daniel Defoe not included in Exquemelin's text when it was

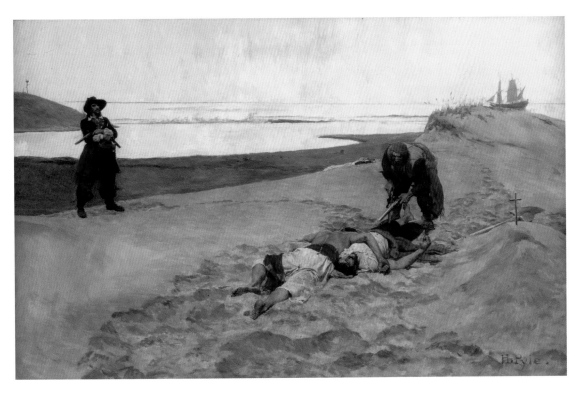

Figure 60. Howard Pyle (1853–1911). *Dead Men Tell No Tales*, 1899. For Morgan Robertson, "Dead Men Tell No Tales." *Collier's Weekly*, December 17, 1899. Oil on canvas, 20¼ × 30¼ inches. The Kelly Collection of American Illustration

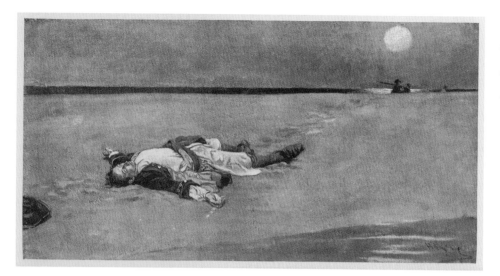

Figure 61. Howard Pyle (1853–1911). *Pirates Used to Do That to Their Captains Now and Then*. From Thomas A. Janvier, "The Sea Robbers of New York." *Harper's New Monthly Magazine*, November 1894. Printed matter. Helen Farr Sloan Library and Archives, Delaware Art Museum

published in English in 1684. Pyle explained the need for this new edition—and the Defoe additions—by juxtaposing an ordered society with moral disarray:

> There is another, a deeper, a more humanitarian reason for such a sequel. For is not the history of the savage outlawry of the marooners a verisemblance of the degeneration, the quick disintegration of humanity the moment that the laws of God and man are lifted? The Tudor sea-captains were little else than legalized pirates, and in them we may see that first small step that leads so quickly into the smooth downward path. The buccaneers, in their semi-legalized piracy, succeeded them as effect follows cause. Then as the ultimate result followed the marooners—fierce, bloody, rapacious, human wild beasts lusting for blood and plunder, godless, lawless, the enemy of all men but their own wicked kind.
>
> Is there not a profitable lesson to be learned in the history of such a human extreme of evil—all the more wicked from being the rebound from civilization?[21]

In essence then Pyle used the pirate stories as a warning, an example of how the beginnings of moral breakdown can lead to total collapse. Other pirate tales by Pyle and his contemporaries follow this formula as well, even if less explicitly. Readers may be enticed by the wealth of the pirate, his greed, his physical strength, and his independence. Through his illustrations Pyle exaggerates these qualities, entertaining viewers and inviting them to live vicariously, while simultaneously encouraging them to read the accompanying tale. If Pyle is successful, viewers-cum-readers learn an important lesson: enjoy the fantasy, but return to the world of morality.

As a fin-de-siècle brainworker himself, Pyle had to stride the line between acceptance into respectable society and desire for unrestricted adventure, a boundary that was drawn for him by his own history as "the boy with two hundred years of pure Quaker blood in his veins" and his "strong liking for pirates and for highwaymen." As a commercial artist, Pyle most likely saw another line too: the border between the type of imagery that was then fit for print and tantalizing, illicit subject matter. In his thrilling illustrations, some that even take place on a pirate ship aptly named *Adventure*, Pyle walked this fine line between decency and despicability. "It only takes a very little while for a boy of thirteen or fourteen to grow into a man," Pyle wrote knowingly of his audience, "and, provided you can interest him when he is thirteen or fourteen, he is much more apt to look with a certain deference upon anything you may have to say to him after the years have become more mature."[22] Heeding these words, Pyle shrewdly captured "a certain deference" from both young and more mature audiences with his illustrated pirate. This borderline hero-villain—greedy and independent, murderous and strong—continues to baffle and delight to this day.

NOTES

1 Howard Pyle to Edith Robinson, Mar. 26, 1895, Howard Pyle Manuscript Collection, box 1, folder 7, Helen Farr Sloan Library and Archives, Delaware Art Museum.

2 Captain Charles Johnson is the name that appears on several editions of the historical pirate tome known as *A General History of the Robberies and Murders of the Most Notorious Pyrates* now ascribed to Daniel Defoe. Some scholars have suggested that Defoe is the author, and that he adopted that moniker in order to give credibility to his descriptions. Others, however, have contended that Johnson is not an alias assumed by Defoe but an author in his own right. For a more detailed discussion of this disagreement, see David Cordingly, *Under the Black Flag: The Romance and the Reality of Life among the Pirates* (New York: Random House, 1995), xix–xx.

3 Captain Charles Johnson, *A General History of the Robberies and Murders of the Most Notorious Pirates*, introduction by David Cordingly (London: Conway Maritime Press, 1998), 60.

4 Ralph D. Paine, *Blackbeard, Buccaneer* (Philadelphia: Penn Publishing Company, 1922), opposite 224. The same illustration appeared with a different caption in Paine, "Blackbeard the Buccaneer," *American Boy* 23, no. 10 (August 1922): 18.

5 *Henry Morgan Recruiting for the Attack* appeared in Howard Pyle, "Buccaneers and Marooners of the Spanish Main," *Harper's New Monthly Magazine* 75, no. 447 (Aug. 1887): 363. *Morgan at Porto Bello* appeared across from a poem by Edmund C. Stedman: "Morgan," *Harper's New Monthly Magazine* 78, no. 463 (Dec. 1888): 116–17.

6 For more information on the changing face of the labor force during this era, please see Peter G. Filene, *Him/Her/Self: Gender Identities in Modern America*, 3rd ed. (Baltimore: Johns Hopkins University Press, 1998), 78. His calculations were based on statistics in U.S. Bureau of the Census, *Historical Statistics of the United States, Colonial Times to 1957* (Washington, D.C.: U.S. Bureau of the Census, 1960), 74.

7 E. Anthony Rotundo, "Learning About Manhood: Gender Ideals and the Middle-Class Family in Nineteenth-Century America," in J. A. Mangan and James Walvin, eds., *Manliness and Morality: Middle-Class Masculinity in Britain and America, 1800–1940* (New York: St. Martin's Press, 1987), 46.

8 Ibid., 40.

9 For a more detailed analysis of John L. Sullivan, Eugen Sandow, and Tarzan and their relationship to turn-of-the-century masculinity, see John F. Kasson, chapters 1 and 3, in *Houdini, Tarzan, and the Perfect Man: The White Male Body and the Challenge of Modernity in America* (New York: Hill and Wang, 2001).

10 Edgar Rice Burroughs's "Tarzan of the Apes" first appeared in *All-Story Magazine* 12, no. 2 (Oct. 1912). *Tarzan of the Apes* subsequently appeared as a novel (Chicago: A. C. McClurg and Co., 1914).

11 Edgar Rice Burroughs, "The Tarzan Theme," *Writer's Digest* 12, no. 7 (June 1932): 31.

12 Howard Pyle, "Introduction," in Alexandre O. Exquemelin, *The Buccaneers and Marooners of America: Being an Account of the Famous Adventures and Daring Deeds of Certain Notorious Freebooters of the Spanish Main*, ed. Howard Pyle (New York: MacMillan and Co., 1891), 15.

13 Ibid., 16 (emphasis added). Pyle was not the first to present the dichotomy between civilized life and the life of maritime adventure. The distinction was made even more clearly in an earlier novel by Frederick Marryat, whose character exclaims: "Every high-spirited boy wishes to go to sea . . . but if the most of them were to speak the truth, it is not that they so much want to go to sea, as that they want to go from school or from home." Captain [Frederick] Marryat, *Masterman Ready; or, the Wreck of the Pacific* (London: Longman, Orme, Brown, Green, and Longmans, 1841), 54. Like Parliament for Pyle, school and home were used by Marryat to represent mundane contemporary life in counterdistinction to adventure.

14 Pyle, "Introduction," 16–17.

15 Henry D. Sheldon, *Student Life and Customs* (New York: D. Appleton and Company, 1901), 250.

16 Howard Pyle, "Ye Pirate Bold," in Pyle, *Howard Pyle's Book of Pirates: Fiction, Fact and Fancy concerning the Buccaneers and Marooners of the Spanish Main*, compiled by Merle Johnson (New York: Harper and Brothers, 1921), 1.

17 Marcus Rediker, *Between the Devil and the Deep Blue Sea: Merchant Seamen, Pirates and the Anglo-American Maritime World, 1700–1750* (Cambridge, England: Cambridge University Press, 1987), 255.

18 There are a few exceptions to this rule. For example, Pyle wrote *Within the Capes* (New York: Charles Scribner's Sons, 1885), a story of privateering during the War of 1812. In addition, Frank Schoonover wrote and illustrated a story titled "In the Haunts of Jean Lafitte," which appeared in *Harper's Monthly Magazine* 124, no. 739 (Dec. 1911): 80–91. He also illustrated a young adult novel by Ralph D. Paine: *Privateers of '76* (Philadelphia: Penn Publishing Company, 1923). It should be noted, however, that the illustrated story about Lafitte makes no mention of his wartime efforts, focusing instead upon his accepting a ransom, among other piratical activities.

19 Woodrow Wilson, "Colonies and Nation," *Harper's Monthly* 102, no. 612 (May 1901): 915.

20 "The Ghost of Captain Brand" was first released in the Christmas issue of *Harper's Weekly* 40, no. 2,087 (Dec. 19, 1896): 1236–42. Pyle later released it (with three other stories) in book form in *Stolen Treasure* (New York: Harper and Brothers, 1907), 97–174. According to Pyle's biographer, Charles D. Abbott, that issue of *Harper's Weekly* "sold out in record time, and the edition was very large." Charles D. Abbott, *Howard Pyle: A Chronicle* (New York: Harper and Brothers, 1925), 148. The issue's sales attest to the public's fanaticism for Pyle's pirate lore.

21 Pyle, "Introduction," 38–39.

22 Pyle to Robinson, Mar. 26, 1895.

Heather Campbell Coyle

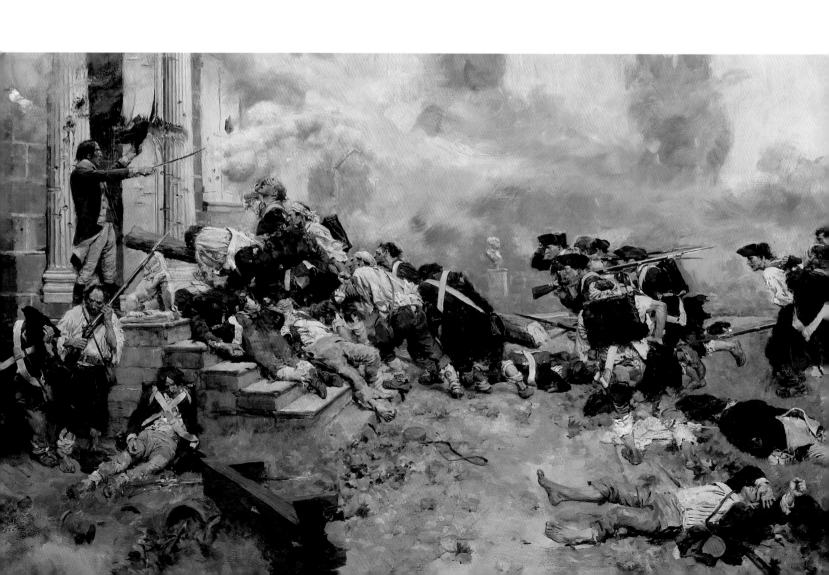

COMPOSING AMERICAN HISTORY: HOWARD PYLE'S ILLUSTRATIONS FOR HENRY CABOT LODGE'S "THE STORY OF THE REVOLUTION"

4.

I have lived so long in our American past that it is like a certain part of my life. My imagination dwells in it and at times when I sit in my studio at work I forget the present and see the characters and things of these old days moving about me.

—HOWARD PYLE

As his words make clear, Howard Pyle immersed himself in the nation's past, facilitating the creation of his convincing illustrations of historical subjects. Through his vividly realized images Pyle helped the nation to visualize its own history. His historical subjects were among his most esteemed works, and his paintings of battles still appear in American history textbooks. Yet Pyle configured the American past through the prism of the late nineteenth-century art world, borrowing compositional strategies from respected painters, even as he visited battlefields and collected antiques in a quest for authenticity. Pyle's lively historical illustrations were so popular in part because his vision of bygone days was effectively filtered through the art and culture of his own time.

Pyle began his work as a professional illustrator in the late 1870s, when two related topics consumed conversations about art in the American press: the influence of European technique and the search for a distinctively American art. Critics and artists discussed the present and future of the nation's art in newspapers, popular magazines, and art journals. In an 1880 article, "The Younger Painters of America," for *Scribner's Monthly*, William Brownell noted the significance of European-trained artists on the national art scene. Like many cosmopolitan critics, Brownell applauded this development, seeing it as a sign of a country approaching artistic maturity. He declared triumphantly: "We are beginning to paint as other people paint."[1] By the end of the decade European influences were even more pronounced, and critics were beginning to question the role of imported styles and subjects. In Clarence Cook's "The Art Year," published in 1888, the author predicted that for the next decade: "The most we can look for is reflection as it were in hundreds of small mirrors of the work that is doing in Europe."[2] The following year in "Tendencies of Art in America," S. G. W. Benjamin stated: "American art at present is largely based upon imitation of other art,—not only the art of past ages, but of contemporary art in other countries ... We are now floating on the full tide of the imitative period."[3] Like Brownell

and Cook, Benjamin was not entirely disheartened by this dependence: "This, however, is no cause for discouragement; for every nation has to pass through its imitative period, and, as we have indicated, the signs are not wanting which give us reason to hope that American art will soon attain the strength and courage to assert its powers in a vigorous manhood."[4]

It was not only in major exhibitions that the influence of Europe was felt. In 1880 William H. Bishop, also writing for *Scribner's*, identified artists who had returned from time spent in Europe as "the most prominent element" in the artistic life of New York City: "It is not only in the schools, where they occupy the professorships and control the coming generation, but in all the movements, formal and informal, without."[5] The schools to which Bishop referred included the Art Students League, where Pyle took classes from 1876 into 1879, and the informal activities encompassed the Salmagundi Sketch Club, where Pyle exhibited alongside Edwin Austin Abbey, George Inness, Jr., and Charles S. Reinhart in 1879 and 1880. (Salmagundi artists illustrated Bishop's article.) Living in New York in the late 1870s, Pyle had a circle of friends that included William Merritt Chase and Walter Shirlaw, both recently returned from studying in Munich and exhibiting to acclaim in the United States. Despite these surroundings, as a young artist Pyle resisted the call of European training, though he longed for a benefactor to send him abroad when *Harper's Monthly* dispatched Abbey to England in 1878.[6]

Pyle did not travel to Europe until the end of his life, yet his pictures—and none more so than his images of American history—testify to the influence of contemporary European painting on American art and illustration. In her essay in this catalogue Margaretta S. Frederick suggests that the international print trade and the presence of many European pictures in American museums and private collections explain Pyle's familiarity with European art. Art schools, libraries, and individual collectors purchased and displayed engravings and photomechanical reproductions of famous paintings. Important paintings were also reproduced in books and magazines, leading to a lively cultural exchange across the Atlantic Ocean. For artists, the copying of engravings was often the first step in their training. With many Americans studying and exhibiting in Paris, and American collectors purchasing major works from the Salons, events in the French art world were thoroughly discussed in the American press in the late nineteenth century.

Indeed, the general interest magazines for which Pyle made illustrations circulated images of European art and reported on major exhibitions, sales abroad, and other art-world events. In 1891 the death of the French academic painter Ernest Meissonier was reported in the *New York Times* and *Harper's Weekly*, as well as in art publications.[7] Throughout the decade the *Century Magazine* profiled French painters such as Jean-Léon Gérôme and Édouard Détaille.[8] The broad interest in foreign art seems to have influenced Pyle. In the 1890s—at the very moment that he was making a case in his writing for a uniquely American art—Pyle combined American subjects and details with compositional devices borrowed from European masters to create successful illustrations of the nation's past.

Henry Cabot Lodge's "The Story of the Revolution," which was serialized in *Scribner's Magazine* throughout 1898, provided Pyle and several other illustrators with the opportunity to produce ambitious paintings of American historical subjects. In the Lodge illustrations Pyle proved his versatility, creating a range of images from expansive battle scenes to single-figure compositions. His paintings were deemed the strongest of the group.[9] Pyle's first picture for the series appeared with the initial installment of Lodge's text in January 1898. Titled *The Fight on Lexington Common, April 19, 1775* (1898, fig. 62), this painting was modeled on a colonial print engraved by Amos Doolittle within weeks of the skirmish. The engraving (1775, see fig. 63) provides a distant and slightly elevated view of Lexington Common, where the British troops are massed in organized rows firing on the colonists, a few of whom stand, at lower left, while others scatter across the foreground and middle ground. Historian Ian M. G. Quimby summarizes the significance of Doolittle's print as "the only pictorial record by a contemporary American" of the event. "Unaware of prevail-

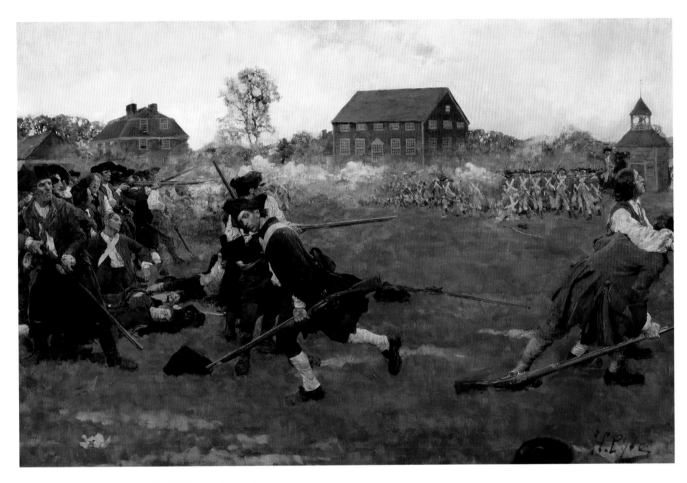

Figure 62. Howard Pyle (1853–1911). *The Fight on Lexington Common, April 19, 1775*. For Henry Cabot Lodge, "The Story of the Revolution." *Scribner's Magazine*, January 1898. Oil on canvas, 23¼ × 35¼ inches. Delaware Art Museum, Museum Purchase, 1912

ing canons of art, Doolittle gave us a realistic version of the events totally outside the heroic tradition that dominated historical painting at the time," he continues.[10] While he may overstate the unmediated nature of the print, Quimby gets to the heart of its appeal as a source. Produced by a local printer active in the Revolutionary cause, the print was a key historical document and was almost certainly consulted by Lodge, whose text describes the conflict in terms that echo

Doolittle's depiction: "The Minute Men, not yet realizing that the decisive moment had come, hesitated, some standing their ground, some scattering. They fired a few straggling shots, wounded a couple of British soldiers, and drew off."[11]

In the caption for Pyle's picture, the engraving is identified as the basis for his illustration. Incorporating this firsthand evidence, "supplemented by careful studies of other documents," Pyle demonstrated his dedication to historical

Figure 63. Amos Doolittle (1754–1832). *The Battle of Lexington, April 19th, 1775,* 1775. Color engraving, 13¾ × 19 inches. Winterthur Museum, Garden and Library

accuracy, an important aspect of his practice.[12] He wrote to Joseph Chapin, art editor at *Scribner's*: "I think that the drawing represents Lexington and the fight as correctly as we of the nineteenth century can gather our facts."[13] This must have been important to Lodge and Chapin, as the series is studded with images high in evidentiary value—engravings after period portraits and reportorial images of important buildings and battlefields—as well as stirring illustrations of the sort that Pyle was commissioned to produce.

In significant ways Pyle retained the engraving's composition and the information it conveyed: the distribution of the buildings is the same, as is the general placement of the British troops and the colonists. Pyle even preserved the wedge of empty space at the center of the picture, though he adjusted the perspective, increasing the size of the figures in the foreground. The illustrator's alterations draw attention to the colonists being gunned down, rendering them larger and turning several faces, including those of the fallen colonists, toward the viewer, while the redcoats remain an undifferentiated mass in the background. Compared to the engraving, more of Pyle's colonists stand and fewer flee. Those that are

scattering appear to be injured, and one wounded man is supported by another, adding a heroic element absent from the written narrative.

For *The Fight on Lexington Common, April 19, 1775,* Pyle adopted the theatrical devices of history painting—using a few large figures, depicting them in moments of heroic action, and facing them toward the viewer—while combining them with the composition of the engraving, a historical document.[14] In doing so, Pyle endeavored to create an accurate image suffused with patriotic sentiment. However, despite his efforts—or perhaps because of his attempt to combine two different forms—the final illustration is confusing. Particularly strange is the central figure, whose face registers shock. While other figures stand or fall in stylized positions, echoing the conventions of history painting, he appears frozen with a photographic immediacy, his body pitched forward and a startled look in his eyes. Placed front and center, looking out of the picture, this uncertain figure dominates the composition, leaving the viewer with questions. Has he been shot? Or is he fleeing the volley of bullets out of fear or the need to reload his weapon? His lurching

position may have been drawn from the running figures in Doolittle's print, but, portrayed large in a history painting, the figure appears out of place. Pyle may have sensed the awkwardness of the image: he described it as "unsatisfactory" and confessed to Chapin that he "somehow felt as timorous about it as a young artist presenting his first work."[15] Pyle would not allow his other illustrations to confound his viewers or disappoint himself, and he adopted more familiar models that made his images legible to his audience.

His next contribution, appearing in February 1898, represented the Battle of Bunker Hill (1898, fig. 64). The caption published describes the specific location and moment of action depicted, situating the picture as "the second attack . . . taken from the right wing of the Fifty-second Regiment."[16] Likewise, the canvas conveys a sense of terrain, including the hill with its thick grasses, and of geography, with the port in the background. Presenting a broad view of the battlefield with soldiers massed in the middle ground,

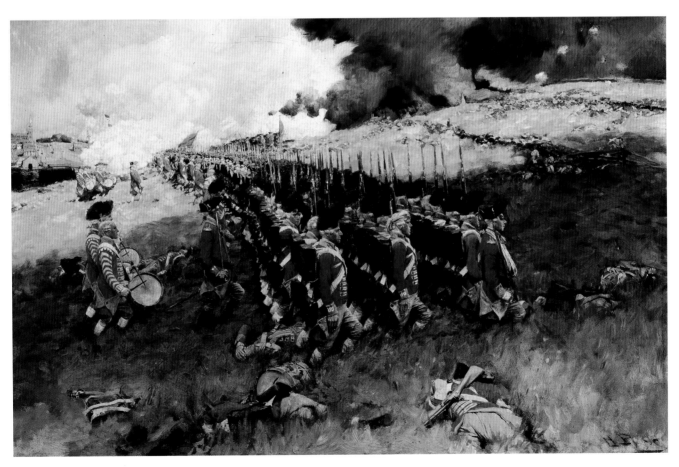

Figure 64. Howard Pyle (1853–1911). *The Battle of Bunker Hill.* For Henry Cabot Lodge, "The Story of the Revolution." *Scribner's Magazine*, February 1898. Oil on canvas, 24¼ × 36⅜ inches. Whereabouts unknown

Figure 65. Howard Pyle (1853–1911). *Thomas Jefferson Writing the Declaration of Independence.* For Henry Cabot Lodge, "The Story of the Revolution." *Scribner's Magazine*, March 1898. Oil on canvas, 35¼ × 23¼ inches. Delaware Art Museum, Museum Purchase, 1912

The Battle of Bunker Hill resembles paintings by nineteenth-century French masters of military painting, such as Détaille and Meissonier.[17]

For the March installment of Lodge's text, Pyle produced an intimate interior scene that contrasts with his battle pictures of the previous months. In a scene he may have suggested to Lodge, Pyle captured Thomas Jefferson while reviewing the Declaration of Independence by candlelight (1898, fig. 65).[18] The modest composition, convincing detail, and directional lighting recall the Dutch-inspired figure paintings of Meissonier (1857, fig. 66), which were popular in the second half of the nineteenth century. At Meissonier's death, a writer at the *New York Times* described him as "essentially the studio artist who paints interiors and figures

lit by side lights through diamond panes high up in casements of Holland make," a description that could nearly serve for Pyle's *Thomas Jefferson Writing the Declaration of Independence*.[19] Meissonier painted dozens of pensive men—alone or in small groups—reading, smoking, and playing cards in their comfortable rooms. Some of these "little figures in the costumes of past ages" were in American collections, and Pyle's historical interiors seem to draw on them in a general way.[20] Although for *Thomas Jefferson* Pyle adapted

Meissonier's fashionable form and compositional strategy, the illustrator made it clear that his subject was not a print collector or a gentleman composing a love letter. The scattered papers and Jefferson's expression of concentration indicate the gravity of the scene pictured.

A more overt borrowing from Meissonier can be seen in Pyle's fourth illustration, published in April: *The Retreat through the Jerseys* (1898, see fig. 67), which seems to derive its composition from Meissonier's *Campaign of France, 1814* (1864) or a reproductive engraving of it (1864, see fig. 68). Pyle likely knew Meissonier's painting only in print, since the original remained in France. The selection was an appropriate one in terms of subject matter, as Meissonier's painting also shows a retreat, that of Napoleon and his troops.[21]

Pyle repeated significant aspects of the composition—the leader on the white horse, pictured in midstep with a line of exhausted soldiers behind him, and a rutted, well-trodden path ahead—but, as he had with *Thomas Jefferson*, adapted his source significantly. In particular, Pyle's sense of color and motion are his own. (Although his series of illustrations for "The Story of the Revolution" appeared in black and white, Pyle produced them in color.[22] By the late 1890s he was painting many of his pictures in color, having already developed a palette that reproduced clearly, even in black and white. Moreover, if he knew the painting only through a print, Pyle would not have been familiar with Meissonier's color choices.) Pyle also managed to convey greater movement: because he painted with looser brushstrokes, Pyle's horse appears less like a sculpture, and the infantry, leaning into the wind as they trudge along, add a sense of motion and atmosphere. Placed higher on the canvas, and higher on his horse, Pyle's General Washington appears more energetic than Meissonier's Napoleon. Moreover, the walking soldiers, pushed forward in the picture plane so the viewer can see their expressions, seem determined rather than demoralized. Overall Pyle's compositional changes and his use of bright color lend his painting a more heroic tone.

Despite these significant differences, *Campaign of France, 1814* was likely an inspiration to Pyle. Meissonier's Napoleonic cycle was particularly well known in the United States.

Figure 66. Jean-Louis Ernest Meissonier (1815–1891). *The Reader in White*, 1857. Oil on panel, 8½ × 6 inches. Musée d'Orsay, Paris. Photograph © Giraudon and the Bridgeman Art Library

Figure 67. Howard Pyle (1853–1911). *The Retreat through the Jerseys.* For Henry Cabot Lodge, "The Story of the Revolution." *Scribner's Magazine*, April 1898. Oil on canvas, 23⅜ × 35⅜ inches. Delaware Art Museum, Museum Purchase, 1912

Another work in the series, *1807, Friedland* (c. 1861–75), was purchased for $60,000 by American collector Alexander T. Stewart in 1876 and subsequently sold at the auction of Stewart's collection in 1887 to Henry Hilton, who immediately donated it to the Metropolitan Museum of Art, New York. All these transactions rated notice in the general media.[23] *Campaign of France, 1814* was also discussed in various American art journals and was widely available in reproductive prints. At least two New York publishers sold editions of Meissonier's masterpiece: Wellstood, Leggo, and Co. proffered an engraving (illustrated here), and A. J. Bishop advertised a photogravure.[24] Interest in Meissonier was strong in the 1890s, with his death at the beginning of the decade, the publication of an American edition of Vallery C. O. Gréard's tome *Meissonier: His Life and His Art* in 1897, and Charles

Yriarte's personal recollections of the painter appearing in various publications the following year.[25]

That Pyle would have borrowed from Meissonier then is not surprising. The French painter was a high-profile artist engaged with similar subjects. In the last quarter of the nineteenth century few American painters essayed historical subjects. Mark Thistlethwaite has estimated that only about twenty of the approximately six hundred oil paintings at the Centennial Exhibition (1876) in Philadelphia were history pictures; after 1876 history paintings typically represented around one percent of the pictures in the influential annual exhibitions at the National Academy of Design, New York, and the Pennsylvania Academy of the Fine Arts, Philadelphia.[26] At the same time, earlier paintings of the Revolution, like John Trumbull's cycle (1817–24) in the Capitol Rotunda in

Washington, D.C., and Emanuel Leutze's *Washington Crossing the Delaware* (1851), fared poorly with contemporary critics.[27] When the illustrations for "The Story of the Revolution" were shown at Avery Gallery in New York in 1898, a writer noted: "Hitherto, the theme of the American Revolution, notwithstanding its pictorial interest, has remained a little-worked field and the exhibition showed its great possibilities."[28]

The lack of interest in history painting reflected changes in the field of American art. As artists, critics, and collectors became more interested in questions of (often imported) technique and personal expression, history paintings—focused as they were on subject matter—fell out of favor. While a handful of artists, including Jennie Brownscombe, Jean Leon Gerome Ferris, and Edward Lamson Henry, consistently exhibited and sold pictures of the American past during the late nineteenth and early twentieth centuries, they rated comparatively little notice in the art press. On the other hand, French academic painters who concerned themselves with historical subjects—especially Détaille, Gérôme, and Meissonier—were constantly in the news in reference to their students, their latest paintings, and the stunning prices they commanded.

Beyond the popularity and success accorded him, another part of Meissonier's appeal may have been his reputation for exacting research into his historical subjects, a characteristic Pyle demonstrated in his own illustrations. It was reported that Meissonier had "the coat worn by Napoleon I copied by a tailor ... He put the garment on himself, mounted a wooden horse in his studio, saddled like the Emperor's steed, and passed hours in studying his figure and the fall of the skirts in a mirror."[29] The same article related how he studied Eadweard Muybridge's photographs of horses in motion and how, in order to accurately depict ruts worn into the ground by heavy wagons, he built a miniature

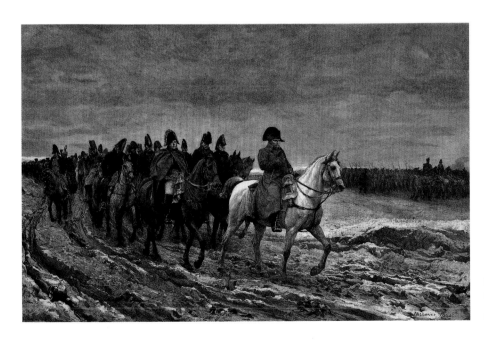

Figure 68. Wellstood, Leggo, and Co., after Ernest Meissonier (1815–1891). *Campaign of France*, 1864. Engraving, 16 × 24 inches. Helen Farr Sloan Library and Archives, Delaware Art Museum

set in his studio and dragged tiny carts through imitation snow.[30] Meissonier's obsessive research reflects the naturalist paradigm gaining ground in French art and literature of the late nineteenth century. Marc J. Gotlieb has contrasted Meissonier's approach with traditional, idealizing history painting.[31] Although Meissonier was an extreme case, historical accuracy was a concern of other popular European academic painters, including his countryman Gérôme and Lawrence Alma-Tadema in England.

Meissonier considered himself to be "a student of the architecture, the dress, the habits, of each period."[32] And this knowledge meant that when he learned a historical fact he could depict it accurately. His biographer Gréard quoted the artist:

> I see it all, in flesh and blood. Everything really and truly happens under my very eyes; I plunge into it at once, I see the people with their weapons, in their costumes, with the very faces they used to wear; it is a vivid, involuntary incarnation, which gives me a sensation quite different to any you experience.[33]

Meissonier's language echoes Pyle's own exhortations to his students to "live in the picture," and Pyle's methods would be similarly described.[34] In commenting upon *Clark on His Way to Kaskaskia* (1898), another illustration for "The Story of the Revolution," a writer for the *Philadelphia Inquirer* reported that Pyle had based his depiction of the subject and his costume on a photograph of a painted portrait and had copied Clark's rifle, sword, and powder horn from photographs of the originals.[35]

The illustrator also collected authentic costumes, accessories, and furnishings. The catalogue of Pyle's estate sale lists over one hundred pieces of clothing, many identified as colonial and some assigned approximate dates: item thirty-five is described as "Breeches of 1770 (original), used in Revolutionary pictures." Others are identified with specific stories and characters: number sixty-three is a "Woman's Dress, 1770, used for Aunt Gaynor in Hugh Wynne." Like the details in his paintings, Pyle's estate encompassed more than just cloth-

ing: the sale included tankards, ale pitchers, and arms and armor, with many pieces identified as old, rare, or colonial.[36]

Pyle's research went beyond collecting and the study of photographs; he visited battlefields and colonial buildings and discussed historical details with his authors.[37] For *The Attack upon the Chew House* (1898, fig. 69), which depicts Washington's unsuccessful attack on a British encampment in October 1777, Pyle sent his students to photograph the site in the Germantown section of Philadelphia, studied accounts of the siege, and corresponded with descendants of the Chew family, creating what may be his most successful fusion of heroic imagery and period detail in a battle picture.[38] In Lodge's book Pyle's caption—identified as "Note by the artist"—names specific individuals and describes details of the attack not presented by the author.[39]

Like Meissonier, Pyle had educated himself so he could conjure the past almost involuntarily, especially in the presence of colonial structures like the Chew House. After seeing carpenters making repairs on the late seventeenth-century Old Swedes Church in Wilmington, Delaware, Pyle wrote:

> Old buildings and fragments of the past are to me very and vitally alive with the things of the past. When, for instance, I saw your carpenters working upon the Old Swede's [*sic*] Church I could not but picture to myself in fancy the old builders of that past day in knee breeches and their leather aprons and their queer uncouth tools building up that which the present generation was tearing down.[40]

The final phrase, which laments the destruction of a historical building, signals his sympathy with the aims of the emerging historic-preservation movement, which fed on the colonial revival of the late nineteenth century, a widespread enthusiasm that gained steam after the Civil War. In 1877, when he published his first illustration showing an event from American history, Pyle was not unusual in his passion for the nation's past. The Centennial Exhibition stoked the flames of interest in national history, spreading the nascent colonial revival in architecture and design. Americans began

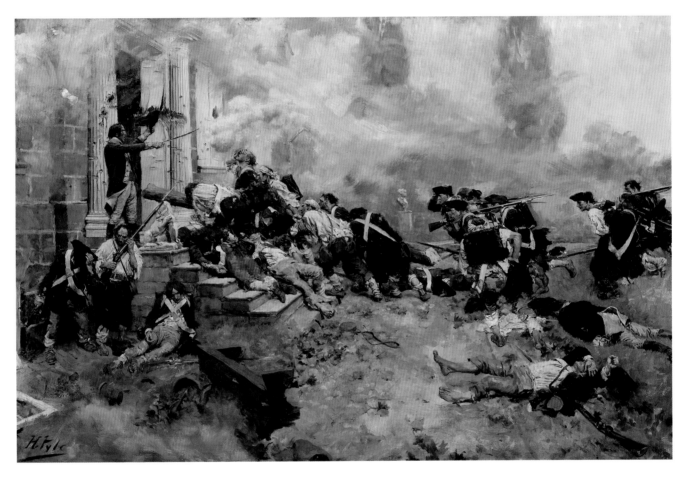

Figure 69. Howard Pyle (1853–1911). *The Attack upon the Chew House.*
For Henry Cabot Lodge, "The Story of the Revolution." *Scribner's Magazine*, June 1898.
Oil on canvas, 23¼ × 35¼ inches. Delaware Art Museum, Museum Purchase, 1912

to collect examples of colonial and federal furniture and objects, and architects incorporated elements of colonial and federal styles into their designs. By 1897–98, when he produced the images for "The Story of the Revolution," the Germantown home belonging to the Chew family, called Cliveden, was gaining recognition as a significant eighteenth-century mansion associated with the Revolutionary War.[41]

For an illustrator, the increased interest in the American past was profoundly important, as publishers sought out images to accompany the many historical studies and stories being produced. Pyle would illustrate more than 130 books, articles, stories, and poems set in colonial and Revolutionary America. And Pyle was not alone. In the Lodge project Pyle was joined by contemporaries Benjamin West Clinedinst, Ernest Peixotto, F. C. Yohn, and others. Historical subjects would be important for several of his students, including Stanley M. Arthurs and N. C. Wyeth. In 1895 the *Monthly Illustrator* published an article by Cook entitled

Figure 70. Unknown photographer. Interior of Howard Pyle's Franklin Street studio, c. 1900. Photograph, 3¾ × 4½ inches. Howard Pyle Manuscript Collection, Helen Farr Sloan Library and Archives, Delaware Art Museum

"Artists as Historians," which describes the demands made by audiences on then contemporary illustrators who undertook historical subjects:

> We insist on the minutest accuracy in dress and scenery and take infinite pains to get them, so the artist must be archaeologist, scientific man, traveler, man of the world, and not only go everywhere and see everything, but report what he sees and learns, as in honor bound to tell the truth. It is not permitted to Alma Tadema, to Gérôme, to Meissonier, to Béraud, to Menzel, nor to Frank Millet nor Remington, nor Abbey, to make mistakes; they must be accurate to a gaiter-button or a fibula, or they lose their rank.[42]

These demands led artists to become collectors of period objects. Pyle participated in the colonial revival as an author, illustrator, and enthusiast: he penned and pictured stories set in the colonial era and collected and displayed antiques.[43] Pyle's illustrated interiors are peppered with old furnishings—elegant paw-footed tables, simple slat-back chairs—many matching the listings in the catalogue to his estate sale and the items in extant photographs of his home and studio. Indeed, the unusual grandfather clock behind Jefferson in the *Scribner's* image kept time in Pyle's studio among Windsor and Chippendale chairs (c. 1900, fig. 70). In his illustrations the antiques are not always precisely accurate to the time and place depicted—the clock was not an authentic colonial piece—but accuracy and romance were

equally strong motives of the colonial revival.[44] Pyle's combination of historical research, familiar composition, and romantic action perfectly suited his public. He would be accepted as "the foremost of our illustrators of early American life."[45]

Late in 1897 Scribner's decided to exhibit some of the completed illustrations by Pyle and others for "The Story of the Revolution." Pyle was not pleased, feeling that his paintings, while sufficient for reproduction, were not ready for exhibition. He wished his works to look their best, particularly because he hoped that the set would be purchased for the Congressional Library Building in Washington, D.C. Therefore he set about retouching the canvases.[46] The exhibition traveled to New York, Boston, Providence, New Haven, Hartford, and Philadelphia, where the paintings were well received. Although Pyle's works were singled out by critics as being among the finest in the exhibition,[47] Pyle's pictures were not acquired by the federal government. In Philadelphia a critic who had seen the exhibition observed: "The skill now acquired by American artists turned from the imitation of foreign schools to the development of an American art by the portrayal of American life." Pyle's work could be of service "in substituting home for foreign standards . . . and promoting a just pride and independence in things American."[48] The writer's words echo Pyle's aspirations as put forth in his article "A Small School of Art," which had appeared in *Harper's Weekly* a little less than a year earlier.[49]

With that 1897 text Pyle had entered the conversation about the future of the nation's art, inquiring, "Why have we no national art?" Like some other critics, Pyle voiced concern over the nation's continued dependence on European models. He complained that "American art, as a whole, appears to me to lack in individuality, and to partake more of the nature of French art."[50] As a remedy Pyle proposed the system of instruction he had introduced at Drexel Institute of Art, Science, and Industry (where he had been teaching since 1894), which was a distinctively practical approach in contrast to the academic training imported from Paris. Stressing the importance of composition and drawing from the clothed model, Pyle situated his system in opposition to the curriculum centered on life study in many American art schools, perhaps most notably at the Pennsylvania Academy of the Fine Arts. Despite their appearance alongside Pyle's nationalist rhetoric and his practical plans, the student pictures that accompany his article bear significant traces of European academic painting. Like others of his generation, Pyle incorporated what he considered the best of European painting into his vision of a distinctly American art.

NOTES

The epigraph is from an undated letter from Howard Pyle to W. H. Mersereau quoted in Charles D. Abbott, *Howard Pyle: A Chronicle* (New York: Harper and Brothers, 1925), 153.

1 William C. Brownell, "The Younger Painters of America," *Scribner's Monthly* 20, no. 1 (May 1880): 1.

2 Clarence Cook, "The Art Year," *The Chautauquan* 8, no. 7 (Apr. 1888): 417.

3 S. G. W. Benjamin, "Tendencies of Art in America," in Walter Montgomery, ed., *American Art and American Art Collections* (Boston: E. W. Walker and Co., 1889): 1004.

4 Ibid.

5 William H. Bishop, "Young Artists' Life in New York," *Scribner's Monthly* 19, no. 3 (Jan. 1880): 360.

6 Pyle tells his mother of his desire to go abroad in a letter dated Nov. 3, 1878, quoted in Charles D. Abbott, *Howard Pyle: A Chronicle* (New York: Harper and Brothers, 1925), 56–57.

7 "Meissonier the Master, End of the Career of a Great French Artist," *New York Times*, Feb. 1, 1891; and "Master of the Minute," *Harper's Weekly* 35, no. 1,781 (Feb. 7, 1891): 101–02.

8 Fanny Field Herring, "Gérôme, the Artist," *The Century Magazine* 37, no. 4 (Feb. 1887): 483–500; and Armand Dayot, "Edouard Detaille, Painter of Soldiers," *The Century Magazine* 56, no. 6 (Oct. 1898): 803–14.

9 "Art and Portraits," *New York Times*, Feb. 10, 1898; "Howard Pyle's Revolutionary Pictures," *Philadelphia Inquirer*, May 10, 1898.

10 Ian M. G. Quimby, "The Doolittle Engravings of the Battle of Lexington and Concord," *Winterthur Portfolio* 4 (1968): 83.

11 Henry Cabot Lodge, *The Story of the Revolution* (New York: Charles Scribner's Sons, 1898), 1: 35.

12 The caption states: "A drawing of the Battle of Lexington was made by Earl, a portrait painter, and engraved by Amos Doolittle (both soldiers of the Connecticut Company), from narratives of participants of the affair, within a month or two after the fight. This drawing must remain the best source of information, but it has been supplemented by careful studies of other documents." Ibid., 37. It is worth noting that the other illustrators for this chapter, Ernest Peixotto and F. C. Yohn, who could have drawn on Doolittle's other engravings of the fight at Concord Bridge and the retreat from Concord for their pictures, did not incorporate his images in a meaningful way.

13 Pyle to Joseph Chapin, Sept. 21, 1897, quoted in Abbott, *Howard Pyle: A Chronicle*, 165.

14 Quimby contrasts Doolittle's engravings with academic history paintings like John Trumbull's images of the Revolutionary War. Quimby, "Doolittle Engravings," 83.

15 Pyle to Chapin, Sept. 23, 1897, quoted in Abbott, *Howard Pyle: A Chronicle*, 166. Pyle was concerned, in particular, about the color.

16 Lodge, *Story of the Revolution*, 1: 85.

17 See, for example, Édouard Détaille's *Battle of Fontenoy* and Ernest Meissonier's *Napoleon III at the Battle of Solferino*.

18 Trying to convince Lodge that one particular scene and not another should be illustrated to accompany a later installment of "The Story of the Revolution," Pyle wrote: "I feel, for instance, that my drawing of the single figure of Jefferson, as I described it to you, added far more to your fine text than a more elaborate illustration of some definite point might have done." From that letter, I extrapolated that the scene of Jefferson may have been Pyle's suggestion: Pyle to Henry Cabot Lodge, Dec. 28, 1897, quoted in Abbott, *Howard Pyle: A Chronicle*, 169.

19 "Meissonier the Master," *New York Times*, Feb. 1, 1891.

20 Interiors by Meissonier were listed in several American collections, including those of Jay Gould (*The Reader* and *The Smoker*) and William H. Vanderbilt (*Man Reading*) in "Meissoniers Owned by Americans," *The Art Amateur* 24, no. 4 (Mar. 1891): 6. The quote is from "Jean Louis Ernest Meissonier," *The Critic* 15, no. 371 (Feb. 7, 1891): 76. There are several Pyle paintings in the collection of the Delaware Art Museum, for example, that seem to be derived from Meissonier's interiors, including *The Diplomats* and *This Last Picture*.

21 It was often observed in the late nineteenth century that the painting depicted not a scene from Napoleon's French campaign but his retreat from Moscow. For one example of the painting identified as *Retraite au Russie*, see "The Pictures of Napoleonic Episodes," *New York Times*, Jan. 29, 1884.

22 Pyle to Charles Scribner, Jan. 6, 1898, Archives of Charles Scribner's Sons, 1786–2003, box 117, Manuscripts Division, Princeton University Library.

23 See, for example, "Another Princely Gift," *New York Times*, May 3, 1887; "Two Great Masterpieces," *New York Times*, Mar. 26, 1887; and "Why Paintings Cost So Much," *Messenger* 46, no. 6 (Feb. 7, 1877): 3.

24 When it was sold in 1890, Meissonier's *Campaign of France, 1814* was rumored to have surpassed Jean-François Millet's *The Angelus* as the costliest painting ever sold. American publications were atwitter about the sale to Alfred Chauchard, a department-store magnate. Discussions of the sale of the painting include: "American and European Art Notes," *The Art Interchange* 25, no. 2 (July 5, 1890): 15; "The Fine Arts," *The Critic* 13, no. 336 (June 7, 1890): 290; and Montezuma [Montague Marks], "My Note Book," *The Art Amateur* 23, no. 2 (July 1890): 22. An advertisement for A. J. Bishop's "Framed Photo-Gravures" appears in *Belford's Magazine* 2, no. 8 (Jan. 1889): 21.

25 Several single-figure interior compositions with strong similarities to Pyle's *Thomas Jefferson Writing the Declaration of Independence*, including *The Poet*, appear in Gréard's book; *Campaign of France, 1814* is reproduced in photogravure. Vallery C. O. Gréard, *Meissonier: His Life and His Art*, trans. Lady Mary Loyd and Florence Simmonds (New York: A. C. Armstrong and Son, 1897), 201, opposite 242; Charles Yriarte, "E. Meissonier: Personal Recollections and Anecdotes," *The Eclectic Magazine of Foreign Literature* 68, no. 1 (July 1898): 104.

26 Mark Thistlethwaite, "A Fall from Grace: The Critical Reception of History Painting, 1875–1925," in William S. Ayres, ed., *Picturing History: American Painting, 1770–1930* (New York: Rizzoli in association with Fraunces Tavern Museum, 1993): 177–78, 182.

27 On the reception of history painting in the late nineteenth century, see ibid., esp. 177–83.

28 "Exhibition Notes," *The Art Interchange* 40, no. 3 (Mar. 1, 1898): 71.

29 "Meissonier, Jean Louis Ernest," *Appletons' Annual Cyclopedia and Register of Important Events* 31 (Jan. 1, 1891): 502.

30 Ibid. On Meissonier's incorporation of Eadweard Muybridge's discoveries, see Marc J. Gotlieb, *The Plight of Emulation: Ernest Meissonier and French Salon Painting* (Princeton, N.J.: Princeton University Press, 1996), 175–84.

31 Gotlieb, *The Plight of Emulation*, esp. 150–54.

32 Gréard, *Meissonier*, 187–88.

33 Ibid., 188.

34 Allen Tupper True, Notebook Containing Miscellaneous Thoughts and Observations, 1904–1908, Allen Tupper True and True Family Papers, 1841–1987, microfilm reel 4,895, Archives of American Art, Smithsonian Institution, Washington, D.C.

35 "Literary Notes," *Philadelphia Inquirer*, June 19, 1898.

36 Philadelphia Art Galleries, *Catalogue: The Estate of Howard Pyle, Deceased* (Philadelphia: Philadelphia Art Galleries, 1912). A copy is in the Howard Pyle Manuscript Collection, box 1, Helen Farr Sloan Library and Archives, Delaware Art Museum.

37 For an example of a debate between Pyle and an author over historical points, see correspondence between Pyle and Woodrow Wilson, Nov. 1895–Jan. 1896, esp. Wilson to Pyle, Nov. 4, 1895; Dec. 20 and 30, 1895; and Jan. 12, 1896, Andre De Coppet Collection, 1566–1936 (filed under Woodrow Wilson) Manuscripts Division, Princeton University Library. Pyle illustrated Wilson's series of articles on George Washington, published in *Harper's New Monthly Magazine* in 1896, and Wilson's *A History of the American People* published by Harper and Brothers in 1902.

38 Notes Taken from Conversation between Frank Schoonover and Gertrude Brinklé, Feb. 1949, Howard Pyle Manuscript Collection, box 5, Helen Farr Sloan Library and Archives, Delaware Art Museum. According to these notes, the green bench in the foreground of the painting was present when Schoonover and Arthurs photographed the site. Pyle said "that if it were threat [*sic*] the time the photograph was taken, it would probably always be there—even at the time of the battle."

39 Lodge, *Story of the Revolution*, 1: 291–93.

40 Pyle to W. H. Mersereau quoted in Abbott, *Howard Pyle: A Chronicle*, 153. *Potter's American Monthly* 7, no. 56 (Aug. 1876): 81–88.

41 Thompson Wescott, "Cliveden, the 'Chew House,' Germantown," *Potter's American Monthly* 7, no. 56 (Aug. 1876): 81–88.

42 Clarence Cook, "Artists as Historians," *Monthly Illustrator* 3, no. 9 (Jan.–Mar 1895): 103.

43 Other American artists with similar penchants for research and collecting included Edwin Willard Deming, John Ward Dunsmore, and Jean Leon Gerome Ferris. For more information, see Barbara J. Mitnick, "Paintings for the People: American Popular History Painting, 1875–1930," in William S. Ayres, ed., *Picturing History: American Painting, 1770–1930* (New York: Rizzoli in association with Fraunces Tavern Museum, 1993), 168–74.

44 The author would like to thank Wendy A. Cooper, the Lois F. and Henry S. McNeil Senior Curator of Furniture, Winterthur Museum, Library and Garden, for examining the photographs of Pyle's studio furnishings.

45 "Howard Pyle's Revolutionary Pictures."

46 Pyle to Charles Scribner, Dec. 30, 1897, and Jan. 6 and 8, 1898, Archives of Charles Scribner's Sons, 1786–2003, box 117, Manuscripts Division, Princeton University Library, N.J.

47 In a review of the illustrations for Lodge's book, shown at Avery Gallery in New York, the anonymous author noted: "Howard Pyle leads all the rest with his paintings of the 'Fight on the Common, Lexington,' two of the series of twelve pictures of the 'Battle of Bunker Hill,' of which the remainder are still to appear, and of 'Jefferson Writing the Declaration of Independence.'" "Art and Portraits," *New York Times*, Feb. 10, 1898.

48 "Howard Pyle's Revolutionary Pictures."

49 "Howard Pyle, "A Small School of Art," *Harper's Weekly* 41, no. 2,117 (July 17, 1897): 710.

50 Ibid.

Margaretta S. Frederick

5. CATALYSTS AND CONCEPTS: EXPLORING PYLE'S REFERENCES TO CONTEMPORARY VISUAL CULTURE

Not long ago a group of young English artists in one of the London clubs were discussing the merits of contemporary American illustrators. The general opinion was that Howard Pyle was the best of them all, original in conception, skillful and ingenious in execution.

—*NEW YORK TIMES*

The vibrant exchange of visual information during the second half of the nineteenth century, made possible by new innovations in print technology and production, as well as in transportation, fueled a new transcontinental appreciation and understanding of global stylistic developments. Howard Pyle's unique approach to the art of illustration was honed through his intensive study of the art of his time, including a range of both American and European styles. In addition to viewing original works of art in Wilmington, Philadelphia, and New York, Pyle accessed contemporary imagery through illustrated periodicals and books, reproductive prints, and photomechanical reproductions of fine art, all of which were available to him via the new, expanding, international trade in prints and other publications. Emerging from a culture of transatlantic artistic exchange, Pyle's success was abetted by his audience's appreciation of his adaptation of American and European sources.

Pyle was born and educated in an age in which the possibilities for the training of a budding illustrator were limited, yet the demand for illustrations was high. In addition, reproductive technology was changing rapidly, requiring a high degree of adaptability on the part of even the most seasoned practitioners. Since he chose not to go abroad to study, unlike many of his colleagues, Pyle did not view firsthand international artistic trends but seems to have relied instead on developing his own in-depth knowledge of both past and contemporary styles in the fine arts. His personal visual repertoire was then transformed to serve the specific needs of illustration art.

Pyle acknowledged the unique requirements of illustration that partitioned it from mainstream fine arts. He wrote, for instance:

There is one exceptional branch of art, which, directed perhaps by the force of circumstances, has been

compelled to seek its inspiration from a broader field than that of academic traditions. The illustrator must image Nature in his art, or else his art is of no avail. His people must look like living people, and his mimic world must represent a living world, or else he labors in vain to gain an audience.[1]

An original work needed to translate legibly to the printed page by way of the specific technical process utilized for reproduction. Its composition had to be readable, allowing the viewer a quick visual synopsis of the accompanying text. These prerequisites required a delicate balance between narrative detail and clear, simplified composition. Pyle's borrowings from recognizable sources accelerated audience comprehension of the story being told. His understanding of this mechanism of stimulating visual memory among his public is a significant factor in his work's ultimate popularity within his lifetime and continuing to the present day.

Pyle's style was described by a contemporary critic as "varied" and occupying "new ground."[2] I would suggest that at least in part it was Pyle's ability to draw strategically from diverse aspects of the fine and graphic arts, tailoring the appropriated elements to the specific demands of his subject and the medium at hand, that facilitated audience appreciation. Pyle's sources lay in Pre-Raphaelitism, Aestheticism, Japonisme,[3] Symbolism, and American realist painting. In addition to enhancing the images' visual connections to the accompanying text, these "high art" references surreptitiously guided his reading and viewing public to a higher level of art-literate sophistication. The recognition of Pyle's sources undoubtedly contributed to viewers' enjoyment of the imagery, as they would have had some satisfaction in acknowledging their own visual awareness.[4]

Born in Wilmington, Delaware, in 1853, Pyle was raised amid a vibrant world of popular printed imagery. Internationally, the Industrial Revolution was helping to create an expanding middle class that had the luxury of leisure time unknown in generations past. Access to education steadily improved for most of the nineteenth century, resulting in a more literate population. As the demand for books and periodicals grew, industrial advances provided the means with which to meet this demand. Mechanized innovations, including steam-powered printing presses and machine-produced paper, greatly increased the capacity to produce periodicals.[5] New and faster modes of transportation aided in the circulation of periodicals and books across the United States and the Atlantic Ocean. Like most middle-class Americans, Pyle was introduced to art and illustration through the printed materials in his home. His recollections of his early childhood substantiate an immersion in the new print culture:

> My mother was very fond of pictures; but especially was she fond of pictures in books. A number of prints hung on the walls of our house: there were engravings of Landseer and Holman Hunt's pictures, and there was a colored engraving of Murillo's Madonna standing balanced on the crescent moon, and there was a pretty smiling Beatrice Cenci, and several others that were thought to be good pictures in those days. But we—my mother and I—liked the pictures in books the best of all. I may say to you in confidence that even to this very day I still like the pictures you find in books better than wall pictures.
>
> As for our picture-books: not only did we have the old illustrated Thackeray and Dickens novels, and Bewick's Fables, and Darley's outline drawings to Washington Irving's stories, and others of that sort, but the *London Punch* (and there were very great artists who drew pictures for the *London Punch* in those days) and the *Illustrated London News* came into our house every week. I can remember many and many an hour in which I lay stretched out before the fire upon the rug . . . Turning over leaf after leaf of those English papers, or of that dear old volume of *The Newcomes* (the one with the fables on the title page), or of *The Old Curiosity Shop* where you may see the picture of Master Humphrey with the dream people flying about his head.[6]

As a young man, Pyle trained privately in Philadelphia with Francis Van der Wielen beginning in 1869. Van der Wielen was an academically trained artist of Dutch-Flemish descent. Much of what we know of his training program is found in the autobiography of the artist Cecilia Beaux, who studied with Van der Wielen after Pyle's departure. Van der Wielen's program appears to have followed classic academic methods—including drawing from plaster casts and completing drills in perspective. Beaux describes her first task upon arriving at the school as having to transpose an image from a small-scale lithograph into a larger format.[7] This age-old exercise of copying the work of established artists would have echoes in Pyle's later practice, when he adapted imagery for use in his illustrations.

Pyle's earliest work shows the results of various nascent visual influences. A group of Pyle's early pencil sketches reveals his efforts to encapsulate character development in a single figure in the absence of any defining physical attributes—relying solely on costume, pose, and facial expression to convey information to the viewer.[8] The communication of visual data within an abbreviated linear language was a hallmark of the work of English Pre-Raphaelite illustrators of the 1860s, like William Holman Hunt, John Everett Millais, and Frederic Shields.[9] For instance, Millais's illustration for Alfred, Lord Tennyson's poem "Edward Gray," published in his *Poems* (1857), in which a young man turns away from a female figure in obvious distress—an emotion conveyed deftly by the droop of the man's shoulder, his right hip defensively braced and his head tilted downward—is accomplished with an economy of line and limited accessories.[10] A similar attempt to convey inner feelings, albeit tentatively in this early stage of his stylistic development, can be discerned in Pyle's drawing of a woman in a maid's cap and apron thoughtfully gazing down into the teacup she holds in her hands (n.d., fig. 71).

In 1876 Pyle had two illustrations accepted for publication in *Scribner's Monthly*, initiating his professional career and setting him on the path that would lead him to relocate to New York, where he could be closer to the large publishing houses.[11] There he enrolled at the Art Students League

Figure 71. Howard Pyle (1853–1911). *Untitled*, no date. Pencil on paper, 8⅛ × 6⅛ inches. Delaware Art Museum, Gift of Willard S. Morse, 1925

at the suggestion of *Scribner's* editor Richard Watson Gilder. Pyle attended life classes, where he met a group of ambitious young artists. The League, formed in response to the rumored termination of the life class at the school of the National Academy of Design, also in New York, was particularly sensitive to the importance of "the cultivation of a spirit of fraternity among art students."[12] Pyle developed collegial relationships there with Edwin Austin Abbey, William Merritt Chase, and Julian Alden Weir.

Figure 72. Howard Pyle (1853–1911). *Wreck in the Offing!*, 1878. For "'Wreck in the Offing!'—Scene in a Life-Saving Station." *Harper's Weekly*, March 9, 1878. Gouache on paper, 14¾ × 21⅛ inches. Delaware Art Museum, Gayle and Alene Hoskins Endowment Fund, 1984

In addition to the opportunity to draw from the live model, an Art Students League membership offered the privilege of sketching at the Metropolitan Museum of Art, New York, and access to its growing collection of "photographs, etchings and engravings of the work of old masters, and of the different modern painters who have won distinction."[13] As his education progressed, Pyle seems to have looked more and more to the fine arts for inspiration.

That said, the division between fine art and illustration that is so clearly demarcated in the present day was less relevant in the New York art scene of the 1870s. The blurring of boundaries between disciplines carried over to less formal sketch clubs, including the Salmagundi Club, with which Pyle had become associated by 1878. There he spent weekly evening critiques with such diversely positioned artists as Chase, Arthur Burdett Frost, and George Inness, Jr.

In March 1878 the publication of *Wreck in the Offing!* (1878, fig. 72) in *Harper's Weekly* commenced Pyle's professional career. This early yet well-developed example of Pyle's work presents a group of men huddled around a table, faces lit by candlelight, just as they are interrupted with news of a shipwreck. In its composition and dramatic lighting, Pyle's picture recalls Dutch old master paintings of card games, examples of which would have been on view at the Metropolitan Museum of Art. The work of such painters as Adriaen Brouwer (see, for instance, Brouwer's *The Smokers* [probably c. 1636], Metropolitan Museum of Art) would also have been readily available as reproductive prints. The monochromatic tonality of these prints would have served as a useful source for a young illustrator who was producing images to be published in black and white. Pyle could also have gained inspiration from sources closer to home, like his friends Chase

and Walter Shirlaw, both of whom had trained in Munich and were imitating the darker tonalities of European academic schools.

Pyle was clearly keeping abreast of developments in English illustration, as is apparent in his early work employing newly developed color-printing processes. In 1881 he had two books published simultaneously, a retelling for children of Tennyson's *The Lady of Shalott* (1881, fig. 73), and *Yankee Doodle: An Old Friend in a New Dress* (1881, fig. 74), whose story derived from the traditional American folk song. Both

are technically and stylistically based on the productions of the English painter and illustrator Walter Crane.[14] Crane was one of the first to benefit from chromoxylography, a color-printing method developed by the English printer and engraver Edmund Evans. Crane issued a series of illustrated children's "Toy Books" (1873, see fig. 75) with Evans beginning in 1865, which were extremely popular and to which Pyle would have had easy access. In a manner similar to Crane's use of bright color encased in strong, dark outlines, Pyle drew the illustrations for both his books in ink outline

Figure 73. Howard Pyle (1853–1911). *Untitled*. From Alfred, Lord Tennyson, *The Lady of Shalott*. New York: Dodd, Mead and Company, 1881. Printed matter. Helen Farr Sloan Library and Archives, Delaware Art Museum

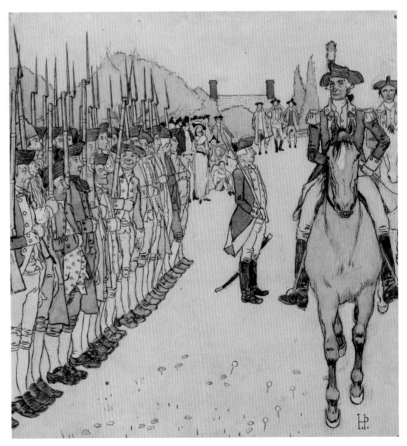

Figure 74. Howard Pyle (1853–1911). *Untitled*. For Howard Pyle, *Yankee Doodle: An Old Friend in a New Dress*. New York: Dodd, Mead and Company, 1881. Watercolor on illustration board, 8¾ × 7¾ inches. Delaware Art Museum, Bequest of Joseph Bancroft, 1942

and then colored them in with watercolor, creating an overall patterned effect.[15]

A comparison of Pyle's illustrations accompanying these two texts, which the artist worked on simultaneously, reveals that, even at this early date in his career, subject matter dictated stylistic approach. The mannered, marionettelike figures in *Yankee Doodle* are distinctly different from the sinuous, Art Nouveau–inspired staffage of *The Lady of Shalott*. This stylistic coordinating of image and text is an approach that would become a hallmark of Pyle's methodology.

Throughout his busy and prolific career in illustration, Pyle was required to address an eclectic range of subjects, both nonfiction—from the distant past to the present day—and allegorical. In approaching these diverse topics, he often looked to the work of others for sources that best suited the project at hand. Sometimes this visual foraging provided compositional elements that were quite closely mimicked, while other borrowings were more general—stylistic or atmospheric. As his career progressed, these translations became more sophisticated. Fine-arts sources were incorporated to a greater degree than graphic references. This strategic application of aesthetic components could be quite obvious or more subtle and refined, largely depending on the eligibility of the source to the subject at hand.

For instance, Pyle's interest in medieval subject matter was one shared by his Pre-Raphaelite predecessors. Arthurian tales had been favored by members of the Pre-Raphaelite circle in England in the early 1850s and 1860s and reproduced in popular books and periodicals. In America Pyle and others continued this trend. In addition to commissioned work, Pyle wrote and illustrated several books set in the Middle Ages, including *Otto of the Silver Hand* (1888), *The Story of King Arthur and His Knights* (1903), and *The Story of the Champions of the Round Table* (1905), all published by Charles Scribner's Sons. Pre-Raphaelite wood engravings of the medieval era were certainly one source to which

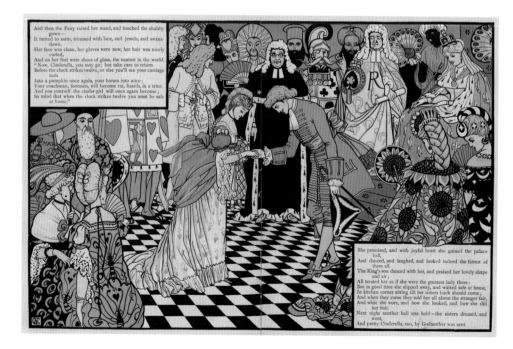

Figure 75. Walter Crane (1845–1915). *Untitled*. From Walter Crane and Edmund Evans, *Cinderella*. London: George Routledge and Sons, 1873. Printed matter. Helen Farr Sloan Library and Archives, Delaware Art Museum

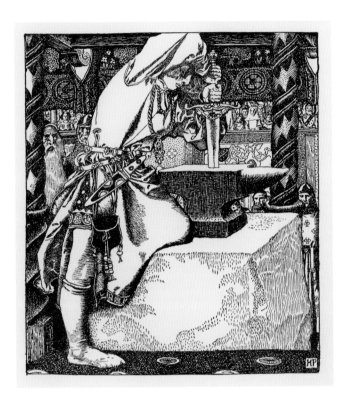

Figure 76. Howard Pyle (1853–1911). *How Arthur Drew Forth a Sword.* From Howard Pyle, *The Story of King Arthur and His Knights.* New York: Charles Scribner's Sons, 1903. Printed matter. Helen Farr Sloan Library and Archives, Delaware Art Museum

Figure 77. Dante Gabriel Rossetti (1828–1882). *The Lady of Shalott.* From Alfred, Lord Tennyson, *Poems.* London: Edward Moxon, 1857. Printed matter. Helen Farr Sloan Library and Archives, Delaware Art Museum

Pyle would have had ample exposure, both through prints and illustrations, as well as firsthand in Wilmington in the private collection of his contemporary Samuel Bancroft. A comparison of Pyle's *How Arthur Drew Forth a Sword* (1903, fig. 76) from *The Story of King Arthur* with Dante Gabriel Rossetti's *The Lady of Shalott* (1857, fig. 77) from Tennyson's *Poems* reveals a shared use of exaggerated foreshortening, with the figures pushed abruptly to the very forefront of the picture plane. The two compositions are sharply cropped, further heightening the drama of the events portrayed.

Evidence of a transatlantic exchange of medieval imagery can also be seen in illustrations by Pyle and his former Art Students League colleague Abbey, who lived as an expa-triate in England for most of his life (beginning in 1878). Medieval subjects by Pyle and Abbey echo one another in consecutive issues of *Harper's Monthly* in a style that suggests a deeply shared sensibility. In 1906 Pyle's illustrations to James Branch Cabell's "The Sestina" appeared within months of Abbey's full-color frontispiece for William Shakespeare's *Henry IV, Part I.* Abbey's illustration of King Henry IV and Prince Henry (1905, see fig. 79), also shares decorative motifs and elements of composition and color with Pyle's *Richard de Bury Tutoring Young Edward III* (1903, see fig. 78), which was distributed as an etching by William Bicknell.[16]

Classical subjects were particularly popular both in the United States and abroad during the second half of the

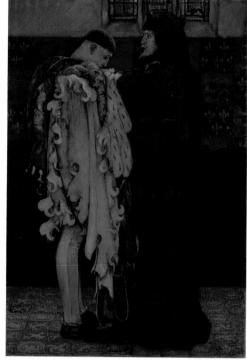

Figure 78. Howard Pyle (1853–1911). *Richard de Bury Tutoring Young Edward III*, 1903. Oil on canvas, 35¼ × 20⅛ inches. Jointly owned by the Delaware Art Museum (Louisa du Pont Copeland Memorial Fund and Gayle and Alene Hoskins Endowment Fund) and the Brandywine River Museum (By purchase), 2006.

Figure 79. Edwin Austin Abbey (1852–1911). *King Henry IV, Part I: The King to the Prince of Wales: "Thou Shalt Have Charge and Sovereign Trust Herein." (Act III, Scene ii)*, 1905. Oil on canvas, 36 × 24 inches. Yale University Art Gallery, Edwin Austin Abbey Memorial Collection

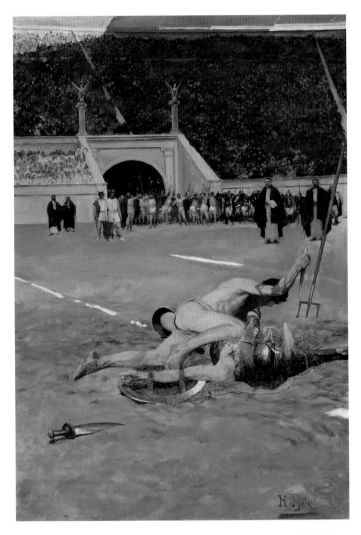

nineteenth century. In France at midcentury, a group of students of the academic painter Paul Delaroche, including Jean-Léon Gérôme, began painting archaeologically accurate scenes of daily life in the ancient world, resulting in a unique combination of history and genre painting. A decade later similar subjects were taken up by Lawrence Alma-Tadema, Frederic Leighton, Edward Poynter, and others in England. These works were quite popular when exhibited both in Europe and in the United States.[17] A significant number of classical subject paintings were purchased by American collectors, including Catharine Lorillard Wolfe and Alexander T. Stewart in New York and William Walters in Baltimore. In addition, reproductive prints were produced prolifically and became affordable to a less well-heeled clientele. Pyle would have had ample opportunity for viewing source imagery when considering illustration commissions for Henryk Sienkiewicz's *Quo Vadis* (1897), Nathaniel Hawthorne's *A Wonder Book for Girls and Boys and Tanglewood Tales* (1900), and *The Odes and Epodes of Horace* (1901), all of which required classical settings.

Pyle's *Peractum Est!* (1897, fig. 80), one of six illustrations for *Quo Vadis*, bears a distinct similarity to a painting by Gérôme entitled *Pollice Verso* (1872, fig. 81). From the time of its creation, Gérôme's image was reproduced in numerous editions by Goupil et Cie, Paris, the art dealers who purchased the painting and the right to reproduce it.[18] The firm opened a gallery at 289 Broadway in New York (Goupil, Vibert and Co.) in 1848. There fine-art reproductions and original work were offered for sale. The original painting of *Pollice Verso* was purchased in 1875 by the American

Figure 80. Howard Pyle (1853–1911). *Peractum Est!*, 1897. For Henryk Sienkiewicz, *Quo Vadis*. Boston: Little Brown and Company, 1897. Oil on canvas, 26 × 16¾ inches. Delaware Art Museum, Gift of Mrs. Richard C. du Pont, 1965

Figure 81. Jean-Léon Gérôme (1824–1904). *Pollice Verso*, 1872. Oil on canvas, 15½ × 23 inches. Phoenix Art Museum, Museum Purchase

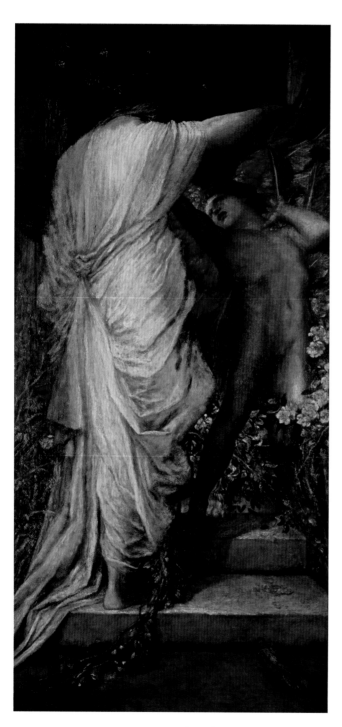

Figure 82. George Watts (1817–1904). *Love and Death*, c. 1885–87. Oil on canvas, 97½ × 46 inches. Tate Collection, Presented by the Artist, 1897

dry-goods merchant Stewart, and was displayed in the paintings gallery attached to his mansion at Thirty-fourth Street and Fifth Avenue. Pyle could have viewed the painting either at Stewart's home or at the sale of his estate held at the American Art Association in March 1887.[19]

Pyle's visual source for his interpretation of an ancient form of combat was of particularly high status. The painting was possibly Gérôme's most recognized work.[20] Thomas Eakins recalled Gérôme using *Pollice Verso* "to illustrate to me his principles of painting."[21] In addition to the shared gladiatorial subject matter, Pyle clearly made use of Gérôme's figural placement within the amphitheater and even replicated the grid of sunlight patterning the combat floor. Pyle's rendering is necessarily less crowded with detail—a simplified version of Gérôme's rendering—in order to facilitate, and not distract the reader from, the story illustrated.[22] While Pyle's role as illustrator limited the amount of extraneous information that could be included, Gérôme's work was intended to provide multifarious, authentic details for the viewing public to ponder.[23]

In the case of philosophical subjects, Pyle seems to have drawn from Symbolist developments in European painting. In a rare display of verbal enthusiasm for the work of another artist, Pyle is recorded as having told his students: "Not more than once in a century is an abstract subject treated in a way worthy of a place in good art. There are a very few such subjects in the world—among them Watts' *Love and Death*" (c. 1885–87, fig. 82).[24]

Pyle's passionate outburst occurred just a fortnight after the death in 1904 of George Frederick Watts, the English painter of portraits and allegories. Watts was widely memorialized in the press on both sides of the Atlantic. His fame in America had been secured with an exhibition of his work at the Metropolitan Museum of Art in 1884, which Pyle would surely have seen.[25] The display at the Metropolitan was so popular that Watts was approached by the museum with a request to extend the period of viewing: "The exhibition of your works in this city has been a boon not only to the citizens of New York, but to the American people at large. Thousands are daily visiting our galleries and the general

admiration your paintings have created is as genuine as it will be lasting . . . your name is today a household word in this great metropolis."[26] Watts's star continued to rise with the inclusion of his work among the English offerings at the 1893 World's Columbian Exposition in Chicago.

Before *Love and Death* was ever on view in New York and Chicago, it had already reached near iconic status in England. Watts's subject, which exists in over a dozen versions, was initially taken up by the artist in response to the premature death of a close friend. An oil sketch was exhibited as early as 1870, and the first finished composition was included in the opening exhibition of the avant-garde Grosvenor Gallery in London in 1877. There Oscar Wilde saw it, describing its "inevitable and mysterious power . . . Except on the ceiling of the Sistine Chapel in Rome, there are perhaps few paintings to compare with this in intensity of strength and in marvel of conception. It is worthy to rank with Michael Angelo's 'God dividing the Light from the Darkness.'"[27] From the Grosvenor the painting traveled to the Exposition Universelle held in Paris the following year, where it was similarly singled out for review by critics.

The American press had certainly caught on by the time of the 1883 retrospective of Watts's work, also at the Grosvenor, as is made clear in the following passage:

> If Mr. Matthew Arnold is right in claiming for
> Wordsworth the first place among English poets by
> virtue of the purity and dignity of his moral ideas, we
> may surely award to Mr. Watts a somewhat similar
> praise. If Mr. Ruskin is right in demanding that Art
> shall be conscious of its moral power, and that a paint-
> ing shall be finally judged by the poetical and moral
> grandeur of the truths that it conveys, then surely we
> may find in Mr. Watts's work one at least of the essen-
> tial conditions of all that is noble and valuable in art.[28]

It is not surprising then that Pyle should be familiar with and attach such high praise to this particular image. And yet his reinterpretation of Watts is subtler than simple compositional borrowing: it is Watts's distinctive stylistic approach

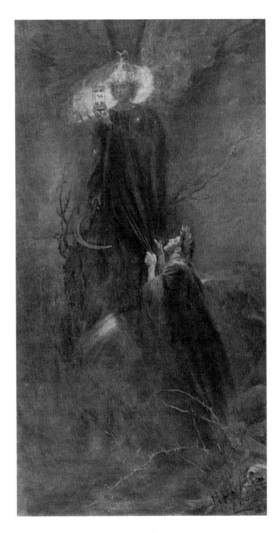

Figure 83. Howard Pyle (1853–1911). *Question*, 1895. From William Dean Howells, *Stops of Various Quills*. New York: Harper and Brothers, 1895. Printed matter. Helen Farr Sloan Library and Archives, Delaware Art Museum

that Pyle seems to have mimicked when composing idealized or philosophical subjects, as in his illustrations made for the poems of his friend and correspondent William Dean Howells. Images such as *Question* (1895, fig. 83), accompanying Howells's meditation on the coming of death, "Monochromes" (1895), show a looseness of handling, visible even in reproduction, that is akin to Watts's application of paint in

such canvases as *Love and Death*. Pyle described his *Question* in a letter to Henry Mills Alden, editor of *Harper's Monthly*:

> I think I myself have felt just such experiences as the Poem describes and I have tried to embody in the painting pictorially what I felt psychologically. I do not know whether I have at all succeeded in expressing to the outside world what I meant but I warmed myself up very much by my own fire. I have tried to represent what I felt, in the figure holding to the skirts of Death. And that is what I have tried to embody in the thorny fields and the rocks and the purple gloom and the sky smeared with blood and even the moon of ones [*sic*] acquired intelligences eclipsed almost to nothingness.[29]

The subject of the painting and Howells's poem clearly struck a personal note with Pyle, who had experienced the death of his seven-year-old son, Sellers, in 1889. Pyle's visual response to the poem—"painting pictorially" what it evoked "psychologically"—is closely aligned with the critical understanding of Watts's canvas as the "poetical and moral grandeur of the truths that it conveys," as stated by the reviewer cited above.

It is notable that when confronted with the shared subject matter of human mortality, Pyle turned for inspiration to an artist who was widely published and exhibited in the United States.[30] And yet even some of Watts's most supportive critics found fault with his execution, the very aspect of Watts's work that Pyle chose to mimic. *Love and Death* was described, for example, as "neither well drawn nor beautiful in color," the kind of criticism that prompted Watts to defend his approach with the explanation: "My intention has not been so much to paint pictures that charm the eye as to suggest great thoughts that will appeal to the imagination and the heart, and kindle all that is best and noblest in humanity."[31] This plea for humanity over visual pleasure is echoed in Pyle's instruction to his students: "The real painter paints for Humanity—not for technique or to please his fellow artists."[32]

First published in *Harper's Monthly* in March 1893, the poem "Monochromes" later appeared in a collection of Howells's work entitled *Stops of Various Quills* (Harper and Brothers, 1895). In this anthology illustrated by Pyle, monochromatic paintings in the style of Watts are accompanied by numerous decorative head- and tailpieces in ink, which Pyle clearly derived from the art of Aubrey Beardsley, Ferdnand Khnopff, Simeon Solomon, and others frequently associated with Symbolism. Pyle drew from the visual material that served his subject best. In the case of the abstract concepts projected by Howells, Pyle ignored narrative models such as Gérôme's paintings, favoring instead similarly abstruse renderings such as those of Watts or the continental Symbolist painters.

Accompanying the greater subtlety in Pyle's pictorial sourcing was a new note of personal ambition: he wanted to recategorize illustration as a recognized branch of the fine arts. Pyle's claim for illustration as "the rarest and the most difficult of all the Arts" was set forth in an essay published in 1902 in which he concluded: "The only distinctly American Art is to be found in the Art of Illustration."[33] This last hints at his growing disillusionment with the state of fine arts in the United States.[34]

The one American artist whose accomplishments never seemed to dim in Pyle's estimation, however, was Winslow Homer. Although it is unclear whether Pyle was actually personally acquainted with Homer, the older artist was still based in New York during Pyle's three-year tenure there in 1876–79.[35] Certainly they inhabited the same social circle, sharing acquaintances including Abbey and, later, membership in the Century Club. Homer was among the artists most admired by Pyle, who championed his work as "a sufficient rebuttal of the dictum that our country lacks in the picturesque."[36] Homer was one of a few artists who had transitioned successfully from illustration to fine art, with much of his success based on his ability to transfer the best of his talent in illustration to narrative painting.

Homer's *The Life Line* (1884, fig. 84), exhibited at the National Academy of Design in 1884, seems to have been a key source for Pyle's much later illustration *He Lost His Hold*

Figure 84. Winslow Homer (1836–1910). *The Life Line*, 1884. Oil on canvas, 28⅝ × 44¾ inches. Philadelphia Museum of Art, The George W. Elkins Collection, 1924

and Fell, Taking Me with Him (1909, see fig. 85), made for Morgan Robertson's story "The Grain Ship," published in *Harper's Monthly*.[37] Homer's painting was one of the first sea subjects he exhibited after spending time abroad in England. Considered a turning point in his career, the canvas was lauded in the press and described in the *Independent*, for example, as "the most popular subject in the Exhibition" and "one of the best pictures."[38] *The Life Line* was bought from the exhibition by Wolfe and was the first American painting to enter her collection, previously consisting entirely of European objects. Even if the painting somehow managed to slip Pyle's notice at this juncture, he would have had ample opportunity to see it in the ensuing years, either when exhibited in New York or later in Philadelphia, for it was acquired in 1899

by the Philadelphia collector George W. Elkins, in whose holdings it remained until given to the Philadelphia Museum of Art in 1924.

The subject was also circulated through two etched versions made by Homer.[39] The first etching, made almost immediately after the painting and published in 1884, is very similar to the original composition. In this print the amount of skyline visible at the top of the composition has been diminished, and very few indications of the ship at left or the land at right remain.[40] The second version was published in 1889, with the new title of *Saved*. This rendering differs quite significantly from both the painting and the earlier print: the composition is reversed and the accompanying narrative detail is further reduced, leaving the figures encapsulated in

a whiteout of frothing wave. The rocks looming at left seem to diminish any chance of a successful rescue and escalate the image's level of drama.

While Pyle's illustration did not appear in print until 1909, he may also have been inspired by a loan exhibition of Homer's work featured at the *Twelfth Annual Exhibition* of the Carnegie Institute, Pittsburgh, in the previous year (although *The Life Line* does not appear to have been included). The showing of Homer's art received laudatory reviews, several of which positioned the artist as "the greatest living American painter."[41]

Pyle's interest in Homer's *The Life Line* and the etchings derived from it was undoubtedly piqued by his fascination with shipwrecks and the early days of the United States Life-Saving Service. He first explored this interest visually in *Wreck in the Offing!*, a double-page illustration that accompanied an editorial on recent failings in the lifesaving system and proposals for improvement. But the later illustration *He Lost His Hold and Fell, Taking Me with Him* does not address the heroism (or failings) of a coastal lifeguard. Instead it depicts a death struggle between two sailors who are hanging off the bowsprit of a cargo ship off the coast of South America.

While the storylines and characters are not identical, the compositional similarities are remarkable. As Homer did, Pyle chose to isolate his two dangling figures within a background of rolling sea, the skyline sharply delineated at the top edge of the composition. In both, the details are spare, providing only the barest essentials of narrative. Body language—the flailing legs, torsos bent backward—plays a significant role in conveying the desperation of the epic struggle between man and nature. Pyle even replicates (in reverse) Homer's placement of one figure's arm across the chest of the other. Pyle's choice to quote Homer at the most

lauded moment of his career could not have been serendipitous. These were the years that Pyle too was making a claim for illustration. What better way to subtly make his point than to reference a work deemed by the *New York Herald* "a masterpiece" of American art.[42]

As Pyle's illustration career progressed and he chose not to join his colleagues in transitioning to the realm of the fine arts, his views on the relative merit of academically trained artists were voiced more authoritatively.[43] In a lecture given before the Society of Arts and Crafts in Boston in 1902, Pyle defined what he felt to be the primary failing of American art: its inability to express a national individuality. He wrote, "The American picture is generally an exponent of the failure of trying to express a native thought in a foreign model."[44] While he understood the need and the benefit of studying European sources, he cautioned: "Those methods should be studied, not for themselves, but because they are the means by which ends have been achieved."[45] This was exactly what Pyle practiced in his own work, as has been detailed above. He studied and observed both old masters and contemporary art, mining it for the compositional, stylistic, and philosophical elements that might best suit his work at hand. With this information, he produced thoroughly original, entirely American works of art. This is perhaps the key to their lasting popularity. Pyle concluded his Boston talk with: "The great pictures *stimulate* a true artist to renewed effort but they do not *inspire* that effort."[46]

Opposite: Figure 85. Howard Pyle (1853–1911). *He Lost His Hold and Fell, Taking Me with Him*. For Morgan Robertson, "The Grain Ship." *Harper's Monthly Magazine*, March 1909. Oil on canvas, 27½ × 17⅞ inches. Delaware Art Museum, Museum Purchase, 1912

NOTES

My research on this topic has been greatly facilitated by suggestions and contributions from Heather Campbell Coyle, Paul Preston Davis, and Ian Schoenherr, to all of whom I am deeply grateful. The epigraph comes from the *New York Times, Saturday Review of Books and Art*, June 27, 1903, BR8.

1 Howard Pyle, "Note on the Illustrations," in Henry Wadsworth Longfellow, *Evangeline: A Tale of Acadie*, illustrated by Violet Oakley and Jessie Willcox Smith (Boston: Houghton, Mifflin and Company, 1897), xiv.

2 "Our Illustrated Magazines," *New York Times*, Aug. 12, 1899.

3 Howard Pyle's patronage of Shintaro Morimoto's Boston emporium, Yamanaka and Company, importers of fine objects from Japan, is revealed in extant receipts that document books he purchased on Hokusai and Japanese wood engravings in 1909. Howard Pyle Collection, Harry Ransom Center, University of Texas at Austin. In addition, repeated references to Japanese art appear throughout Pyle's correspondence.

4 Editors of art periodicals made a point of educating readers to improve their tastes in contemporary art. See Hartley S. Spatt, "The Aesthetics of Editorship: Creating Taste in the Victorian Art World," in Joel H. Wiener, ed., *Innovators and Preachers: The Role of the Editor in Victorian England* (Westport, Conn.: Greenwood Press, 1984), 43–59.

5 On changes in printing technologies, see Estelle Jussim, *Visual Communication and the Graphic Arts: Photographic Technologies in the Nineteenth Century* (New York: R. R. Bowker Co., 1974).

6 Howard Pyle, "When I Was a Little Boy: An Autobiographical Sketch," *Woman's Home Companion* 39, no. 4 (Apr. 1912): 5.

7 Cecilia Beaux, *Background with Figures: Autobiography of Cecilia Beaux* (Boston: Houghton Mifflin Company, 1930), 64–65.

8 Ian Schoenherr suggests this group of drawings was made in the late 1870s, when Pyle was a student in New York. Schoenherr, comment on "Pyle Study," Nov. 19, 2008, Gurney Jurney, http://gurneyjourney.blogspot.com/2008/11/pyle-study.html.

9 The influence of the English illustrators of the 1860s, including the Pre-Raphaelites, has been well documented. See Henry C. Pitz, *Howard Pyle: Writer, Illustrator, Founder of the Brandywine School* (New York: Clarkson N. Potter, 1975), 8. Pyle wrote of how much he valued his copy of Anthony Trollope's *Orley Farm* (1862), describing its "wonderful illustrations" by John Everett Millais. Pyle to [Thomas?] Nast, July 3, 1892, Thornton Oakley Collection of Howard Pyle and His Students, Rare Book Department, Central Library, Free Library of Philadelphia.

10 Millais's illustration appeared in the infamous "Moxon Tennyson" (Alfred, Lord Tennyson, *Poems* [London: Edward Moxon, 1857]), which was subsequently issued in a transatlantic edition (London: Routledge, Warne and Routledge, 1864).

11 Pyle's illustrations were titled *"Ah Me!" Said the Parson, "I Wish I Were Young!"* and *Alas! He Had Turned to a Terrible Boy!* They accompanied his story "The Magic Pill," *Scribner's Monthly* 12, no. 446 (July 1876): 446.

12 William C. Brownell, "The Art Schools of New York," *Scribner's Monthly* 16, no. 6 (Oct. 1878): 776.

13 Ibid., 777. Elizabeth Hawkes has explained Pyle's debt to Albrecht Dürer, among others, citing specific borrowings in the illustrations for Pyle's book *Otto of the Silver Hand* (New York: Charles Scribner's Sons, 1888). Hawkes, "Drawn in Ink: Book Illustrations by Howard Pyle," in Gerald W. R. Ward, ed., *The American Illustrated Book in the Nineteenth Century* (Winterthur, Del.: Henry Francis du Pont Winterthur Museum, 1982), 206–07.

14 For a detailed account of Pyle's debt to Crane, see Frederic Daniel Weinstein, "Walter Crane and the American Book Arts, 1880–1915," PhD diss., Columbia University, New York, 1971, 189–93.

15 See, for instance, Crane's preparatory drawings for *The Sleeping Beauty* (1876) in the collection of the Kelvingrove Art Gallery and Museum, Glasgow. Reproduced in Greg Smith and Sarah Hyde, *Walter Crane, 1845–1915: Artist, Designer, and Socialist* (London: Lund Humphries in association with Whitworth Art Gallery, University of Manchester, 1989), 76.

16 William Bicknell's etching of Pyle's *Richard de Bury Tutoring Young Edward III* was given out to members of the Bibliophile Society of Boston. While Abbey was not a member, he had strong connections to Boston and painted murals for the Boston Public Library between 1890 and 1901.

17 Lawrence Alma-Tadema had several works included in the British section of the World's Columbian Exposition in Chicago in 1893. Works by Edward Poynter were on view at the Centennial Exhibition held in Philadelphia in 1876.

18 Goupil et Cie published the reproduction of *Pollice Verso* in four sizes, first in "photographic form" in 1873–75 and then as a photogravure. Régine Bigorne, "Visions of Antiquity," in Musée Goupil, Bordeaux, *Gérôme and Goupil: Art and Enterprise* (Paris: Éditions de la Réunion des Musées Nationaux, 2000), 105. The painting was also reproduced as a double-page spread in the *Illustrated London News*, Apr. 11, 1874.

19 Alexander T. Stewart seems to have been generous in admitting interested parties to view his collection. Thomas Eakins mentioned his desire to see this painting in particular and proposed writing the collector for permission in Eakins to Earl Shinn, Jan. 30, 1875, quoted in Gerald M. Ackerman, "Thomas Eakins and His Parisian Masters Gérôme and Bonnat," *Gazette des Beaux-Arts*, series 6, 73 (Apr. 1969): 241–42. From Cadbury Collection, Swarthmore College Library.

20 Gerald M. Ackerman, *The Life and Work of Jean-Léon Gérôme with a Catalogue Raisonné* (London: Sotheby's Publications, 1986), 232, cat. no. 219.

21 Ackerman, "Thomas Eakins," 242.

22 As James Gurney explains in his essay in this volume, Pyle taught his students the importance of eliminating extraneous details in their illustrations.

23 Jean-Léon Gérôme's painting set off a widespread debate regarding the correct translation of the Latin phrase with which it is titled. See Ackerman, *Life and Work of Jean-Léon Gérôme*, 94.

24 Pyle quoted in Ethel Pennewill Brown and Olive Rush, "Notes from Howard Pyle's Monday Night Lectures, 1904–1906," July 11, 1904, 12, Howard Pyle Manuscript Collection, box 3, folder 2, Helen Farr Sloan Library and Archives, Delaware Art Museum.

25 Pyle was back and forth to New York for various commissions and could easily have viewed the exhibition at the Metropolitan Museum of Art. Certainly, fellow Wilmingtonian Samuel Bancroft, from whom Pyle's students

rented studios, was aware of and had visited the retrospective, as he owned a copy of the catalogue. This particular copy of the catalogue is now in the Samuel and Mary R. Bancroft Pre-Raphaelite Manuscript Collection, Helen Farr Sloan Library and Archives, Delaware Art Museum.

26 T. Johnson and L. P. de Cesnola to George Frederick Watts, Feb. 13, 1885, quoted in Veronica Franklin Gould, *G. F. Watts: The Last Great Victorian* (New Haven: Yale University Press, 2004), 186. The American response to Watts's work was so positive that Watts was encouraged to and did in fact give *Love and Life*, the companion piece to *Love and Death*, to the nation.

27 Oscar Wilde quoted in Gould, *G. F. Watts*, 135, from *Dublin University Magazine* (1877): 119.

28 G. W. Prothero, "Mr. Watts at the Grosvenor Gallery," *The Century Magazine* 26, no. 4 (Aug. 1883): 559.

29 Pyle to Henry Mills Alden, Aug. 28, 1891, *Harper's Magazine* Autograph Letter Collection, 1851–1895, microfilm reel N710, Archives of American Art, Smithsonian Institution, Washington, D.C.

30 In addition to the various exhibitions in which it was shown, *Love and Death* was included as plate 9 in a sixty-three-plate portfolio issued by the Century Gallery of prints after "famous examples of the Italian, Dutch, French, Spanish, English, and American schools of painting and illustrating." *Love and Death* was reproduced in this portfolio as an engraving by Timothy Cole. The portfolio was advertised in *Outlook* (Jan. 19, 1895): 51. The painting was also photographed and the resulting photographic prints sold by Frederick Hollyer: *Catalogue of Platinotype Reproductions of Pictures, Etc. by Mr. Hollyer, of London, England* (London, 1896), 14.

31 Watts quoted in John C. Van Dyke, "The Story of Watts' 'Love and Death,'" *Ladies' Home Journal* 21, no. 12 (Nov. 1904): 26.

32 Pyle quoted in Richard Wayne Lykes, "Howard Pyle, Teacher of Illustration," *The Pennsylvania Magazine of History and Biography* 80, no. 3 (July 1956): 363. From Notebook Containing Miscellaneous Thoughts and Observations, 1904–1908, Allen Tupper True and True Family Papers, 1841–1987, microfilm reel 4895, Archives of American Art, Smithsonian Institution, Washington, D.C.

33 Howard Pyle, "Concerning the Art of Illustration," in *First Year Book* (Boston: Bibliophile Society, 1902), 18, 21.

34 Pyle's views are expressed in, for example, Howard Pyle, "The Present Aspect of American Art from the Point of View of an Illustrator," *Handicraft* 1, no. 6 (Sept. 1902): 125–42. This statement was originally a paper read before the Society of Arts and Crafts, Boston.

35 Pitz suggests Pyle and Homer were friends in Pitz, *Howard Pyle*, 188. Pyle did write a letter to Homer in 1905, according to a letter Pyle wrote to William Macbeth in 1905. He was tracking down a few of Homer's pictures, so he could have slides made: "I may say that I have Mr. Homer's permission to photograph the pictures, but he himself writes that he does not know where they are at present located." Pyle to William Macbeth, Oct. 10, 1905, Macbeth Gallery Records, Archives of American Art, Smithsonian Institution, Washington, D.C.

36 Howard Pyle, "A Small School of Art," *Harper's Weekly* 41, no. 2,117 (July 17, 1897): 710.

37 Homer's painting may also have been the source for Pyle's *He Looked Down and Sang Out, "Lower Away!,"* which was painted in 1899 and published in Howard Pyle, "A Life for a Life," *Scribner's Magazine* 27, no. 1 (Jan. 1900): 75.

38 "Fine Arts: The National Academy Exhibition: Genre Subjects," *The Independent* 36, no. 1,848 (May 1, 1884): 7.

39 In addition to possibly seeing the painting in Catharine Lorillard Wolfe's private gallery, Pyle could also have viewed it in New York on public display at the *Fifty-ninth Annual Exhibition of the National Academy of Design* in 1884, at the Manhattan Club in 1896, at the Union League in 1898, or at the two-day sale of Thomas B. Clarke's collection held at the American Art Association in February 1899. Nikolai Cikovsky, Jr., and Franklin Kelly, *Winslow Homer* (Washington, D.C.: National Gallery of Art, 1995): 223–25.

40 This etched version was published much later, accompanying the article Gustav Kobbé, "Heroes of the Life-Saving Service," *The Century Magazine* 55, no. 6 (Apr. 1898): 924.

41 For example, "A Great Painter of the Ocean," *Current Literature* 45, no. 1 (July 1908): 54.

42 "Fine Arts: Fifty-ninth Annual Exhibition of the National Academy of Design: The First View," *New York Herald*, Apr. 5, 1884.

43 At the very end of his life Pyle did turn his pictorial focus toward mural painting, and, very occasionally, he painted stand-alone paintings, most of which were gifts and fewer of which were commissions.

44 Pyle, "Present Aspect of American Art," 129.

45 Ibid., 136.

46 Ibid., 137.

Mary F. Holahan

6. "THE BITTER DELIGHT": HOWARD PYLE AND THE SWEDENBORGIAN FAITH

*The great problems of life and death have always largely
occupied my thoughts from my youngest childhood. Even in
my infancy, the fear of death and annihilation hung above me
like a cloud . . . Whatever change of views I may since have
arrived at, I have had to reach by myself, by my own reason,
and without such outside assistance—excepting such as I
could obtain from the writings of Swedenborg.*

—HOWARD PYLE

To anyone familiar with Howard Pyle's repu-
tation as a convivial mentor to many students, a sympa-
thetic correspondent, and an engaged colleague of artists
and authors, the tone of this declaration seems jarring,
more extreme than an expression of romantic melancholy.
Although commentators have long recognized a mystical
element in some of Pyle's work, his admission—and the
image of a lifelong black cloud—speaks more of deep per-
sonal struggle than a leaning toward the esoteric.

Pyle's remark appeared in a commentary about his book
Rejected of Men: A Story of Today (1903), published by Harper
and Brothers after his eight years' labor over its unillustrated
text and refusals by several other publishers. *Rejected of Men*
is a story of how Christ, if he reappeared in contemporary
times, would be shunned by the modern version of Phari-
sees. The commentary's author, James MacArthur, defers to
Pyle's noble intentions without unduly praising the book.
Anticipating this response, Pyle stated only the resolute, if
rather dispirited, satisfaction of having "said my say."[1] He did
not elaborate on what "assistance" Emanuel Swedenborg's
writings had given him throughout his life.

That the redeeming lens of Swedenborg had been his
guide, if apparently a hard-earned and fragmentary one,
about "the great problems of life and death" is not surpris-
ing, given Pyle's upbringing in the Swedenborgian faith, his
commitment to his Swedenborgian church in Wilmington
in Delaware, his ongoing reading of Swedenborg's writings,
and his love of talking about "such things" with his main cor-
respondent on the matter, William Dean Howells, who also
came from a Swedenborgian background.[2] Letters between
Pyle and Howells, exchanged regularly between 1890 and
1895, reveal Pyle's continual attempt to master Swedenborg's
complex Christian religious philosophy. Pyle's spiritual quest

involved casting about for answers, prodding his own beliefs as well as Swedenborg's, reversing himself, ranging freely from certainty to doubt, and rejoicing at enlightenment. This path conforms to the Swedenborgian philosophy still expressed by Pyle's own church (now the Church of the Holy City) in Wilmington: "Questioning is part of our spiritual journey."[3] Pyle's illustrations for Howells's book of poems *Stops of Various Quills* (1895) reinforce the illustrator's and the author's common pursuit of spiritual enlightenment.

A more implicit expression of Pyle's Swedenborgian beliefs resonates in the text and illustrations for *The Garden behind the Moon: A Real Story of the Moon-Angel* (1895), written six years after Pyle experienced "the bitter delight of a keen and poignant agony": the death of his six-year-old son, Sellers.[4] The spiritual duality of mourning and faith inspired this tale of a child's journey to a magical kingdom.

THE SWEDENBORGIAN FAITH IN
LATE NINETEENTH-CENTURY AMERICA

Emanuel Swedenborg, a member of the Swedish nobility and the son of a Lutheran bishop, was an eminent and versatile scientist, his publications ranging from physics to mineralogy to engineering, as well as to physiology and the relationship of the mind to the body. Beginning in 1743 Swedenborg had visionary experiences that allowed him to "see into the other world, and in a state of perfect wakefulness converse with the angels and spirits."[5] After this spiritual awakening, he devoted much of the rest of his life to writing books of theology and moral philosophy.

Although Swedenborg envisioned a new Christianity, he did not found a church. But shortly after his death in London, adherents published translations of his works and gathered for meetings, in a process that in 1787 resulted in the establishment of the Church of the New Jerusalem, also called the New Church. By the mid-1820s American Swedenborgian believers had brought the faith to Wilmington in the form of informal, probably home-based, groups. In 1858 the members of the newly built Swedenborgian church included Pyle's mother. Pyle's parents had been Quakers, and they kept their affiliation with both groups until they were

disowned by the Quakers, when Howard Pyle was seven years old.[6]

Any overview of Swedenborg's complex theology invites oversimplification, but several of his ideas echo in Pyle's letters and illustrations.[7] In his interpretation of the Hebrew and Christian scriptures, Swedenborg asserted that the words of the Bible are symbolic, with deeply layered meanings often obscured by the literal sense of the text. To unveil the meaning of scripture, he revived the ancient concept of correspondences, a worldview traditionally distilled as "as above, so below." That is, all physical objects correspond to a spiritual equivalent, and truths about the divine reside in all natural things. This point of view, that the physical world is symbolic of the spiritual, posited an unbroken link between the material and spiritual worlds.

Swedenborg emphasized love—God's love for us and our love for our fellow human beings—as a central element of reality. Doing good, by responding to the needs and feelings of others, fosters our spiritual growth. Each individual has a core of divinity that is perfected throughout a person's spiritual journey. He affirmed human freedom of will, emphasizing that we must actively choose to cooperate with God's love and to do good, although good actions should not be motivated by self-centered hope of reward. Evil exists to preserve human freedom, and to do evil is to oppose God's flowing into the human soul. During our earthly lives, we are surrounded by both angels and devils, each desiring to influence us for good or evil. It is our responsibility to put our faith into practice in our daily lives.

Swedenborg believed that people are spirits living within material bodies. As literature from the Church of the Holy City explains, at death, "the material body is put aside and we continue living in the spiritual world in our inner, spiritual body, according to the kind of life we have chosen while on earth."[8] After death, souls enter a transitional state, a state "corresponding" in all appearance and experience to the material world, where they are instructed and prepared by angels for their final states, heaven or hell, which they choose by continuing to accept or reject divine love. In this way final judgment becomes a realization of an individual's

choices rather than a divine decree. Angels, who themselves are constantly being perfected in the spiritual world, have lived as human beings on earth.

Despite his reticence in explaining his Swedenborgian faith, Pyle could have expected many educated readers of *Harper's Weekly*—the self-described "journal of civilization"—to have at least a nodding acquaintance with Swedenborg. But their familiarity would likely have come not from Swedenborgianism as a religious denomination but as one stream in a flow of mystical thinking present in nineteenth-century American culture.

In 1850 Ralph Waldo Emerson introduced Swedenborg to broad American intellectual circles in his series of essays *Representative Men*, establishing his subject's identity with the succinct title: "Swedenborg; or, The Mystic." For Emerson, and for many American writers such as Henry James, Sr., and Walt Whitman, who were sympathetic to Swedenborgianism but not to organized religion, "Swedenborg's great strength lay in his powers of introspection, which revived consciousness of subjective experience."[9] This emphasis on personal interpretation, individualism, and recognition of the interpenetration of nature and spirit calls to mind essential elements not just of Emerson's Transcendentalism but also of Romanticism and Symbolism. Beginning in the mid-nineteenth century a number of American visual artists were identified with Swedenborgian thinking, but—like their literary counterparts—did not join the church.[10] An exception was the painter George Inness, who converted to the faith in the 1860s.[11]

THE PYLE-HOWELLS LETTERS AND
PYLE'S ILLUSTRATIONS FOR HOWELLS'S
STOPS OF VARIOUS QUILLS

The novelist, poet, editor, critic, and social activist Howells was the son of a Swedenborgian father, who had edited a Swedenborgian newspaper in Ohio during Howells's youth.[12] After his daughter's death in 1889, Howells's grief led him to revisit religious belief, to read Swedenborg again, and to attend services of various denominations. In 1890, shortly after Pyle and Howells met at Harper's, Pyle wrote and gave

his reaction to Howells's novel *The Shadow of a Dream* (1890), an exploration of the psychological and ethical motives among members of a romantic triangle.

The protagonist should have let love triumph, Pyle tells Howells, unimpeded by the chaos of the perceived moral proscriptions that resulted in tragedy. Doing the right thing only for the sake of self-denial is selfish. Pyle advises Howells that the characters who were attracted to each other would have been better off acknowledging and living by their mutual love.[13] Pyle's remarks capture two Swedenborgian ideas: the primacy of love in human relationships and the rejection of virtue merely for its own sake.

Howells's brief reply is a statement of his feelings of doubt and powerlessness rather than a vigorous defense of his fictional characters. He strives to reach above the "earthly plane" for faith and certainty, but is obsessed with suffering, eliciting Pyle's concession that human suffering is the price of spiritual enlightenment (which conforms to the Swedenborgian view of life as a spiritual journey).[14] He encourages Howells not to cling "to the earthly plane" but to aspire to the higher realm. Perhaps to sympathize with Howells, he ends with an admission of his own uncertainties.[15] These exchanges reflect the prevailing tenor of the correspondence: Pyle's reliance on Swedenborg for a fundamentally optimistic worldview, sometimes tempered, probably in deference to Howells; and Howells's frequent expression of the skepticism that characterized this period of his life, sometimes enlivened by his agreement with Pyle.

Another conversation centers on dreams. Pyle addresses Howells's report of dreams with his own mistrust of dreams as a sort of pale imitation of the nonmaterial world. Better, Pyle says, to aim for glimpses of the higher sphere.[16] Howells grants him this point, while characteristically chastising himself in regarding his dreams as punishment "for my unbelief."[17] The topic brings out Pyle's willingness to diverge from Swedenborg's ideas, since Swedenborg recorded interpretations of his own dreams, thinking them worthy of rational analysis. But Pyle further refines his position by noting that "even Swedenborg" was deceived by dreams.[18] Pyle then was not merely a passive receiver of Swedenborg's ideas. He

discusses or alludes to them as points of exploration rather than as dogma.[19] This is further confirmed when Pyle challenges Swedenborg, suggesting to Howells that Swedenborg's *Heaven and Hell* (1758) is "a stumbling block," a point of view he later softens. Sensing that Howells might benefit from another text, Pyle relates that when he read Swedenborg's *Divine Love and Wisdom* (1763), "truths came until a real glow of light began to grow before me." And if Howells would only read Swedenborg's *Arcana Coelestia* (1749–56), Pyle is certain that he would find his "doubts removed."[20] Pyle's eagerness to probe the spiritual makes him alternately Howells's fellow doubter and an advocate for Swedenborg.

The confluence of rational and mystical thinking, an integral part of Swedenborg's thought, interests both men. Pyle mocks astronomers who use spectrum analysis to understand the sun, but miss the "tremor of its beating pulse."[21] Howells agrees and in the same vein asks if Pyle has read William James's *The Principles of Psychology* (1890), because of his "Swedenborgian origin" (James was the son of a Swedenborgian father) and because he is one of the "scientific men who do not seem to snub one's poor humble hopes of a hereafter."[22] Pyle confirms his own belief that intellect and spiritual awareness are inextricably linked: "Reasoning cannot teach a man to walk but it is the lantern light that God has vouchsafed us in the night and by it we may direct our steps (carefully and guardedly) until the brightness of a larger day shows us the highroad with a greater clearness."[23]

Accepting Swedenborg's conviction that science and intuition are not irreconcilable, both men wanted to investigate the soul's life after death. In appreciating Pyle's story "To the Soil of the Earth!," which takes place partly in the afterlife, Howells tells Pyle that "I have had it in mind myself to write a story of the future life . . . using Swedenborg as my *entourage*."[24] Two decades later Pyle would reveal an even more ambitious goal to John Ferguson Weir: "I have . . . begun a series of small essays which I have been writing upon for a great many years . . . intended to prove the fact of a life after death, the arguments being based upon scientific facts."[25]

Over the course of their correspondence Pyle asked Howells to read two of his stories. The first was "In Tenebras:

A Parable" (1894).[26] Its Latin title meaning "into darkness," the story tells of two townsmen: one lives a life of traditional good works, and the other, beset by problems beyond his control, causes pain to everyone he encounters.[27] After their entry into the afterlife—described as a Swedenborgian correspondence to life on earth and set in states of spiritual perfection—the conventional hero, devoid of humility, is so enraged that his townsman, aware of his own unworthiness, is ascending to a higher state, that he ultimately chooses his own hell of anger and bitterness. The supposedly virtuous man is thrown (or, in Swedenborgian terms, throws himself) *in tenebras*, recalling the biblical unfaithful servant who has wasted his life on earth and is cast into darkness. The story echoes Pyle's Swedenborgian reference in his second letter to Howells, suggesting that "self-denial and virtue and goodness"—practiced only for their own sake—are meaningless.[28] Howells recognized the story's Swedenborgian "conjecture of the life hereafter," and praised the work as "a romance which . . . will vividly impress every reader."[29] Predictably, he concludes his praise with his own recurring doubts about an afterlife, but admits that he still senses the presence of the spiritual. "In Tenebras" addresses a moral problem that may have preoccupied Pyle: how does a person like himself—hard-working and generous in others' eyes—constantly and consciously progress toward true perfection on the spiritual level?

The second story, another exploration of Swedenborgian ideas about the soul's afterlife, was "To the Soil of the Earth!" (1892), the tale of Daihas, a boy who dies in infancy and is received by angels into the paradise of those with no knowledge of evil. In accord with Swedenborg's belief that after death children's souls continue to grow to young adulthood, Daihas grows up to recognize that his endless joy is lifeless, and that true joy involves "looking toward fulfilment from a plane of unfulfilment."[30] He is now merely a shell, and to develop spiritually he must undergo trials and overcome temptations, experiences that ultimately lead him to (the soil of the) earth, where his soul can continue toward perfection. Throughout his spiritual journey Daihas is accompanied by a loving female counterpart named Aiha, reinforcing

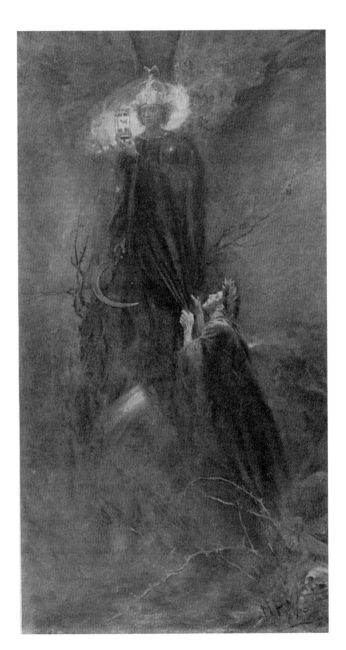

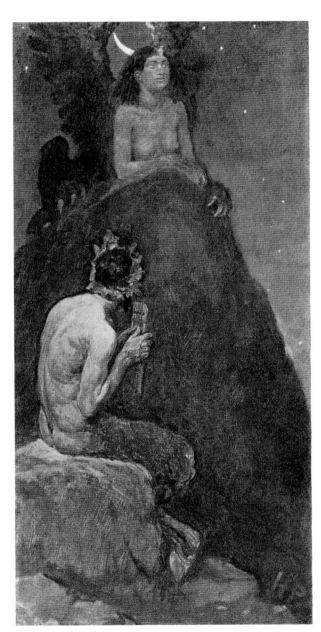

Figure 86. Howard Pyle (1853–1911). *Question*, 1895. From William Dean Howells, *Stops of Various Quills*. New York: Harper and Brothers, 1895. Printed matter. Helen Farr Sloan Library and Archives, Delaware Art Museum

Figure 87. Howard Pyle (1853–1911). *Sphinx*, 1895. From William Dean Howells, *Stops of Various Quills*. New York: Harper and Brothers, 1895. Printed matter. Helen Farr Sloan Library and Archives, Delaware Art Museum

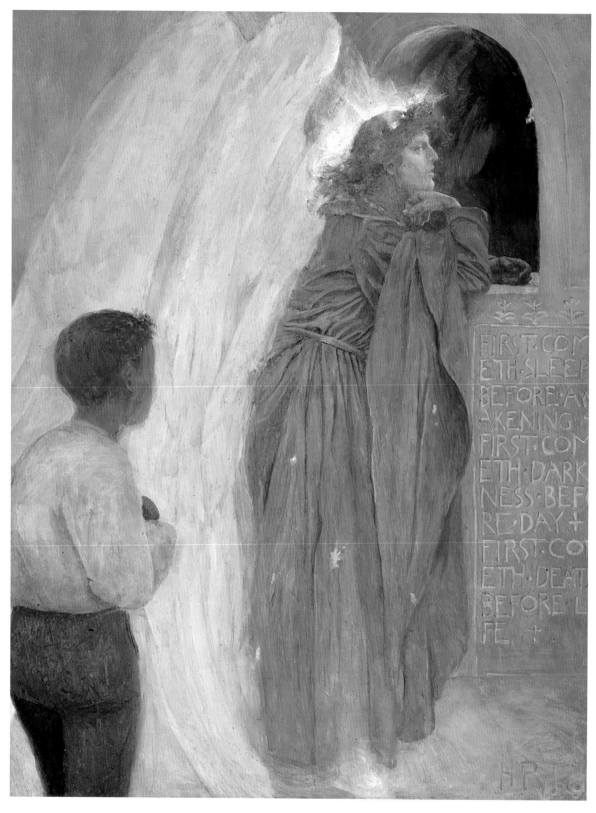

Figure 88. Howard Pyle (1853–1911). *He Was Standing at an Open Window.*
For Howard Pyle, *The Garden behind the Moon: A Real Story of the Moon-Angel.* New York: Charles Scribner's Sons, 1895. Oil on board, 12⅗₁₆ × 9⅝₁₆ inches. Delaware Art Museum, Museum Purchase, 1915

the Swedenborgian ideas of the complementarity of men and women and the existence of marriage after death. The story's interweaving of planes of earthly and heavenly reality, which crystallizes Pyle's observation in a letter that it is "impossible . . . to live . . . entirely divorced from anything evil or from anything painful," foreshadows *The Garden behind the Moon: A Real Story of the Moon-Angel*, a tale of a child who returns to earthly life changed by a supernatural experience.[31] "To the Soil of the Earth!," Howells said, "has been with me . . . like a vivid experience."[32]

In May 1891 Pyle persuaded Howells to let him illustrate a group of nine poems to be published in 1893 as "Monochromes," in *Harper's Monthly*. These were the first of many illustrations for Howells's poems that would be republished in book form in 1895 as *Stops of Various Quills*.[33] Howells's often-epigrammatic poems reflecting emotional states, particularly doubt and despair, appeared in *Harper's Monthly* from 1893 through 1895.

For Howells's poem "Question" (1895, see fig. 86), Pyle portrayed a desperate figure in an anguished appeal to know when Death will strike. He depicted a related theme with an image of a sphinx (1895, see fig. 87). The subject and style of the illustrations for Howells were so "out of my usual style," that Pyle wrote to the art editor of *Harper's Monthly*, F. B. Schell, imagining the reaction at the publishing house: "What's the matter with Pyle, has he gone crazy?"[34] He reassured Schell, who had apparently recoiled from some of the more eerie drawings, that he would include no more skeletal heads.[35]

The Howells scholar Delmar Gross Cooke remarked that Pyle's illustrations for *Stops of Various Quills* are "of the Boecklin school."[36] While the illustrations lack the eerie mordancy of the Symbolist images of the Swiss painter Arnold Böcklin, they are replete with the similar but more sedate symbols of the American Renaissance in the visual arts: hooded figures, attributes of death, lyres, laurel wreaths, winged figures, and a variety of images suggesting the soul's aspirations caught by the bonds of earth.[37]

Pyle considered *Stops of Various Quills* "our book" and gave Howells the sphinx painting "as some token of the plea-

sure I had in illustrating your poems."[38] He summed up their achievement in Swedenborgian terms: "In your poems, the piping Pan of your soul went up into just such twilight altitudes as I have tried to depict."[39] Together, he implies, their souls had transcended the boundaries of the physical universe and reached a place higher than the clearly delineated, earthbound world.

In 1902, several years after they had stopped corresponding frequently, Howells responded to a note from Pyle, closing on an elegiac note: "I too regret that we no longer meet in the years that are so swiftly passing."[40]

THE GARDEN BEHIND THE MOON: A REAL STORY OF THE MOON-ANGEL

As they concluded their conversations about *Stops of Various Quills*, Pyle sent Howells a copy of *The Garden behind the Moon: A Real Story of the Moon-Angel*,[41] remarking that "I have embodied some of my best and truest thought" in this book about "my little boy." The story is not tragic, Pyle assures Howells, as "death is so thin a crust of circumstance that I can feel his heart beat just on the other side."[42] In the book, in the voice of the kindly and humorous narrator and picture maker, Pyle guides his young readers through an indefinable mystery, revealed to him by the Moon-Angel himself (1895, fig. 88).[43] So, an incorporeal being with a "real" story announces the convergence of imagination and materiality in the tale to come.

The narrative recalls the story line of "To the Soil of the Earth!" in its arc from earth to heaven and back again. And some of the major plotlines are typical of the fairy-tale genre: traveling to a magical land full of wondrous beings, deciphering enigmatic events, triumphing over frightening creatures, and winning a royal marriage. But the whimsical and lyrical language and Pyle's occasional first-person remarks to his young readers abound with Swedenborgian spirit.

The foreword touches on the central Swedenborgian concept of "use."[44] The reflection of the moon on the water, inviting us to walk, must have some use, Pyle suggests, as does everything else in the world. For Swedenborg, God's love and wisdom are manifest through uses, the actions

of human beings. The mysterious walking forward on the moon-path, then, will be a living out of spiritual values. Pyle confides that he has seen his own son, happy and carefree, the son who "had gone out along the moon-path, and . . . had not come back again." Just once, he glimpsed his son as if in a dream, as one "might see such a beautiful place through a piece of crooked glass."[45] The allusion to the scriptural passage "For now we see through a glass, darkly, but then face to face" makes clear that Pyle has seen his son—"dim and indistinct"—in the garden of the afterlife.[46]

The book opens with a description of the beautiful but emotionless Princess Aurelia, "whom everybody said . . . had no wits."[47] With a promise to return to her later, the story continues with the only slightly less dreamy David, known as simple in his seaside village. Pyle's description of David's silly knowledge as superior to that of learned men who examine the natural world with sharp spectacles but the wrong lenses recalls his remarks to Howells about the obtuse sun-scientists.

David's terrified first attempt to walk the moon-path results in his nearly drowning from panic, and he returns home to his mother, Margaret (Pyle's mother's name). But when David perceives the Moon-Angel guiding him (or perhaps giving him faith), he runs across "shifting, changing gravel of shining gold" and enters the moon-house.[48] This is, in Swedenborgian terms, the outermost part of heaven, the first part of the after-death transition. The new arrival has left his material body behind—or, for child readers of David's passage—"you have left your hat and clothes and shoes . . . and nobody down there knows otherwise than that you are in them."[49]

Soon David advances to a second floor, possibly reflecting the first step in his ascent through his Swedenborgian new world. From the windows he sees "very strange . . . but singularly familiar" landscapes and people, an appropriate manifestation of correspondences.[50] He witnesses the cruelties inflicted on an enslaved woman and her baby on a slave ship leaving Africa, and then "like a flash," sees the same mother and child rescued by the Moon-Angel and brought to a flowering garden and sunlit city.[51] Pyle may have chosen

slavery to personify savagery not just because it was a recent historical reality but also because Swedenborg wrote that Africans were, of all people on earth, closest to the celestial world. Although anti-abolitionists did exist among American Swedenborgians, including those in the Wilmington church, followers of Swedenborg are credited with forming the first known abolitionist society in the world in Sweden in 1779.[52]

After the idyllic mother-and-child scene, Pyle makes a statement that signifies an essential Swedenborgian idea as well as David's incomplete spiritual knowledge: "He did not then know that it was one of the gardens behind the moon."[53] For Swedenborgians, the world beyond us is full of places representing varying states of spiritual realization. At the beginning of his enlightenment, David is not yet aware that there are many gardens beyond his own experience.

The Moon-Angel explains to David, saddened by the pain of the black woman and child, about the "outside" and the "inside" of things.[54] The outer shell (physical existence and experience and their related suffering), while necessary, is ephemeral. This recalls Daihas's description of his unfulfilled self as just a shell, housing his eternal soul.

By now David is ready for the next stage of his journey: to a higher floor of the moon-house, where he will work (or, be useful) by polishing stars. Pyle notes David's still relatively lowly status with a solemn reminder of a higher sphere: "There are some few stars that even those in the moon do not polish. Those are given to the sun children to burnish in the sun-oven. This is not all nonsense."[55]

David encounters the Moon-Angel again, humming at a window, concentrating on "making old things over into new things."[56] In Pyle's illustration (1895, fig. 88) the inscription on the wall confirms the angel's oversight of transitions to spiritual enlightenment: "First cometh sleep before awakening—first cometh darkness before day—first cometh death before life."[57]

The Moon-Angel now sends David to the moon-garden, a verdant paradise for children, watched over by a "lady with a soft gentle face," clearly one of the angels whom Swedenborg describes as guardians and teachers of young children

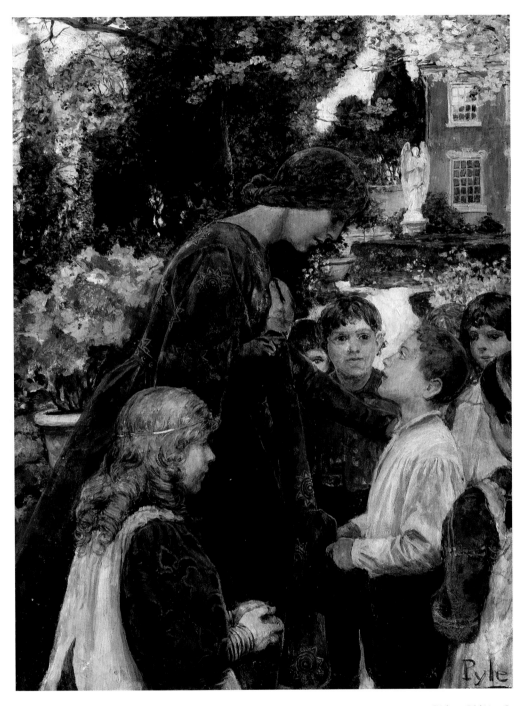

Figure 89. Howard Pyle (1853–1911). *"Where Did You Come from, Little Boy?" Said She.* For Howard Pyle, *The Garden behind the Moon: A Real Story of the Moon-Angel.* New York: Charles Scribner's Sons, 1895. Oil on board, 12⅝ × 9⅝ inches. Delaware Art Museum, Museum Purchase, 1915

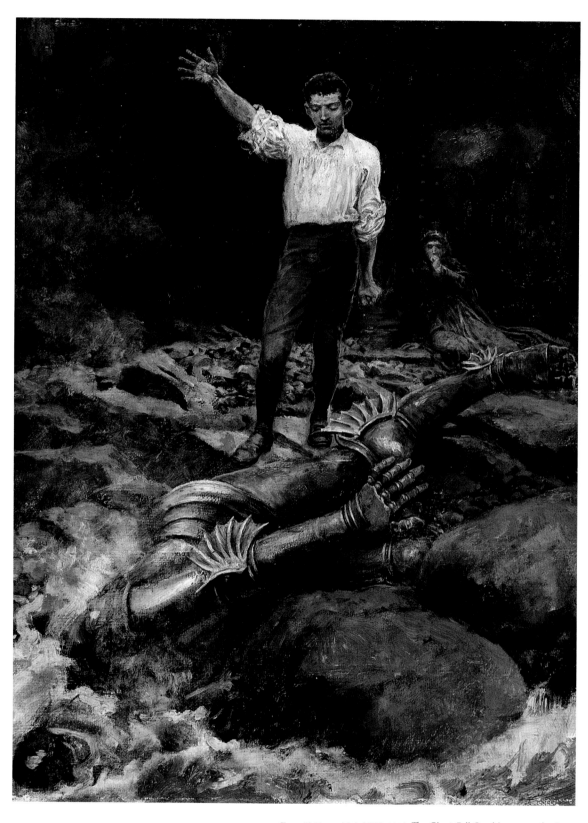

Figure 90. Howard Pyle (1853–1911). *The Giant Fell Crashing upon the Stones.*
For Howard Pyle, *The Garden behind the Moon: A Real Story of the Moon-Angel.* New
York: Charles Scribner's Sons, 1895. Oil on board, 12⅜ × 9⅜ inches. Delaware Art
Museum, Museum Purchase, 1915

(1895, see fig. 89).[58] A princess named Phyllis becomes his best friend there; their relationship will later be an example of the Swedenborgian belief that marriage for compatible couples exists in the afterlife.

David's assigned time in the garden, along with his prescribed days for work, reflect Pyle's sensitivity to the conflation of earthly and spiritual time in Swedenborg's world, an awareness that the author shares in a letter to Henry Mills Alden. In trying to convince Alden, author of *God in His World* (1890), to read Swedenborg, Pyle notes that "Swedenborg tells us that in the coadjacent life man now disintegrates and reforms with marvelous rapidity. I think he says that it takes only about a year and a half (of material time) for the face to turn one way or the other."[59]

David's days in the garden are limited because he has sights to see and tasks to do. The lady tells him of "the work for which you were sent," giving him the charge to seize the Wonder-Box and the Know-All Book from the Iron Man, a fearsome giant.[60] To accomplish all this David must go behind the Moon-Angel. This sounds like the promise of another paradise, but it proves to be an alarming "dream in which there was something of terror and darkness."[61] His passage behind the Moon-Angel takes ten years in human time, and David emerges as a young man in a place resembling earth. And because he now has gained a degree of spiritual insight, he recognizes that the iron Wonder-Box, containing the Know-All Book, and the golden key, all of which were left behind when Adam and Eve fled the Garden of Eden, are worth his quest, even though they are the source of the greatest sorrow as well as the greatest joy. David cleverly seizes key, box, and book from the Iron Man's castle, and rescues the now captive Phyllis, who calls, "This is the moon-garden! Oh, help me away from it!"[62] Her experience of despair is another face of her spiritual journey: for her, too, endless peace has become a prison.

The giant Iron Man pursues the fleeing pair on their winged horse, on which they escape, only to have the Iron Man reappear. With a well-aimed stone, David—like his biblical namesake—kills the Iron Man. Pyle's illustration thrusts the base metal of the giant's armor, rather than his face,

toward the viewer, emphasizing his symbolic nature (1895, fig. 90). David and Phyllis then realize that they have been transported back to the moon-house, ready to begin their journey home to earth. But Phyllis, holding the Wonder-Box and Know-All Book, vanishes, leaving David with only the golden key. Pyle explains this sudden disappearance in Swedenborgian terms of the individual's spiritual development: "Everybody ... has a different moon-path from everybody else ... So, when they began to return back to the brown earth again, one went one way and the other went the other way."[63] David is undisturbed, confident that "it will all turn out right, by and by."[64] He is greeted at home by friends and family as the familiar simpleton, although it is they who fail to realize that he has been gone a long time.

Eventually, Princess Aurelia, from the beginning of the book, "come[s] back into her senses."[65] She is, of course, Phyllis; the Aurelia-Phyllis-Aurelia transformation involves a spiritual journey comparable to David's. Her names reflect her place on the spiritual continuum: Aurelia, the golden one, appropriate for a princess but also evoking the celestial, and Phyllis, conjuring up the greenery of a garden. She has brought the Wonder-Box and Know-All Book to the royal court, and now a search begins for the golden key. Aurelia confides to her father, the king, that she was betrothed to David in the moon-garden; David is discovered as the holder of the golden key and is feted at court. The image of the golden key recalls an account of Swedenborg's own writings: Swedenborg "mentioned that he saw a representation of a certain golden key that he was to carry, to open the door to spiritual things."[66]

David unlocks the Wonder-Box and reads the words repeated endlessly throughout the pages of the Know-All Book, a chant of Swedenborgian import: "When we grow up we shall be married ... when we are married we shall grow up; when we are married there shall be joy; hence there shall be joy when we are married."[67] Love—Swedenborg's central element of reality—is the essence of the human existence that David and Aurelia will share during their marriage (1895, see fig. 91). The marriage concludes Pyle's tale, but he assures us that David and Aurelia did go back to the

moon-garden, and that all who understand the words in the Know-All Book may freely "go to or come from anywhere."[68] Love is the passage throughout the spectrum of the natural and supernatural worlds. Other than that, we must be content with his "never-to-be-altogether-understood" book.[69]

With the story completed, Pyle's vision of "the little boy whom I loved best of all," told in his foreword, is elucidated. It happened as "though in a dream," but even more tellingly, when he thought he "was looking into the garden out of one of the moon windows."[70] Pyle himself has experienced a time and place beyond the material world—perhaps the artist's imagination, or the seeker's illumination, but certainly a Swedenborgian revelation.

THE "ASSISTANCE" OF SWEDENBORG

Pyle did not "discover" Swedenborg, as had many American writers and artists of his time. From Pyle's youth, when he and his mother read Swedenborg together, through his

working life, when he had Swedenborg read to him daily, and undoubtedly from sermons and discussions in his church, Swedenborg's thought was woven into his worldview and vocabulary over many years.[71] His letters to Howells reveal a grappling with Swedenborg's ideas that motivated some of his fiction and illustration. This correspondence also demonstrates Pyle's gratification in sharing spiritual questions and rewards with a like-minded friend.

Sellers's death in 1889—certainly another specter of Pyle's black cloud—seems to have been a catalyst for a deeper awareness of the life of the soul, for a stronger confidence in the Swedenborgian continuum of life through death to eternal life. His agony of loss was an essential part of the completion of life on earth, and the gradual cessation of pain left him with an increase of faith:

> I love . . . the homely joys of a wholesome family life . . . joys . . . made up not only of the love of wife and children but of the bitter delight of a keen and poignant agony that was only needed to make it complete—an agony that has dissolved much—almost all of the poison flesh leaving only a thin membrane to hide from the eyes the brighter light of a life beyond.[72]

The Garden behind the Moon: A Real Story of the Moon-Angel is a deeply personal confrontation with death. The writings of Swedenborg allowed Pyle to transform his mourning for Sellers, "a noble little fellow of six years old . . . and . . . a child of deep mind and noble generosity of character," into the creation of an affecting and entertaining fable for children.[73] His glimpse of Sellers in the moon-garden allowed him to place his trust in God's angels to oversee his son's own spiritual ascent.

An analysis of Pyle's religious thinking risks comparison to his lines from *The Garden behind the Moon*: "It does not fit easily into the words of A B C's, and when a body begins telling it, it breaks all into a jumble."[74] Still, it was clearly the assistance of Swedenborg—matched by his own powerful imagination—that allowed Pyle to create some order in his personal spiritual journey.

NOTES

The epigraph is quoted in James MacArthur, "Books and Bookmen," *Harper's Weekly* 47, no. 2,431 (July 25, 1903), 1224.

1 Howard Pyle quoted in James MacArthur, "Books and Bookmen," *Harper's Weekly* 47, no. 2,431 (July 25, 1903), 1224.

2 The phrase "such things" comes from a letter: Howard Pyle to William Dean Howells, Dec. 21, 1890, William Dean Howells Papers, Houghton Library, Harvard University, Cambridge, Mass.

3 "As Swedenborgians We Believe," Church of the Holy City website, http://www.churchoftheholycity.org/12.html. The Swedenborgian church worldwide is also known as the Church of the New Jerusalem and the New Church. In his eulogy for Pyle, Reverend George Henry Dole gave examples of Pyle's participation in his church. The eulogy is quoted in "Howard Pyle," *New Church Messenger* (Nov. 22, 1911), 331–32.

4 Pyle to Edmund Clarence Stedman, Jan. 25, 1891, Edmund Clarence Stedman Papers, 1840–1960, Columbia University Libraries, New York. Transcript courtesy of Ian Schoenherr.

5 Emanuel Swedenborg, quoted in George Trobridge, *Swedenborg: Life and Teaching* (New York: Swedenborg Foundation, 1938), 111.

6 Delaware Art Museum, *Howard Pyle: Diversity in Depth* (Wilmington, Del.: Wilmington Society of the Fine Arts, 1973), 6.

7 The summary of relevant Swedenborgian ideas is derived from several sources, including the website of the Swedenborgian Church of North America, the branch of the church to which Pyle belonged: http://www.swedenborg.org.

8 Church of the Holy City, *The Swedenborgian Church and Its Teachings* (Wilmington, Del.: Church of the Holy City, n.d.), unpaginated.

9 Marguerite Block, "Swedenborg and the Romantic Movement," in Leon James, *Swedenborg Glossary*, http://www.soc.hawaii.edu/leonj/leonj/leonpsy/instructor/gloss/block.html. For Swedenborg as a seminal force in the nineteenth-century American Renaissance literary movement, see Arthur Versluis, *The Esoteric Origins of the American Renaissance* (Oxford, England: Oxford University Press, 2001), esp. 17–20.

10 For the intersection of mystical schools in late nineteenth-century European and American art, see Linda Dalrymple Henderson, "Editor's Statement: Mysticism and Occultism in Modern Art," *Art Journal* 46, no. 1 (spring 1987): 5–8; Jane Dillenberger and Joshua C. Taylor, *The Hand and the Spirit: Religious Art in America, 1700–1900* (Berkeley: University Art Museum, University of California, Berkeley, 1972); and Maurice Tuchman, et al., *The Spiritual in Art: Abstract Painting 1890–1985* (New York: Abbeville Press, 1986).

11 For George Inness and Swedenborgianism, see Mary E. Phillips, "The Effect of Swedenborgianism on the Later Paintings of George Inness," in Erland J. Brock, ed., *Swedenborg and His Influence* (Bryn Athyn, Penn.: Academy of the New Church, 1988), 427–37; and Sally M. Promey, "The Ribband of Faith: George Inness, Color Theory, and the Swedenborgian Church," *The American Art Journal* 26, nos. 1–2 (1994): 44–65.

12 For William Dean Howells and Swedenborgianism, see Susan Goodman and Carl Dawson, *William Dean Howells: A Writer's Life* (Berkeley: University of

California Press, 2005), esp. 382; and Rodney D. Olsen, *Dancing in Chains: The Youth of William Dean Howells* (New York: New York University Press, 1992).

13 Pyle to Howells, Apr. 13, 1890. Unless otherwise indicated, all correspondence between Pyle and Howells is quoted from transcriptions by Charles D. Abbott in Howard Pyle Manuscript Collection, box 1, folder 16, Helen Farr Sloan Library and Archives, Delaware Art Museum.

14 Howells to Pyle, Apr. 17, 1890.

15 Pyle to Howells, May 5, 1890.

16 Pyle to Howells, Dec. 21, 1890.

17 Howells to Pyle, Dec. 22, 1890.

18 Pyle to Howells, Dec. 29, 1890.

19 Pyle married Anne Poole in a Quaker ceremony, perhaps another indication that he was not doctrinaire in his religious thinking.

20 Pyle to Howells, Dec. 29, 1890.

21 Pyle to Howells, Nov. 30, 1890.

22 Howells to Pyle, Jan. 30, 1891.

23 Pyle to Howells, Dec. 29, 1890.

24 Howells to Pyle, Dec. 22, 1890.

25 These essays have not survived. Pyle to John Ferguson Weir, n.d., Howard Pyle Papers, 1887–1911, Clifton Waller Barrett Library, Accession No. 6547 to 6547-g, Special Collections, University of Virginia Library, Charlottesville. Transcript courtesy of Ian Schoenherr.

26 Howard Pyle, "In Tenebras: A Parable," *Harper's New Monthly Magazine* 88, no. 525 (Feb. 1894): 392–408.

27 Following Swedenborg's stance, Pyle notes that those who inherit ills (such as the drunkenness of the story's evil character) cannot be morally blamed for them, a judgment placing him ahead of his time.

28 Pyle to Howells, May 5, 1890.

29 Howells to Pyle, Dec. 22, 1890.

30 Howard Pyle, "To the Soil of the Earth!," *The Cosmopolitan* 13, no. 2 (June 1892): 219.

31 Pyle to Mrs. Fairchild, July 22, 1893, Howard Pyle Papers, 1887–1911, Clifton Waller Barrett Library, Accession No. 6547 to 6547-g, Special Collections, University of Virginia Library, Charlottesville. Transcript courtesy of Ian Schoenherr.

32 Howells to Pyle, Feb. 2, 1892.

33 William Dean Howells, "Monochromes," *Harper's New Monthly Magazine* 86, no. 514 (Mar. 1893): 546–51; Howells, *Stops of Various Quills* (New York: Harper and Brothers, 1895).

34 Pyle to F. B. Schell, Aug. 15, 1891, quoted in Elizabeth Hawkes, "Drawn in Ink: Book Illustrations by Howard Pyle," in Gerald W. R. Ward, ed., *The American Illustrated Book in the Nineteenth Century* (Winterthur, Del.: Henry Francis du Pont Winterthur Museum, 1982), 225. From *Harper's Magazine* Autograph Letter Collection, 1851–1895, microfilm roll N710, Archives of American Art, Smithsonian Institution, Washington, D.C.

35 Pyle to Schell, Sept. 2, 1891, *Harper's Magazine* Autograph Letter Collection, 1851–1895, microfilm roll N710, Archives of American Art, Smithsonian Institution, Washington, D.C.

36 Delmar Gross Cooke quoted in Charles D. Abbott, *Howard Pyle: A Chronicle* (New York: Harper and Brothers, 1925), 191, from Cooke, *William Dean Howells: A Critical Study* (New York: E. P. Dutton and Company, 1922), 123.

37 For Pyle's place in the American Renaissance in the visual arts, see Brandywine River Museum, "Howard Pyle and the American Renaissance," in Traditional Fine Arts Organization, Resource Library, 2007, "page 1": http://www.tfaoi.com/aa/7aa/7aa719.htm.

38 Pyle to Howells, Oct. 30, 1895.

39 Pyle to Howells, Nov. 3, 1895.

40 Howells to Pyle, July 8, 1902, quoted in Mildred Howells, ed., *Life in Letters of William Dean Howells* (Garden City, N.Y.: Doubleday, Doran and Company, 1928), 2: 160.

41 Howard Pyle, *The Garden behind the Moon: A Real Story of the Moon-Angel* (New York: Charles Scribner's Sons, 1895). Hereafter referred to as *Garden*.

42 Pyle to Howells, Oct. 30, 1895.

43 Pyle makes clear to an adult correspondent that the Moon-Angel is the angel of death: Pyle to Phoebe Griffith, n.d., quoted in Abbott, *Howard Pyle: A Chronicle*, 198. The Moon-Angel's imposing figure and long sweep of drapery bear some resemblance to the character of Death in George Frederick Watts's painting *Love and Death*, which Pyle praised and recommended to his students; see Delaware Art Museum, *Howard Pyle: Diversity in Depth*, 20. For Watts's tangential connections to Swedenborgianism, see Adelheid Kegler, "Elements of Swedenborgian Thought in Symbolist Landscapes: With Reference to Sheridan Le Fanu and George MacDonald," in Stephen McNeilly, ed., *Between Method and Madness: Essays on Swedenborg and Literature* (London: Swedenborg Society, 2005); and Kegler, "*Wilfrid Cumbermede*: A Novel in the Context of European Symbolism," in *North Wind* (London: George MacDonald Society, 2002), 21: 71–84.

44 Reverend Kimberly M. Hinrichs, "The Work of Love and Wisdom," sermon, Sept. 5, 2004, Swedenborgian Church of North America website, http://www.swedenborg.org/sermons/pastsermons/04-09-05/The_Work_of_Love_and_Wisdom.aspx. Pyle refers to "use" elsewhere, referring to his own art (Pyle to Howells, Oct. 31, 1895) and to art itself (Pyle to Frederick Dielman, Mar. 27, 1907 and Apr. 2, 1907); both quoted in Elizabeth Hawkes, "Proposal: Selected Letters of Howard Pyle," Oct. 25, 1993, unpaginated, Howard Pyle Manuscript Collection, Helen Farr Sloan Library and Archives, Delaware Art Museum.

45 Pyle, *Garden*, 3.

46 "Dim and indistinct" is from Ibid. "For now we see . . . " is from 1 Corinthians 13:12 (King James Version).

47 Pyle, *Garden*, 8.

48 Ibid., 39.

49 Ibid., 47.

50 Ibid., 49.

51 Ibid., 51.

52 For a study of Swedenborg's attitude toward Africans and its effects on American thinkers, see Josephine Donovan, "A Source for Stowe's Ideas on Race in *Uncle Tom's Cabin*," *NWSA Journal* 7, no. 3 (fall 1995): 24–34. For Union-Confederate divisions in the Wilmington congregation, see Sue Ditmire, "Church of the Holy City, Wilmington, Celebrates 150 Years," *The Messenger*

228, no. 4 (April 2007). For a study of the Swedenborgian intersection with other American spiritual movements, see Scott Trego Swank, "The Unfettered Conscience: A Study of Sectarianism, Spiritualism, and Social Reform in the New Jerusalem Church, 1840–1870," PhD diss., University of Pennsylvania, Philadelphia, 1970.

53 Pyle, *Garden*, 53.

54 Ibid., 55.

55 Ibid., 60.

56 Ibid., 70. A humming angel at a window, the polishing of the stars, and the up-and-down staircase are several of the motifs, along with a magic place found behind a natural one, that have led commentators to suggest that Pyle's source for *The Garden behind the Moon* was George MacDonald's fantasy *At the Back of the North Wind*, serialized in the children's magazine *Good Words for the Young* beginning in 1868 and published in book form in 1871. MacDonald's story reflected his own Swedenborgian interests. See, for example, Perry Nodelman, "Pyle's Sweet, Thin, Clear Tune: *The Garden behind the Moon*," *Children's Literature Association Quarterly* 8, no. 2 (summer 1983): 22–25.

57 Pyle, *Garden*, 69.

58 Ibid., 76.

59 Pyle to Henry Mills Alden, Mar. 30, 1890, Howard Pyle Papers, 1887–1911, Clifton Waller Barrett Library, Accession No. 6547 to 6547-g, Special Collections, University of Virginia Library, Charlottesville. Transcript courtesy of Ian Schoenherr.

60 Pyle, *Garden*, 97.

61 Ibid., 107.

62 Ibid., 150.

63 Ibid., 169.

64 Ibid., 170.

65 Ibid., 178.

66 Emanuel Swedenborg and Samuel M. Warren, *A Compendium of the Theological and Spiritual Writings of Emanuel Swedenborg: Being a Systematic and Orderly Epitome of All His Religious Works* (Boston: Crosby and Nichols, 1853), 51.

67 Pyle, *Garden*, 188–91.

68 Ibid., 192.

69 Ibid., 10. "Never-to-be-altogether-understood" is the adjective Pyle gives to the Moon-Angel's book.

70 Ibid., 3.

71 The 1890s were a decade of ferment for Swedenborgians. Disagreements resulted in a split within the church. Pyle stood with the Wilmington church in resisting the idea that, as Pyle says, Swedenborg was "in himself almost Divine." Pyle to Howells, Feb. 18, 1892.

72 Pyle to Edmund Clarence Stedman, Jan. 25, 1891. Edmund Clarence Stedman Papers, 1840–1960, Columbia University Libraries, New York. Transcript courtesy of Ian Schoenherr.

73 Pyle to Hjalmar Hjorth Boyesen, Apr. 13, 1889, Howard Pyle Papers, 1887–1911, Clifton Waller Barrett Library, Accession No. 6547 to 6547-g, Special Collections, University of Virginia Library, Charlottesville. Transcript courtesy of Ian Schoenherr.

74 Pyle, *Garden*, 106.

Eric J. Segal

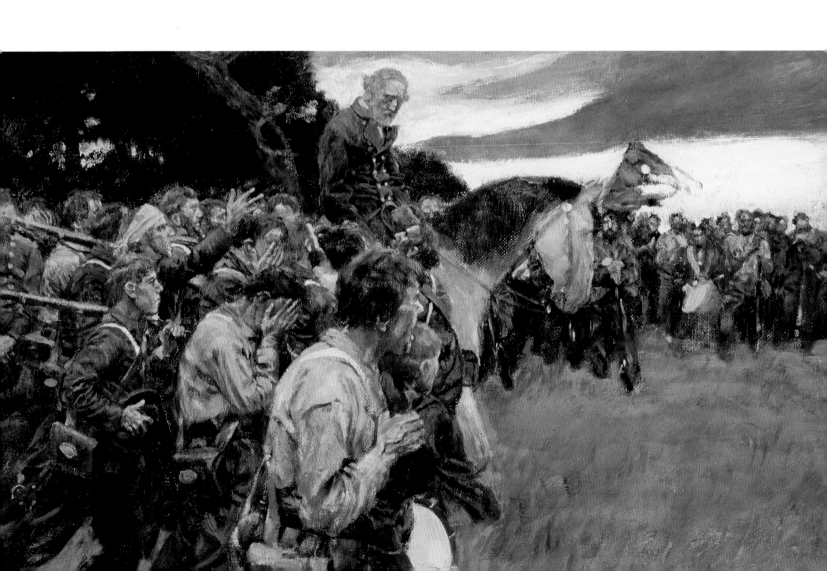

7.

THE GENDER OF ILLUSTRATION: HOWARD PYLE, MASCULINITY, AND THE FATE OF AMERICAN ART

Sometime around 1905 illustrator and author Howard Pyle wrote to Joseph Pennell about the distinguished painter and etcher James McNeill Whistler, who had died two years earlier.[1] Pennell—himself an illustrator, etcher, and fervent advocate of graphic arts—was leading an effort to raise funds for a proposed sculptural monument by Auguste Rodin to honor the renowned expatriate artist Whistler. That is to say, the American artist Pennell was promoting a memorial to another American artist wrought by a Frenchman to be raised in England. Although, according to Pennell, artists had responded to his solicitation with universal enthusiasm, Pyle alone demurred, replying, "I am not very much interested in Whistler. If it were a question of a Whistler Memorial to Rodin instead of a Rodin Memorial to Whistler, I think it would touch me more nearly."[2] One might expect that Pyle, rather than declining to support the endeavor, would have taken heart in the success of an etcher, a kinsman in graphic art, as an advancement for his own métier as penman and painter of illustrations. But Pyle remained unsympathetic.

Pennell himself—who had written admiringly of Pyle as an artist who "preserved much that was good in the old work, and yet kept pace with modern technical and mechanical developments"—claimed that Whistler's foray into illustration proper placed "him above all American—all modern illustrators."[3]

That Pyle would have preferred to memorialize Rodin, the living French sculptor, rather than Whistler, the American painter whose etchings were widely celebrated as major artistic accomplishments, helps illuminate the meaning of illustration for Pyle and his contemporaries. Ultimately, Pyle distanced himself from the Whistler monument not because he thought Whistler was a poor artist (after all, he imagined endorsing a monument *by* Whistler) but because he believed that Whistler's work provided a poor example of an *American* art. To Pyle, the nation's cultural maturity ought to be represented by an art that was distinctly American in form and spirit, neither of which Whistler's work accomplished. Pyle, the illustrator who never desired to visit Europe until the very end of his life, was not prepared to see the expatriate painter presented on the world stage as a paragon of American art.

Pyle's investment in illustration went beyond its promise to fulfill the destiny of American cultural achievement,

and was further imbricated with contemporary concerns about maintaining and fostering middle-class masculinity. The state of American manhood was a topic of discussion and concern among those of Pyle's contemporaries who saw modern social life as weakening the nation. Pyle, however, saw such concerns through the lens of a professional illustrator, believing that the best work in his field could embody a manly American spirit vital to national culture.

THE ORIGIN OF ART

In seeking to understand how illustration—the making of pictures for books and magazines—could carry such weight for Pyle as both a national cultural achievement and a vital masculine expression, we might examine the illustrator's own ideas about picture making and connect these to widely shared ideas about art and illustration. Yet Pyle's investment in illustration can also be investigated by looking at his thinking about writing. The two activities were closely related for Pyle, whose most enduring works are books he both wrote and decorated, including *The Merry Adventures of Robin Hood of Great Renown, in Nottinghamshire* (1883), *The Wonder Clock, or Four and Twenty Marvellous Tales, Being One for Each Hour of the Day* (1887), and the four volumes recounting the exploits of King Arthur and the champions of the Round Table (1903–10).[4] In fact, as Pyle struggled to begin his professional career in New York in the mid-1870s, he very nearly committed himself exclusively to a "literary life" against his mother's advice to stick to illustrating as his "particular branch."[5] Ultimately, he concluded that his literary abilities best fit into the narrower realm of children's literature as a complement to his greater talents in the field of illustration, although he never gave up writing. Pyle himself explained: "In a story you get the soul. The [drawing] pencil gives a body to the words of the author . . . The arts of writing and delineation ought to go hand in hand."[6] Thus Pyle's comments on writing are cautiously treated below as providing insight into his ideas about creative expression—including illustration—more generally.

One of Pyle's earliest recollections, as recorded in a short autobiographical piece published shortly after his death, concerned the creative endeavors that would mark his life. Feeling himself inspired to write a poem and being but a child, he took pencil and paper and set to work:

> It was not until I had wet my pencil point in my mouth, and was ready to begin my composition, that I realized that I was not able to read or write. I shall never forget how helpless and impotent I felt.
>
> I must have been a very, very little boy at that time, for in those days a boy was sent to school almost as soon as he was old enough to wear trousers.[7]

Notably, Pyle here associates his floundering "impotence" with the period before a young boy begins to acquire signs of male social identity. In his recollection the young Pyle has not yet left the confines of the domestic sphere for the public realm of school, and he has not yet exchanged the dresses, which toddlers of both genders wore in the nineteenth century, for the pants that will visibly mark his maleness. In other words, the creative impulse that he cannot yet express—because it is not yet shaped by socially acquired literacy—is connected in some manner to his nascent sense of maleness. Pyle's retrospective account of the episode (an anecdote likely much revised in the course of the half century following the event) encodes something of his adult perspective on the relation between creative expression and masculine accomplishment. In the telling, he joined together the culturally vague gender definition of male babies with an inability to create. As an adult, Pyle came to adopt a personal association between the achievement of masculine competence and the mastery of creative expression.

One of Pyle's great artistic concerns was the uncertain fate of American art. He admired what he called the "real" American artist as "broad-shouldered and big among his fellows."[8] He also thought of this artist as very nearly untouched by foreign influences, having lived and studied in the United States without kowtowing to Europe. However, most American art students in the late nineteenth century desired nothing more than to train abroad, an enthusiasm pointedly expressed by William Merritt Chase when he declared:

"My God, I'd rather go to Europe than go to heaven!"[9] Although Pyle counted Chase among his friends in the late 1870s, Pyle nonetheless complained years later of American painters whose "pictures, in the main, might as well have been painted in the studios of Paris . . . They do not tell anything of the Americanism of the men who wrought them . . . and I do not wonder that Americans do not seem to care to buy them."[10] Indeed, Pyle believed that painters had failed to establish the basis for a national aesthetic culture. As a result, as will be discussed below, Pyle came to the conclusion that "the only distinctly American Art is to be found in the Art of Illustration."[11]

Pyle's ideal of a manly stay-at-home artist, the likes of Winslow Homer, was quite distinct from the figure cut by the expatriate Whistler.[12] While Pyle could have appreciated that the image of the artist Whistler advocated was strong willed and deeply committed to his craft, the illustrator hated the painter's insistence on the total freedom of art. Where Whistler's ideal artist was indifferent to and unconstrained by shared social concerns and conventional belief systems, in Pyle's mind the purpose of art was to express something profound, and the artist's efforts could be judged true when "the thought which he has conveyed is one that fits the emotional experience of many other human beings."[13] Pyle held that the American artist was subject to a social bond requiring his work to be accessible to the sensibilities of Americans and to speak of things "that plain, thoughtful, men really know or care . . . about."[14]

Pyle would have dismissed Whistler's account of the origin of art itself expounded in his "Ten O'Clock" lecture, presented to a fashionable London audience in 1885. In his lecture and subsequent publication, Whistler argued that artists created from their own genius, and had done so since the very origins of human society:

> In the beginning, man went forth each day—some to
> do battle, some to the chase; others to dig and delve in
> the field—all that they might gain and live, or lose and
> die. Until there was found among them one, differing
> from the rest, whose pursuits attracted him not, and

so he stayed by the tents with the women, and traced strange devices with a burnt stick on a gourd.[15]

Unpromising beginnings perhaps, but for Whistler artistic genius that might be born in any age is simply innate. While his narrative assumes that the first artist was male, Whistler's claims are fascinatingly indifferent to conventional conceptions of masculine social roles and spaces.[16] Pyle's contemporaries certainly took exception to Whistler's version of the emergence of art. One author dismissed the imaginative account with a corollary example, arguing that "among modern savages it is not the females nor the effeminate males who do the artistic work of the tribe," and claimed that the "primitive artist was evidently a mighty hunter."[17]

Pyle seems rarely to have written about Whistler by name. Yet he likely had the painter in mind when he wrote sardonically about the motto "Art for Art's sake" as a high-sounding phrase giving license "for a painter to paint obscurely, producing great works unrecognized by the vulgar world."[18] And undoubtedly he meant to evoke Whistler, whose widely admired works bore titles such as *Symphony in White*, as the regrettable influence on art students who produced "*affected* 'symphonies' of green and purple, or of gray and red."[19] In the gendered language of the turn of the century, Pyle's characterization of Whistler-like symphonies of color as "affected" certainly impugned them as distinctly unmasculine.

THE AMERICAN ARTIST

Pyle fervently believed that, although American art had potential, American artists and art training were failing in reaching that promise. In following European models—and accepting the delusion "that a wooden shod Dutch fisherman is really more interesting or more beautiful than his Yankee brother"[20]—American artists neglected native subjects and ignored the particularities of the American spirit. He objected to the fact, as he saw it, "that painters demand that Art efforts should be limited to arrangements of color, tonic effects, and the technical application of paint to canvas rather than to a statement of vital truths."[21]

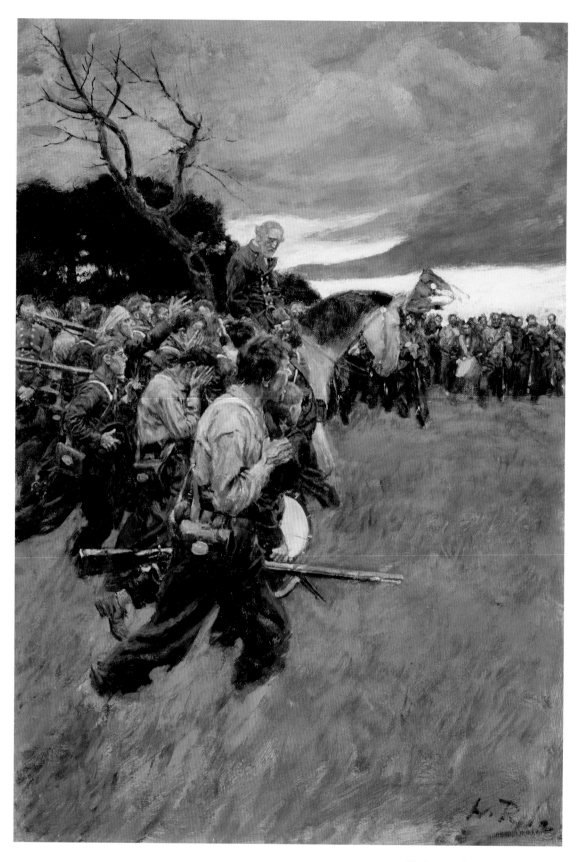

Figure 92. Howard Pyle (1853–1911). *His Army Broke Up and Followed Him, Weeping and Sobbing*. For A. R. H. Ranson, "General Lee as I Knew Him." *Harper's Monthly Magazine*, February 1911. Oil on canvas, 24⅛ × 16 inches. Delaware Art Museum, Bequest of Jessie Harrington, 1987

The poet and art critic Sadakichi Hartmann, who wrote admiringly of Pyle as "the classic illustrator of America," echoed some of his concerns in observing that "the majority of our artists have, through their European schooling, acquired a foreign way of looking at things that can be readily traced to Paris, London, or Munich. A few, and among them the best, pose, like Whistler, as cosmopolitans. They profess to believe that art is universal."[22] This leads them to a fault that Hartmann articulates through language opposing cultured femininity to masculine power, writing that the best art "painted in America by Americans" unfortunately displays "refinement rather than strength," and is patronized by wealthy Americans, whose softness leads to "the lack of rough, manly force, and the prevailing tendency to excel in delicacy and subtlety of expression."[23]

Pyle's own aversion to an effeminate image of the artist led him at times to make fine distinctions about artistic sensibilities. On the one hand, he repeatedly insisted that illustrators must fully imagine their subjects as a task integral to creating a picture. The idea became central to his pedagogical approach, as evident in his remark that the students he selected to teach "shall possess, first of all, imagination."[24] As illustrator Elizabeth Shippen Green recalled, Pyle's first rule of painting was: "To realize as hard as you possibly can the situation that you are about to depict."[25] Pyle himself seemed to live in the images he was creating. As W. H. D. Koerner, a successful illustrator of Western subjects and a former Pyle student, claimed: "Howard Pyle taught, fought, sang, struggled, and sobbed through his work."[26] On the other hand, despite such testimony, Pyle himself publicly denied the romantic image of a creative man whose own emotions corresponded to those he rendered. Thus, in responding to the question "Do Novelists Cry over Their Work?" for an article in *The Critic*, Pyle wrote that the notion of the writer "suffering anguish and tears over his own lucubrations is, to say the least, *droll*."[27] For Pyle, the artist's total visualization of a scene might, as he told his students, include recalling the icy pain of stepping into frigid water in order to paint a winter scene of soldiers at Valley Forge, but it left off before the laughable act of succumbing to unmanly emotions.[28]

Pyle's distinction between the empathetic imagination he advocated and the excessive—one might say *affected*—identification he considered silly reflects broader cultural concerns about the gendering of the arts. Michele H. Bogart has argued convincingly that in the late nineteenth century the field of illustration was perceived as subject to a general feminizing influence, as women increasingly found career opportunities in the graphic arts.[29] In response to such changes, various commentators shored up the masculine status of the field wherever they could. For example, in detailing the fantastic salaries awarded to top illustrators, who could "turn up their noses at the wage of a bank President," the *New York Times* observed that the workshop of one such leading figure, Harrison Fisher, was not the "dainty and voluptuous studio of a dilettante, but rather the setting for a man of concentrated action, even though it be artistic."[30]

Although Pyle complained about the influx of amateur female students in his courses at Drexel Institute of Art, Science, and Industry in Philadelphia, he gave real support and encouragement to a number of talented professional illustrators, including Violet Oakley and Jessie Willcox Smith, his former students, and Alice Barber Stephens, whose work he published in *McClure's*.[31] Nonetheless, Pyle's contemporaries noted that he perceived women as limited by a feminine outlook and aspirations, which meant they were "only qualified for sentimental work," and he thought "that the average woman with ambitions loses them when she marries."[32] Thus, at the school he established at his home in Wilmington, Delaware, Pyle devoted the greater part of his teaching efforts to training young men, who would be able to carry forward the field of American illustration.

To this point, it is clear that Pyle believed deeply in the possibility of fostering a great artistic culture rooted in American soil, and that American artworks must be created in a manly fashion. The artist must be possessed of originality and a sense of self strong enough to resist the lure of European influence. But the forgoing has also hinted that illustration had a special role to play in fulfilling that destiny of American greatness in the arts. In order to develop a complete understanding of what illustration meant to Pyle,

and exactly how an artistic field was coded for him in terms of gender, it is necessary to conclude by considering how he saw illustration in relation to fine art.

THE AMERICAN ILLUSTRATOR

Pyle frequently advanced the distinction between painting and illustration, once declaring, "I'm not a painter. I'm an Illustrator which means to Illumen which is a very great work to accomplish!"[33] In the late nineteenth century, illustration was often seen as a stepping-stone to the more prestigious field of painting. Among the foremost American artists of the era who had started as successful illustrators and worked their way up to the fine arts were Homer, Edwin Austin Abbey, and Frederic Remington, the last of whom gleefully declared after exhibiting his paintings in a New York gallery: "I am no longer an illustrator . . . I have landed among the painters."[34] Illustrators themselves generally accepted that, in the hierarchy of cultural values, their field stood above the mere commercial work of advertising but beneath the realm of "true art."

However, Pyle thought differently. It is not that he saw illustration as on a par with fine art. Rather illustration had the better of art, accomplishing something that gallery painting in America had failed to do. The best illustration fostered an American realism forged out of profound acts of imagination, while most fine art did little more than make flourishes of technique in mimicry of European practices. American painters, Pyle wrote in 1902, exhibited "a vast dabbling in color, a prodigious pottering with methods, an emptiness of result that makes the heart ache at the thought of so much precious time expended."[35]

In his youth he had been rather more ambiguous on the point, as he considered pursuing either illustration or fine art. As he set out to undertake his first serious art studies, Pyle chose the Philadelphia school of an immigrant from Belgium named Francis Van der Wielen. There he followed for three years a rigorous program based upon methods of European academic art instruction.[36] Soon after concluding these studies, Pyle asked himself, if rather than pursuing a career in illustration: "Would it be possible that I might make a success in Art?"[37] And during the next couple of years he sometimes explored the enticing possibility of going to Europe to study painting.[38]

Although over the next twenty-five years he would repudiate his youthful weakness for Europe, his turn to mural painting in later years led Pyle to a renewed interest in—and his first trip to—the Continent. His letters home from Italy reflect a burgeoning passion for old master painting and express his regret at having ignored for so long this vast reservoir of aesthetic knowledge. In the winter of 1910 he wrote to his former student Stanley M. Arthurs: "Both you and Frank [Schoonover] ought to come over here to Italy. It will be a great lesson to you in the way of color, composition, etc., for the old masters certainly were glorious painters and I take back all that I ever said against them."[39] As he focused his attention on European paintings, he began to feel constrained by his professional work, as well as his failing health, writing, "Of course, I have to earn my living, but it is rather hard to be limited to illustration . . . "[40] Soon thereafter Pyle would die in Florence, before he could fully realize his new artistic aspirations.

Pyle's late openness to Europe, his enthusiasm for old master painting, and even his seeming disillusion with illustration certainly do not diminish his vast accomplishments and his engaging body of work as a writer and an illustrator. However, these late developments in his career do suggest that his own prejudices and investments in illustration had blinded him to the marvels of artistic achievement there to be discovered in the history of art. Before resolving to study in Europe, Pyle had characterized the art of the past as the product of mankind in its youth: for example, he wrote that the medieval Italians were marked by an "ardent and childlike enthusiasm," and the "old masters of Art were big children."[41] By comparison, the modern artist was burdened with "a man's work to do" and "adult purposes."[42]

The manly purpose Pyle invoked was a necessary response to tensions within a culture in crisis. On the one hand, a widespread perception in the United States held that evolutionary progress had led civilization itself to new heights, the culmination of which lay in American rational

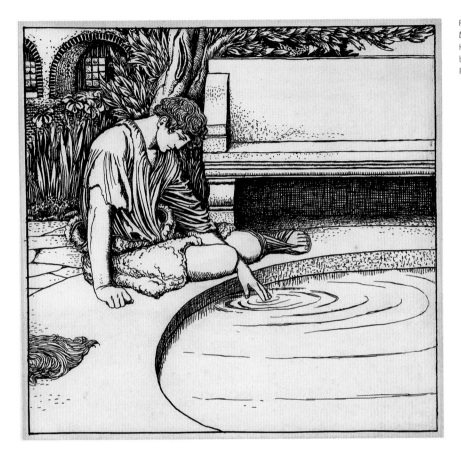

Figure 93. Howard Pyle (1853–1911). *The Prince Bathes in the Fountain*. For Howard Pyle, "The Princess on the Glass Hill." *Harper's Young People*, July 24, 1888. Ink on illustration board, 6½ × 6½ inches. Delaware Art Museum, Museum Purchase, 1912

thinking and instrumental economic organization. On the other hand, the promise of this inheritance was marred by a national self-image of manhood weakened by a pervasive softening of physical and mental faculties, especially among middle-class desk workers.[43] In a context where masculinity was increasingly defined in physical terms—think of Theodore Roosevelt's clarion call for the "strenuous life"—it made sense for Pyle to articulate his ideas about the struggle to produce great art through the image of a fit body.[44] Contemporary critics certainly saw it this way, describing Pyle's books as "always virile" and noting that in them "no strength

is wasted on mere refinements of form; the several incidents are sketched with a firm, bold hand."[45]

When Pyle, at the end of his life, looked back on his earliest memories of his creative efforts and found himself to have been impotent, he was precisely measuring the child tottering about in its gown against the figure of the artist, a boy grown to adulthood. In order to articulate the critical importance of illustration as a cultural form worthy of serious study and able to embody the national spirit, Pyle was virtually compelled to use the language of masculinity

of the day. In doing so, he certainly could not turn to Whistler's cosmopolitanism, with its lack of American content and ambiguous masculinity.

As a final point in this effort to understand the gendering of illustration, it is important to note that Pyle never so much *insisted* that only men could be great artists; rather he more nearly held that to be a great artist an individual had to be manly—to act like a man. A woman might do so by committing herself completely to her work, but, ultimately, he claimed, "The pursuit of art interferes with a girl's social life and destroys her chances of getting married."[46] This, of course, was not the norm for middle-class and well-to-do women.

Pyle was both wrong and right here. His essentially conservative outlook led him to the mistake of limiting the horizons of women's potential achievements. He found it difficult to shed conventional ideas about gender, even where the field of illustration might benefit. At the same time, he was correct in understanding that a discipline such as illustration might actually be gendered in a particular historical moment, not simply by virtue of being dominated by men but by the ideological imperatives laid upon it by its practitioners as well as the broader culture. The more Pyle wanted illustration to be a paragon of American cultural achievement the more he was bound to use masculinist language and ideas of his day to articulate its accomplishments.

NOTES

1 Auguste Rodin left the monument unfinished at his death in 1917. See Elizabeth Robins Pennell and Joseph Pennell, "Appendix II: The Whistler Memorial," in *The Whistler Journal* (Philadelphia: J. B. Lippincott Company, 1921), 307–16.

2 Ibid., 314.

3 Joseph Pennell, *Pen Drawing and Pen Draughtsmen, Their Work and Their Methods: A Study of the Art Today with Technical Suggestions* (New York: Macmillan Company, 1920), 287, 276. Yet Pennell also judged Howard Pyle's late work harshly in the same publication, as well as in another book, where he remarked: "He became a mere hack, and, dying, regretted it." See, respectively, ibid., 394–95; and Pennell, *The Graphic Arts: Modern Men and Modern Methods* (Chicago: University of Chicago Press for the Art Institute of Chicago, 1921), 92.

4 One should mention also a posthumous compilation of stories: Howard Pyle, *Howard Pyle's Book of Pirates: Fiction, Fact and Fancy concerning the Buccaneers and Marooners of the Spanish Main*, compiled by Merle Johnson (New York: Harper and Brothers, 1921).

5 Pyle's letter to his mother, Nov. 18, 1876, quoted in Charles D. Abbott, *Howard Pyle: A Chronicle* (New York: Harper and Brothers, 1925), 25.

6 Pyle quoted in Alpheus Sherwin Cody, "Artist-Authors," *Outlook* 49, no. 21 (May 26, 1894): 910.

7 Howard Pyle, "When I Was a Little Boy: An Autobiographical Sketch," *Woman's Home Companion* 39, no. 4 (Apr. 1912): 5, 103.

8 Howard Pyle, "The Present Aspect of American Art from the Point of View of an Illustrator," *Handicraft* 1, no. 6 (Sept. 1902): 130.

9 Kathleen Adler, "'We'll Always Have Paris': Paris as Training Ground and Proving Ground," in Adler, Erica E. Hirshler, and H. Barbara Weinberg, *Americans in Paris, 1860–1900* (London: National Gallery, 2006), 14.

10 On Pyle's friendship with William Merritt Chase, see Abbott, *Howard Pyle: A Chronicle*, 56–66. The quotation is from Pyle, "Present Aspect of American Art," 128–29.

11 Howard Pyle, "Concerning the Art of Illustration," in *First Year Book* (Boston: Bibliophile Society, 1902), 21.

12 On Pyle's admiration of Winslow Homer, see Abbott, *Howard Pyle: A Chronicle*, 216. On Homer's masculine reputation in late nineteenth-century America, see Sarah Burns, *Inventing the Modern Artist: Art and Culture in Gilded Age America* (New Haven: Yale University Press, 1996), 187–217.

13 Pyle, "Present Aspect of American Art," 135.

14 Ibid., 128.

15 James McNeill Whistler presented his "Ten O'Clock" lecture several times in 1885 and first had it published as *Mr. Whistler's "Ten O'Clock"* (London: Chatto and Windus, 1888). The quote is from page 11.

16 For a discussion of Whistler's maintenance of a masculine public persona, see Burns, *Inventing the Modern Artist*, 115–16.

17 Herbert Green Spearing, *The Childhood of Art, or the Ascent of Man* (New York: G. P. Putnam's Sons, 1913), 101.

18 Pyle, "Present Aspect of American Art," 126.

19 Ibid., 132 (emphasis added).

20 Ibid., 133.

21 Ibid., 134.

22 Sadakichi Hartmann, *A History of American Art* (Boston: L. C. Page & Co., 1901), 2: 106; 1: 190.

23 Ibid., 1: 190–92.

24 Abbott, *Howard Pyle: A Chronicle*, 216–17.

25 Elizabeth Shippen Green quoted in Richard Wayne Lykes, "Howard Pyle, Teacher of Illustration," *The Pennsylvania Magazine of History and Biography* 80, no. 3 (July 1956): 346.

26 W. H. D. Koerner quoted in Lykes, "Howard Pyle, Teacher of Illustration," 346.

27 A minor kerfuffle took place over several issues of *The Critic* as artists responded to Walter Besant's claim that writers indeed experience the emotional agony of their tragic scenes. Wilkie Collins doubted whether Pyle ever wrote "anything that anybody . . . could possibly cry over." In "'The Melting Mood' Again," *The Critic*, no. 232 (June 9, 1888): 284.

28 The Valley Forge example was recalled by Frank Schoonover, quoted in Lykes, "Howard Pyle, Teacher of Illustration," 367. Pyle's *The Garden behind the Moon: A Real Story of the Moon-Angel* (New York: Charles Scribner's Sons, 1895) stands out among his oeuvre for its emotional power: it likely reflects Pyle's feelings of loss at the death of his seven-year-old son, Sellers, in 1889. For more on this subject, see Mary F. Holahan's essay in this book.

29 Michele H. Bogart, "The Problem of Status for American Illustrators," in *Artists, Advertising, and the Borders of Art* (Chicago: University of Chicago Press, 1995), 15–78. In addition, Burns makes compelling arguments about gender and American artistic identity in the fine arts proper in her *Inventing the Modern Artist*, 159–86.

30 "A Latter-Day Industry and Its Rewards; How a Group of Illustrators Is Making Fortunes by Drawing Pictures of the 'Modern Girl,'" *New York Times, Sunday Magazine*, Feb. 6, 1910, 9.

31 On Pyle's complaints about female amateurs in his classes, see Richard K. Doud, Oral History Interview with Frank Schoonover, April 6, 1966, Archives of American Art, Smithsonian Institution, Washington, D.C. Transcript, p. 10, in Howard Pyle Manuscript Collection, box 4, folder 12, Helen Farr Sloan Library and Archives, Delaware Art Museum. On women who studied with Pyle, see Helen Goodman, "Women Illustrators of the Golden Age of American Illustration," *Woman's Art Journal* 8, no. 1 (spring–summer 1987): 13–22; and Alice A. Carter, *The Red Rose Girls: An Uncommon Story of Art and Love* (New York: Harry N. Abrams, 2000).

32 "Why Art and Marriage Won't Mix—By Howard Pyle," *Philadelphia North American*, June 19, 1904; Jessie Trimble, "The Founder of an American School of Art," *Outlook* 85, no. 8 (Feb. 23, 1907): 455. Despite its confusing title, "Why Art and Marriage Won't Mix—By Howard Pyle" is an anonymous article *about* Pyle, not *by* him. The unknown author claims that Pyle "has cleared all the girls out of his school—closed the doors, excepting admission to a general lecture once a week. Only eight young men belong to his 'class.'" The article contains quotations from unidentified former female students and an illustration by Sarah S. Stilwell, another former student.

33 Pyle quoted by Cornelia Greenough in Lykes, "Howard Pyle, Teacher of Illustration," 342 n. 9.

34 Frederic Remington quoted in Nancy K. Anderson, "'Curious Historical Artistic Data': Art History and Western American Art," in Jules David Prown et al., *Discovered Lands, Invented Pasts: Transforming Visions of the American West* (New Haven: Yale University Press, 1992), 21.

35 Pyle, "Present Aspect of American Art," 131.

36 Abbott, *Howard Pyle: A Chronicle*, 10–13.

37 From a letter from Pyle to his mother, Dec. 5, 1876, quoted in ibid., 37.

38 Abbott, *Howard Pyle: A Chronicle*, 65–66.

39 Pyle to Stanley M. Arthurs, Dec. 21, 1910, quoted in ibid., 241–42.

40 Pyle to Arthurs, Jan. 11, 1911, quoted in Abbott, *Howard Pyle: A Chronicle*, 244–45.

41 Pyle, "Present Aspect of American Art," 138.

42 Ibid.

43 T. J. Jackson Lears, *No Place of Grace: Antimodernism and the Transformation of American Culture, 1880–1920* (New York: Pantheon Books, 1981), 164–65. Lears places Pyle within his important discussion of the turn-of-the-century enthusiasm for the Middle Ages, but mistakenly conflates into this Pyle's reference to Renaissance old masters. For accounts of Pyle's rewritings of the medieval King Arthur tales and concerns about masculinity, see Jeanne Fox-Friedman, "Howard Pyle and the Chivalric Order in America: King Arthur for Children," *Arthuriana* 6, no. 1 (spring 1996): 77–95; and Anne Scott MacLeod, "Howard Pyle's Robin Hood: The Middle Ages for Americans," *Children's Literature Association Quarterly* 25, no. 1 (spring 2000): 44–48.

44 Theodore Roosevelt presented "the strenuous life" in a speech of that title in Chicago in April 1899 and repeated the theme in many letters, public addresses, and publications. See E. Anthony Rotundo, "Body and Soul: Changing Ideals of American Middle-Class Manhood, 1770–1920," *Journal of Social History* 16, no. 4 (summer 1983): 23–38.

45 "Howard Pyle, Illustrator, 1853–1911: Some Notable Examples of His Work from *Harper's Magazine*," *Harper's Monthly Magazine* 124, no. 740 (Jan. 1912): 256; "A Half Score New Novelists," *Atlantic Monthly* 57, no. 340 (Feb. 1886): 265.

46 Pyle quoted in "Why Art and Marriage Won't Mix."

Joyce K. Schiller

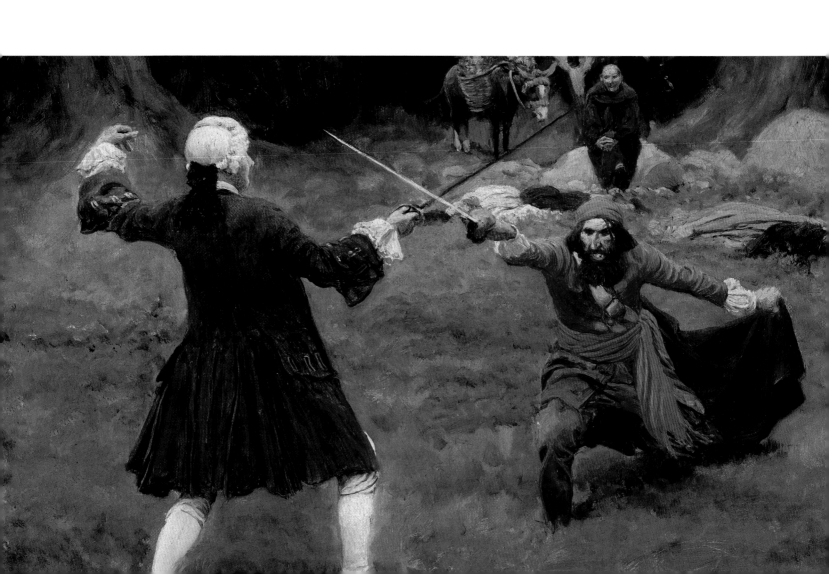

8. | TEACHING STORYTELLING

"When, however, I came under the tuition of Howard Pyle I began to think of illustration in a light different from that of a 'pot-boiler,'" Jessie Willcox Smith told a reporter in 1922.[1] Seeing the possibilities of illustration in a new light required conceiving of the field in a new way. What was it that Howard Pyle taught to his students to help them understand how to visually tell the story required? What did he do to give them an advantage when they sought commissions as professional illustrators? Most especially, how did Pyle himself make the leap to being one of America's great illustrators of the fin de siècle, when, like most artists of the nineteenth century, his own training was based on the standard formula of lessons anchored in line, space, perception, and color?

While living in New York and studying at the Art Students League, Pyle pursued his career as an illustrator. Since there was no codified instruction in how to create illustrations, Pyle assumed his nascent skills were sufficient to the task and sought assignments to produce work for some of the nation's most respected weekly and monthly periodicals. Although his ideas about teaching illustration would find rapid acceptance in the 1890s, some of his early sub-

missions were not considered adequate for direct transference to woodblocks by engravers, and they were redrawn by artists in the periodicals' employ.[2] As much as that must have singed the young Pyle's artistic ego, it was not his compositions that were considered deficient but his methods: he needed to adapt his style and refine his figure drawings for the demands of reproduction. Consulting with art editors and continuing to attend the Art Students League, Pyle made a conscious effort to improve his work. By 1880 his drawings were easily transformed into printable woodblocks by professional wood engravers. Pyle was soon attracting praise for the boldness of his illustrations and his ability to find a believable and engaging focus for his images.[3]

True or not, even a critic at the *New York Times* assumed that the creation of illustrations—in other words, learning by doing—developed an artist's ability to make convincing storytelling images. As one wrote, "The young men who design for the illustrated papers get a facility in composition and strength of expression which nothing else teaches."[4] This point of view was echoed nearly fifty years later when John W. Vandercook recounted Pyle's career in an issue of the *Mentor*:

For years he devoted himself exclusively to that department of Art, pushing forward with energy and courage—for a while almost alone—and pouring into hundreds of illustrations such sincerity, enthusiasm and dramatic force that the world of magazine and book readers gazed upon his work with amazement . . . In all forms of illustrative art he was easily the master.[5]

His successes convinced Pyle that it was direct experience infused into a two-dimensional image that produced the best illustration results. In 1902 Pyle would describe fully the challenge of being an illustrator:

Illustration is the rarest and the most difficult of all the Arts, for he who would practise [sic] it cannot depend upon mere craftsmanship alone to produce his results. Craftsmanship he must possess, and must possess it in a very ample measure. He must be a draughtsman, and he should be a colourist; he must have a knowledge of tonic values, and a true sense of relation and of proportion; composition must be at his command, and a correct instinct for the value of lights and darks . . .

He must know the men who live in the world about him before he may hope to depict their mimic images upon the pages of his book; he must understand with sympathy their joys and sorrows, their hopes and despairs; he must know how they laugh and how they weep before he can paint for you the thousand-fold expression of the human countenance divine . . .

And the Illustrator cannot spend weeks and months upon his work. His pictures must be made not only perfectly but quickly. He must set forth sharply and instantly that which he has to say of man and of the world of Nature.[6]

Pyle's understanding of and commitment to achieving success as an illustrator would make him an effective and inspiring teacher. Most importantly, it was his experience that aided this goal. He had, through trial and error, found a

path to success that he offered to share with students when he began to teach in the 1890s.

It took almost two decades as a professional illustrator for Pyle to begin to codify, in his approach to teaching, what appears to have been a natural talent. In fall 1894 Pyle began teaching classes in illustration at Philadelphia's Drexel Institute of Art, Science and Industry. Building on the popularity of these courses, from 1896 to 1900 he directed and taught in the Drexel Institute's School of Illustration. The school's program included lectures on "practical illustration," which stressed composition, and courses in drawing from the costumed model, architectural drawing, and design and decoration.[7] A new departure in art education, Pyle's illustration courses were described in detail in an article in the *New York Times*:

Howard Pyle, the well-known and deservedly popular draughtsman, has a class at the Drexel Institute, in Philadelphia, that is unique in its way. It differs entirely from the ordinary classes in composition, in that the pupils are kept constantly at work on one or two subjects during the entire term, so that they modify their original drawing many times before it becomes a finished piece of work. Mr. Pyle selects these subjects, and the first step consists in the pupil's execution of the idea in a charcoal sketch. This is submitted to the teacher, who critcises [sic] it and hands it back for overhauling. The finished illustration is made in black and white oil. Not only do the highest-grade students at the institute take the course, but Mr. Pyle's class every Saturday is attended by a number of pupils from other schools, as well as by several of those who are already known as illustrators.[8]

Refining his methods, in 1898 Pyle arranged that a summer class be offered through the school, by invitation only, to about a dozen of his most talented students. He hoped that direct experience with the generation of specific products—images that would help tell a written story—might provide the proper stimulus for their education as illustrators. Dur-

ing these summer sessions, held in Chadds Ford, Pennsylvania, for three consecutive years, Pyle's students studied and sketched from models and nature and also worked on "compositions . . . intended for publication in book form or for use in periodicals."[9] The previous summer, through an article published in *Harper's Weekly*, he had shared his evolving approach with the public, writing about his effort "to embody certain experimental methods into a practical form." He continued:

> Fundamentally that instruction was based upon teaching the student to represent his impressions or his ideas in the practical form of a composition drawn with charcoal . . .
>
> It seems to me that unless the artist has some emotion or some impression or some real thought to express, it is useless to waste time in teaching him the technique required to express emotions, impressions, or thoughts upon canvas. Unless there is some meaning to convey, the technical vehicle to carry a meaning cannot, it seems to me, be of any use.[10]

Pyle resigned from the Drexel Institute in 1900, choosing instead to offer classes to advanced students in Wilmington, Delaware. He built three new studios adjoining his own and called the undertaking the Howard Pyle School of Art. In summer 1901 Pyle resumed taking students to Chadds Ford. Each week they turned in compositions in progress, and Pyle selected several for commentary on Monday nights.[11] Some of the most revealing of Pyle's instructions as a teacher may be found in the handwritten notebook kept by his students Ethel Pennewill Brown and Olive Rush, who transcribed Pyle's comments from his Monday night lectures beginning in 1904.

Pyle dispensed some practical advice, directing his students to select their subjects and points of view with care. For Pyle, the instinct to create an image was in part based in the material at hand. In a 1906 letter to the author James Branch Cabell, Pyle thanked him for providing an extra bit of description of one of the characters in his story "In the Second April" (1907), so that Pyle could "find first-rate illustrations in it" (see fig. 94).[12] Pyle cautioned against choosing an image to illustrate because it was picturesque. Rather it "should hold some great truth."[13] The illustrations needed to be prods to the imagination.

Effective composition was at the heart of Pyle's program. As James Gurney discusses in his essay in this book, Pyle taught that there should be only "one great point of interest in a picture."[14] He also explained: "In painting we can only picture the supreme moment leaving to the imagination what precedes and follows."[15] A couple of months later Pyle further elaborated on this point during a critique of N. C. Wyeth's picture of a pony race:

> A while ago I said that the moment of violent action is not so good a point to be chosen as the preceding or following instant. Here the interest lies in the excitement of uncertainty & eagerness to know who shall win, and this interest is heightened by seeing the figures in greatest action.[16]

A week later Pyle said: "To put figures in violent action is theatrical and not dramatic."[17]

Even with the right subject and a captivating composition, Pyle acknowledged, an artist still needed the basic skills to be capable of producing something beyond a mere image: "As you know it takes five years to learn how to paint a picture and then you come to find that you only have to imagine things vividly and make them real as they are."[18] Often, and especially when speaking of imagination, Pyle sounded almost mystical in his directions, declaring, "A matter of tones will not make a picture but one must imagine and feel it all vividly."[19]

A glimpse of what Pyle was trying to communicate may be inferred when he advocated living in the moment depicted in each illustration. At one of the Monday night sessions, he was looking at the work of a student named Du Bois, a painting of an old man and a child walking through the grass.[20] Pyle's comments posed questions: "Don't you know how one does when the grass is knee-deep? How one's

Figure 94. Howard Pyle (1853–1911). *The Duel between John Blumer and Cazaio*. For James Branch Cabell, "In the Second April." *Harper's Monthly Magazine*, April 1907. Oil on canvas, 24¼ × 17⅜ inches. Delaware Art Museum, Museum Purchase, 1912

muscles strain as the feet are entangled in the weeds and grasses? And how, on looking backward one sees the waving grass moving like the sea with the dark pathway where one has been? . . . The thought must be complete."[21] These sorts of questions were meant to lead the student into expressing his physical experience on the canvas.

To tell the story in a picture, Pyle urged his students, submit the subject "to the crucible of your own imagination and let it evolve into the picture. Project your mind into it—identify yourself with the people and sense—that is, feel and smell the things naturally belonging there."[22] He advocated "living *in* a subject," the projection of one's own perception into the character or the situation one wished to portray.[23] Pyle counseled N. C. Wyeth that he should live with the things he wanted to picture or, by using his imagination, visualize the objects as if he "*had* lived with them."[24] This was "a novel approach in that day of academic training," in the words of Wyeth's biographer, David Michaelis, who continues:

> Working alone in turn-of-the-century Wilmington, Pyle had discovered that by merging his feelings with the factual reality of the world of objects, he produced pictures that made conventional illustration look wooden. At his easel, Pyle "fought, sang, struggled, and sobbed through his work."[25]

One student, Allen Tupper True, attempted to communicate Pyle's teachings back to his family in his letters home. He quoted Pyle: "Have something to say . . . and live in your picture." True concluded, "A person has got to illustrate the life that he knows about . . . and my sphere seems to be the West."[26] While being immersed in a locale or lifestyle certainly would help an illustrator with his or her perceptions, that was not exactly what Pyle seemed to have had in mind. He wanted the illustrator to feel a story instinctively. The goal was to create vivid images full of movement and believable life. For example, if an illustrator wanted to paint grass, he or she should observe a blade of grass and study how it looks and moves, adapting that experience of perception to an expression of it on the canvas.

Through his exhortations, Pyle managed to shape his students' understanding of how to visually tell a story as required. While it may not be possible to take Pyle's encouragement to live in one's subject and derive from it a specific method of instruction, his approach was successful both for himself and for his students. That said, it should also be acknowledged that not everyone applauded Pyle's approach to picturing a story. After Pyle gave a presentation to Yale University's art students and before another at the School of the Art Institute of Chicago in 1903, the *New York Times* reported: "His lectures at Yale are said to have been too radical to please the art department of the university."[27]

NOTES

1 Jessie Willcox Smith quoted in Mary Haeseler Dougherty, "Peter Pan's Portrait Painter," *Philadelphia Public Ledger*, July 16, 1922.

2 Howard Pyle's struggles to adapt his technique, as well as his visits to engravers to improve it, are described in letters to his mother dating from November to December 1876. Quoted in Charles D. Abbott, *Howard Pyle: A Chronicle* (New York: Harper and Brothers, 1925), 19–43.

3 "Our Best Illustrators: The Great Progress Made in Pictorial Work," *New York Times*, Nov. 7, 1880.

4 "The Water-Color Society," *New York Times*, Feb. 6, 1881.

5 John W. Vandercook, "Howard Pyle: Artist, Author, Founder of a School of Illustration," *The Mentor* 15, no. 5 (June 1927): 1.

6 Howard Pyle, "Concerning the Art of Illustration," in *First Year Book* (Boston: Bibliophile Society, 1902), 18–20.

7 Drexel Institute of Art, Science and Industry, *Catalogue of School of Illustration under the Direction of Howard Pyle* (Philadelphia: Drexel Institute of Art, Science and Industry, 1896).

8 "Art Notes," *New York Times*, Jan. 14, 1896.

9 Drexel Institute of Art, Science and Industry, *Catalogue of Exhibition of Work Done by Students of the Summer School, Session 1899, under the Direction of Howard Pyle* (Philadelphia: Drexel Institute of Art, Science and Industry, 1899), unpaginated.

10 Howard Pyle, "A Small School of Art," *Harper's Weekly* 41, no. 2,117 (July 17, 1897): 710–11.

11 After 1903 Pyle did not offer regular classes in Chadds Ford. In 1905 he stopped teaching formal classes, yet continued to offer constructive criticism to former students and other artists at their request. Rowland Elzea, "Introduction," in Elzea and Elizabeth Hawkes, eds., *A Small School of Art: The Students of Howard Pyle* (Wilmington: Delaware Art Museum, 1980), 3.

12 Pyle to James Branch Cabell, Nov. 3, 1906, James Branch Cabell Papers, 1860s–1960s, Series 1, box-folder 2.50, Special Collections and Archives, James Branch Cabell Library, Virginia Commonwealth University, Richmond. Photocopy in Howard Pyle Manuscript Collection, Helen Farr Sloan Library and Archives, Delaware Art Museum.

13 Ethel Pennewill Brown and Olive Rush, "Notes from Howard Pyle's Monday Night Lectures, 1904–1906," June 20, 1904, 2, Howard Pyle Manuscript Collection, box 3, folder 2, Helen Farr Sloan Library and Archives, Delaware Art Museum. While the Howard Pyle School of Art's classes were limited to twelve students, Pyle welcomed others to join his lectures on composition. Allen Tupper True to Henry Alfonso True, May 24, 1902, Allen Tupper True and True Family Papers, 1841–1987, microfilm reel 4892, Archives of American Art, Smithsonian Institution, Washington, D.C.

14 Brown and Rush, "Notes from Howard Pyle's Monday Night Lectures," June 20, 1904, 2.

15 Ibid., June 27, 1904, 9.

16 Ibid., Aug. 15, 1904, 38.

17 Ibid., Aug. 22, 1904, 38.

18 Ibid., Aug. 8, 1904, 28.

19 Ibid., June 20, 1904, 4.

20 Ibid., "List of Students," Nov. 15, 1904, 1. The last name in the right-hand column of this list is "Mr. Du Bois"; that individual has not been identified specifically.

21 Ibid., Nov. 15, 1904, 70–71.

22 Ibid., June 20, 1904, 2.

23 Ibid., 3.

24 Ibid., June 27, 1904, 6.

25 David Michaelis, *N. C. Wyeth: A Biography* (New York: Alfred A. Knopf, 1998), 61.

26 Allen Tupper True to Margaret Tupper True, Apr. 25, 1903, Allen Tupper True and True Family Papers, 1841–1987, microfilm reel 4892, Archives of American Art, Smithsonian Institution, Washington, D.C.

27 "Art Notes," *New York Times*, Oct. 11, 1903.

Virginia O'Hara

9. INSPIRING MINDS: HOWARD PYLE AND HIS STUDENTS

An extraordinarily perceptive and able teacher, Howard Pyle forged an atmosphere of high artistic creativity in the studio. His classes were unlike any others his many students had experienced. They marveled at how he was able to "dispel the gloom of the art school" and "simply blew away all that depressed atmosphere and made of art an entirely different thing."[1] While it was true that Pyle required the traditional art-school training of drawing from plaster casts, regarded by most art students as necessary drudgery, his approach was different. He made them see that drawing was the first step in creating pictures. It was the crucial point where ideas, emotion, and imagination crystallized and gave purpose and meaning to art. And he suggested the idea—incredible to them—that drawing was easy if they just would observe.[2]

The impact of Pyle's philosophy and persona on students was immediate. His teaching was not abstract in method or discussion. He told his students he could offer them "twenty years of practical experience in illustration, and . . . a few things that will be helpful to those of you who are beginning,"[3] explaining what worked and did not work in a picture and why that was so. Many would agree that his encouraging manner, together with "his whole spirit, the spirit that he breathed into the field of illustrative art," made all the difference to those he taught.[4] As artist Elizabeth Shippen Green put it, "It seems to me he did not so much teach me how to draw, but he taught me how to interpret life."[5] During Pyle's 11 years of teaching and even more in giving professional advice, over 150 young, and some seasoned, artists learned "a few things" from Pyle. Moreover, the successful careers of these artists—among them, John Wolcott Adams, Stanley M. Arthurs, Clifford Ashley, Ethel Franklin Betts, Harvey Dunn, Walter Everett, Green, Thornton Oakley, Violet Oakley, Frank Schoonover, Jessie Willcox Smith, Allen Tupper True, and N. C. Wyeth—testify to the importance and impact that Pyle's standards had on book and magazine illustration. A number of the students became teachers and promoted Pyle's classroom approach, furthering the legacy of the so-called Brandywine School, for future generations of professional illustrators.

PYLE AS A TEACHER

While at the peak of his career as an illustrator, Pyle sought to develop a training program specific to his profession. He

offered his teaching services to, yet was refused by, the Pennsylvania Academy of the Fine Arts and was subsequently approached by the Drexel Institute of Art, Science, and Industry in Philadelphia. Pyle's first class at Drexel met on Saturday afternoons in the fall semester of 1894. By 1896, to accommodate the overwhelming popularity of Pyle's class, which had been continued, Drexel created the Department of Illustration with him as its director. The curriculum included lectures on illustration in black and white, the study of facial construction and expression, and the creation of effective compositions. He discussed drawing and painting as a practical matter based on common sense, and his students commended his conviction, humor, and encouragement. Green remembered Pyle saying in a critique: "You will have noticed how a piece of white paper in shadow is darker than a black coat in sunlight." She continued, in her own words: "You might have noticed it, or you might not have, but he made you feel that you had. He included you in his observations on life, and made you feel that you had thus observed yourself."[6]

The students were instructed by Pyle to draw and paint the costumed model instead of the nude. Pyle believed this practice, a break with traditional teaching methods, would help students interpret the figure from a creative point of view instead of merely imitating what they saw.[7] He brought in period artifacts and props to create the feel, and even the smell, of another time and to stress the importance of accuracy in details. Pyle urged his students to gain knowledge of unfamiliar subject matter through travel and research, so they could paint with solid authority. Pyle had demonstrated evidence of this in his own work: his trip in 1889 to the West Indies incubated his own stories and memorable illustrations of pirates and sea lore.

Other aspects of Pyle's teaching were backed by his example. In addition to the availability of Pyle's published works for study, his paintings and drawings could be closely evaluated by students in a special exhibition held at Drexel in 1897. Also Pyle would assign themes preoccupying him in his own work. Surviving photographs of models posed for classes suggest strong relationships between classroom set-ups and his completed works (see figs. 95 and 96). Sketches he made for demonstration during class also afforded students the opportunity to see how his ideas developed. As he drew and painted with them, Pyle shared his excitement of searching for the idea, then the joy of elaborating the form.[8]

Of singular importance to Pyle was teaching students to mentally project themselves into their pictures and become the character they portrayed. An artist must "observe the emotions, the thoughts, the actions of his fellow-men," and "be taught not alone to draw the face from a model, but to reproduce it from his memory. I would have him learn, thus, from memory and from imagination, all the forms and all the subtleties of form of the face."[9] This would eventually enable them "to paint the human figure [so] that it shall appear to live and move and to breathe in a world of its own."[10] This part of Pyle's instruction was embedded in his work as a successful author and illustrator.

The opportunity to create work for publication under Pyle's guidance attracted many students. Beginning in 1896 Pyle made this a key feature of his curriculum and vigorously promoted his best students to publishers. Publishers agreed to send him manuscripts, and class members competed to win commissions. In some cases one or two students would work on a project together, while perhaps four or five (and Pyle too) simultaneously contributed illustrations for the same book. Among the projects undertaken by Pyle's classes at Drexel were illustrations for Paul Leicester Ford's *Janice Meredith: A Story of the Revolution* (1899), Mary Johnston's *To Have and to Hold* (1900), Henry Wadsworth Longfellow's *Evangeline* (1897), and Everett T. Tomlinson's *A Jersey Boy in the Revolution* (1899). In addition, Pyle's students created drawings and paintings for *Collier's Weekly*, *Harper's Monthly*, and the *Saturday Evening Post*, among other popular magazines of the day.

In 1898 Pyle convinced Drexel to arrange for the funding of a summer school with scholarships for ten students. A limited number of additional students were invited to attend at their own expense. For its location Pyle recommended the village of Chadds Ford, thirty-five miles west of Philadelphia. It was not far north from his home in Wilmington,

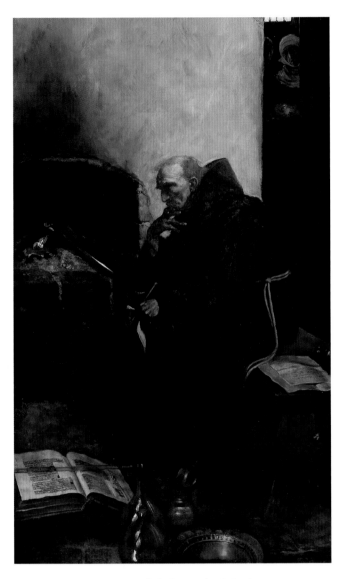

Figure 95. Howard Pyle (1853–1911). *"Friar" Bacon in His Study*, 1903. Oil on canvas, 35⅛ × 20⅛ inches. Collection of Brandywine River Museum, Gift of Mr. and Mrs. Howard Pyle Brokaw, 2007

Figure 96. Unknown photographer. Posed model in Howard Pyle's class at Drexel, 1899. Photograph. Brandywine River Museum Library, Special Collections, Gift of Mr. and Mrs. Howard Pyle Brokaw

Delaware, and family connections would facilitate the use of various buildings for a class studio as well as housing for students and Pyle's family. His conviction, as summarized in the text of an exhibition catalogue produced by the summer school, was that "Nature might stimulate those aspirations for truth and beauty not always evoked by the walls of a school-room."[11]

In truth, the summer program would offer Pyle respite from traveling to Philadelphia to teach and alleviate his frustration about working with an unwieldy number of students, including some who proved not to have the requisite talent, dedication, or imagination. Pyle's summer school would operate for five years, from 1898 through 1903, skipping 1900. In 1898 and 1899 the summer school was sponsored

Figure 97. Unknown photographer. Howard Pyle's students painting in Chadds Ford, 1899. Photograph. Brandywine River Museum Library, Special Collections, Gift of Mr. and Mrs. Howard Pyle Brokaw

by Drexel, but it was discontinued when Pyle resigned from teaching there. Pyle would offer the Chadds Ford summer program again through his own school in Wilmington, the Howard Pyle School of Art, from 1901 to 1903. For participants, it was a mixture of play and hard work, as students made drawings and painted landscapes from early morning until late afternoon. The region's natural setting and historic buildings served as the background for models in colonial garb and gave the students a sense of earlier times (1899, fig. 97). Daily life and art became inseparable experiences. The students painted farmers in the field and villagers at work, wandered and sketched the countryside, observed wildlife, had humorous, if not hazardous, encounters with farm animals, and soaked off the summer heat and dust in the cooling waters of the Brandywine River.[12]

The American Revolution's Battle of the Brandywine had been fought in and around Chadds Ford. Pyle, the avid historian, launched impromptu buggy rides through the battle site, enthralling students with his "vivid description of the battle and all the minute details and anecdotes."[13] The historic region inspired subjects for painting during that first summer, such as "A Rest from War," "A Waif from the Battle," and sketches of the headquarters of Generals Lafayette and Washington. Some students used the setting to work on illustrations for publication: Winfield S. Lukens's oils for James Otis's *The Charming Sally: Privateer Schooner of New York: A Tale of 1765* and Sarah S. Stilwell's images for Ellen Olney Kirk's *Dorothy Deane: A Children's Story* were both published by Houghton, Mifflin and Company in 1898. The students' model studies, landscapes, and commissioned illustrations were displayed in an exhibition at Drexel in fall 1898.[14]

In the process of learning Pyle's principles, it was natural that many students attending his classes at Drexel and later in Wilmington would emulate his style. This tendency was both noted by students and remarked about in published reviews of the exhibitions of their work.[15] Expressing his concern, Pyle said, "My close criticism is apt to leave the impress of my style, but I do not desire this. I make every effort to encourage individual vein and peculiarity."[16] Most of the students got through this phase by integrating Pyle's teaching with their other aesthetic interests, as they developed their individual styles.

In February 1900 Pyle resigned from Drexel to better economize his time for his own art, as well as for lecturing, researching, writing, and teaching. The school he opened in Wilmington in September 1900 included three new studios

near Pyle's own. Admittance was limited to twelve students, who paid no tuition but assumed the costs of studio space and supplies. Pyle was able to have more control over his student body in this fashion. He stated: "The pupils whom I choose shall possess, first of all, imagination; secondly, artistic ability; thirdly, color and drawing; and I shall probably not accept any who are deficient in any of these three requisites."[17]

Pyle's format for teaching at Wilmington followed the Drexel curriculum. By this time publishers and their editors at such publications as *Century Magazine*, *Harper's Monthly*, *Saturday Evening Post*, and *Scribner's* had come to depend upon Pyle's recommendations for illustrators. Many issues of these weeklies and monthlies would contain at least one, but usually several, illustrations by current students of Pyle. As advanced students and graduates shouldered their portfolios to Philadelphia and New York to seek jobs, William Fayal Clarke, editor of *St. Nicholas*, joked:

> A file of pupils shortly began to stream out from his [Pyle's] hospitable class-room into New York editorial offices! One day, when passing into the Art Department of the Century Company, I found the waiting-room so crowded that I whispered to Mr. Drake that he would better put up a placard reading: "The line of Howard Pyle's pupils forms on the right!" . . . It is more than likely that several of the leading illustrators of today were in it![18]

PYLE'S STUDENTS: THEIR EXPERIENCES
AND CAREERS
The women in Pyle's Drexel class found solidarity in the serious pursuit of art and shared a taste for drawing decorative lines and patterns. Although Pyle later complained that some of his former female pupils produced linear works that were affected and less serious,[19] Elizabeth Shippen Green, Violet Oakley, and Jessie Willcox Smith, in particular, became stars in his legacy. Their preparations for entering the field of illustration were different, but each had academic artistic training and had published illustrations prior

to study with Pyle. Living in a time when career choices for women were still very limited, they showed more drive for an artistic life than for marriage and family. Pyle's guidance sharpened their skills and gave clearer direction to their ambitions.

Pyle was known to caution his students that marriage would ruin a woman's artistic career.[20] (Marriage and children certainly ended or limited the professional aspirations of some female students including Bertha Corson Day, Caroline Gussman, and Charlotte Harding.) Although Pyle was gibed for occasionally expressing conventional views about women, there was apparently no difference in the instruction and encouragement he provided to male and female students.[21]

Many of the male students in Pyle's program gravitated to scenes of action and drama. Of the young men who studied under Pyle, from beginners to experienced illustrators, many were attracted by his comprehensive knowledge of history and his skill in rendering action. As they matured, a number of them emphasized such scenes in a robust manner by thickly applying paint in bold brushstrokes. During their time at Pyle's school in Wilmington they formed factions and competed actively with each other. Among them, Thornton Oakley, Frank Schoonover, and N. C. Wyeth had been raised on the exciting and informative world presented in popular magazines, and, undoubtedly, their youthful impressions were an influence in their early work. While each had drawing skills, none had received thorough training at a traditional art school prior to attending Pyle's classes. The critical success they later achieved testifies to Pyle's skill at kindling students' imaginative powers.

Elizabeth Shippen Green
When Green entered Pyle's class at Drexel, she had studied at the Pennsylvania Academy of the Fine Arts between 1889 and 1893, under Robert Vonnoh and Thomas Anshutz. Despite her academic milieu, she had paid close attention to the images in illustrated periodicals. After graduation she contributed drawings to the *Philadelphia Public Ledger*, worked as a fashion illustrator for Strawbridge and Clothier,

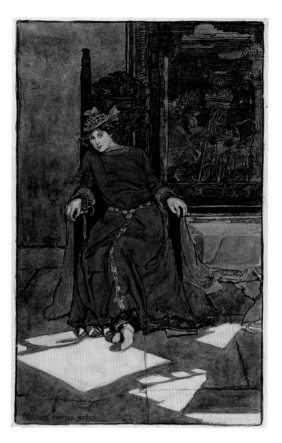

Figure 98. Elizabeth Shippen Green (1867–1954). *I Was Alone in a Palace of Leaves.* For Richard Le Gallienne, "Our Tree-Top Library," *Harper's Monthly Magazine*, March 1902. Charcoal and wash on paper, 27³⁄₁₆ × 18⅜ inches. Collection of Brandywine River Museum, The Claniel Art Acquisition Fund, 2003

Figure 99. Elizabeth Shippen Green (1867–1954). *She Was Lying Back, Watching Him, in the Great Chair.* For Warwick Deeping, "Tiphaine la Fée." *Harper's Monthly Magazine*, April 1906. Watercolor on illustration board, 23½ × 14½ inches. Delaware Art Museum, Samuel and Mary R. Bancroft Memorial, 1935

and was on staff at *Ladies' Home Journal.*[22] She enrolled in Pyle's courses at Drexel, signing up for lectures on composition and practical illustration and for figure drawing, in which students drew from costumed models. There she befriended Oakley and Smith.

After finishing Pyle's program at Drexel and returning from a tour of Europe, Green joined Oakley and Smith at an apartment the two had moved into on Chestnut Street in Philadelphia.[23] The three continued to share living and studio quarters subsequently at the Red Rose Inn and later at a house they called Cogslea, forging a lifestyle that supported them both financially and spiritually. In 1911 the women dissolved their domestic partnership due to Green's marriage, Oakley's strict Christian Scientist views, and the women's diverging and demanding careers.

Green's mature drawings emphasize elegant and delicate linear qualities and variations in texture. Many of her works continued to show allegiance to Pyle and his teaching in their content and compositional approach. In addition, some drawings show Green's use of photography as a tool to develop composition and tonal value (1902, fig. 98). She garnered a steady stream of assignments for *Ladies' Home Journal* and the *Saturday Evening Post*, and in 1901 signed an exclusive contract with *Harper's Monthly* that continued until 1924 (1906, fig. 99).

Violet Oakley
Already well advanced in drawing skills and technique when she arrived at Pyle's school in 1897, Oakley quickly caught on to Pyle's instruction. She had been encouraged to draw and

participate in the arts from early childhood. After studying in France and England, she began study in the United States in 1896 under Cecilia Beaux, the first woman artist hired to teach at the Pennsylvania Academy. When her family's fortunes declined, Oakley decided to shift her focus to illustration, enrolling in Pyle's class.[24] He teamed her with Smith to illustrate a new edition of Longfellow's epic *Evangeline*. Using strong and limited values and creating a palpable sense of atmosphere, their drawings for the book closely reflect Pyle's lessons in composition. Oakley finished Pyle's illustration program at Drexel in June 1897 and then moved to Philadelphia.

Her interests eventually shifted away from book and magazine illustration. Her skill in composition and her expressive use of strong lines reportedly led Pyle to suggest that her artistic gifts lay in stained-glass design (1899, fig. 100). Oakley enthusiastically pursued this medium in a design for All Angels' Church in New York City in 1900.[25] The same year she also took on the challenge of painting murals for the Pennsylvania State Capitol in Harrisburg, which, upon completion in 1906, received much acclaim for their depictions of William Penn and the founding of Pennsylvania (c. 1903, fig. 101). In style, the strong, outlined images read like large book illustrations. They pay homage to Edwin

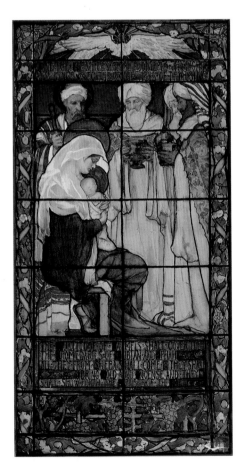

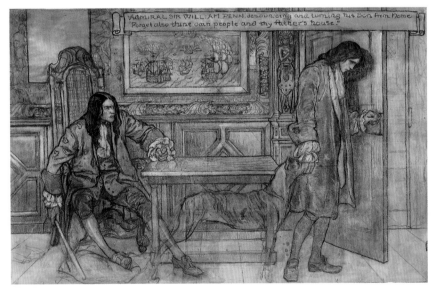

Left: Figure 100. Violet Oakley (1874–1961). *The Epiphany* (Study for a stained glass window), 1899. Watercolor, gouache and ink on board, 23¾ × 11⅜ inches. Delaware Art Museum, Gift of the Violet Oakley Foundation, 1982

Above: Figure 101. Violet Oakley (1874–1961). *Admiral Sir William Penn, Denouncing and Turning His Son from Home, "Forget Thine Own People and Thy Father's House"* (study for mural in the Pennsylvania State Capitol, Harrisburg), c. 1903. Charcoal on paper, 18 × 27 inches. Collection of Brandywine River Museum, Museum Volunteers' Purchase Fund, 1978

Austin Abbey's murals at the Boston Public Library and in Harrisburg, as well as to the work of Pyle. In 1911, shortly after Abbey's death, she was commissioned to complete an additional series of murals that he had begun. These two major mural projects would comprise forty-three murals and more than twenty-five years of work for Oakley.

Jessie Willcox Smith

Already a published illustrator but not yet seasoned in her style or approach, Smith joined Pyle's first class at Drexel in 1894 at the age of thirty-one. She had formerly been a kindergarten teacher and then took classes at the Philadelphia School of Design for Women in 1885. Dismayed by the finishing-school-like operation she found there, she subsequently enrolled in the Pennsylvania Academy of the Fine Arts.[26] A newcomer to the cosmopolitan world of art and by nature pragmatic and reserved, she did not find this institution to be a perfect fit either. She later remarked: "At the Academy we had to think about compositions as an abstract thing, whether we needed a spot here or a break over here to balance, and there was nothing to get hold of."[27] Nonetheless, she stuck it out, graduating in 1888 from the Academy after studying with Thomas Eakins, whom she privately called a mad man.[28]

Put off by the rarified air of Academy aesthetics and the perception of artistic life it gave her, Smith was uncertain of her future, but began to pursue the more practical path of illustration.[29] She was hired by the advertising department of the *Ladies' Home Journal* to draw images for advertisements, and she received a commission to create drawings for a children's book in 1892.[30] For inspiration she looked to English artist Kate Greenaway's dainty Arts and Crafts–style drawings of children in historical dress, as well as to the sentimental images of fashionably dressed cherubic children popularized by the American Maud Humphrey. Smith absorbed this mix of aesthetic design and popular imagery into her style, which she would further transform through study with Pyle. Like Oakley, Smith finished her formal study with Pyle in 1897 and moved to the Chestnut Street apartment.

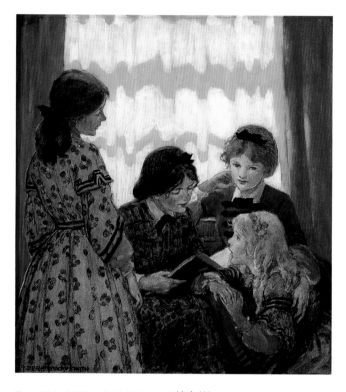

Figure 102. Jessie Willcox Smith (1863–1935). *Little Women*. For the cover of *Good Housekeeping*, February 1923. Mixed media on illustration board, 25½ × 24½ inches. Collection of Brandywine River Museum, Gift of the Women's Club of Ardmore, 1979

Smith went on to become America's foremost illustrator specializing in images of children and childhood. Her work epitomizes feminine ideals of domestic life in the late nineteenth and early twentieth centuries. Through Pyle's teachings she honed her sensitivity to the manner and expression of subjects, which would aid in her ability to develop techniques to best reveal their character. She combined charcoal, pastel, watercolor, and oil to emphasize linear qualities and to obtain varied textures. Smith was also able to integrate compositional elements from poster design, Japanese art, and the Arts and Crafts movement into her own style. Meeting with critical praise, the images she and Green jointly created for a calendar were published a second time, when they appeared alongside poems by Mabel Humphrey in *The Book of the Child* (1903). Her artistry was also widely celebrated

in such publications as an edition of Robert Louis Stevenson's *A Child's Garden of Verses* (1905) and *The Jessie Willcox Smith Mother Goose* (1914). She became famous nationwide through her cover illustrations for *Good Housekeeping*, which appeared from 1917 to 1933 (1923, fig. 102).

Thornton Oakley

In 1902, after graduating from the University of Pennsylvania, Philadelphia, with a degree in architecture, Oakley joined Pyle's summer school in Chadds Ford.[31] Unrelated to Violet Oakley, he had grown up in Pittsburgh, where he was energized by the city's sprawling industry and public works. After his father's death in 1897, Oakley had been persuaded by his mother to study architecture instead of art. Before his final year of college, however, he had applied to the Howard Pyle School of Art. With some hesitation concerning Oakley's thin background in art, Pyle agreed to give him a chance.

His first days painting in the field were rough:

> There we four—my new cronies—Allen Tupper True, George Harding, Gordon McCouch and I—made our first sketches from a model, and our efforts were frightful to behold! Not one of us had had a palette in our hands ever before; I had not the least idea as to procedure. My attempts were terrifying to behold, and when H. P. came to me to criticize my work he paused for a long, long time before speaking, and I know that he must have been appalled.[32]

For three years Oakley studied at the school in Wilmington, claiming later to never have heard a definitive statement from his teacher on method or technique, but much on "underlying spirituality," and how to "throw ourselves into the subject . . . heart and soul."[33] By 1904 the immersion in Pyle's teaching and principles brought transition and growth in Oakley's work and rewarded him with commissions from popular magazines.[34] Pyle made a deep and lasting impression on Oakley, and for a time Oakley's work paid obvious homage to Pyle's in composition and the theatrical expressions of figures. Gradually, Oakley transformed his awkward

beginnings into mature art. After he completed his training, Oakley moved to Philadelphia in 1905 and opened a studio, supporting himself by illustrating a range of subject matter for publication.

For Oakley, Pyle's counsel to know one's subject through direct experience inspired a return to what he already knew

Figure 103. Thornton Oakley (1881–1953). *Beneath the 6th Street Bridge/Fulton and Bessemer Buildings*, 1913. Mixed media on paper, 25¼ × 15¾ inches. Collection of Brandywine River Museum, Gift of Lansdale Oakley Humphries, 1983

best. Oakley's architectural education and early fascination with industrial power began to coalesce in illustration work focused on American industry and technology. He first made his name through a series of industrial landscapes created for "In the Anthracite Region," published in the *Century Magazine* in 1906.[35] He further demonstrated his interest in "the quest of man[,] his inventions[,] and his might" in a series of twenty-nine drawings of industrial history and progress in Pittsburgh (1913, see fig. 103). [36] A critic's comments on these drawings underscore Oakley's direct interpretation of Pyle's philosophies:

> In the power of their appeal, his drawings emphasize the fact that it is thought which makes art vital—not technique. His pictures represent realities—actual steel mills, gas tanks, railway stations and bridges of Pittsburgh.[37]

The same can be said of later projects, including a series made during World War II for the *National Geographic Magazine*, which celebrated the industrial might of wartime America.[38] In 1938–39 Oakley produced six murals celebrating milestones in science for the Franklin Institute in Philadelphia. After the war he painted works for the Pennsylvania Railroad, Philadelphia Electric Company, and Sun Oil. His interests in the exploration of foreign cultures continued, as he produced illustrated travel articles with his writer wife, Amy Ewing.

In 1914–19 and 1921–36, Oakley served as head of the Department of Illustration at the Pennsylvania Museum School of Industrial Art in Philadelphia, succeeding another former Pyle student, Walter Everett. He also taught drawing at the University of Pennsylvania. As a teacher, Oakley adhered tenaciously to the philosophies of Pyle and sought to rekindle the master's spirit.[39] However, young artists saw his approach as outdated and inapplicable to modern illustration. For over twenty years Oakley, the enthusiastic champion of modern technology, refused to see the reality of changing times in his own profession. In 1936 he finally retired. Taking on the mantle of historian, Oakley

focused on building a collection to memorialize Pyle and his school, much of which he donated to the Free Library of Philadelphia.

Figure 104. Frank Schoonover (1877–1972). *White Fang's Free Nature Flashed Forth Again and He Sank his Teeth into the Moccasined Foot (Canadian Trapper).* For Jack London, "White Fang, Part III—The Gods of the Wild." *Outing Magazine,* July 1906. Oil on canvas, 35⅜ × 19⅝ inches. Collection of Brandywine River Museum, Gift of Mr. and Mrs. Andrew Wyeth, 1985

Figure 105. Frank Schoonover (1877–1972). *Hopalong Takes Command.*
For Clarence Edward Mulford, "The Fight at Buckskin." *Outing Magazine,*
December 1905. Oil on canvas, 30 × 20 inches. Delaware Art Museum, Bequest
of Joseph Bancroft, 1942

Frank Schoonover

Schoonover was among Pyle's youngest students. While growing up, he had taught himself the basics of drawing by copying magazine illustrations, many of which were by Pyle. Learning of Pyle's illustration class in Philadelphia, Schoonover, with more enthusiasm and promise than able talent, enrolled in 1896 at Drexel. For three semesters he labored in introductory classes in the Department of Drawing and Painting and finally, in 1898, was admitted into Pyle's class.

Students like Schoonover—hardworking and fired with imagination—were the raw ingredients Pyle believed would make the best illustrators. He was convinced that too many art students and illustrators squandered their talent on displays of technique rather than meaningful expressions of life.[40] His teaching aimed to correct this habit and to populate the profession with serious-minded talent.

By the late 1890s Drexel was offering illustration classes according to students' level of ability. As many of Schoonover's surviving class studies show, the school's tiered instruction increased his drawing proficiency, improved his understanding of light and atmosphere, and developed his imagination in transforming costumed models into figures of the past. Winning a scholarship to Pyle's summer class in 1898, Schoonover painted landscapes and costume studies. In summer 1899 his advanced work prompted Pyle to offer him the opportunity to create illustrations for *A Jersey Boy in the Revolution* by Tomlinson.

Schoonover followed Pyle to the Wilmington school. There he accepted a commission to illustrate a novel by Gilbert Parker, which required a brief trip to the environs of Montreal and Quebec in 1902.[41] This experience stirred Schoonover's fascination with the Canadian wilderness. Acting on Pyle's advice to live around and be part of a subject, Schoonover seized an opportunity to embark on a wilderness adventure. Traveling on foot and by dogsled with Eskimo fur traders across northern Canada from November 1903 through March 1904, he lived as they did and learned the art of trapping small game. In temperatures well below freezing, he constructed a canvas hut heated with a wood stove, where he sketched, painted, and photographed his experiences. Schoonover chronicled this trip in a two-part article for *Scribner's* in 1905.[42] His Canadian sojourn also served as a direct reference for his illustrations to Jack London's "White Fang" (1906, fig. 104).[43]

After Pyle closed his school, Schoonover opened his own studio in 1906 in Wilmington. He and fellow Pyle student Arthurs kept close ties with Pyle and assisted him with a mural commission for the Hudson County Courthouse, Jersey City, in 1910. Schoonover also traveled on assignment

to Colorado and Montana, making photographs and sketches for articles. His drawings of cowboys for magazine stories and books assisted Clarence Edward Mulford in conceiving his character Hopalong Cassidy (1905, see fig. 105).[44] Whereas Schoonover undertook a wide range of subjects for illustration, his paintings, drawings, and photographs of outdoor experiences have remained among his best work.

In 1942 Schoonover opened his own art school in Wilmington, where he taught for nearly thirty years. As book and magazine illustration began to wane by the mid-twentieth century, Schoonover devoted more time to painting and exhibiting his landscapes.

N. C. Wyeth

In 1902, not long after Thornton Oakley's arrival at Pyle's school and before Schoonover's first Canadian adventure, a new student, Newell Convers Wyeth, arrived in Wilmington from Massachusetts. Wyeth's enthusiasm and imagination for illustration were well primed before he came to Pyle's school, although his facility and accuracy in drawing were not. Pyle accepted Wyeth on a trial basis.[45] Wyeth was soon able to achieve a better handling of paint and more fully comprehend Pyle's words in each successive work. His first work published as a Pyle student was an image of a bronco buster for the cover of the February 1903 issue of the *Saturday Evening Post*. Attending the last session of Pyle's summer school in 1903 instilled in Wyeth a deep love for Chadds Ford, which would become the subject of significant paintings and eventually his home.

Upon his graduation from Pyle's tutelage in 1904, Wyeth's avid fascination for the West spurred his impulse to take Pyle's advice and experience it firsthand. His trips through Colorado, New Mexico, and Arizona in 1904 and 1906 brought direct experience of ranching and herding, as well as Native American and cowboy life. Like Schoonover, he shared this knowledge in articles for *Scribner's*.[46] Through his travels Wyeth honed his understanding of color, which, as Pyle had explained, was increasingly important in creating works for reproduction. This was soon evident in his series of paintings of eastern woodland Indians published by *Out-*

Figure 106. N. C. Wyeth (1882–1945). *In the Crystal Depths*, 1906. For "The Indian in His Solitude." *Outing Magazine*, June 1907. Oil on canvas, 38 × 26 inches. Collection of Brandywine River Museum, Museum Purchase, 1981

ing Magazine as a portfolio of reproductions (1906, fig. 106),[47] which became known for their complexity of mood, composition, and color.

Driven by a vivid imagination, poetic feeling, and passion to reach a higher artistic plane, Wyeth eventually began to diverge from Pyle's philosophies by asserting the limitations of illustration. In confidence to Sidney M. Chase, Wyeth wrote: "I have come to one *conclusion*, and that is painting and illustration *cannot* be mixed—one cannot merge from

one into the other . . . The viewpoints of the illustrator and the painter are so entirely different."[48] Wyeth's enthusiasm "for *practical* work" was "replaced by the desire for a bigger and *lasting* achievement."[49] As Wyeth increasingly sought art as the means to express the core of his being he saw illustration as a dead end.

However, with a young, growing family to support, he could not cut his ties to illustration. Instead, he read widely and forged ties with other important artists and art-world

figures, which influenced his experimentation in painting and led him to exhibit independent works. Working frequently on large canvases, Wyeth painted in an exuberant manner, imbuing them with nuances of light, shadow, and color and rendering his figures with a full range of expression. His 1911 illustrations for a new edition of Stevenson's classic, *Treasure Island*, were masterful, painterly works that established his fame and importance as an illustrator (1911, fig. 107). Throughout his long and successful career, his

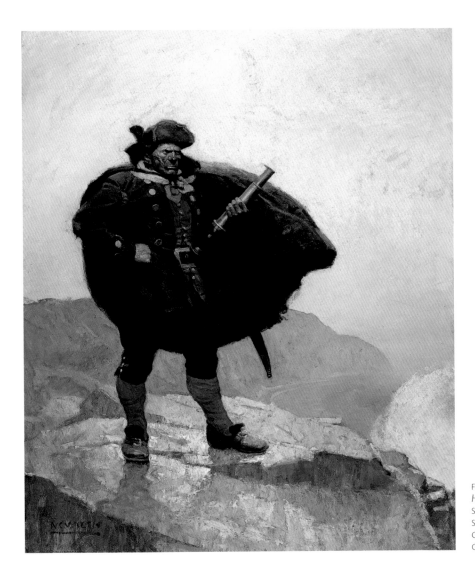

Figure 107. N. C. Wyeth (1882–1945). *All Day He Hung Around the Cove.* For Robert Louis Stevenson, *Treasure Island.* New York: Charles Scribner's Sons, 1911. Oil on canvas, 47¼ × 38¼ inches. Collection of Brandywine River Museum, Bequest of Gertrude Haskell Britton

experimentation with realist, Impressionist, and Precisionist styles and in different mediums was not confined to landscapes, figure painting, and still life but found its way into his illustrations.

Pyle's art and his instruction were paramount to the development of Wyeth's work. Although in episodes of frustration with painting he blamed Pyle for misguided teaching, Wyeth actually sustained many of Pyle's beliefs. Separated only by age and experience, Wyeth and Pyle were kindred spirits in terms of their imaginative powers. They could virtually see Robin Hood and his men traversing the woodland trails, feel the physical privations of Washington and his army's encampment, and hear the clash and clang of swords and the boom of gunnery from a pirate ship. That was the heart and soul of what Pyle taught and the invaluable qualities he gave to future generations through his teaching.

PYLE'S LATER LIFE AND LASTING INFLUENCE

In 1905 Pyle closed his school in Wilmington. He continued to advise students living locally and to receive established professionals who wanted to polish their work. Pyle offered an evening class once a week and informal sketching sessions. He had tried in 1904–05 to extend his teaching by giving lectures at the Art Students League in New York and the Art Institute of Chicago. However, those institutions and their students had seemed unreceptive. Some of these experiences suggested to Pyle that he was beginning to be out of step with the times. The ideals he taught seemed to contradict the realities of mainstream illustration.[50] At mid-career his goals for the future of his profession seemed to unravel. Receiving commissions to illustrate fiction that he considered superficial left Pyle frustrated.[51] Dissatisfaction with his own work crept up, and, at least on one occasion, he was seen furiously stomping a canvas on the floor.[52] Pyle found that magazine publishers were increasingly willing to sacrifice old standards to satisfy popular taste, and art editors exerted greater control over illustrators' styles. As photographic illustrations were beginning to compete seriously with drawings, more illustrators accepted commissions to produce advertisements or decided to work exclusively for book publishers. These changes challenged Pyle's assumptions about illustration's importance to society. He tried to wield control over quality by becoming art editor at *McClure's*. Former students felt alienated when Pyle asked them to drop commitments with other publishers and demonstrate their allegiance to him by working for *McClure's*.[53] Realizing his own shortcomings and dislike for the job, Pyle resigned after six months. He decided to branch into mural painting, but felt the need for further study. After resisting Europe for years, he traveled to Italy with his family for an extended stay. Tragically, Pyle's transition to a new phase in his career was delayed by self-doubt and cut short by fatal disease.

The profession of illustration did not follow the direction that Pyle had hoped it would. It had, more than any other artistic form, quickly become an instrument that shaped and was shaped by society and economics. However, Pyle's diligence and commitment to high ideals and artistic excellence, as an illustrator and as a teacher, raised the bar for the profession higher than it ever had been. The work produced by Pyle's students reflects the essential ideals and spirit of his teaching, while demonstrating the particular expression of each individual's interests and personality. Many adapted their subject matter and approach to meet the demands of changing times. Some, such as Green, Schoonover, and Smith, used photography as an aid in creating their art. Even Wyeth later found the use of photographic slides essential in his mural work. Some students, unhappy with modern changes, abandoned illustration for other careers. Some became painters or decorators. Of those who became teachers, Harvey Dunn was probably the most successful in incorporating Pyle's ideals with contemporary trends. Dunn inspired a group of students who became known as the "second-generation Pyle school," among them Dean Cornwell (the son of a former Pyle student), Mead Schaeffer, and Saul Tepper.

By the mid-twentieth century, publishers were substantially reducing the use of illustration in magazines and books. Public awareness of Pyle, his students, and the tradition of American illustration drastically dwindled. Historians and

members of the publishing industry were among the few who recalled the glory days of illustrated magazines and the outstanding achievements of Pyle and his school. Over the last forty years, recognition for the illustrators of the past and the work of Pyle and his students has reemerged. In the 1970s, articles and books about illustration began to appear. Henry C. Pitz, an illustrator and teacher who studied with former Pyle student Everett, did much to keep Pyle's career and teaching alive in his books *The Brandywine Tradition* (1969) and *Howard Pyle: Writer, Illustrator, Founder of the Brandywine School* (1975).

Since then publications on illustrators and illustration have proliferated; museums and private individuals have established collections of illustration; and the organization of exhibitions has greatly raised the public's consciousness of illustration's visual power. In the last twenty-five years an explosion in lavish, full-color illustrated books for children has revealed many contemporary illustrators who credit Pyle and his students among their inspirations. One hundred years after his death Pyle's students have proved their teacher's words true: there is "no better legacy a man can leave to the world than that he had aided others to labor at an art so beautiful."[54]

NOTES

1 Comments by Elizabeth Shippen Green (Mrs. Huger Elliot) and Jessie Willcox Smith in Art Alliance, *Report of the Private View of the Exhibition of Works by Howard Pyle* (Philadelphia: Art Alliance, 1923), 12, 19.

2 Green in ibid., 13.

3 Howard Pyle quoted by Smith in ibid., 19–20.

4 Smith in ibid., 18.

5 Green in ibid., 12.

6 Ibid.

7 Howard Pyle to James McAlister (president of Drexel Institute of Art, Science, and Industry), Oct. 6, 1896, quoted in Charles D. Abbott, *Howard Pyle: A Chronicle* (New York: Harper and Brothers, 1925), 205. In February 1897 Drexel issued an announcement about a new class for the spring semester intended to focus on drawing from the costumed model. This, instead of study from the nude, was described as "a radical departure." The class was described as having more practical applications to the students' future work in producing finished illustrations. See James MacAlister, *Special Announcement, Class in the Costumed Model in Connection with the Classes in Illustration* (Philadelphia: Drexel Institute of Art, Science, and Industry, 1897). Photocopy in Brandywine River Museum curatorial files, Chadds Ford, Pa.

8 Green relayed a memorable moment when Pyle, who was working on a drawing of a king's costume, expressed his love of being able to "cake-on the jewels." Pyle quoted by Green in Art Alliance, *Report of the Private View*, 13.

9 Howard Pyle, "A Small School of Art," *Harper's Weekly* 41, no. 2,117 (July 17, 1897): 711.

10 Ibid.

11 Drexel Institute of Art, Science, and Industry, *Catalogue of Exhibition of Work Done by Students in the Summer School under the Direction of Howard Pyle* (Philadelphia: Drexel Institute of Art, Science, and Industry, 1898), unpaginated. Drexel University Archives and Special Collections, Philadelphia. Photocopy in Howard Pyle Brokaw Collection, box 2, Special Collections, Brandywine River Museum Library, Chadds Ford, Pa.

12 N. C. Wyeth described a walk with fellow student George Harding during which their absorption in the pastoral setting nearly led to their being attacked by an angry bull. N. C. Wyeth to Henriette Zirngiebel Wyeth, July 16, 1903, quoted in Betsy James Wyeth, ed., *The Wyeths: The Letters of N. C. Wyeth, 1901–1945* (Boston: Gambit, 1971), 48.

13 N. C. Wyeth to Henriette Zirngiebel Wyeth, July 5, 1903, quoted in Betsy James Wyeth, *Wyeths*, 47.

14 Drexel Institute of Art, Science, and Industry, *Catalogue of Exhibition of Work Done by Students*, unpaginated.

15 An undated newspaper clipping from an unknown paper states: "Something of Mr. Pyle's own vigorous and frank manner, and something, too, of his fine genius for composition and arrangement is seen reflected in these works by his pupils." The article describes some of the work as very good, while other examples were less imaginative. "Exhibit by Mr. Pyle's Class," Drexel University Archives and Special Collections, Philadelphia. Photocopy in Brandywine River Museum curatorial files. In later years Jessie Willcox Smith humorously recalled that Pyle's influence resulted in classes "filled with rows

of temporary Howard Pyles in miniature." Smith quoted in Mary Tracy Earle, "The Red Rose," *The Lamp* 26, no. 4 (May 1903): 278.

16 Pyle quoted in Charles Hall Garrett, "Howard Pyle," *The Reader* 1, no. 6 (May 1903): 518.

17 Pyle to Edward Penfield, Mar. 17, 1900, in Abbott, *Howard Pyle: A Chronicle*, 216–17.

18 Comment by William Fayal Clarke in Art Alliance, *Report of the Private View*, 10.

19 Pyle to Alice Barber Stephens, June 25, 1906, Alice Barber Stephens Papers, microfilm reel 4152, Archives of American Art, Smithsonian Institution, Washington, D.C.

20 Jessie Trimble wrote: "It is said, however, that although some of Mr. Pyle's best-known pupils are women, he has no very strong faith in the permanent artistic ambitions of the feminine sex, and rarely encourages women to study with him. He is merely another man who believes that the average woman with ambitions loses them when she marries." Trimble, "The Founder of an American School of Art," *The Outlook* 85, no. 8 (Feb. 23, 1907): 455.

21 "Why Art and Marriage Won't Mix—By Howard Pyle," *Philadelphia North American*, June 19, 1904. The article states in jest that Pyle desired to have only male students in his Wilmington school due to space limitations and because female students would be a distraction to male students and himself. The author, however, largely touts the accomplishments of Pyle's teaching and his school's camaraderie. Many women students attended Pyle's Monday night lectures and critiques at the school. Some, such as Ethel and Anna Whelan Betts, Ethel Pennewill Brown, Olive Rush, and Dorothy Warren, did occupy some of the school's studios. Many others, like Harriet Roosevelt Richards, Mary Ellen Sigsbee, and Sarah Stilwell, rented or maintained home studios nearby and benefited from Pyle's continued guidance.

22 On Green's background and early illustration work, see Alice A. Carter, *The Red Rose Girls: An Uncommon Story of Art and Love* (New York: Harry N. Abrams, 2000), 27–29; Rowland Elzea and Elizabeth Hawkes, eds., *A Small School of Art: The Students of Howard Pyle* (Wilmington: Delaware Art Museum, 1980), 82–83; and Catherine Connell Stryker, *The Studios at Cogslea* (Wilmington: Delaware Art Museum, 1976), 18–21.

23 Two other students, Ellen Wetherald Ahrens and Jessie Dodd, also shared the apartment with them for a short time. See Carter, *Red Rose Girls*, 46–47.

24 For background on Oakley, see Carter, *Red Rose Girls*, 30–35; Elzea and Hawkes, *Small School of Art*, 136–37; and Stryker, *Studios at Cogslea*, 27–32.

25 Various publications on Pyle's students report that Pyle was the first to suggest that Violet Oakley design stained glass. A Philadelphia Museum of Art publication states that the suggestion came from Caryl Coleman, head of the Church Glass and Decorating Company in New York. See "The Violet Oakley Exhibition," *Philadelphia Museum of Art Bulletin* 75, no. 325 (1979): 10.

26 Carter, *Red Rose Girls*, 18–19. For background on Smith, see ibid., 10–21; Elzea and Hawkes, *Small School of Art*, 180–81; and Stryker, *Studios at Cogslea*, 8–12.

27 S. Michael Schnessel, *Jessie Willcox Smith* (New York: Thomas Y. Crowell, 1977), 21.

28 Carter, *Red Rose Girls*, 21.

29 Smith in Art Alliance, *Report of the Private View*, 18–19.

30 Mary Wiley Staver, *New and True: Rhymes and Rhythms and Histories Droll for Boys and Girls from Pole to Pole* (Boston: Lee and Shepard, 1892).

31 On Thornton Oakley's background and the facts of his career, see Gėnė E. Harris, *Thornton Oakley, 1881–1953* (Chadds Ford, Pa.: Brandywine River Museum, 1983).

32 Thornton Oakley, *Howard Pyle: His Art and Personality* (Philadelphia: Free Library of Philadelphia, 1951), 8.

33 Thornton Oakley, *Howard Pyle*, 9; and Richard Wayne Lykes, "Howard Pyle, Teacher of Illustration," *The Pennsylvania Magazine of History and Biography* 80, no. 3 (July 1956): 358.

34 His early commissions included Edwin L. Arnold, "In the Prophet's Treasury," *Collier's Weekly* 33, no. 12 (June 18, 1904): 15; and in Lawrence Perry, "As in Younger Days: A Tale of a Tugboat Captain," *Leslie's Monthly Magazine* 58, no. 6 (Oct. 1904): 678.

35 "In the Anthracite Region: Pictures by Thornton Oakley," *The Century Magazine* 72, no. 5 (Sept. 1906): 724–28.

36 Thornton Oakley, address, in Art Alliance, *Report of the Private View*, 1; and Oakley, "From Pittsburgh toward the Unknown," *The Western Pennsylvania Magazine* 31 (Sept.–Dec. 1948): 99–112. Thornton Oakley Collection, box 10, Special Collections, Brandywine River Museum Library.

37 Emma B. Suydam, "Pittsburgh's Industries Portrayed as Actually Seen by the Passerby, Series of Remarkable Drawings in Black and White by Thornton Oakley, an Exhibition Here," *Pittsburgh Sunday Post*, Jan. 4, 1914. Thornton Oakley Collection, box 12, folder 1, Special Collections, Brandywine River Museum Library.

38 Thornton Oakley, "American Industries Geared for War," *The National Geographic Magazine* 82, no. 6 (Dec. 1942): 716–32; Oakley, "American Transportation Vital to Victory," *The National Geographic Magazine* 84, no. 6 (Dec. 1943): 671–88; and Oakley, "Science Works for Mankind," *The National Geographic Magazine* 88, no. 6 (Dec. 1945), 737–52. Each issue of *National Geographic* contains sixteen illustrations by Oakley. See also "The Greatest Shipyard in the World: Building Our New Merchant Marine at Hog Island: A Series of Sketches by Thornton Oakley," *Harper's Monthly Magazine* 137, no. 821 (Oct. 1918): 657–64.

39 Henry C. Pitz, "Four Disciples of Howard Pyle," *American Artist* 33, no. 1 (Jan. 1969): 41.

40 Howard Pyle, "The Present Aspect of American Art from the Point of View of an Illustrator," *Handicraft* 1, no. 6 (Sept. 1902): esp. 129, 135, 139.

41 Gilbert Parker, *The Lane That Had No Turning* (New York: Doubleday, Page and Co., 1902).

42 Frank E. Schoonover, "The Edge of the Wilderness," *Scribner's Magazine* 37, no. 4 (Apr. 1905): 441–53; and Schoonover, "Breaking Trail," *Scribner's Magazine* 37, no. 5 (May 1905): 565–76.

43 Jack London, "White Fang," *Outing Magazine* 48, no. 4 (July 1906): 442.

44 Cortlandt Schoonover, *Frank Schoonover: Illustrator of the North American Frontier* (New York: Watson-Guptill Publications, 1976), 23.

45 On Wyeth's background and career, see David Michaelis, *N. C. Wyeth: A Biography* (New York: Alfred A. Knopf, 1998); and Christine Podmaniczky, "N. C. Wyeth," in *N. C. Wyeth: Catalogue Raisonné of Paintings* (Chadds Ford, Pa.: Brandywine River Museum, 2008), 1: esp. 17–23.

46 N. C. Wyeth, "A Day with the Round-up, an Impression," *Scribner's Magazine* 39, no. 3 (Mar. 1906): 285–90; and Wyeth, "A Sheep-herder of the Southwest," *Scribner's Magazine* 45, no. 1 (Jan. 1909): 17–21.

47 These paintings first appeared as "The Indian in His Solitude," in *Outing Magazine* 50, no. 3 (June 1907): color frontispiece and between 301 and 305. Starting in December 1907, the magazine also advertised the reproductions' availability as *A Wyeth Portfolio.*

48 N. C. Wyeth to Sidney Chase, Mar. 16, 1908, quoted in Betsy James Wyeth, *Wyeths,* 244.

49 N. C. Wyeth to Henrietta Zirngiebel Wyeth, Aug. 7, 1909, quoted in Betsy James Wyeth, *Wyeths,* 315.

50 Pyle stated: "I somehow felt that my ideas were not altogether pleasing to the [Yale] University people, for they were very radical." Pyle to W. M. R. French, Sept. 28, 1903, quoted in Abbott, *Howard Pyle: A Chronicle,* 221.

51 See Pyle to Thomas B. Wells (editor of *Harper's Monthly Magazine*), Apr. 23, 1907, quoted in Abbott, *Howard Pyle: A Chronicle,* 125–26.

52 Thornton Oakley, "Remarks on Illustration and Pennsylvania's Contributors to Its Golden Age," in *The Pennsylvania Magazine of History and Biography* 71, no. 1 (Jan. 1947): 12.

53 Henry C. Pitz, *Howard Pyle: Writer, Illustrator, Founder of the Brandywine School* (New York: Clarkson N. Potter, 1975), 178–82.

54 Pyle to McAlister, Apr. 7, 1896, quoted in Abbott, *Howard Pyle: A Chronicle,* 207.

Stephanie Haboush Plunkett

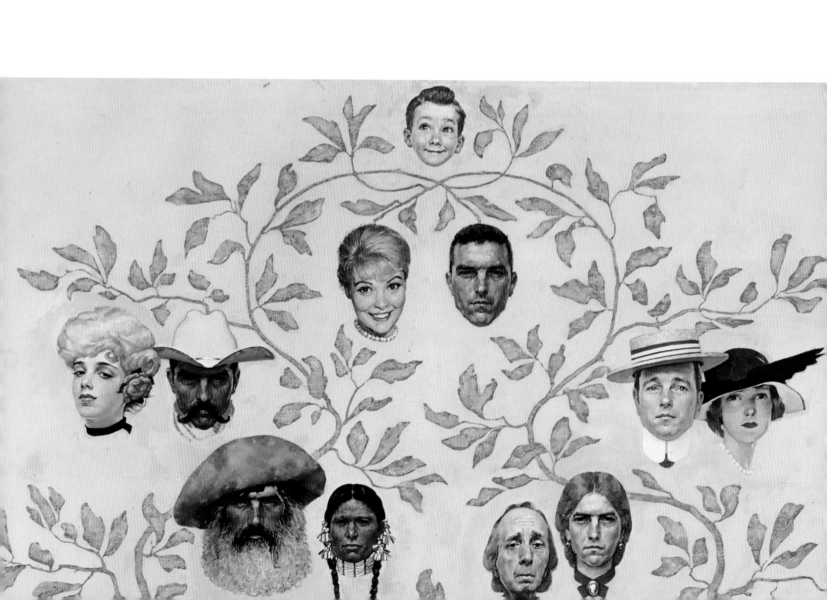

10. CHASING THE MUSE: NORMAN ROCKWELL AND THE LEGACY OF HOWARD PYLE

In art school we said, "One day we'll be as good as Pyle or Abbey or J. C. Leyendecker."

—NORMAN ROCKWELL

Many artists who have achieved significant recognition for their work were initially moved to create because they possessed a natural gift, and Norman Rockwell was no exception. Known as a masterful visual storyteller and the unrivaled creator of fictional realities that many twentieth-century Americans aspired to, Rockwell began his life as an artist in the world of his imagination, carefully honing his skills at home, at the dining room table in his family's modest New York City apartment.

As a boy, the fledgling artist and his father, Jarvis Waring Rockwell, relished time spent reading and drawing in the evenings, finding inspiration for their sketches in the popular magazines of the day. Rockwell was surely acquainted with Howard Pyle's stirring narratives for the pages of *Harper's Monthly* and *Scribner's*, and it is perhaps not surprising that daring pirates, fleets of battleships from the 1898 Spanish-American War, Native Americans, and frontiersmen were favored themes in his early repertoire. The young Rockwell also meticulously illustrated the richly described characters in the stories of Charles Dickens, as his father read aloud in his "even, colorless voice, the book laid flat before him to catch the full light of the lamp, the muffled noises of the city—the rumble of a cart, a shout—becoming the sounds of the London streets, our quiet parlor Fagin's hovel or Bill Sikes's room with the body of Nancy bloody on the floor."[1] Rockwell recalled his visceral reactions to Dickens's graphic depictions, but the complex tapestry of emotions and details thrilled him and prompted him from that time forward to look more deeply into our visual, sensory world. For Rockwell, stories were "the first thing and the last thing," and would remain so throughout his seven-decade career.[2]

When Rockwell began the formal study of art after his sophomore year in high school, he was determined to forge a path in illustration—a career opportunity made possible by the illustrators of the Golden Age. Edwin Austin Abbey, Howard Chandler Christy, Charles Dana Gibson, Pyle, Frederic Remington, and others set the stage for later generations of artists, establishing that imagery created for mass distribution could be well conceived, aesthetically pleasing, and lucrative. In America, publishing's most rapid period of

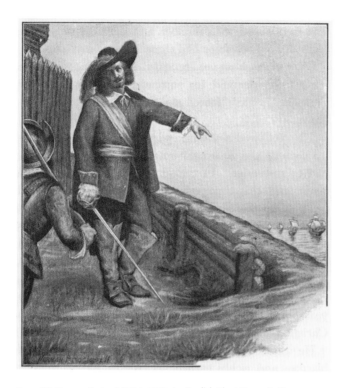

Figure 108. Norman Rockwell (1894–1978). *An English Fleet Came Sailing Up the St. Lawrence*, 1911. From Fanny E. Coe, *Founders of Our Country*. New York: American Book Company, 1912. Printed matter. Helen Farr Sloan Library and Archives, Delaware Art Museum

expansion occurred between 1865 and 1920, when the industry was established as a great national enterprise. A career in illustration was first seen as a viable profession during the Civil War, spurred by the public's strong desire to witness historic events as they unfolded. To satisfy public demand and to attract readership and advertisers, magazines and newspapers hired artists like Theodore Russell Davis and Winslow Homer as reporters, dispatching them to capture impressions of life on and around the battlefield. After the Civil War, hundreds of new periodicals were launched. While only seven hundred periodicals existed in 1865, by 1900 nearly five thousand more had come into being.[3]

Publications like the *Century Magazine* and *Harper's Monthly* reserved a full fifteen percent of their pages for illustrations at that time, offering ample opportunities for artists. By the 1890s, advances in pictorial technology had made it possible for an artist's work to be seen as it was created, without the need for interpretation by a skilled engraver's hand. Abbey, Homer, Pyle, and others had established illus-

tration as a significant art form in which high standards and broad appeal were not yet in contradiction.[4]

At the end of the nineteenth century and during the early decades of the twentieth, books and periodicals were a lifeline to the larger world. When Rockwell's first cover for the *Saturday Evening Post* appeared in 1916, the *Post*, *Good Housekeeping*, *Ladies' Home Journal*, *McCall's*, *Woman's Home Companion*, and other leading journals had vast, loyal followings and were richly illustrated, enticing readers to purchase magazines and the products featured within them. By 1930 the weekly *Saturday Evening Post* boasted a circulation of nearly three million, but the anxiously awaited magazines were shared among family and friends, bringing readership even higher.[5] Far more than just picture makers, illustrators became influential visual commentators whose art was linked to an industry determined to provide a "clear and friendly roadmap to the American dream."[6]

Rockwell and his fellow students at the Art Students League in New York felt the weight of history on their shoulders. "To us," Rockwell commented, illustration was "an ennobling profession . . . That's part of the reason I went into illustration. It was a profession with a great tradition, a profession I could be proud of."[7] He began his studies at the League in 1911, when publishing was in its heyday, and legends of Pyle's time there as a drawing and composition student from 1876 to 1878 were still actively shared among the school's accomplished faculty.[8] Even the League's longtime models, who were said to have posed for Pyle, were questioned by art students: "How did he begin a painting?" "What kind of paints did he use?" "Did he make preliminary sketches?" Pyle's artistic association with historical subjects and "fine writing" rather than advertising was valued, as advertising was considered far too commercial by an idealistic Rockwell and his fellow students. "Had Pyle or Abbey done advertisements? we asked each other. No. And we wouldn't either."[9] Rockwell's prediction did not ultimately stand, as at least one quarter of his body of four thousand works was created for our nation's most prominent corporations.[10]

At the League, Rockwell's mentors and teachers, the illustrator Thomas Fogarty and the painter and anatomist

Figure 109. Howard Pyle (1853–1911). *Arrival of Stuyvesant in New Amsterdam.* For Woodrow Wilson, "Colonies and Nation." *Harper's Monthly Magazine,* February 1901. Oil on canvas, 23½ × 15½ inches. The Neville Public Museum of Brown County and the Green Bay and De Pere Antiquarian Society

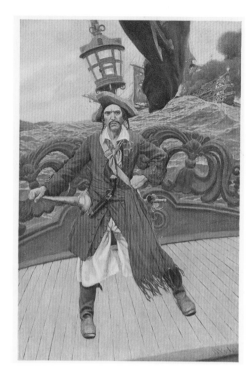

Figure 110. Howard Pyle (1853–1911). *Captain Keitt.* From Howard Pyle, *The Ruby of Kishmoor.* New York: Harper and Brothers, 1909. Printed matter. Helen Farr Sloan Library and Archives, Delaware Art Museum

George B. Bridgman, held Pyle up as a revered model for their students. Fogarty was pragmatic in his approach to teaching and inspired his students to emulate successful practitioners in class. After summarizing a story, he queried his aspiring illustrators on how to best represent it in pictorial form. Reproductions revealing the approach that Pyle and other well-known artists had taken to the same text were discussed, and their conceptual and compositional decision-making process was explored.[11] These lessons proved effective for Rockwell, who, with Fogarty's recommendation, received his earliest professional commission, to create illustrations for C. H. Claudy's *"Tell Me Why" Stories* in 1912.[12]

Bridgman, whose tenure at the League lasted for almost half a century, paid homage to Pyle by sharing reflections on the artist and his legacy with Rockwell and others who remained after class to absorb his wisdom.[13] For Rockwell, Pyle was the embodiment of illustration's Golden Age. He remembered clearly both Bridgman's emotional pronouncement that the great artist had died—on November 9, 1911, at just fifty-eight years of age—and his difficulty in conducting drawing class through tears that day.[14]

Pyle's insistence on authenticity made a significant impact on Rockwell, who remembered him as "a historian with a brush. His drawings of colonial days, of the Revolution, of pirates, were authentic re-creations, backed by years of study and research."[15] Rockwell discussed his artistic influences in an interview published in *Famous Artists Magazine*, naming Rembrandt as most significant to his artistic development and expressing admiration for Pieter Bruegel, J. A. D. Ingres, Pablo Picasso, and Jan Vermeer. Pyle and J. C. Leyendecker were identified as having had great impact during his impressionable student days.[16] In *An English Fleet Came Sailing Up the St. Lawrence* (1911, see fig. 108), a drawing featuring the French navigator and explorer Samuel de Champlain, Rockwell emulated the compositional structure and attention to the details of character, costume, and setting in Pyle's *Arrival of Stuyvesant in New Amsterdam* (1901, see fig. 109), an illustration published a decade earlier in *Harper's Monthly*.

Throughout his career Rockwell kept Pyle's imagery close at hand in books and prints, which were an ongoing source of inspiration. Pyle's *Captain Keitt* (1909, fig. 110) adorned the walls of Rockwell's Prospect Street studio in New Rochelle, New York, and he relished seeing it again after his 1918 discharge from service in the United States Navy during World War I. "Look at that fiery crimson coat against the dull green sea," he remembered thinking, intending to create that effect in his own work someday.[17] Years later Rockwell paid homage to Pyle in *Family Tree* (1959, fig. 111), a cover painting for the *Saturday Evening Post*, which traces the ancestry of a fictional American family. In the piece the family's lineage is rooted in the union of a weathered pirate and a demure Spanish princess swept away from a sinking galleon—a

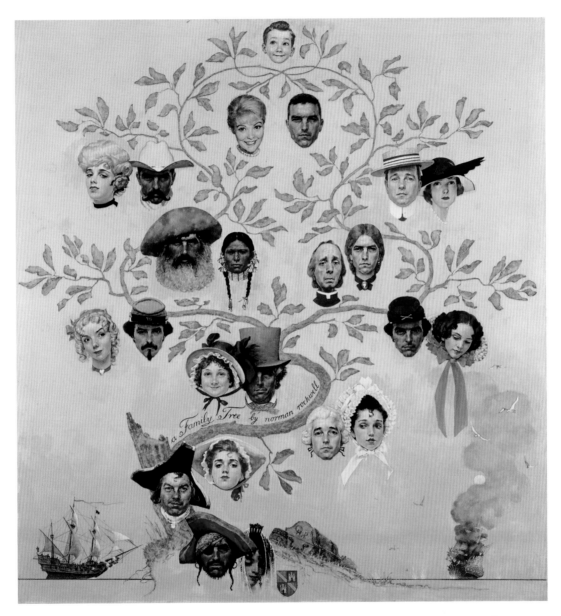

Figure 111. Norman Rockwell (1894–1978). *Family Tree*, 1959. Cover for *The Saturday Evening Post*, October 24, 1959. Oil on canvas, 46 × 42 inches. Norman Rockwell Art Collection Trust, Norman Rockwell Museum, Stockbridge, Massachusetts

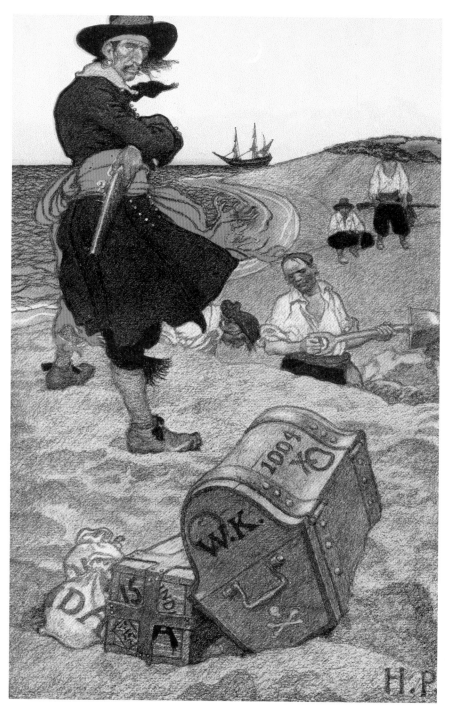

Figure 112. Howard Pyle (1853–1911). *Buried Treasure*. From
John D. Champlin, Jr., "The True Captain Kidd." *Harper's Monthly
Magazine*, December 1902. Printed matter. Helen Farr Sloan
Library and Archives, Delaware Art Museum

vessel clearly inspired by Pyle's theatrical sailing ships, such as the one pictured in *An Attack on a Galleon* (1905, see fig. 118). The initials *H. P.* are inscribed on the chest in Rockwell's image, echoing the inscription on William Kidd's coffer in Pyle's painting *Buried Treasure* (1902, fig. 112), an illustration reproduced first in *Harper's Monthly* and later in *Howard Pyle's Book of Pirates* (1921), which Rockwell owned.

Rockwell readily acknowledged that great art is not created in a vacuum, and his extensive library of prints and books was reflective of that sentiment. Even after a 1943 fire devastated Rockwell's Arlington, Vermont, studio, including "all my antiques, my favorite covers and illustrations which I'd kept over the years, my costumes, my collections of old guns, animal skulls, Howard Pyle prints, my paints, brushes, easel, my file of clippings—everything," he made sure to bring Pyle's imagery back into view.[18] Sixteen Pyle images were among Rockwell's frequently referenced print collection when his Stockbridge, Massachusetts, studio and its contents were placed in trust to the Norman Rockwell Museum in 1976, two years before his death. Among them was a series of five engravings created after Pyle works by W. H. W. Bucknell and issued by the Bibliophile Society of Boston in 1905, including *Bishop De Bury Tutoring Young Edward III, Whose Chancellor He Became Afterwards* and *Erasmus, Colet and More.*

Though not a collector in the traditional sense, Rockwell enjoyed surrounding himself with original works by artists he admired. Modest pieces by major talents like Leyendecker, Maxfield Parrish, Edward Penfield, Pyle, and Arthur Rackham, among others, filled the walls of his home and studio, a reminder of qualities to which he continually aspired. Thomas Rockwell, the artist's son, recalled that several works by Pyle were brought to his father's attention by E. Walter Latendorf, one of the first art dealers in New York to handle illustration art.[19] Beautifully illuminated letters from *The Wonder Clock* (1887), Pyle's original book of fairy tales, as well as elegant linear drawings for *Twilight Land* (1894) and "The Evolution of New York" (1893) were in Rockwell's personal collection.[20] Another treasure, *I Will Teach Thee to Answer Thy Elders* (1896, fig. 113)—Pyle's full-color accompa-

niment to S. Weir Mitchell's "Hugh Wynne, Free Quaker" in the *Century Magazine*—clearly captured Rockwell's imagination. The piece is visually linked to another classroom altercation, a flogging portrayed in a Rockwell illustration for *The Adventures of Tom Sawyer* (1936, see fig. 114).

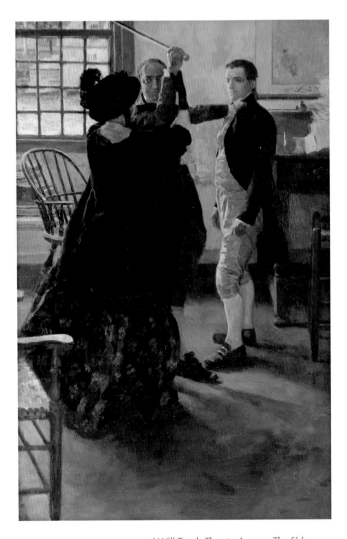

Figure 113. Howard Pyle (1853–1911). *I Will Teach Thee to Answer Thy Elders.* For S. Weir Mitchell, "Hugh Wynne, Free Quaker." *The Century Magazine*, December 1896. Oil on composition board, 18 × 12 inches. Norman Rockwell Museum, Stockbridge, Massachusetts

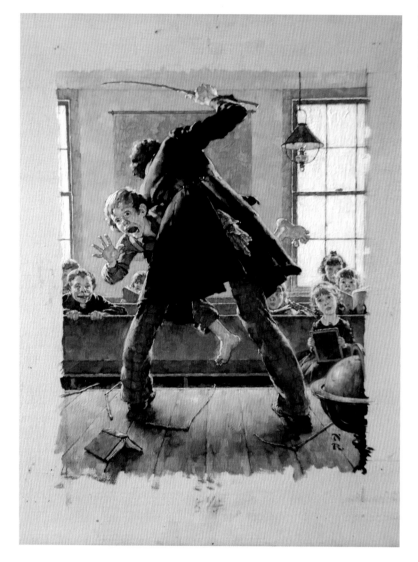

Figure 114. Norman Rockwell (1894–1978). *The Master's Arm Performed Until It Was Tired and the Stock of Switches Notably Diminished*. For Samuel L. Clemens, *The Adventures of Tom Sawyer*. New York: Heritage Press, 1936. Oil on canvas, 25 × 20 inches. Mark Twain Boyhood Home and Museum, Hannibal, Missouri

"It's hard to say what one artist gets from studying the works of other artists," Rockwell reflected. "I guess an artist just stores up in his mind what he learns from looking at the work of other artists. And after awhile all the different things he has learned become mixed with each other and with his own ideas and abilities to form his technique, his way of painting."[21] Pyle's insistence on authenticity and his ability to render dynamic, meticulously designed compositions that speak of humanity inspired Rockwell to demand the same level of excellence from himself, in his own way. When asked what art he would take to a desert island, in a 1962 interview for *Esquire* magazine, Rockwell replied without hesitation, a "Rembrandt or two" and "a good Howard Pyle."[22]

NOTES

The epigraph is from Norman Rockwell (as told to Tom Rockwell), *Norman Rockwell, My Adventures as an Illustrator* (1960; New York: Harry N. Abrams, 1988), 166.

1 Norman Rockwell (as told to Tom Rockwell), *Norman Rockwell, My Adventures as an Illustrator* (1960; New York: Harry N. Abrams, 1988), 28–29.

2 Norman Rockwell, Recorded Talk at the Otis College of Art and Design, Los Angeles, 1949, Norman Rockwell Museum Audio Recording Collection, 1949–2002, Norman Rockwell Museum Archival Collections, Stockbridge, Mass.

3 On the expansion of the publishing industry, see Susan E. Meyer, *America's Great Illustrators* (New York: Harry N. Abrams, 1978), 8–24; and Meyer, *Great American Illustrators* (New York: Galahad Books, 1989).

4 Laura Claridge, *Norman Rockwell: A Life* (New York: Random House, 2001), 87.

5 On circulation of the *Saturday Evening Post*, see Jan Cohn, *Creating America: George Horace Lorimer and the* Saturday Evening Post (Pittsburgh: University of Pittsburgh Press, 1989), 165, 307 n. 18.

6 Alice A. Carter, *Ephemeral Beauty: Al Parker and the American Women's Magazine, 1940–1960* (Stockbridge, Mass.: Norman Rockwell Museum, 2007), 12.

7 Rockwell, *Norman Rockwell*, 52–53.

8 Delaware Art Museum, *Howard Pyle: The Artist, the Legacy* (Wilmington: Delaware Art Museum, 1987), 7–8.

9 Rockwell, *Norman Rockwell*, 52.

10 For a complete listing of works by Norman Rockwell, see Laurie Norton Moffatt, *Norman Rockwell: A Definitive Catalogue* (Stockbridge, Mass.: Norman Rockwell Museum, 1986). Rockwell's illustrations for advertising campaigns are in the first volume.

11 Rockwell, *Norman Rockwell*, 64–65.

12 C. H. Claudy, *"Tell Me Why" Stories* (New York: McBride, Nast and Company, 1912). Rockwell produced eight illustrations for the interior of this book. Rockwell mentions that Thomas Fogarty recommended him for this job in *Norman Rockwell*, 70.

13 Rockwell, *Norman Rockwell*, 61.

14 Ibid., 97.

15 Ibid., 52.

16 Mary Anne Guitar, "A Closeup Visit with Norman Rockwell," *Famous Artists Magazine*, unknown issue, c. 1960, 27–30, 41. Clipping file, Norman Rockwell Museum, Stockbridge, Mass.

17 Rockwell, *Norman Rockwell*, 134.

18 Ibid., 324.

19 Thomas Rockwell, *Off His Walls: Selections from the Personal Art Collection of Norman Rockwell* (Stockbridge, Mass.: Norman Rockwell Museum, 1991), unpaginated.

20 First published in serial form in *Harper's Young People* between October 1889 and January 1891, *Twilight Land* is a collection of stories written and illustrated by Howard Pyle (New York: Harper and Brothers, 1894). "The Evolution of New York" is a detailed history of the settlement of New York by Thomas Janvier that was also illustrated by Pyle. The illustration in Rockwell's collection details the Dutch West India Company's departure from the settlement of Fort Amsterdam as the English took possession of it on September 8, 1664. It appears in Janvier, "The Evolution of New York: First Part," *Harper's New Monthly Magazine* 86, no. 66 (May 1893): 829.

21 Rockwell, *Norman Rockwell*, 43.

22 Norman Rockwell, "Norman Rockwell," *Esquire* 57, no. 1 (Jan. 1962): 69.

David M. Lubin

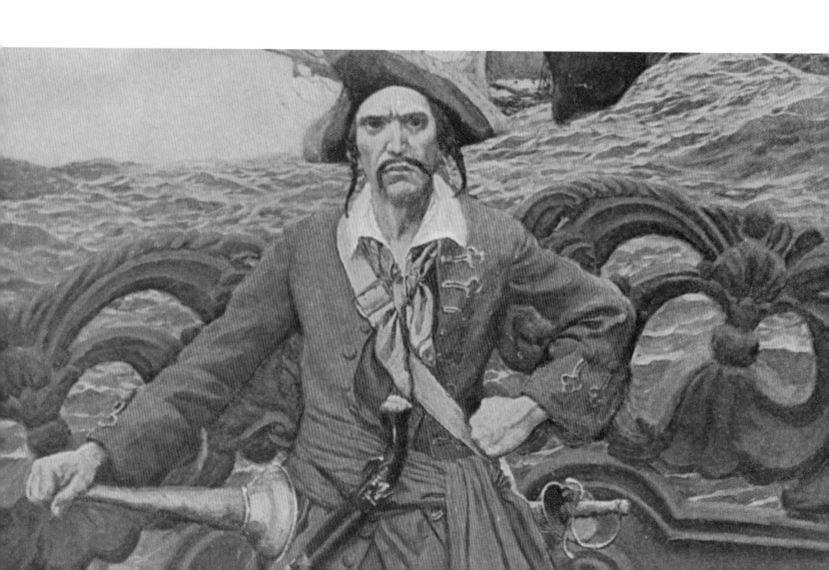

11. THE PERSISTENCE OF PIRATES: PYLE, PIRACY, AND THE SILVER SCREEN

The Golden Age of Piracy—a period of French corsairs and English buccaneers plundering gold-laden Spanish galleons in the Caribbean Sea—stretched roughly from 1660 to 1720. The Golden Age of Pirate Movies, if we may invent such an era, lasted only half as long, from the mid-1920s to the mid-1950s.[1]

Of the numerous pirate-themed movies that appeared during this period, all but a handful are deservedly forgotten. The most distinguished exceptions are the silent epic *The Black Pirate* (1926), which starred the very acrobatic Douglas Fairbanks and was among the first films to explore Technicolor cinematography; MGM's production of *Treasure Island* (1934), the earliest and best of several sound versions of that tale; *Captain Blood* (1935) and *The Sea Hawk* (1940), two rousing swashbucklers with Errol Flynn; and, as the period drew to a close, two Walt Disney productions: another *Treasure Island* (1950), notable for its "Arrrr"-spewing, parrot-shouldering Long John Silver, and the animated *Peter Pan* (1953), featuring a sinister but comically eccentric Captain Hook, garbed in a crimson frock coat and scarlet sash. Over the next half century, attempts to revive the pirate genre found little success at the box-office until Disney's *Pirates of the Caribbean* franchise began raking in box-office gold in 2003. This series of films, inspired by a popular indoor water ride at the Disney amusement parks, is less a loving restoration of classic pirate cinema than a special-effects-driven behemoth used to market a wide range of merchandise tie-ins.

All the films mentioned above, as well as the theme-park ride that spawned *Pirates of the Caribbean*, owe an enormous debt to Howard Pyle, who was the leading figure in yet a third golden age, that of American book illustration, which shone from the 1880s to the 1920s. Pyle invented our present-day image of *the pirate*. Eighteenth- and early nineteenth-century books on pirates had provided engraved drawings of notorious buccaneers—Captain Henry Morgan, Blackbeard, Captain William Kidd, and so forth—but these images were generally stiff, bland, and static. They offered little in the way of dramatic anecdote, compelling narrative, or romantic charisma. Pyle changed all that by expanding a tradition of bare-bones pirate representations by means of color, flair, and vividly rendered settings.

Compare the engraved view of Blackbeard (Captain Edward Teach) in Charles Johnson's *A General History of the*

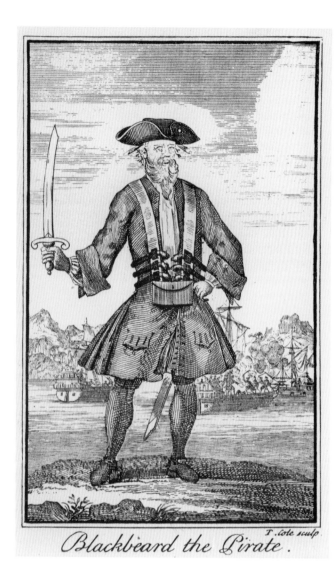

Figure 115. T. Cole (dates unknown). *Blackbeard the Pirate*, c. 1724.
From Alexandre O. Exquemelin, *The Buccaneers and Marooners of America: Being an Account of the Famous Adventures and Daring Deeds of Certain Notorious Freebooters of the Spanish Main*, ed. Howard Pyle.
New York: Macmillan and Co., 1891. Originally published in Charles Johnson, *A General History of the Robberies and Murders of the Most Notorious Pyrates*, 1724. Printed matter. Helen Farr Sloan Library and Archives, Delaware Art Museum

Robberies and Murders of the Most Notorious Pyrates (1724, fig. 115) with Pyle's *Captain Keitt* (1909, fig. 116), a depiction of a fictional pirate captain, Robertson Keitt, planting his boots on a steeply canted deck. While the engraving does have a distinct advantage over Pyle's illustration in terms of its antiquarian quaintness, giving it a sense of historical authenticity, the Pyle has far more life and movement to it. The perspectival lines of the aft deck shoot the eye back beyond the captain to the roiling sea, where a distressed galleon churns heavy clouds of smoke, which visually rhyme with the baroque turnings of the ship's railing and the folds of the pirate flag at the captain's ear. Pyle's illustration, painted at a time when motion pictures were still in their infancy, anticipated by years, if not decades, the capacity of movies to portray pirates with elaborate costumes and sets, fully realized sea-going environments, action on multiple planes, dramatic coloring, and intensity of psychological expression.

This last-mentioned quality refers to Pyle's ability to convey a sense of the pirate's inner life: he was able to create an impression of pirate interiority. In *Captain Keitt* the sea captain anchors himself on deck in an uneasy stance, his toes pointed in one direction, his knees in another, and his eyes in a third. He wedges a fist into one hip and for balance pushes a horn into the other, the opening of the horn poised close to the pointed tip of the phallic firearm tied to his waist. A heavy lantern swings precariously near his head: all in all, it is a portrait of uncertainty, instability, and perhaps even thwarted sexuality.

The source of Pyle's success as an illustrator was his flair for transcending cliché and endowing his characters—as well as the scenes in which he placed them—with a richness and complexity that his source material lacked. That Pyle self-consciously sought to avoid stereotype in his illustrations allows his work, at its best, to offer fresh perspectives on old material. A charismatic teacher, he insisted to his students that they project themselves emotionally—but also physically—into the situations they chose to portray. In a sense, he was always looking for the visual equivalent to Gustave Flaubert's *mot juste*, the "right word": a carefully

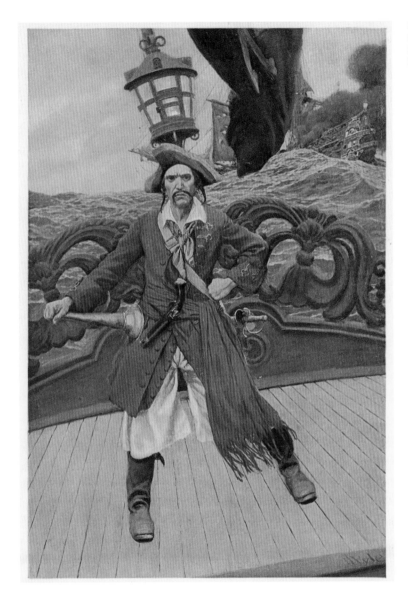

Figure 116. Howard Pyle (1853–1911). *Captain Keitt.* From Howard Pyle, *The Ruby of Kishmoor.* New York: Harper and Brothers, 1909. Printed matter. Helen Farr Sloan Library and Archives, Delaware Art Museum

chosen detail of costume, setting, physical gesture, or facial expression that would set off reverberations in the viewer's mind, unleashing the imagination rather than restraining it through an overabundance of hard fact, static information, and prosaic description. He taught that every good story contained a hidden core or essence—a buried treasure, shall we say—that the illustrator needed to locate and extract, transferring it from the written page to the pictorial image.[2]

Pyle's theory of "mental projection" has been compared to "the method" taught at approximately the same time

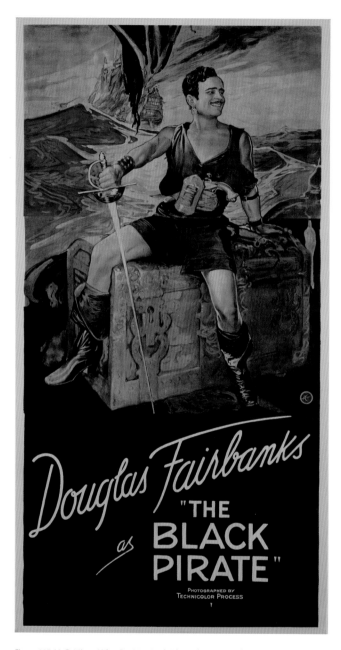

Figure 117. H. C. Minor Litho Co., New York. Three-sheet poster for *The Black Pirate*, 1926. Stone lithograph, 81 × 41 inches. Margaret Herrick Library, Beverly Hills

by Russian theater director Konstantin Stanislavsky, who encouraged actors to connect to the inner lives of the characters they played by tapping into their own reservoirs of personal memory and feeling.[3] Pyle's emphasis on projection was less rigorous, systematic, and emotionally draining than that of Stanislavs`ky (of whom Pyle no doubt knew nothing), and Hollywood did not encounter the Stanislavsky method until the early 1950s—at the very time that the Golden Age of Pirate Movies was coming to an end. All the same, as an artist who consistently tried to bring the narrative on the page to life by plunging himself emotionally and, as much as possible, experientially into its fictive universe, he anticipated an approach to screen acting that lay decades in the future.

The first of the great screen pirates, Fairbanks, the then-reigning Hollywood leading man, was inspired by the posthumously published *Howard Pyle's Book of Pirates* (1921) to produce, coauthor, and star in *The Black Pirate*. "When Fairbanks decided he would do his pirate story in color," notes biographer Jeffrey Vance, "he wanted the film to have the overall visual design of the production be akin to an illustrated book by Howard Pyle."[4] The film's advertising poster (1926, fig. 117) draws directly on several of Pyle's pirate illustrations, among them *Captain Keitt* and *An Attack on a Galleon* (1905, fig. 118).[5]

But Fairbanks was so deeply committed to creating an aura of all-American optimism and exuberance that he never allowed his hero to touch the emotional depths limned by Pyle. The most famous moment in *The Black Pirate* occurs when Fairbanks's character, single-handedly capturing an enemy ship, makes a rapid yet graceful descent from the heights of a mast by plunging his dagger into the canvas of a billowing sail and riding the knife down to the deck below. A spectacular stunt, it is rich in symbolic overtones, showing at one level the self-reliant individual taming the surging power of technology (in this case, epitomized by the eighteenth-century sail), while declaring, at another, the artist's mastery over his chosen medium (the large white sheet a metaphor for the blank motion-picture screen).

Figure 118. Howard Pyle (1853–1911). *An Attack on a Galleon*. For Howard Pyle, "The Fate of a Treasure Town." *Harper's Monthly Magazine*, December 1905. Oil on canvas, 29½ × 19½ inches. Delaware Art Museum, Museum Purchase, 1912

Figure 119. Howard Pyle (1853–1911). *Marooned*, 1909. Oil on canvas, 40 × 60 inches. Delaware Art Museum, Museum Purchase, 1912

Pyle, on the other hand, never permitted his pirates, whether heroes or blackguards, such unmitigated control of their environment. In this regard, Pyle's pirates are the antithesis of what Hollywood later envisioned. As often as not, they are victims of a hostile environment, not its joyful masters. The dour view of existence, in which a cruel universe torments poor, suffering humanity with its perverse indifference, conveyed by the literary naturalism of Pyle's more high-minded colleagues, including Stephen Crane, Theodore Dreiser, and Frank Norris, found expression in Pyle's pirate pictures.

Take, for example, the superb late painting *Marooned* (1909, fig. 119), which enhances the subject of an earlier canvas painted to illustrate *Harper's Monthly* (1887, fig. 120). In both images a lone figure sits hunched over on a strip of beach. In the later one, however, Pyle excised the prop of a bottle, from which the marooned pirate might drink or even send a call for help. The artist also increased the expanse of sand, reduced the size of the figure, and placed him at a greater distance, making him seem that much more remote from human contact. In the illustration, water is lapping gently at the base of the sand spit, a condition the viewer might readily recognize from any day trip to the oceanside. A vintage photograph of Pyle with his family at the beach in the mid-1890s shows just such an occasion (fig. 121). In the painting, the water is minimized to a small

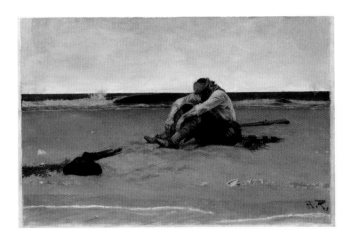

Figure 120. Howard Pyle (1853–1911). *Marooned*. For Howard Pyle, "Buccaneers and Marooners of the Spanish Main." *Harper's New Monthly Magazine*, September 1887. Oil on canvas, 18 × 25¾ inches. Private collection

patch in the lower left-hand corner, removing, in a sense, its touristic familiarity or the comforting reassurance that the harrowing situation depicted is but make-believe.

Further darkening the mood is the sky; no longer clear and unthreatening, as in the magazine image, it now palpitates with clouds. A flock of birds, wheeling about in the heights, taunts the grounded sailor with the freedom of mobility and transcendence that he so sadly lacks. Pyle denies his pirate the chance of hunting them for survival: the rifle that was by his side in the illustration has disappeared from the painting. Adding a subtle and poignant note, the artist altered the position and character of the marooned man's hands. In the earlier work they were massive, masculine, and strong, ready to take action once their owner's spirit was restored, but now the fingers interlace delicately in a gesture of resignation, perhaps despair.

None of Hollywood's pirates ever suffered this sort of implied loneliness, helplessness, and remorse. Far from anticipating the joyful piracy of Fairbanks, Flynn, and their swashbuckling brethren of the silver screen, the later canvas in particular looks ahead to what film historian Robert Kolker has memorably termed the Cinema of Loneliness.[6]

The painting's vast horizontal vista inhabited by a sole, diminutive, off-center figure calls to mind the achingly desolate wide-screen compositions of the 1960s masters Michelangelo Antonioni in *L'avventura* (1960), David Lean in *Lawrence of Arabia* (1962), and Stanley Kubrick in *2001: A Space Odyssey* (1968).

As well *Marooned* may remind the viewer of *Christina's World* (1948, see fig. 122), the most famous painting by Andrew Wyeth, the son of Pyle's most famous student, N. C. Wyeth. In both works the discrepancy between field and figure is vast, almost overwhelming. Like Andrew Wyeth's lone figure of Christina, Pyle's marooned pirate provides an archetypal instance of being trapped in one's own body. The subject of the 1948 work, Wyeth's young Maine neighbor Christina Olson, was paralyzed by childhood polio, while the pirate lacks the wings of the birds careening through the sky overhead—or the gills of the fish that might be frolicking invisibly in the waters around him.

The important point to recognize here is that Pyle's pirates—like those of Hollywood too, of course—should never be taken literally, that is, nonmetaphorically. They

Figure 121. Unknown photographer, Pyle family on the beach, Rehoboth, Delaware, mid-1890s. Photograph. Howard Pyle Manuscript Collection, Helen Farr Sloan Library and Archives, Delaware Art Museum

are always more than simply pirates. They are stand-ins for humanity at large, for a particular segment of humanity, or, if nothing else, for the artist who chose to represent them. Indeed, they can signify on all three of those levels, as in Pyle's frontispiece (1900, fig. 123) for Mary Johnston's popular historical novel *To Have and to Hold* (1900). The hero in the illustration, facing away from the viewer, has made a bid to replace the recently deceased captain of a band of pirates. He duels the group's three contenders for captain, fighting his opponents in succession, one after the other. Pyle shows the lunge and parry, as the hero thrusts his weapon at a grimacing figure that mirrors him in form, size, and shape. "Our blades had no sooner crossed than I knew that in this last encounter I should need every whit of my skill, all my wit, audacity, and strength," the first-person narrator recounts, marveling at his conflict-heightened sensibilities. "He made no thrust I did not parry, no feint I could not interpret. I knew that my eye was more quick to see, my brain to conceive, and my hand to execute than ever before."[7] A sinister

audience of pirates studies the pair in grim silence, for they will accept as leader whomever proves stronger and more ruthless. The turbulent sky overhead reflects the trampled sand underfoot, which leads the viewer's eye to the hero's two previous opponents, one bloody but alive, the other bloody but dead.

The picture allegorizes the Social Darwinian philosophy of the Gilded Age that produced Pyle: life is a dog-eat-dog affair, a continuous struggle for limited resources, a relentless competition in which only the fittest and boldest survive—and only for a limited time before they too must succumb. On another level, though, the picture might symbolize Pyle's inner life as an art teacher who surrounded himself with the most talented lights of the next generation, some of whom, such as N. C. Wyeth, threatened to surpass the older artist in fame and fortune. How long could the master keep dueling with his best and brightest students before meeting his match? At best he had to keep his blade sharp, his pencils pointed, and his desire keen, for, in the sexually

Figure 122. Andrew Wyeth (1917–2009). *Christina's World*, 1948. Tempera on gessoed panel, 32¼ × 47¾ inches. The Museum of Modern Art, New York, Purchase © Andrew Wyeth. Digital image © The Museum of Modern Art/Licensed by SCALA/Art Resource, New York

Figure 123. Howard Pyle (1853–1911). *Why Don't You End It?* For Mary Johnston, *To Have and to Hold*. Boston: Houghton Mifflin and Company, 1900. Oil on canvas, 17½ × 12½ inches. The Kelly Collection of American Illustration

Figure 124. Howard Pyle (1853–1911). Advertising poster for *To Have and to Hold*, 1900. Lithograph on paper, 22 × 14½ inches. Delaware Art Museum, Gift of Willard S. Morse, 1923

charged locution of Johnston's narrator, "Sheer audacity is at times the surest steed a man can bestride."[8]

At yet a third level, the picture could be about the artist's confrontation with himself. The near duplication of the one swordsman by the other suggests as much. The nature of the doubling is even more emphatically rendered in the brilliant black, white, and dash-of-red color lithograph that Pyle abstracted from this illustration to advertise the book (1900, fig. 124). The artist must always duel with—or, if you will, deal with—his inner demon, his inner pirate. En garde!

Substitute crossed pens or paintbrushes for crossed blades, and the self-referential nature of these images becomes more apparent.

Indeed, *duel* serves here as an appropriate homonym for *dual*. A photograph of Pyle from about the time he painted this scene shows him in his studio, a bald, bespectacled, middle-aged man whose throat is encircled by a starched collar and a tightly knotted necktie (c. 1900, see fig. 125). Yet he stands astride, like one of his sea captains on deck, hands planted firmly at his hips. A billowing artist's smock,

Figure 125. Unknown photographer, Howard Pyle in his studio, c. 1900. Photograph. Howard Pyle Manuscript Collection, Helen Farr Sloan Library and Archives, Delaware Art Museum

Sentiments such as these made—and continue to make—intuitive sense. Nowhere are they more charmingly expressed than in the anonymous poem "The Armchair Pirate," which opens the adventure film *Blackbeard, the Pirate* (1952):

The meeker the man, the more pirate he
Snug in his armchair, far from the sea,
And reason commends his position:
He has all of the fun and none of the woes,
Masters the ladies and scuttles his foes,
And cheats both the noose and perdition![11]

These lighthearted lines capture the essence of the "Walter Mitty phenomenon." Walter Mitty, an inveterate daydreamer created by *New Yorker* humorist James Thurber in 1939, came to stand for ordinary, unadventurous men and women everywhere who compensate for their dull daily lives with endless streams of fantasy. This everyman figure was invoked, for example, by movie mogul Jack L. Warner when explaining the box-office appeal of his actor Flynn: "To the Walter Mittys of the world he was all the heroes in one magnificent, sexy, animal package."[12]

We would be wrong to assume Pyle loved pirates because he had a milquetoast personality. He was no Walter Mitty. As one of the most influential and highly paid illustrators of his era, he wielded considerable power and enjoyed the respect of others who did the same. Like many of his generation, he seems to have regarded pirates of the bygone days as spiritual forefathers, figures to be emulated (within reason, of course) for their brazen transgression of restrictive social norms. Pyle's pirates, like the cowboy figures romanticized in print and paint by his contemporaries Frederic Remington, Theodore Roosevelt, and Owen Wister, implicitly licensed antisocial behavior in realms far from the Spanish Main and the Great Southwest, such as Wall Street and Capitol Hill.

For all the criticism heaped on the robber barons of the Gilded Age and the Progressive Era, these fictional and real-life figures elicited both envy and admiration. It was not uncommon for them to be likened to pirates. In Dreiser's novel *The Titan* (1914), the hero, Frank Cowperwood, a

the contemporary equivalent to the plaited, loose-fitting blouses of the swordsmen on the beach, sets off the rigidity of the collar and tie. The discrepancy between the two modes of apparel suggests a professional, if not existential, duality within an individual who struggled to balance the adversarial sides of his nature: creative artist and buttoned-up businessman.

Pyle had a sense of humor about this duality, acknowledging in print the irony that "a Quaker gentleman in the farm lands of Pennsylvania" should devote such ardent attention to men of the past who epitomized violent lawlessness and erotic self-abandon.[9] "It is not because of his life of adventure and daring that I admire" the pirate; "nor is it because of gold he spent—nor treasure he hid," Pyle explained. Quite simply, it was because "he was a man who knew his own mind and what he wanted."[10]

freewheeling, risk-taking, lawbreaking entrepreneur, "was roundly denounced by the smaller-fry as a 'buccaneer,' a 'pirate,' a 'wolf'... [whereas] the larger men faced squarely the fact that here was an enemy worthy of their steel."[13] Newspaper cartoons, in Dreiser's tale, portrayed Cowperwood "as a pirate commander ordering his men to scuttle another vessel—the ship of Public Rights."[14] In photographer Edward Steichen's famous portrait *J. P. Morgan* (1903, fig. 126), the analogy between capitalist and pirate could hardly be more explicit: the scowling financier, bathed in darkness, appears to be wielding a deadly knife, although it is only the glossy arm of his chair flashing in the light.

Several of Pyle's pirate pictures for popular magazines would thus seem to be parables about capitalism and its discontents. In *Dead Men Tell No Tales* (1899, see fig. 127), class hierarchy is schematized: after a contingent from a pirate ship has buried treasure in the sand, the first mate kills the sailors (the proletarians) who have done the digging; he does not realize that he himself is about to be killed by his superior, the captain, who stands at a distance holding two loaded pistols. In *Which Shall Be Captain?* (1911, see fig. 128), two knife-wielding pirates embrace in a death struggle under the setting sun, while the crew looks on and a treasure chest awaits the victor. In *So the Treasure Was Divided* (1905, see fig. 129), pirate workers sit hunched in anticipation, while their boss prepares to dole out their share of the spoils, a gleaming pile of gold that glimmers against the white of a canvas sail stretched out on the sand.

In other words, Pyle's pirate pictures functioned as more than Walter Mittyish fantasy objects. They symbolically addressed an array of social and economic concerns of the day, such as class warfare; the gold-standard debate; America's recently fought war against Spain (see *An Attack on a Galleon*); and the subsequent efforts to control colonial populations (*Extorting Tribute from the Citizens* [1905, see fig. 57]). To the extent that these issues continued to trouble American cultural life, they were reembodied in the pirate movies that Pyle posthumously inspired. Thus, for example, Warner Brothers' 1935 production of *Captain Blood*, although based on a 1922 best-selling novel by Rafael Sabatini, man-

aged to speak directly to its own troubled decade by condemning the rise of political tyranny abroad, while also countering charges of unfair labor practices in Hollywood. When, in a scene drawn directly from Pyle, Captain Blood, with Flynn in the title role, fights a duel in the sand with the French pirate captain Levasseur, played by Basil Rathbone, more is at stake than good guy versus bad guy athleticism: the Anglo-American system of justice upheld by Captain Blood contends with, and at length overcomes, the old-world feudal injustice embodied by Levasseur.[15]

Figure 126. Edward Jean Steichen (1879–1973). *J. P. Morgan*, 1903. Gelatin-silver print, 16½ × 13½ inches. Chrysler Museum of Art, Norfolk, Virginia, Gift of Walter P. Chrysler, Jr. © Joanna T. Steichen, courtesy of Carousel Research

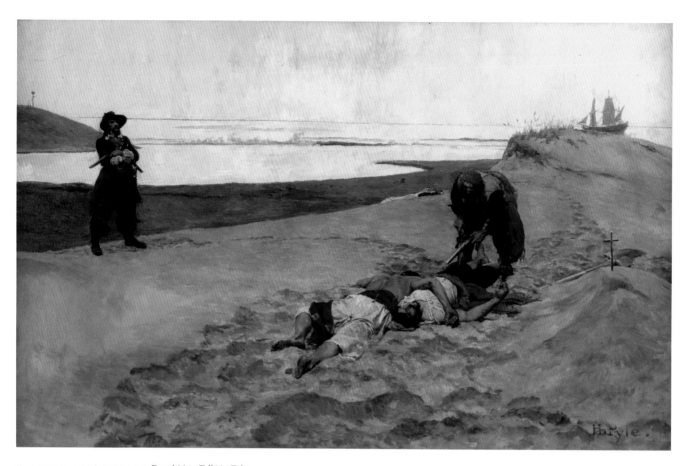

Figure 127. Howard Pyle (1853–1911). *Dead Men Tell No Tales,*
1899. For Morgan Robertson, "Dead Men Tell No Tales." *Collier's
Weekly,* December 17, 1899. Oil on canvas, 20¼ × 30¼ inches. The
Kelly Collection of American Illustration

Over the decades Pyle's themes—which, of course, were
not exclusively his—have found their way into other types
of films besides pirate movies. The atavistic lust for gold
depicted in *So the Treasure Was Divided* returned with a
vengeance in Erich von Stroheim's *Greed* (1924), based on
Norris's masterpiece of literary naturalism *McTeague* (1899),
and again in the Humphrey Bogart classic *The Treasure of
the Sierra Madre* (1948), directed by John Huston. In Oli-
ver Stone's *Wall Street* (1987), Gordon Gekko, the corporate
raider played by Michael Douglas, proudly proclaims, "Greed
is good," thus providing a catchphrase that in Reagan-era
America was both reviled and admired. Action movies that
lean heavily on the depiction of pirate types, whether good
guys or bad, include *The Wild Bunch* (Sam Peckinpah, 1969),
Star Wars (George Lucas, 1977), *Escape from New York* (John

Carpenter, 1981), *Mad Max 2: The Road Warrior* (George
Miller, 1981), *Waterworld* (Kevin Reynolds, 1995), and *Gangs
of New York* (Martin Scorsese, 2002), to name but a few in
which powerfully self-reliant heroes or antiheroes take
charge of marauding gangs in lawless times through sheer
force of will.

Hollywood, in picking up the Jolly Roger after Pyle's
death in 1911 and waving it aloft time and again over the next
one hundred years, found an often reliable creative outlet
for dealing symbolically with the very themes that had per-
sistently troubled Pyle and his contemporaries. The artist-
illustrator returned repeatedly to pirate figures and the
archetypal narratives they inhabited because they provided
him—and many of his genteel readers and viewers—a richly
active visual language for contemplating several of the most

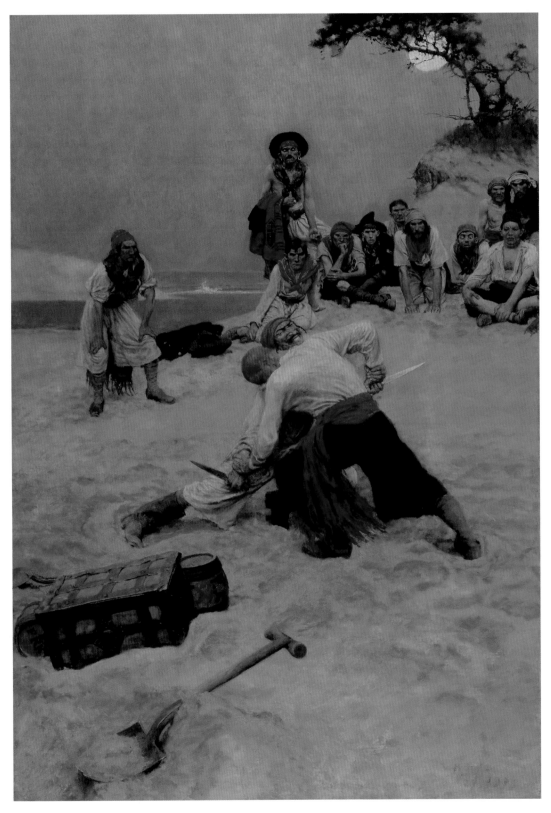

Figure 128. Howard Pyle (1853–1911). *Which Shall Be Captain?* For Don C. Seitz, "The Buccaneers." *Harper's Monthly Magazine*, January 1911. Oil on canvas, 48 × 31¾ inches. Delaware Art Museum, Gift of Dr. James Stillman, 1994

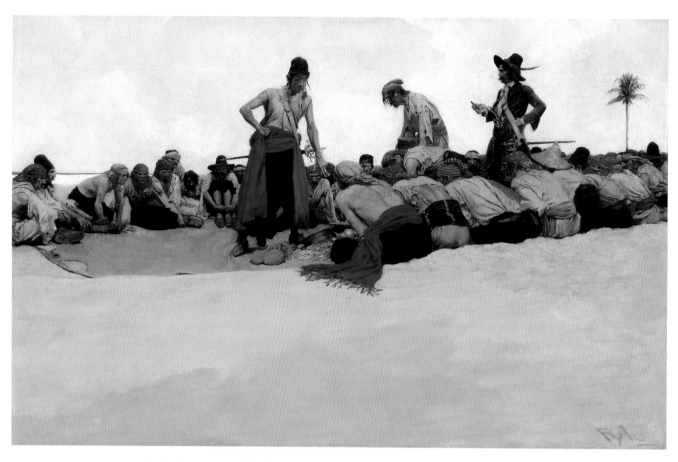

Figure 129. Howard Pyle (1853–1911). *So the Treasure Was Divided,* 1905.
For Howard Pyle, "The Fate of a Treasure Town." *Harper's Monthly Magazine,*
December 1905. Oil on canvas, 19½ × 29½ inches. Delaware Art Museum,
Museum Purchase, 1912

pressing social matters of the day: how to be rugged, bold, and self-sufficient in an increasingly complex, codified, and interdependent society; when to be ruthless and when to be merciful; how to bond socially with other men even when in competition with them; how to be physically graceful and elegant without appearing unmanly or effeminate; and how to discern who is taking advantage of whom in a world surfeited with false rhetoric and deceptive appearances.

Such broadly human concerns aside, piracy as a form of illicit endeavor has long been of special relevance in the narrower sphere of filmmaking. Pop in a DVD of practically any movie today, a pirate film or otherwise, and the first thing you will see is an FBI warning against *piracy,* that is, illegal duplication of the cinematic product. This is not a new worry; three quarters of a century before movies

became easy to copy or download, the studios struggled to defend their "property"—be it stars, script ideas, or affiliated theaters—from ransacking by rival studios. Indeed, industrial piracy has roiled the waters of American cinema from the beginning. In the early days of the twentieth century, renegade filmmakers set up shop in Southern California in order to escape the patent laws that East Coast monopolists, led by inventor Thomas Alva Edison, tried to enforce as a means of maintaining strict financial and creative control over the fledgling movie industry.

Concern over the piracy of intellectual property predates the advent of cinema. In the 1840s Charles Dickens railed against American publishers for ignoring international copyright laws, and in 1879 Gilbert and Sullivan, fed up with the pirating, or unlicensed production, of their hit

opera *H.M.S. Pinafore* by American theatrical companies, wrote *The Pirates of Penzance* in comic protest. In 1891 the Pittsburgh Alleghenies baseball team was nicknamed the Pirates for having lured away the Philadelphia Athletics' best player—not a case of intellectual property theft, to be sure, but of commercial plunder nonetheless—and the team formally adopted the name in 1912. Recently, several Hollywood films have even revolved around the topic of piracy at the corporate level, among them *Michael Clayton* (Tony Gilroy, 2007), *Duplicity* (Tony Gilroy, 2009), *The Informant!* (Steven Soderbergh, 2009), and, most notably, *The Social Network* (David Fincher, 2010).

As a prolific and well-paid commercial artist, Pyle must have been as concerned with piracy as anyone else in the publishing and entertainment industries. Perhaps this is reflected in his endless fascination with the subject. We cannot say for sure. But what does seem clear is that for Pyle, as for his later counterparts on and behind the silver screen, the pirates of olden days were apt stand-ins for heroes and villains of modern times. And Hollywood, which "stole" prodigiously from the illustrator over the course of many decades, has been embroiled with piracy ever since.

NOTES

1 Scholarly and popular histories of the Golden Age of Piracy include Robert Carse, *The Age of Piracy: A History* (New York: Rinehart, 1957); David Cordingly, *Under the Black Flag: The Romance and the Reality of Life among the Pirates* (New York: Random House, 1996); Gabriel Kuhn, *Life under the Jolly Roger: Reflections on Golden Age Piracy* (Oakland, Calif.: PM Press, 2010); C. R. Pennell, *Bandits at Sea: A Pirates Reader* (New York: New York University Press, 2001); Marcus Rediker, *Villains of All Nations: Atlantic Pirates in the Golden Age* (Boston: Beacon Press, 2005); and Frank Sherry, *Raiders and Rebels: The Golden Age of Piracy* (New York: Hearst Marine Books, 1986).

2 For a discussion of Pyle's pedagogy, see Richard Wayne Lykes, "Howard Pyle, Teacher of Illustration," *The Pennsylvania Magazine of History and Biography* 80, no. 3 (July 1956): 339–70. For Pyle's philosophy of illustration, see Howard P. Brokaw, "Howard Pyle and the Art of Illustration," in Douglas K. S. Hyland, *Howard Pyle and the Wyeths: Four Generations of American Imagination* (Memphis: Memphis Brooks Museum of Art, 1983), 13–37. An insightful biographical portrait of the artist and a study of his pirate-themed popular fiction can be found in Lucien L. Agosta, *Howard Pyle* (Boston: Twayne Publishers, 1987), 1–23, 123–40.

3 Walt Reed and Roger T. Reed, "I Had Met My Equal," in John Edward Dell with Walt Reed, eds., *Visions of Adventure: N. C. Wyeth and the Brandywine Artists* (New York: Watson-Guptill Publications, 2000), 46.

4 Jeffrey Vance with Tony Maietta, *Douglas Fairbanks* (Berkeley: University of California Press, 2008), 206. The former child star Jackie Coogan claimed responsibility for introducing Fairbanks to *Howard Pyle's Book of Pirates* at a Hollywood awards ceremony in 1922; see Aljean Harmetz, "Jackie Coogan: Remember?" *New York Times*, April 2, 1972, 11.

5 Pyle's influence on Hollywood extended beyond the vivid depiction of pirates and like-minded scoundrels. As America's first great historical illustrator—that is, one whose book and magazine images described the past rather than the present—Pyle conjured times and places other than the Spanish Main of the seventeenth and eighteenth centuries. In the decades following Pyle's death, his portfolio became a visual sourcebook for a wide variety of costume films produced by Hollywood, not only those depicting pirates at sea but also those portraying King Arthur and his knights, Robin Hood and his men, and the patriots of the American Revolution.

6 Robert Kolker, *A Cinema of Loneliness: Penn, Stone, Kubrick, Scorsese, Spielberg, Altman*, 3rd ed. (Oxford, England: Oxford University Press, 2000).

7 Mary Johnston, *To Have and to Hold* (Boston: Houghton, Mifflin and Company, 1900), 208. Hathi Trust Digital Library, http://hdl.handle.net/2027/uc1 .b102395. See Reed and Reed, "I Had Met My Equal," 46.

8 Johnston, *To Have and to Hold*, 210.

9 Howard Pyle, *Howard Pyle's Book of Pirates: Fiction, Fact and Fancy concerning the Buccaneers and Marooners of the Spanish Main*, compiled by Merle Johnson (New York: Harper and Brothers, 1921), 1.

10 Ibid. This quote comes from an unnumbered page before the frontispiece.

11 Quoted in Jeffrey Richards, *Swordsmen of the Screen: From Douglas Fairbanks to Michael York* (London: Routledge and Kegan Paul, 1977), 250.

12 Jack L. Warner, *My First Hundred Years in Hollywood* (New York: Random House, 1965), 232.

13 Theodore Dreiser, *The Titan* (New York: John Lane Co., 1914), 436.

14 Ibid., 520.

15 Robert E. May, "The Domestic Consequences of American Imperialism: Filibustering and Howard Pyle's Pirates," *American Studies* 46, no. 2 (summer 2005): 37–61; Ina Rae Hark, "Movies and the Resistance to Tyranny," in Hark, ed., *American Cinema of the 1930s: Themes and Variations* (New Brunswick, N.J.: Rutgers University Press, 2007), 142–48.

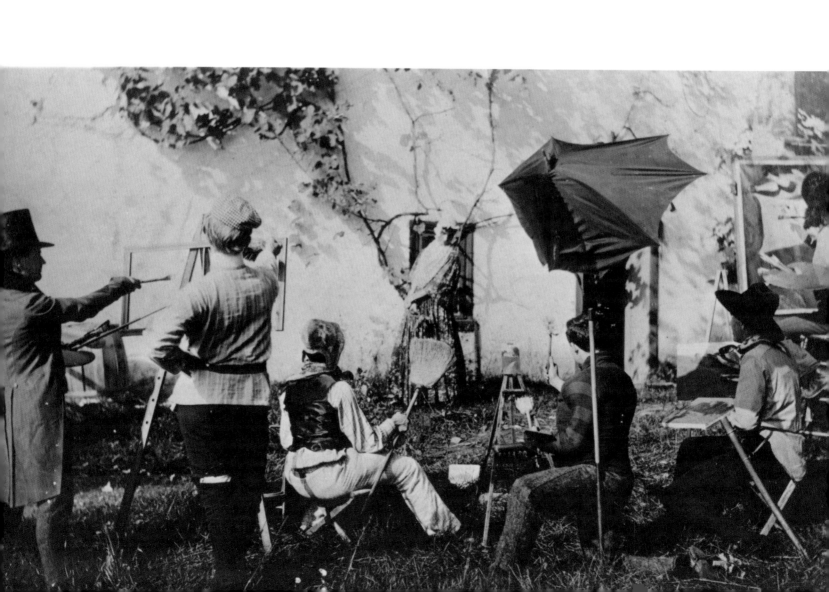

HOWARD PYLE CHRONOLOGY

1853

March 5: Howard Pyle born in Wilmington, Delaware, son of William Pyle and Margaret Churchman Pyle.

1857

Pyle's Quaker parents change the family's religious affiliation to the Swedenborgian church. Pyle will remain a member of Wilmington's Swedenborgian church for the rest of his life.

c. 1869

Commutes to Philadelphia to study with Francis Van der Wielen for about three years.

1870

Admitted into antique class at the Pennsylvania Academy of the Fine Arts.

Works at Wilmington Hide and Tallow Association, his father's business.

Pennsylvania Academy of the Fine Arts sells Chestnut Street building and temporarily relocates classes to the Soldier's Home and later to Professor Christian Schussele's house.

1871

Designs masthead for *Every Evening*, a Wilmington newspaper.

Attends a few sessions of life class at the Pennsylvania Academy of the Fine Arts.

1872

September: Wilmington jewelry shop displays a picture by Pyle. Pyle places an advertisement in newspaper offering lessons in drawing.

1875

Listed in Wilmington directory as an artist.

Begins submitting illustrated stories to Scribner and Sons publications.

Art Students League is founded in New York.

1876

Pennsylvania Academy of the Fine Arts reopens at Broad and Cherry Streets. Thomas Eakins begins career as an instructor at the Academy.

Spring: Travels to Chincoteague, Virginia, and prepares essay with sketches, which would become his first story accepted by *Scribner's Monthly*.

May–November: Centennial Exhibition held in Fairmount Park, Philadelphia.

July: Poem, "The Magic Pill," and two ink drawings appear in *Scribner's Monthly*.

October: Moves to New York City. Stays in boarding house on 48th Street and attends Swedenborgian services.

November: At the recommendation of Richard Watson Gilder, enrolls in evening life class and sketch class at the Art Students League.

Two illustrations are published.

1877

February: Has illustrations published in *Harper's Weekly* and *St. Nicholas*.

April: "Chincoteague: The Island of Ponies" appears in *Scribner's Monthly*.

Rents studio with two other artists.

Forty-three illustrations are published.

1878

March: *Wreck in the Offing!*, Pyle's first full-page picture not redrawn by a staff artist, appears in *Harper's Weekly*.

March: First exhibition of the Society of American Artists, featuring works by European-trained artists including William Merritt Chase, Walter Shirlaw, and Julian Alden Weir.

November: Rents his own studio at 788 Broadway.

Work frequently is published in *St. Nicholas*, *Harper's Weekly* and *Harper's New Monthly Magazine*.

Attends composition class at the Art Students League.

Member of Salmagundi Club.

Social circle includes Edwin Austin Abbey, William Merritt Chase, F. S. Church, Charles Reinhart, Walter Shirlaw, and J. Alden Weir.

Twenty-three illustrations are published.

1879

June: Exhibits work in Salmagundi Club exhibition at the Kurtz Gallery.

Summer: Returns to Wilmington. Sets up studio in upper floor of parents' house at 714 West Street, Wilmington.

First book is published containing Pyle illustrations: *McGuffey's Fifth Eclectic Reader*.

Seventy-five illustrations are published.

1880

April: First illustration is published in *Harper's Young People*. Meets Anne Poole.

July: Becomes engaged to Anne Poole, a widow.

Forty-five illustrations are published.

1881

April 12, 1881: Marries Poole. Illustrator A. B. Frost serves as best man.

Summer: Vacations in Rehoboth, Delaware.

Dodd, Mead, and Company publishes of *The Lady of Shalott* and *Yankee Doodle*, Pyle's first solo books.

118 illustrations are published.

1882

June 4: Sellers Poole, first son, born.

Sixty illustrations are published.

1883

Opens studio at 1305 Franklin Street.

The Merry Adventures of Robin Hood of Great Renown, in Nottinghamshire is published by Charles Scribner's Sons.

Begins work on full-page verses for *Harper's Young People*, which are later published in book form as *Pepper and Salt, or Seasoning for Young Folk*.

129 illustrations are published.

1884

Fifty-four illustrations are published.

1885

Pyle's first novel, *Within the Capes*, is published.

112 illustrations are published.

1886

Thomas Eakins is asked to resign from Pennsylvania Academy of the Fine Arts over use of nude models in classes containing men and women.

December 28: Phoebe born.

Ninety-seven illustrations are published.

1887

August and September: Illustrations for "Buccaneers and Marooners of the Spanish Main" appear in *Harper's New Monthly Magazine*.

June 11–July 30: Pyle's first pirate story "The Rose of Paradise" is published in *Harper's Weekly*.

First half-tone reproductions of Pyle's illustrations appear in James Baldwin's *A Story of the Golden Age* published by Charles Scribner's Sons.

Ninety-nine illustrations are published.

1888

Publication of *Otto of the Silver Hand*, written and illustrated by Pyle, by Charles Scribner's Sons.

227 illustrations are published.

1889

February 22: While Pyle and his wife are in Jamaica, his son Sellers dies.

August 19: Theodore born.

1889–1902: Listed in Wilmington directory as vice president of C. and W. Pyle's Company.

Forty-four illustrations are published.

1890

Begins long correspondence with William Dean Howells.

214 illustrations are published.

1891

August 1: Howard born.

Illustrates Howells's poems for *Harper's Monthly*, later published as *Stops of Various Quills*.

Publication of Pyle's edited version of A. O. Exquemelin's *The Buccaneers and Marooners of America*, with an introduction and illustrations by Pyle.

Drexel Institute of Art, Science, and Industry is founded in Philadelphia.

William Merritt Chase begins first open-air art school in the United States, the Shinnecock Summer School of Art in Southampton, Long Island.

129 illustrations are published.

1892

Publication of Pyle's books *The Rose of Paradise, Men of Iron,* and *A Modern Aladdin* by Harper and Brothers.

June: First mystical writing "To the Soil of the Earth" is published in *Cosmopolitan*.

Publication of Oliver Wendell Holmes's *The One Hoss Shay*, illustrated by Pyle.

Publication of Oliver Wendell Holmes's *The Autocrat of the Breakfast Table*, with fifty-nine illustrations by Pyle.

157 illustrations are published.

1893

World's Columbian Exposition in Chicago. Pyle is represented with ten paintings in black and white lent by Charles Scribner's Sons, Harper and Brothers, and the Century Company.

December: First two-color reproduction, "The Pirates' Christmas," appears in *Harper's Weekly*.

176 illustrations are published.

1894

February 10: Eleanor born.

October: Begins career as instructor of illustration at Drexel Institute. Continues teaching at Drexel until 1900.

Begins unillustrated novel, *Rejected of Men*, which is praised by William Dean Howells, but not published until 1903.

145 illustrations are published.

1895

March: After one month of lectures on artistic anatomy, Thomas Eakins is dismissed from Drexel Institute for using a nude male model in a class of men and women.

October 15: Godfrey born.

Publication of *The Story of Jack Ballister's Fortunes*.

Summer: *Harper's New Monthly Magazine* contracts Pyle to illustrate Woodrow Wilson's articles on George Washington.

Exchanges paintings with illustrator Frederic Remington.

Publication of *The Twilight Land* and *The Garden behind the Moon: A Real Story of the Moon-Angel*, written and illustrated by Pyle.

150 illustrations are published.

1896

Woodrow Wilson's serialized life of George Washington appears in *Harper's New Monthly Magazine,* with illustrations by Pyle.

Pyle is appointed director of School of Illustration at Drexel Institute.

Ninety-nine illustrations are published.

1897

October 29: Wilfred born.

Pyle's paintings of George Washington and American colonial life are exhibited at the Drexel Institute in Philadelphia and the St. Botolph Club in Boston.

April: First full-color reproduction in "Washington and the French Craze of '93" in *Harper's New Monthly Magazine*.

May 29–June 5: First exhibition of Pyle's students' work at Drexel.

Publication of "A Small School of Art," Pyle's first articulation of his principles of instruction, in *Harper's Weekly*.

Fifty-four illustrations are published.

1898

Summer: Pyle's summer program, with focus on illustration produced outdoors, opens in Chadds Ford, Pennsylvania. Ten students from Drexel attend.

January–December: Serial publication of "The Story of the Revolution," by U. S. Senator Henry Cabot Lodge, in *Scribner's Magazine*. The essays include illustrations by Pyle and others.

Seventy-three illustrations are published.

1899

Summer: Class at Chadds Ford under auspices of Drexel Institute.

Twenty-nine illustrations are published.

1900

February: Pyle resigns from Drexel Institute.

Charles Scribner's Sons circulates exhibition of illustrations of American history by Pyle and others.

Opens Howard Pyle School of Art in Wilmington. Plans studios for students next to his studio on Franklin Street.

December: Publication of "The Pilgrimage of Truth," by Erik Bøgh in *Harper's New Monthly Magazine*, a commission that provided Pyle with the opportunity to experiment with the latest technologies for color printing.

112 illustrations are published.

1901

Summer: Class at Chadds Ford.

Fifty-eight illustrations are published.

1902

Member of the Society of Illustrators.

Member of the Bibliophile Society.

Summer: Class at Chadds Ford.

September: *Handicraft* publishes Pyle's article based on a talk read to the Society of Arts and Crafts in Boston.

November 1902–October 1903: "The Story of King Arthur and His Knights" serialized in twelve installments in *St. Nicholas.*

Eighty-four illustrations are published.

1903

June: Gives graduation address at the School of Fine Arts of Yale University.

Publication of *The Story of King Arthur and His Knights* by Charles Scribner's Sons.

Final summer of art classes at Chadds Ford.

Illustrates *The Bibliomania* by Thomas Frognall Dibdin for the Bibliophile Society.

December 3: Exhibition of over one hundred works by Pyle opens at Art Institute of Chicago. Exhibition travels to Toledo, Cincinnati, and Detroit in 1904.

110 illustrations are published.

1904

Draws cartoon and writes article supporting Theodore Roosevelt's presidential campaign.

Becomes friend of Roosevelt.

Joins Century Association in New York.

Member of the Franklin Inn Club of Philadelphia

December 3: Begins biweekly composition lectures at the Art Students League in New York. Lectures last through May 1905. Pyle considers this teaching experience a failure.

Thirty-eight illustrations are published.

1905

Publication of *The Story of the Champions of the Round Table* by Charles Scribner's Sons.

Pyle's work is exhibited for the first time in Washington, D.C., at the Veerhoff Galleries.

Works as art editor for *McClure's Magazine.*

Completes mural decorations for his house at 907 Delaware Ave. One of these murals, *Genius of Art*, is exhibited at the annual exhibition of the Architectural League of New York.

Receives commission to paint mural, *The Battle of Nashville*, for Minnesota State Capitol.

Lectures at Art Institute of Chicago.

Elected Associate Member of the National Academy of Design.

191 illustrations are published.

1906

Pyle's former students N. C. Wyeth, Henry Jarvis Peck, Clifford Ashley, Frank Schoonover, and Stanley M. Arthurs move to four-studio building on Rodney Street.

Eighteen illustrations are published.

1907

Publication of *The Story of Sir Launcelot and His Companions* by Charles Scribner's Sons.

Paints mural *The Landing of Carteret* for the Essex County Court House, Newark, New Jersey.

Elected full member of National Academy of Design.

120 illustrations are published.

1908

February: The Eight (including realist painters Robert Henri, John Sloan, George Luks, Everett Shinn, and William Glackens) holds an exhibition at Fifth Avenue gallery of William Macbeth.

November: Pyle exhibits at Macbeth Gallery, New York.

Writes article supporting William Howard Taft's presidential campaign.

Fifty-four illustrations are published.

1909

Paints *Marooned*, a large easel painting based on an earlier illustration.

Thirty-five illustrations are published.

1910

Publication of *The Story of the Grail and the Passing of Arthur* by Charles Scribner's Sons.

Completes mural for Hudson County Court House, Jersey City, New Jersey, assisted by Frank Schoonover and Stanley M. Arthurs.

Begins painting *The Mermaid,* a large canvas left unfinished on his easel when he departs for Italy.

Fall: Decides to go to Italy to study masterpieces of mural painting.

November 21–December 14: Journey overseas. Pyle is accompanied by Anne, Phoebe, Eleanor, Wilfred, and his secretary Gertrude Brincklé.

Ninety-one illustrations are published.

1911

March: Completes illustration of War of 1812 for E. I. du Pont de Nemours Powder Company calendar.

November 9: Dies in Florence at 6 Via Garibaldi.

Twenty-eight illustrations are published.

1912

The Delaware Art and Library Association (later incorporated as The Wilmington Society of the Fine Arts) is formed to hold an exhibition of work by Howard Pyle. The exhibition opens March 13 at the Du Pont Ballroom.

A large collection of Pyle's work is purchased from Mrs. Pyle and exhibited again in November.

INDEX

Unless otherwise noted, artworks listed are by Howard Pyle. Italicized page references refer to illustrations.